ROMAN ART ROMULUS TO CONSTANTINE

DEAN CLOSE SCHOOL LIBRARY

This book must be returned by the latest date stamped below.

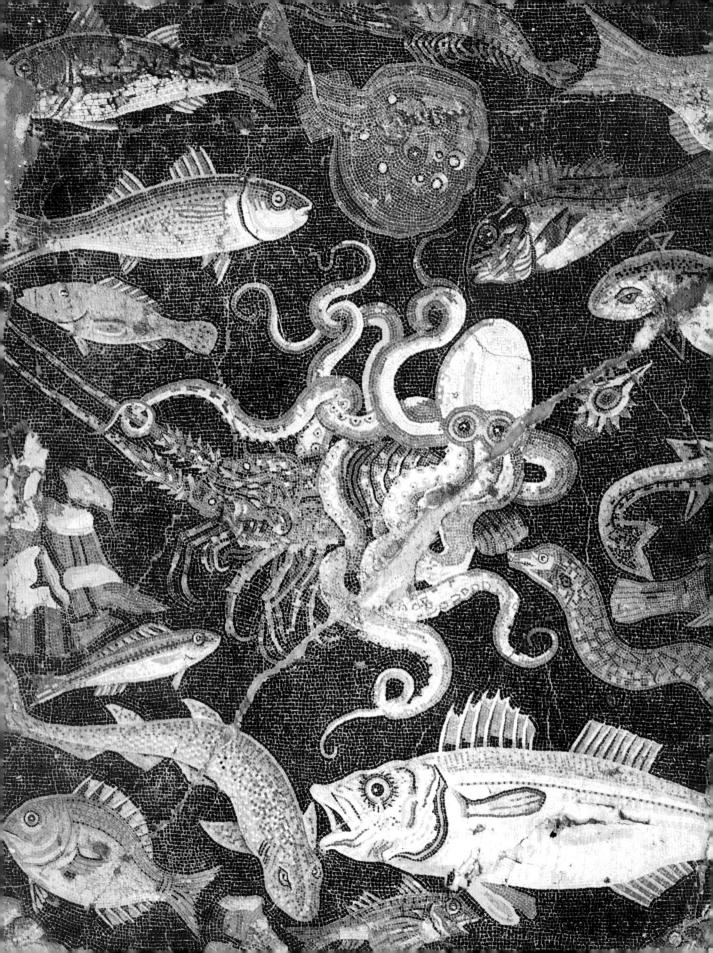

ROMANART ROMULUS TO CONSTANTINE

Nancy H. Ramage & Andrew Ramage

Ithaca College & Cornell University

Prentice Hall, Englewood Cliffs, NJ 07632

In Memoriam Paul Michael Hirschland and John Ramage

All rights reserved. No part of this book may be reproduced, in any form or by any means, without permission in writing from the publisher.

ISBN 0-13-782947-7

This book was designed and produced by JOHN CALMANN & KING LTD, London

Designed by Richard Foenander Picture research by Sara Waterson Typeset by Black Box, Berkshire, England Printed in Hong Kong

10 9 8 7 6 5 4 3

Front cover Detail of a ritual scene in the Villa of the Mysteries, Pompeii. Mid-first century Bc. Wall painting.
Scala Fotografico, Florence

Back cover Crowning of Augustus (above) and the erection of a trophy (below), on the Gemma Augustea. Early first century AD. Double-layered onyx cameo. Height 7½ ins; width 9 ins (19×23cm). Kunsthistorisches Museum, Vienna

Half-title Antinous in the guise of Spring. AD 130–138. Marble relief from the Villa of Hadrian, found in 1735. Villa Albani, Rome

Frontispiece A mosaic with fish, octopus, and other sea creatures, from Pompeii. c. 100 BC, re-used in the early empire. c. 3×3ft (90×90cm). Museo Archeologico Nazionale, Naples

Contents

Preface	9
Introduction	10
The land 12 Chronology 14 The political framework 16 The Republic 16; The Empire 16 Art in the service of the state 16 Rome and Greek art 18 Three periods of Greek art 18; Interconnections 19	
The Villanovan and Etruscan Forerunners	20
1000—200 вс	
The Villanovans 23 The Etruscans 23 Architecture 25 Sculpture 27 Temple terracottas 28; Animal sculpture 29; Funerary sculpture 31; Statuary 33; Portraits 34 Painting 36 Rome, the Etruscans, and Latium 40 Stories of Early Rome 40	
The Roman Republic	44
200–27 BC	
An early sarcophagus 46 Sculpture 47 Historical relief sculpture 47; Portraiture 50 Wall paintings 55 An early tomb 55; House walls 56; Four Pompeian styles 58 Mosaics 65 Architecture 67 Villas and houses 67; Aqueducts 69; Sanctuaries 71; Temples 73 Town planning 75 The Roman Forum, 75; The castrum, 79	
	Introduction The land 12 Chronology 14 The political framework 16 The Republic 16; The Empire 16 Art in the service of the state 16 Rome and Greek art 18 Three periods of Greek art 18; Interconnections 19 The Villanovan and Etruscan Forerunners 1000–200 BC The Villanovans 23 The Etruscans 23 Architecture 25 Sculpture 27 Temple terracottas 28; Animal sculpture 29; Funerary sculpture 31; Statuary 33; Portraits 34 Painting 36 Rome, the Etruscans, and Latium 40 Stories of Early Rome 40 The Roman Republic 200–27 BC An early sarcophagus 46 Sculpture 47 Historical relief sculpture 47; Portraiture 50 Wall paintings 55 An early tomb 55; House walls 56; Four Pompeian styles 58 Mosaics 65 Architecture 67 Villas and houses 67; Aqueducts 69; Sanctuaries 71; Temples 73

3	Augustus and the Imperial Idea 27 BC-AD 14	80
	Architecture 83 The Forum and Tomb of Augustus 83; Theaters 84 Sculpture 86 Portraits 86; Reliefs 90 Wall paintings 99 Stucco 103	
4	The Julio-Claudians AD 14–68	104
	The Gemma Augustea 106 Imperial patronage in the provinces 107 Imperial architecture and sculpture 108 Portraits 110 The other Julio-Claudians 110; Ordinary citizens 112 Sculpture 114 Piety 114; The imperial hero 115 Public works 117 Architecture 118 The Underground Basilica 118; Nero's Golden House 120	
5	The Flavians: Savior to Despot	122
	Vespasian 124 Imperial architecture 124 The Colosseum 124; The Arch of Titus 128; The Flavian palace 131 Sculpture 132 Imperial reliefs 132; Plebeian reliefs 134; Portraits 134 Pompeii and Herculaneum 138 The city of Pompeii 140; Paintings in the Fourth Pompeian style 143; Provincialism in art 149	
6	Trajan, <i>Optimus Princeps</i> AD 98–117	150
	The Baths of Trajan 153	

The Forum and Markets of Trajan 153 The Column of Trajan 156 Other Trajanic sculptural relief 163 The Arch of Trajan at Benevento 164 Timgad 166

7 Hadrian and the Classical Revival

168

AD 117-138

Architecture 171

Hadrian's Villa 171; The Pantheon 175; Other Hadrianic buildings 179

Portraits 183

Reliefs 186

Sarcophagi 188

Attic sarcophagi 188; Asiatic sarcophagi 191; Strigil sarcophagi 193

8 The Antonines

194

AD 138-193

The Antonine family 196

The reign of Antoninus Pius 196

Portraits 196; Architecture 197; Reliefs 200

The reign of Marcus Aurelius and Lucius Verus 200

Portraits 200; The base of the Column of Antoninus Pius 205;

Panels from a triumphal arch 207; The Column of Marcus Aurelius 208;

Sarcophagi 212

The reign of Commodus 216

9 The Severans

218

AD 193-235

The reign of Septimius Severus 220

Portraits 221; Triumphal arches 222; Architecture 228

The reign of Caracalla 235

Public baths 236; Sarcophagi 238

10 The Soldier Emperors

240

AD 235-284

Coins 242

Portraits 242

Maximinus Thrax 243; Balbinus 243; Philip the Arab 244;

Trebonianus Gallus 244; A female portrait 246;

Gallienus 246; Aurelian 248

The Aurelian Wall 248

Sarcophagi 250

11 The Tetrarchs

252

AD 284-312

The establishment of the tetrarchy 255

Architecture in Spalato 255

Architecture in Rome 257

Architecture in northern Greece 259

Mosaics 261

Portraiture 263

Decennalia relief 264

12 Constantine AD 307–337 and the Aftermath

266

Late Antique art 268

Imperial monuments 268

The Arch of Constantine 268; The base of the Obelisk of Theodosius 275

Portraits 275

Architecture 278

A domestic quarter and its paintings 281

Sarcophagi 283

Silver 285

Conclusion 287

Roman Emperors 288

Ancient Authors 289

Glossary 290

Select Bibliography 294

Acknowledgements 296

Photographic Credits 297

Index 298

Preface

This book grows from three roots: first, our teaching, which, time and again, has proven to be a rich field for learning, and for thinking of ways to explain a problem in as straightforward a manner as possible; secondly, our first-hand experience working at Roman sites, primarily in England, Italy, and Turkey; and thirdly, the frequent discussions we hold about Roman affairs — at the bottom of a trench, or over the dinner table. Nancy Ramage's participation in the work of the British School at Rome enabled her to live, so to speak, with the art and the ruins; and our joint work at Sardis, Turkey, has given us the opportunity to participate in an on-going excavation, and to see the results of a group effort unfold over many years.

The book is intended first and foremost for students and readers who are launching into the study of Roman art perhaps for the first time. We assume intelligent readers, but we have tried to explain what may not be obvious in terms of background, be it linguistic, historical, or religious. With a view to showing something of the long study of Roman monuments, we have chosen some of the illustrations from older photographs, engravings, and drawings, which seem to capture the spirit better than modern ones. The architectural remains have been cited and illustrated as their importance requires, but we have tried to illustrate sculpture or

painting from collections in the United States, where possible, so that American students will have a better chance of looking at some of the originals.

Of the many scholars who taught us about Roman art, we would especially like to share our warm appreciation here for the inspiration of several mentors who are no longer living: Doris Taylor Bishop, George M. A. Hanfmann, A. H. McDonald, and John B. Ward-Perkins. For specific ideas, we gratefully acknowledge assistance from Elizabeth J. Sherman, Ellen, Roger, and Edward Hirschland; David Castriota, J. Stephens Crawford, Caroline Houser, Barbara McLaughlin, Andrew Stewart, Susan Woodford, and the anonymous readers for the press, who made many valuable suggestions. We are also grateful to Norwell E Therien, Jr., at Prentice-Hall, and to Rosemary Bradley and Ursula Sadie at John Calmann and King, London, for their outstanding assistance. Our children, Joan and Michael, have been most patient and supportive. We also thank our friends and colleagues with whom we have discussed problems of Roman art - but do not saddle them with responsibility for the positions taken here. And finally, we dedicate this book to the memory of our respective fathers, optimis patribus, each of whom set us upon the Roman road.

Introduction

In Western cultures, we live by Roman institutions and laws. Our buildings, plays, and philosophy owe debts — unacknowledged or patent — to the breadth and power of that long-gone empire. Yet the fact remains that many, living this legacy daily, are unaware of our classical forebears, of the leavings of history — texts in Greek and Latin, and productions in clay, bronze, and stone.

The testimony of art and architecture is mute, and therefore difficult to interpret without some background in how it works and to what it relates. Yet it is no less eloquent than written texts as a source of history. This book is intended to be accessible and informative to those with little prior knowledge of the classical world, and is meant to lead the reader through the tangled skein of evidence produced over many centuries, by peoples of many languages and cultures.

Defining Roman art is a fascinating challenge because an apparently simple question requires a complicated answer. As we shall see, it is not sufficient to say that the Romans produced it: often they did not. They regularly employed artists and architects from the lands they had absorbed into their empire (fig. **0.1**) and willingly allowed them credit for preeminence in the fine arts. Yet we find, in all but the most slavish copies of Greek masterpieces, qualities of subject or approach that mark these monuments as Roman and

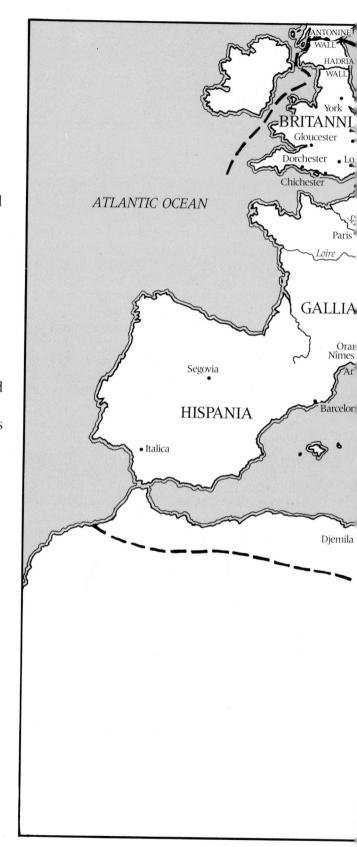

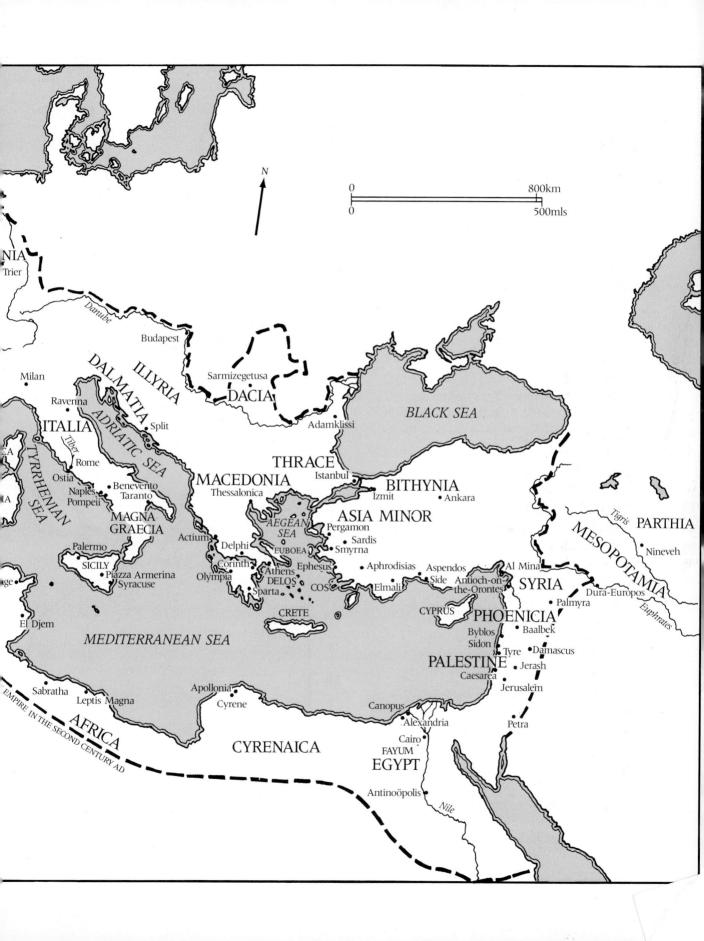

their totality as Roman art. "Roman" and "Romans" have to be defined more broadly than the city of Rome or even the inhabitants of Italy as we know it today. Roman art changed as new groups of people were incorporated and new institutions were required to carry out changing administrative needs. The art of the Romans is the primary focus of this book, be it sculpture, architecture, or painting, but, in our efforts to understand the Roman contribution, we shall not ignore history or politics or literature.

The land

The peninsula of Italy projects far into the Mediterranean, bordered by water on all sides except in the north, where the Alps wall it in (fig. **0.2**). The land is rich and fertile in many parts,

0.2 Topographical map of Italy

0.3 City of Rome, plan

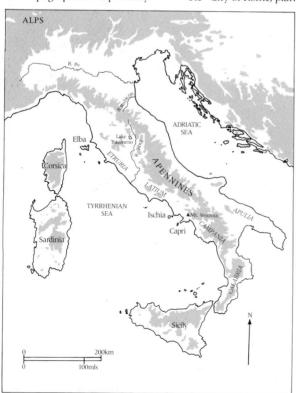

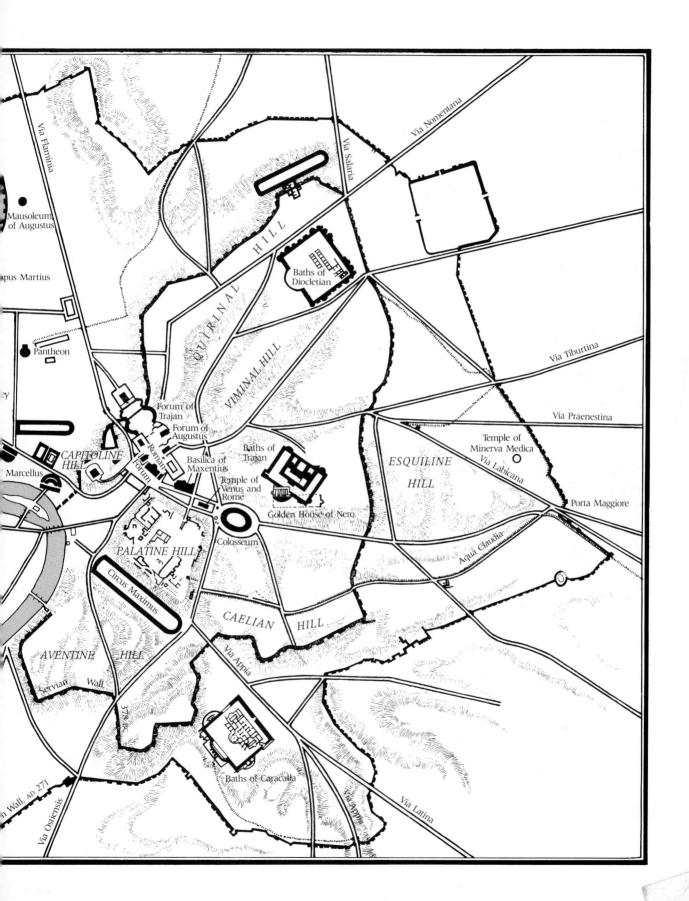

and had supported an agricultural way of life from the sixth millennium BC. There was active exploitation of copper deposits from the first half of the second millennium BC, in the coastal hills to the northwest of Rome, even as far as Elba, an island rich in minerals. Then iron was mined from early in the first millennium. As often in the history of the world, the search for rare or useful metals stimulated intense economic activity and cultural change. This goes far to explain the beginnings of urban culture in this part of Italy.

A rugged chain of mountains, the Apennines, runs down most of the length of Italy like a spine, and acts as a barrier between east and west; even today, passage over these mountains is a challenge, especially in winter. Those towns to the west of the mountains looked to the Tyrrhenian Sea for their trade routes, while those to the east looked to the Adriatic. The rivers played their part in the development of Italic culture and economy, providing the possibility of a network of water transportation in their lower reaches.

Easy access to the sea was to play an important role in acceptance of the foreign influences that had such an effect on the development of the art of Rome and her ancestors. The importance of trade by sea can be seen from the numerous cities that rose to prominence either because they were located on the coast or because they had easy access to the sea by inland waterways. Rome itself had several advantages. Its seven hills (fig. 0.3) rendered it unusually defensible, and its strategic position at a river crossing was useful for inland travel in several directions. Its advantageous location in the center of an agricultural region bounded by hills, and its position somewhat away from the sea, but on a navigable river, are also undoubtedly important reasons why it became such a major city.

Chronology

We shall discuss the monuments chronologically in this book, in the belief that this is the most convenient and enlightening way to begin studying the material. For the earlier eras the conventional division into cultural and historical periods seems appropriate, but later it is more meaningful to organize the material by emperor or groups of emperors in the same family, because the rulers seem to have had such an important effect upon taste and patronage throughout the Roman empire.

Our beginning point is not a fixed date, but it falls somewhere about 1000 BC, so that we may set the scene in Italy before the Romans had established themselves as a presence. In those early days, Rome itself was no more than a group of small hamlets that would have looked much like the other villages that dotted many parts of central Italy. From that humble beginning we shall trace the art of Rome, while looking at the same time at the political and historic background that helps to explain the emergence of the city itself.

Roman art, from Romulus to Constantine, covers a period of well over 1,000 years. In fact, we cannot call all of this truly "Roman," for the early centuries belong to ancestors or rivals, whose material culture Romans may have shared but did not create. The heritage of these groups can be thought of as forming a common Italic background to Roman institutions. The earliest groups are known as the Villanovans, who lived from the tenth century BC to about 700 BC. Subsequently, one group known as the Etruscans created a distinct and more prosperous culture through much of central Italy that lasted from about 700 BC to roughly the first century BC, when their culture was absorbed by the Romans. Many characteristics of Roman art will be found to have their roots in Etruscan art and architecture, and it is therefore important to look back at Etruscan culture (see below, chapter 1).

We end our study with the death of the emperor Constantine the Great in AD 337; however, as there is no real agreement on when Roman art ends, we shall also include a few later objects to illustrate the development of trends that Constantine's policies set in motion.

0.4 The emperor Trajan addresses his troops (*adlocutio*), scene 42 from the Column of Trajan, Rome. AD 113. Marble relief. Height of frieze c. 3ft 6ins (1·1m)

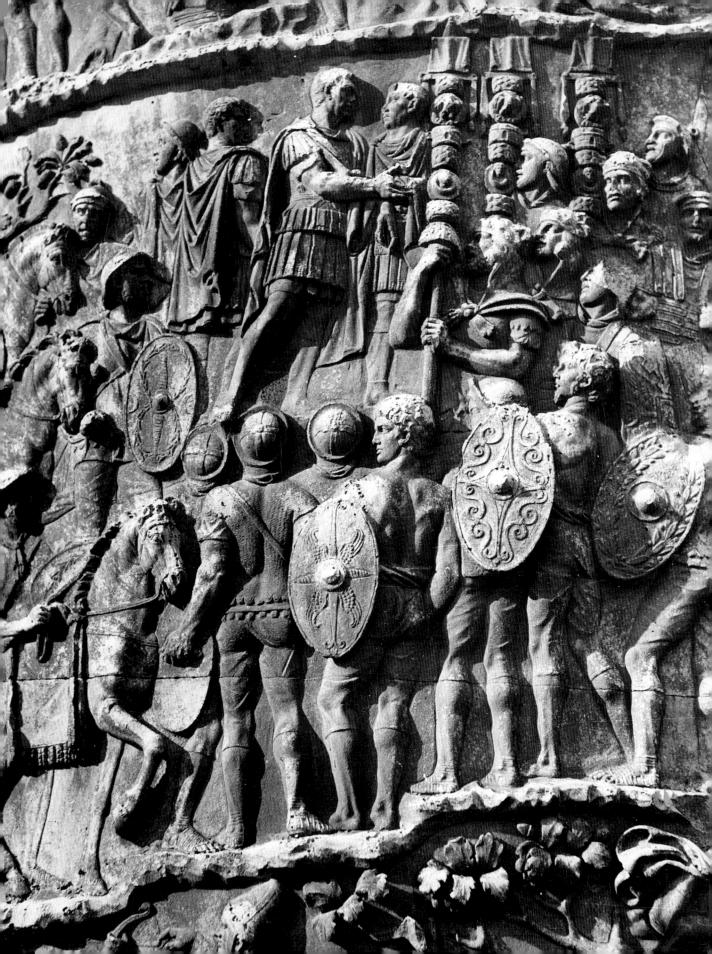

The political framework

THE REPUBLIC

The Roman era itself is divided politically into two periods. The first of these is the Republican period which began, according to tradition, in 509 BC, after the expulsion of king Tarquinius Superbus. The citizens were either patricians (belonging to the upper classes, the aristocrats based mainly in the countryside) or plebeians (those who belonged to the general urban populace of citizens, later associated with the lower classes). In the early Republican period there was a sharp distinction between the two groups, and much tension. The plebeians were grudgingly accorded more and more rights of sharing in the government, and eventually the distinction made little sense except to separate the rich and the poor, or the élite and the masses.

Under the Republic, the people were governed by a set of magistrates with different administrative functions, who were elected annually. Of these, the two consuls, who originally took over the functions of the ousted king, Tarquinius Superbus, were the most important, and they were responsible to the people through the Senate, the supreme council of the Roman state. This system broke down in the late second and first century BC, after several generals who had wielded absolute power as dictators, legally appointed to deal with an emergency, were unwilling to give up their positions after the crisis was over. Civil wars resulted from the ensuing power struggles, between about 100 and 42 BC, but they were brought to an end in 31 BC by the victory of Octavian (later called Augustus) over Mark Antony at the Battle of Actium.

THE EMPIRE

The result of this battle was to leave Octavian sole ruler of the Roman world, but this time with no serious rivals. During his rule the constitution was reorganized a number of times but the crucial change was in 27 BC, when he was given the title of Augustus, "the revered one," and several important honors bestowed by the Senate. Thus the empire began. Members of his own or his wife's family – although none of them were direct descendants – ruled until AD 68, and the period is called the

Julio-Claudian era, after the family names: the Julii and the Claudii. After Augustus, emperors claimed power by virtue of family lineage, adoption, or military power, remembering, however, to pay lip service to the Senate.

Groups of succeeding rulers are often categorized in dynastic terms, although a few, like Trajan and Hadrian, do not fit into long-established families, and others are categorized in political terms and grouped by such names as "the soldier emperors" or the "Tetrarchs." The first term refers to the fact that most of them came to power as the result of a military coup; and the second refers to membership in the tetrarchic system, a new constitutional scheme whereby there were four rulers of the Roman empire, each with his own area of responsibility: two Augusti (senior partners) and two Caesares (junior partners and heirs apparent). The emperor Constantine was the last survivor of the tetrarchic system, and he let it lapse after gaining sole rule, although he shared some authority with his sons. His rule marks the end of an era, for no longer was the empire ruled from Rome. This was the beginning of the triumph of Christianity at Constantinople (present-day Istanbul), the new capital created on the ancient site of Byzantium, at the junction of Europe and Asia.

Art in the service of the state

For the Romans, art and politics were intimately connected. Monuments that recognized public service, and buildings that met public needs, form the core of early Roman art. Many of them must be reconstituted from fragments put together with patient care from innumerable excavations, or imagined from sketchy descriptions of historians or commentators. Additional help in gauging what styles were fashionable at one time or another can be gained from close attention to the examples of the art of private patrons, and from utilitarian objects that were commonly decorated with motifs comparable to those on public monuments.

Civic leaders were well aware of the potential of art as a means of promoting their own ends, during

both the Republican period and the imperial age. The Senate and emperors would erect statues and install commemorative reliefs in public squares, and they sponsored new public buildings or repaired old ones. The sponsorship was almost always explicitly spelled out in an accompanying inscription, prominently displayed. Honorific statues were normally voted by the Senate, and obvious self-promotion was not started until the early first century BC when Sulla, and then Pompey, used propaganda techniques for their own aggrandizement. Julius Caesar was a master at this, and the practice was continued under most of the emperors. Whenever we consider a piece of Roman statuary, or a painting or building, we must consider the circumstances that brought it into being, the meaning it expresses, and the intentions of the patron. Although many formal characteristics were shared with Greek art, as we shall see, the meaning for the Roman patron was often different.

In imperial times the display of relief sculpture on the walls of public monuments became popular. Particular emperors or members of their families were shown in imposing positions, commanding the army, or giving out food to the poor. Many of these images were repeated often, almost like a formula, and were thus easily recognizable. For instance, a subject frequently found in Roman art is an emperor addressing a crowd (fig. 0.4). In this motif, called adlocutio in Latin, the emperor can always be picked out because of his prominent position, either raised above the others or standing in front of a large group. We find it often on sculptural reliefs, and also on coins, because it draws attention to one of the primary functions of the imperial office.

The Romans like to emphasize the "here and now," that is, to depict the details of actual events. Thus, on the breastplate of the emperor Augustus (fig. **0.5**), a Roman soldier, who really represents the whole Roman army or the Roman people, receives a Roman military standard from a man from Parthia in Mesopotamia, also representing the whole nation. The message is clear because the

0.5 Augustus of Prima Porta, detail of head and breastplate. Early first century AD, after a bronze of *c*. 20 BC. Marble. Musei Vaticani, Rome

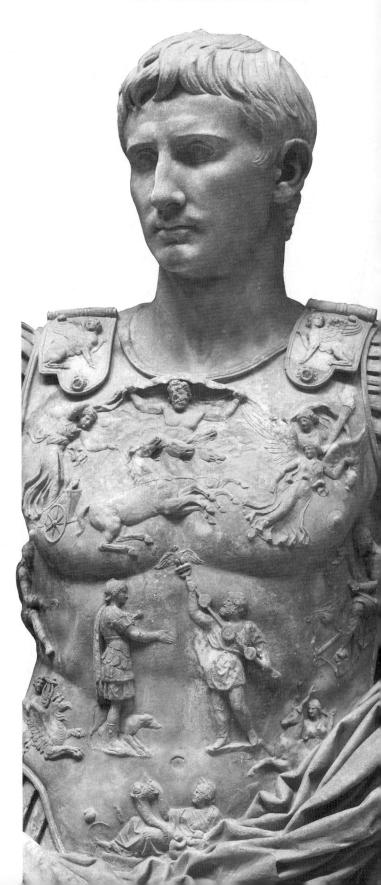

Roman wears typical military dress, while the second figure wears baggy pants - an instantly recognizable sign that this is a foreigner from the east. The event was well known. The standards had been lost in a military disaster, and Augustus made much of the fact that he had retrieved them in 20 BC without bloodshed. This kind of encapsulated narrative enabled the rulers to get clear messages to the people through the visual arts, in a direct form of propaganda. It was not confined to static monuments like historical reliefs or commemorative statues, but was broadcast throughout the Roman world through the medium of coinage. It is hard to overestimate the influence of these images of power and success, generated by the rulers at Rome and disseminated to all their citizens and subjects.

Rome and Greek art

In the course of the book there will be frequent references to the Roman borrowing of Greek forms and styles. Actual works of art were taken by the Romans from Greece itself or from the Greek towns of southern Italy and Sicily. Most of them came into Roman hands as booty from military campaigns, but some, like the great orator Cicero's collection of bronzes, were purchased or commissioned. There is a constant tension in the analysis and evaluation of Roman art between what are sometimes described as the Greek and the Italic contributions, or alternatively as imported Greek as opposed to native Italic. A related division has also been seen as the difference between patrician and plebeian art, depending upon the level of cultivation and association with classical prototypes. Without meaning to endorse the terminology wholeheartedly, we will use the term plebeian, on occasion, to characterize a work that seems to reject classical canons. That there are differences between the styles is undeniable, but the theoretical explanations are not wholly convincing. To see the dualism mentioned above may be helpful, but to insist upon a sharp division is not.

Another way in which differences in style have been interpreted is through the requirements of the subject matter. That is to say, the character of the scene determines the way in which it is to be represented. Deities and personifications, for example, are more likely to be set in classical forms, whereas humans would probably be shown in a more humble style. This dispute has not been settled, and it may always remain an ideological question, but it is important to understand the issues even if a ready solution is not available.

These difficulties often arise because the Romans appropriated Greek forms and frequently used them for different purposes; the result is superficially close but essentially different. Much of the "Romanness" lies in the transformation of Greek vocabulary in all media to express the Roman circumstances, and eventually the whole range of Greek styles was available for use without regard to historical succession.

On the other hand, the Romans could also be sensitive to the original purpose or setting of the works that they borrowed, and the result is often a visual quotation from earlier times that enhances the meaning of the new piece. In other words, they sometimes expected the viewer to recognize the source, and thereby to give additional or new weight to a statue or painting. We shall see this kind of thing, for instance, in a statue of Augustus that was modeled on a famous Greek prototype of the fifth century BC, the classical period (see below, figs. **3.7** and **3.8**).

THREE PERIODS OF GREEK ART

Most of Greek art is conventionally divided into three main periods: the archaic, classical, and Hellenistic. The term "archaic" means "old," and refers to a period, from about 600 to 480 BC, when many of the fundamental ways of portraying the human figure (and other subjects) became established. Similarly, most of the fundamental architectural forms were defined in this period.

The term "classical" carries the weight of excellence, and suggests a standard by which all later art is judged. Artists and connoisseurs from the Renaissance on held the opinion that Greek and Roman art had attained the highest ideals, and, over time, the term has come to refer specifically to the period from about 480 to 330 BC, that is, after the unsuccessful Persian invasion of Athens in 480 to the time when Alexander the Great changed the

balance of power in the eastern Mediterranean. We now mean, in other words, most of the fifth and fourth centuries BC when we refer to classical Greece. Certain conventions, such as the manner in which faces were made, and the portrayals of the human body in the prime of life, were characteristic of this period.

What then does "classicism" mean? It refers to the tendency of later artists and architects to make quotations from the classical period. It also identifies a trend in art to reproduce the kind of idealistic representations associated with that period.

The term "Hellenistic" refers to the spread of Greek culture into non-Greek lands and comes from the Greek term "Hellenes," which is what the Greeks called themselves. It has come to mean the period of later Greek art, from the supremacy of Alexander the Great, about 330 BC, to the time when the military and political power of Rome overcame the independence of the Greeks. When this period ended is a matter of opinion, but, following the usual convention, we place it around the beginning of the first century BC. In fact, many aspects of Hellenistic art were absorbed into the Roman tradition.

INTERCONNECTIONS

Exposure to Greek art on the Italian peninsula began before the city of Rome was big or prosperous, and is most obvious in the large number of imported objects in the great tombs of Etruria and Latium. Equally important is the simultaneous manufacture of local imitations, which is particularly easy to follow in the pottery sequence. The Etruscans seem to have been the primary Italic group trading with Greece and the eastern Mediterranean. Thus, one important line of influence from Greek art comes indirectly through the Etruscan traditions that Rome adopted. Other lines

are direct, but different, in that Rome was first exposed to the material culture and wealth of the Greeks through the conquest and assimilation of towns in southern Italy and Sicily (see above, fig. **0.1**). Much wealth and territory in the western Mediterranean, including Sicily and Spain, was acquired when Carthage, Rome's rival on the coast of North Africa, was eventually overcome. Forays into northern Greece and Asia Minor came later (in the second century BC), and finally the sack of Corinth in 146 BC, and of Athens in 86 BC, brought many famous masterpieces of sculpture and painting into Roman hands.

Rome's expansion around the Mediterranean did not merely change the taste in art; it had a profound effect upon the whole culture and way of life of the wealthy classes. There was an accelerating change from Rome as a country town, whose citizens had local aspirations, to a growing international administrative center. Much of the stored-up wealth of the Greek east poured into Rome, and ostentation and luxury became standard for the rich. This is seen in accounts of the fittings of private houses and of lavish benefactions or expensive public works. Service abroad, captured wealth and artifacts, as well as a large supply of skilled and specialized artisans, all combined in a new and diverse efflorescence of art for the Roman market.

Greek culture was not admired by everyone, and widespread adoption of Greek manners was often denounced as un-Roman and decadent. Tradition was invoked and the hardy ways of the founders of the city and the upright senators were held up in contrast to the hedonistic life of the Greeks and their neighbors to the east. In the end, though, Greek traditions, especially in literature and philosophy as well as art, were grafted onto Roman ways in cultivated circles, and sometimes imitated without understanding by the *nouveaux riches*.

The Villanovan and Etruscan Forerunners 1000–200 BC

In order to get a sense of the long history that lies behind the formation of the art and culture of the Roman people that was to be carried so far afield, we must take a look at their predecessors who lived on the Italian peninsula. Long before one can identify anything as specifically Roman, the ancestors of the Romans were developing their own material culture, language, and social and political organizations, some of which were to have an effect on the culture of the Romans themselves. This formative period in Italy after about 1000 BC is known as the Iron Age.

Of the indigenous people who lived in southern Italy, we have very little preserved except what has been found in their graves, but there is enough material to show that they knew a good deal about farming and about

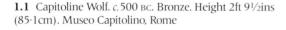

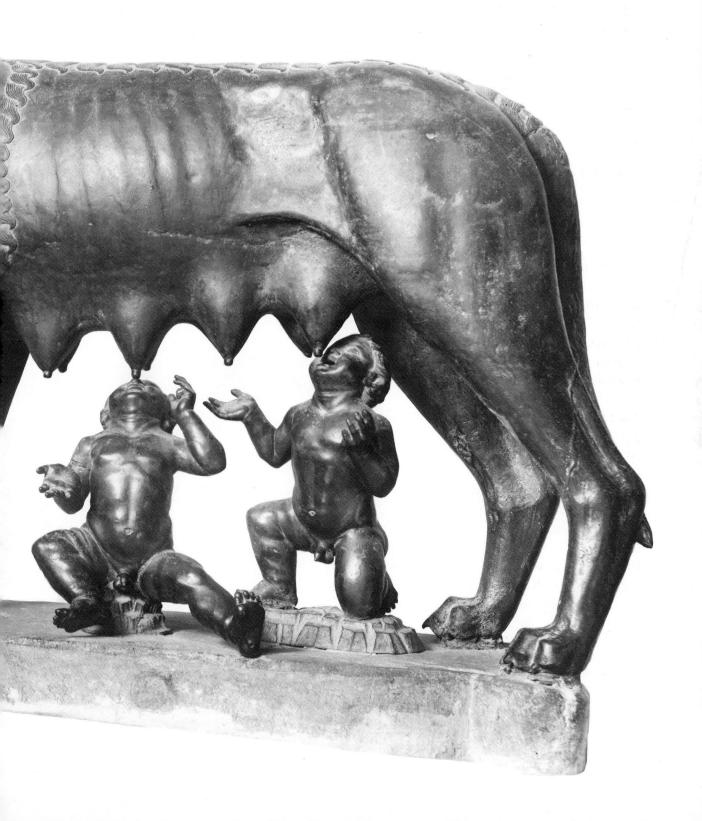

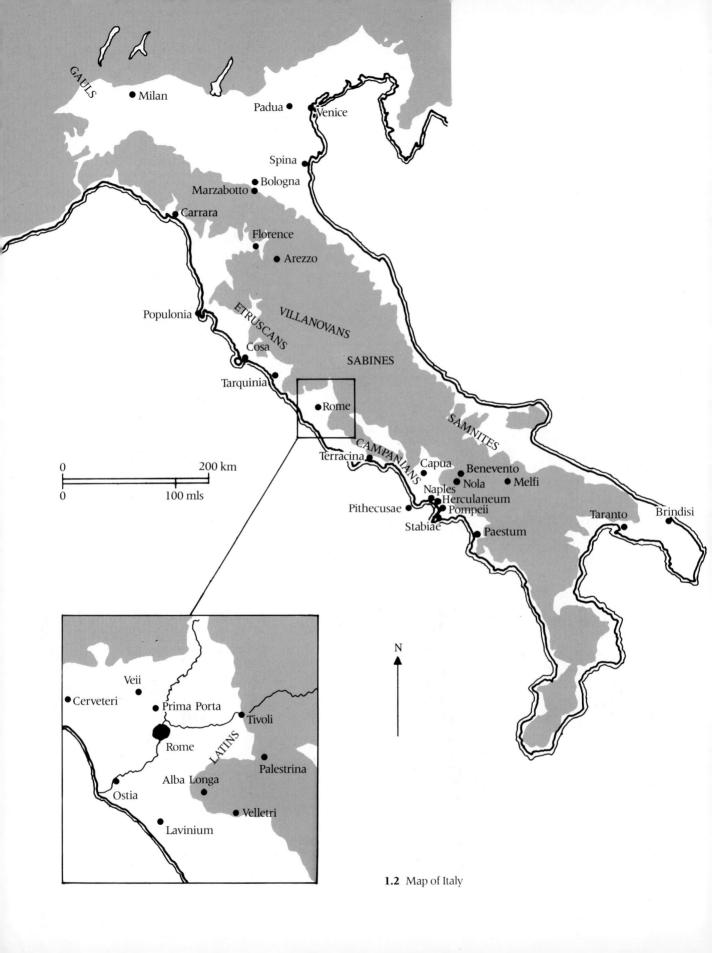

raising animals. The rich and the poor were buried side by side, in the same kinds of graves that can be distinguished only by their contents, which normally consist of clay pots, metal weapons, and personal ornaments. We now know that they had direct contact with the people living in the northern part of the peninsula.

The Villanovans

We call the Iron Age people who lived mostly in the north and west of Italy the Villanovans. They are named after a town close to Bologna (fig. **1.2**) where their gravegoods were first found in 1853. Artifacts found in their graves include objects made

of clay, bronze, iron, bone, and amber. Their men were buried with elaborate bronze belts and helmets (fig. **1.3**) and razors, as well as iron knives and swords. Women had bone hairpins and combs. Both men and women were found with pottery and personal ornaments, such as bronze *fibulae* (safety pins) that were used to fasten their clothes.

It is now clear that the Villanovans were the ancestors of the Etruscans. Many of the objects found in Villanovan graves can be related directly to items in Etruscan contexts, such as this fibula (fig. 1.4), and furthermore, many of the finds from the graves associated with the habitations on the hills of Rome are of the same type. One can thus recreate a common substratum in daily life and religious attitudes, whatever particular differences of language or ethnic type there may have been. It is in this sense that the Villanovans are seen as the ancestors of both the Etruscans and the Romans.

The Etruscans

In the seventh century BC, in the region northwest of Rome, we begin to see, among the traditional artifacts of Villanovan style, many objects that clearly show influence from Greece, as well as from Phoenicia, Assyria, and other parts of the Near East.

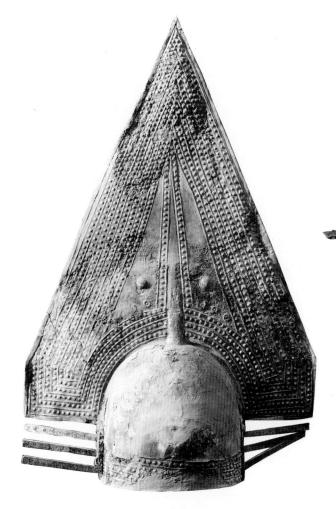

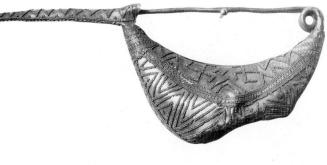

- **1.3** *Left* Villanovan helmet. Eighth century BC. Bronze. Height *c*. 1ft 1in (33cm). Museo Nazionale di Villa Giulia, Rome
- **1.4** *Above* Etruscan fibula, from the Regolini-Galassi Tomb. 700–650 Bc. Gold. Length $3^{1}/4$ ins (8·3cm). Musei Vaticani, Rome

At the same time, these foreign influences were also being introduced in the southern parts of Italy, where several Greek city-states had set up colonies, many of which became prosperous and contributed to the development of Roman art.

Although the make-up of the population north of Rome did not change fundamentally at this time, the character of the art did; native elements mingled with the influences from abroad, and the culture became more cosmopolitan. A written form of the language also appeared for the first time in this period. These people, flourishing around the seventh century, have therefore been conventionally called by a different name from their predecessors: the term "Villanovans" seems too broad, and we, like the Romans, call them the Etruscans, and their land, Etruria.

Etruria was a confederacy of 12 city-states that stretched from just north of Rome into northern

Italy near Florence, but its influence can be seen further north, as far as the valley of the Po River and also in more southern parts of Italy, in the area near Capua and Nola. There was extensive trade with some of the cities established in the south by Greek colonists, as well as with native populations in that region.

Although it is now accepted that the people were largely indigenous, the origins of the Etruscans used to be a subject of debate. The earliest account is given by the Greek historian Herodotus, in the fifth century BC [I. 94]. He explained that the Etruscans were descended from the ancient Lydians, whose capital at Sardis lay across the Aegean Sea in Asia Minor, in what is now Turkey. This story claimed that after the Lydian king's people suffered a long famine, he decided that half the population would remain at Sardis under his rule, while the other half would sail across the sea in search of a

1.5 Below Villanovan amphora, from the Bocchoris Tomb, Tarquinia. c. 700 BC. *Impasto*. Height 1ft 3½ins (39.4cm). Museo Nazionale, Tarquinia

1.6 *Right* Etruscan amphora. Late seventh century BC. *Bucchero*. Height 9ins (22·9cm). Musei Vaticani, Rome

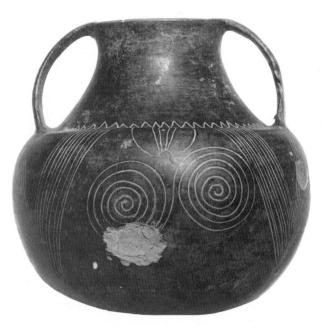

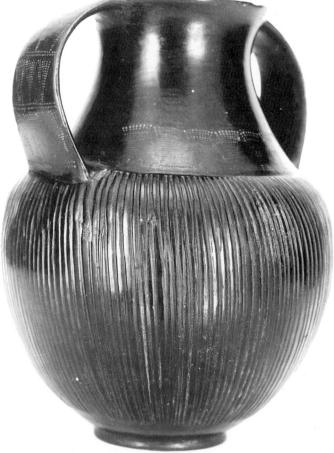

new home. They would have as their leader the king's son, Tyrrhenus, after whom the Tyrrhenian Sea is named. The two segments drew lots, and one group left for new lands to the west.

Already in Roman times, Dionysius of Halicarnassus was questioning this theory, but recently, we have obtained far more information as a result of the discoveries of archaeologists. We now know that the Etruscans were not transplanted Lydians, but local Villanovans eagerly responding to external cultural influences from the east. One way in which the relationship between the Villanovans and Etruscans has been established is through the similarity of their pottery. The amphora, or twohandled vessel, illustrates the close parallels between Villanovan (fig. 1.5) and Etruscan (fig. 1.6) pottery shapes. The similarity of this and other shapes is sufficient to indicate continuity of pottery practices, even though new elements were added to traditional techniques of clay preparation and decoration. One such element can be seen in bucchero pottery, one of the most characteristic Etruscan types. The method by which it was fired turned the clay black, and the surface was shiny and metallic-looking because it was carefully polished before firing. There is a distinct difference in finish and general refinement between Etruscan bucchero (fig. 1.6) and the typical Villanovan pottery known as impasto, which has a dull surface and a grayish-brown color (fig. 1.5).

The earliest material evidence for the arrival of the Greeks in Italy dates from the early eighth century BC, when people from the island of Euboea established a trading colony at Pithecusae on the island of Ischia, just to the west of Naples. This settlement marked the beginning of a long and mutually profitable exchange between the Greeks and the Italic peoples. Greek pottery, decorated with geometric designs painted on the vessels, and notable for the shapes of the pots themselves, served as models for Italic potters, who imitated them in their local clays. There was an important smelting center, too, at Pithecusae, and Etruscan ores must have been important raw materials.

The influence of the Near East was somewhat less direct than that of the Greeks. It was largely through intermediary merchants and manufacturers such as the Phoenicians that objects were brought to Italy. Many small items, like decorated ivory combs and drinking cups, and metal plaques to be sewn onto clothing, traveled easily in the Phoenician ships. Large cauldrons, too, with hammered decoration in relief, as well as figures attached to the rims, were a part of this trade. The most important trading centers must have been cities such as Tyre, Sidon, and Byblos in Phoenicia itself, and Carthage, a colony of Tyre in North Africa. Smaller places like Al Mina, on the coast near Antakya, in modern-day Turkey, have been more thoroughly excavated, and give us a picture of some of these trading stations.

The Etruscans absorbed these influences from Greece and the Near East, and incorporated them into their own art and culture. Their cities grew to be impressive, their military strength was considerable, and at least the wealthy people had luxuries and rich personal ornaments. Many of these have been found in the large round mounds, or tumuli, where the Etruscan aristocracy was buried, and which are among the best preserved of their monuments. Above all, the Etruscans became famous in other parts of the ancient world for their rich supply of metals, for which traders came from far and wide.

Architecture

The Etruscan temple provided a model for the later Roman temple. One of the most important of the early Etruscan temples, dating from about 500 BC, was the one in Veii, the Etruscan town nearest to Rome. Although not much of the structure of the temple at Veii survives, we can tell a good deal from the stone and rubble foundations which reveal the ground plan. It can be supplemented by a reconstruction based on an account of the proportions of Etruscan temples written by the Roman architect, Vitruvius [iv. 7] (fig. 1.7). The temple had a pronaos, a deep porch with two rows of columns that stood at the front of the building. A sanctuary to the god, called the cella, was at the back of the temple, and was entered through a door from the porch. Smaller temples would have a single cella, and larger ones would have three long, narrow, contiguous chambers, each entered from the porch.

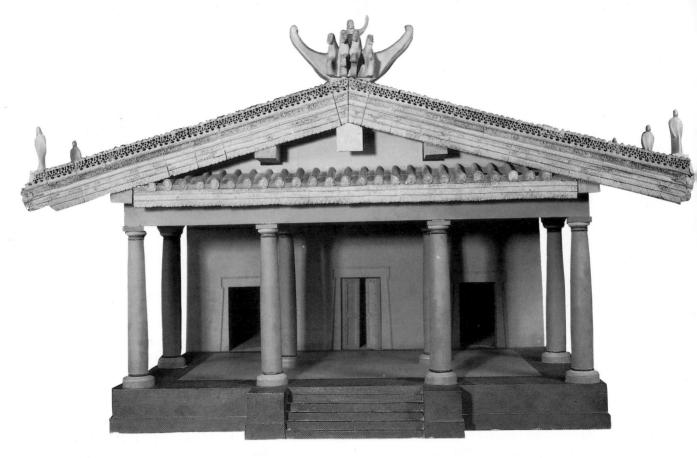

1.7 Above Reconstruction of the temple at Veii

1.8 Below Temple of Aphaia, Aegina. Greek. 510–490 BC

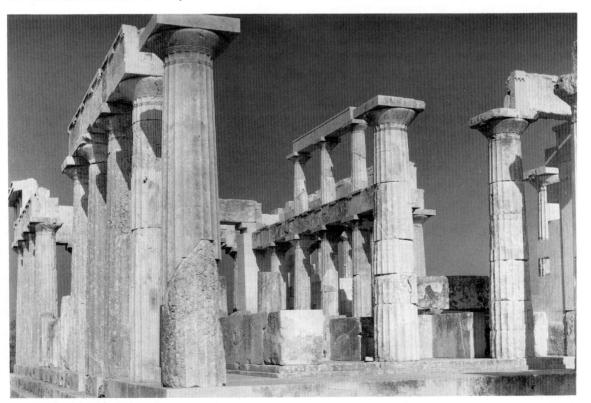

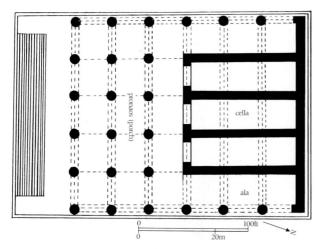

1.9 Temple of Jupiter Capitolinus, Rome, plan. Etruscan. Late sixth century Bc. Podium c. $13 \times 204 \times 175$ ft $(4 \times 62 \times 53$ m)

The fact that so little of Etruscan temples, other than their foundations, survives, can be attributed to the fact that the Etruscans continued to build their temples in wood, mud brick, and terracotta long after the Greeks were using stone masonry. The marble and limestone quarries that are so abundant in Greece were not found in Etruria, where the local volcanic stone, tufa, is relatively soft and porous. They must have preferred to continue the tradition of using perishable materials.

The temple at Veii rested on a tall podium. One could enterit only by climbing a set of steps at the front. This is in distinct contrast to the typical Greek temple, which stood on three steps that could be approached from any angle (fig. 1.8). Etruscan temples, like the one at Veii, had columns only on the *pronaos*, at the front, whereas Greek examples normally had columns on all four sides. On Etruscan temples, the walls that surrounded the interior sanctuary usually came out to the edge of the building, more or less flush with the edge of the podium.

The Capitolium in Rome was a famous temple on the hill named for it — the Capitoline. It was constructed in the Etruscan style by Etruscan builders, and a famous Etruscan sculptor named Vulca made the cult statue. The temple no longer stands, but its ground plan reveals that it had three rows of columns in the *pronaos*, and columns along the sides of the *cella* wall (fig. **1.9**). These sidepassages are called *alae*, meaning "wings." Massive

blocks from the walls survive under what is now the Palazzo dei Conservatori. The temple was very large, with a huge podium, approximately 13 feet (4m) in height, and 204 by 175 feet (62×53m) in length and width respectively. Its width — the largest known in an Etruscan temple — is almost comparable to the grandest of Greek temples.

Sculpture

The Etruscans were no less accomplished as sculptors than they were as architects. One of their earliest forms of sculpture was the clay canopic urn (fig. **1.10**), which was used to hold the ashes after cremation. This frequently had a lid in the form of a human head, and sometimes the entire urn was made with human features. Although these are certainly not accurate representations, some have seen in such heads an early indication of the Etruscan interest in studying the human face, an interest that developed into great skill in portraying individual portraits.

1.10 Canopic urn. Etruscan. 650–600 BC. Terracotta. Height 1ft 5½ins (44·5cm). Museo Archeologico, Florence

TEMPLE TERRACOTTAS

At Veii, although so little of the temple's superstructure survives, we are fortunate to have extensive remains of a group of terracotta figures that originally decorated the roof (see above, fig. 1.7). We are told by Pliny, the writer of an encyclopedia of natural history in the first century AD, that when a wealthy aristocrat called Demaratus was expelled from Corinth, he took with him some artists who worked with clay, and traveled to Italy; they may have had something to do with the making of monumental clay sculpture in Etruria. The use of terracotta sculpture for the decoration of temples may also indicate a connection with south Italy, where terracotta architectural ornaments had been popular for a long time.

The figures on the temple at Veii, who represented gods, must have looked as if they were marching along the ridgepole to which they were attached. One of them represents Apollo (fig. 1.11), who strides forward, dressed in a long, flowing garment full of patterns of sharp folds. By comparing him with a Greek statue (fig. 1.12) of approximately the same date (the late sixth century BC), we can see that, although the Etruscans borrowed important ideas from the Greeks, they adapted them to make something typically Etruscan, and that their art had a lively character all its own.

The standing youth from Greece is called the Anavysos Kouros. The word *kouros* means young man, and Anavysos is the place in Greece where he was found. The figure served as a grave marker, and probably represented the deceased man himself. Note that he places his left foot in front of the right, and is thus intended to be walking, but that both his feet are flat on the ground, and the upper body shows no sign of movement and is entirely symmetrical. These features, and also the large scale, were copied by the Etruscan artist. In comparing their faces we see that both have mouths that curl unnaturally at the corners. This is known as the "archaic smile" and was copied quite closely on the Etruscan piece. But the Greek figure is

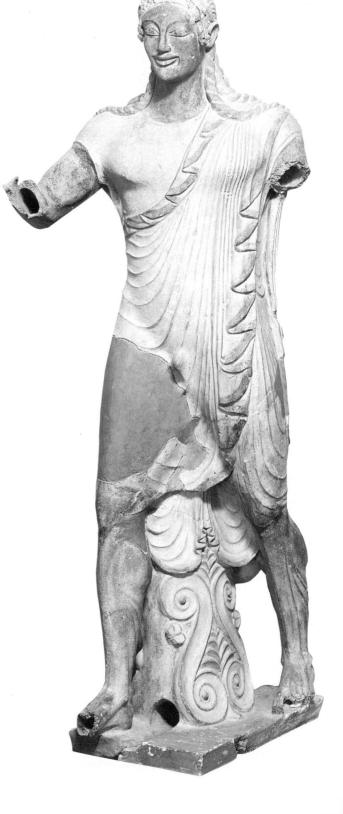

1.11 Apollo of Veii. Etruscan. c.500 Bc. Painted terracotta. Height c.5ft 10ins (1·8m). Museo Nazionale di Villa Giulia, Rome

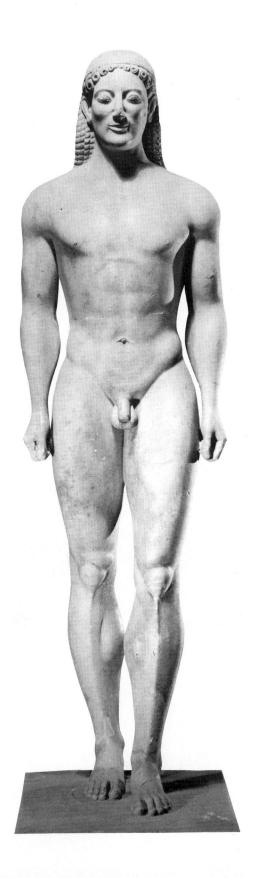

naked, whereas the Etruscan is clothed. Furthermore, the Greeks used marble, but the Etruscans, who did not have a ready source of this material. made their figure of terracotta. This difference must be kept in mind, for the techniques of working the two materials are quite different. Overall, the handling of the Greek youth may seem more confident, but there is a sense of greater movement to the Etruscan statue that makes it full of animation and excitement.

ANIMAL SCULPTURE

The Etruscans are particularly well known for their bronze sculpture. They were astute observers of animals, whose nature they were able to capture while, at the same time, emphasizing the kind of decorative details that appealed to their sense of design. A magnificent example is a larger-than-life female wolf, in bronze, with round, full teats and lean ribs (fig. 1.1, p.20). The care given to her anatomy is combined with an expression of ferocity through her open mouth, sharp teeth, and tense stance. Yet, decorative elements that would not be found in nature intrude, especially in the patterned rows of fur that line her neck and back.

This statue, called the Capitoline Wolf, has often been associated with the famous tale of Romulus and Remus (see below, p.43). We do not know if the statue was originally intended to represent this story or not, for the two suckling babies seen here were added in the Renaissance. The story, and numerous variations of it, was so popular among the Romans that the she-wolf with twins became the symbol of Rome. There was also a live wolf kept on display on the Capitoline Hill, and the great orator Cicero, writing in the middle of the first century BC, reported in one of his speeches [In Catilinam III. 8.19] that the Romans had a statue of a wolf and twins that was struck by lightning.

The Capitoline Wolf was made during the archaic period, probably as a public monument. The combination of anatomical details with interest in pattern and design also characterizes an animal

1.12 Anavysos Kouros, from Anavysos, near Athens. Greek. Late sixth century BC. Marble. Height 6ft 4½ins (1.94m). National Archaeological Museum, Athens

from the classical period: a fourth-century bronze statue of the Chimaera, found in the more northerly town of Arezzo (fig. **1.13**). This is a representation of a beast from Greek mythology that had the head and body of a lion, a tail in the form of a snake, and a goat's head protruding from its back. It was wounded, as we see by the gash on the neck of the goat. The composite animal was traditionally female, and so ferocious that it breathed fire. According to the story in Homer's Greek epic, *The Iliad*, a hero from Corinth known as Bellerophon killed the beast. In versions later than Homer,

1.13 Wounded Chimaera, from Arezzo. Etruscan. Early fourth century Bc. Bronze. Height 2ft 7½ins (80cm). Museo Archeologico, Florence

Bellerophon rode against the Chimaera on the winged horse Pegasus.

The fierce aggression of the animal, its growling head and tense body twisted in action, is perhaps even more obvious here than in the she-wolf. Again the ribs show through the skin, and even veins on the belly seem to pulsate on the sleek body. The artichoke-like mane, with each of its spikes emphasized by deeply ridged lines, acts as a kind of prickly circle around the beast's head; and again, there is a ridge of hair emphasized down its back, but this time, in contrast to the she-wolf, the tufts stand up like the teeth of a saw and project into space. This greater emphasis on depth is characteristic of the classical period, as opposed to the archaic, when the wolf was made.

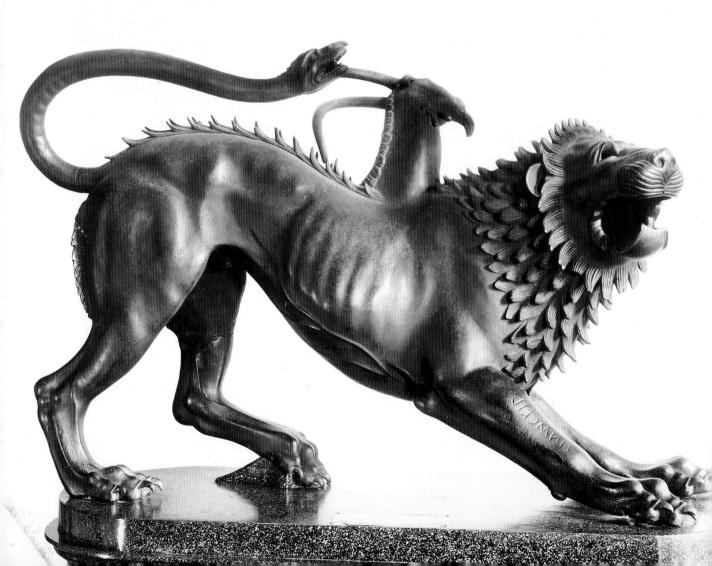

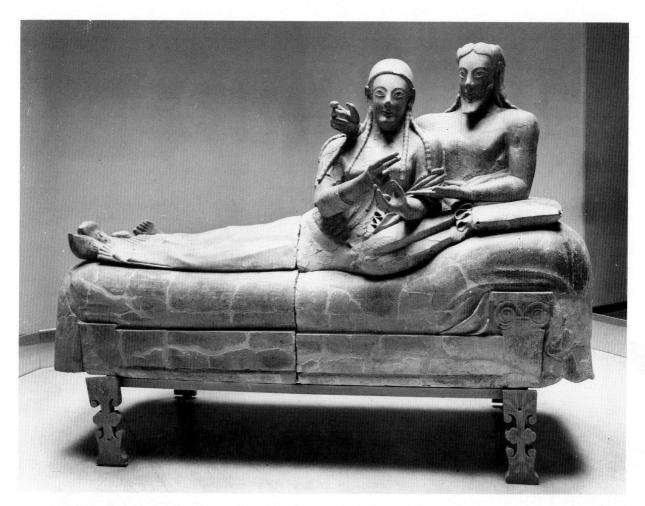

FUNERARY SCULPTURE

The Etruscans excelled in portraying not only animals, but also humans. They had already been making studies of human heads on canopic urns (see above, p.27) since the seventh century BC, and then in the later sixth, about 520 BC, they began to bury their dead in terracotta sarcophagi (coffins). They liked to place an image of the reclining figure of the deceased on the lid, and this offered another opportunity to study the head. The representation of the deceased, either alone or in pairs, was sometimes shown with a drinking cup or other props. The practice of putting figures on the lid was invented by the Etruscans and eventually the Romans picked up the trait. An early Etruscan example is the terracotta coffin of a couple from Veii (fig. 1.14), who lie together on the marriage bed.

1.14 Etruscan sarcophagus, from Caere. Late sixth century BC. Terracotta. Length 6ft 7ins (2·06m). Museo Nazionale di Villa Giulia, Rome

The feeling of affection is well expressed by their close position and the way in which the husband seems to envelop his wife. Note the archaic smile and the patterned drapery, both characteristic of the later sixth century BC.

From the sixth to the mid-fourth centuries BC, the representations of the deceased on sarcophagus lids normally had generalized or idealized features; but from then on, most heads had more or less specific features that would presumably have identified the deceased to their circle of family and friends. The urn of Arnth Velimnas from the Tomb of the Volumnii in Perugia (fig. **1.15**) shows a man

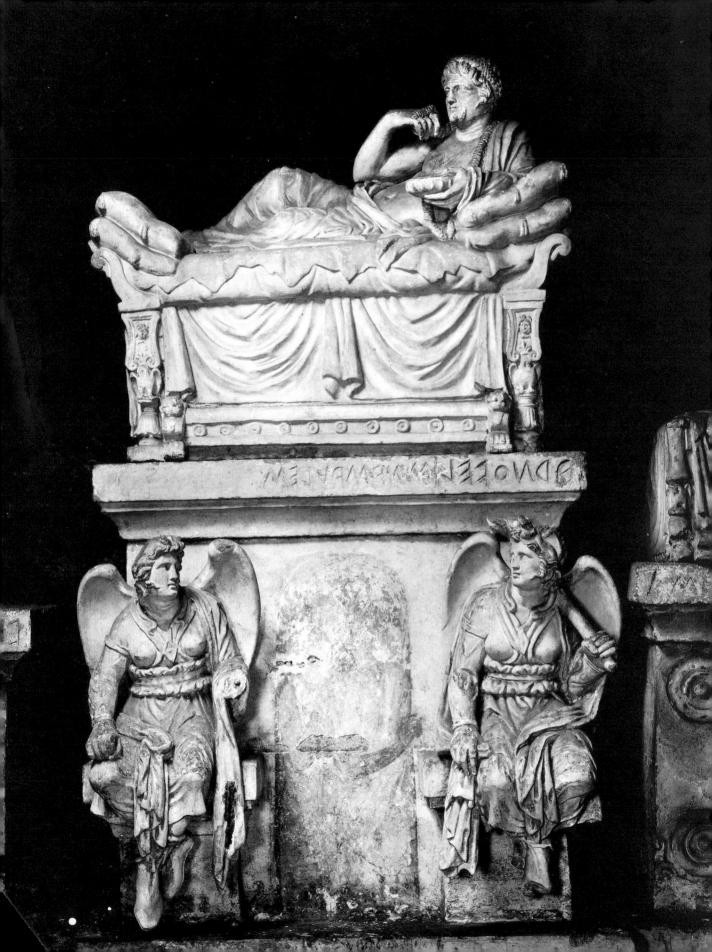

1.15 Opposite Urn of Arnth Velimnas, Tomb of the Volumnii. Perugia. Etruscan. 150-100 BC. Limestone and stucco. Height 5ft 21/2ins (1.59m)

1.16 Right Reclining couple on a sarcophagus lid, from Vulci. Etruscan. Early third century BC. Volcanic stone. Length 6ft 11ins (2·11m). Museum of Fine Arts, Boston, gift of Mr and Mrs Cornelius C. Vermeule III

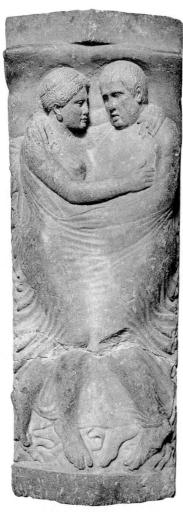

with quite individual features reclining on his couch, supported by pillows at both ends, and holding a cup in his left hand. An unusual sarcophagus shows a couple lying together beneath a light cover and embracing on the marriage bed; the man's face looks like a portrait, while the woman's is generalized (fig. 1.16). This piece is a third-century BC version of the archaic terracotta couple on the sarcophagus from Veii (see above, fig. 1.14).

STATUARY

A nearly lifesize bronze figure of a warrior, known as the Mars of Todi (fig. 1.17), is a particularly well-preserved Etruscan statue of the classical era (early fourth century BC). He carries a sacrificial bowl (patera) in his right hand, and leans on a spear that he holds in his left hand.

The type is best known from Greek vase painting, but here there are local Etruscan characteristics. Most notable is the emphasis on pattern, seen in the leather construction of his cuirass (breastplate) and in the flaps that hang down upon the folds of the tunic. His relaxed stance is static, and shows him standing, not walking. His weight rests primarily on the right leg, with the left drawn out to the side. The artist paid attention to anatomy and drapery in a formal way, without, however, imbuing the statue with the kind of spirit usually found in Etruscan art.

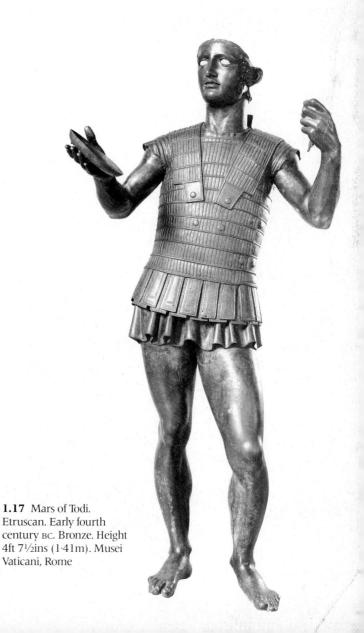

PORTRAITS

In portraits, some heads are idealized, like the late fourth-century bronze head of a boy in Florence (fig. **1.19**); yet he also has certain individualized details, like the set chin, protruding lower lip, and the heavy eyebrows, that give him a great deal of character. Etruscan portraits are often very lifelike, as if they might have been inspired by plaster casts taken from the human face. A good example is the terracotta head from Manganello (fig. **1.18**), where not only are the physical features very natural, but they also suggest the man's character — perhaps gentle, but firm. The hair, eyes, and mouth were painted, giving an even more natural appearance.

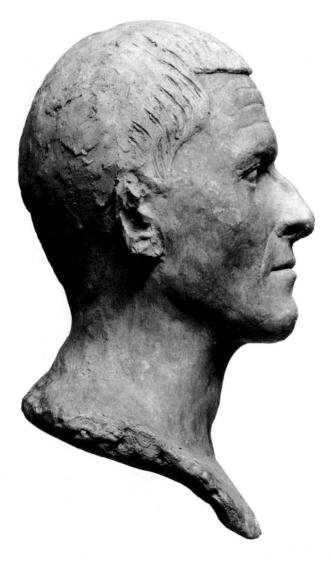

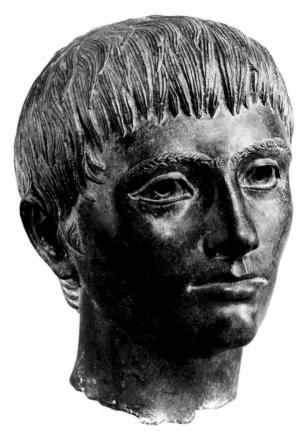

1.18 *Left* Etruscan portrait, from Manganello. First century BC. Terracotta. Height 1ft (30·5cm). Museo Nazionale di Villa Giulia, Rome

1.19 *Above* Head of a boy. Etruscan. Late fourth century BC. Bronze. Height 9ins (22·9cm). Museo Archeologico, Florence

1.20 *Opposite* Head of a bearded man, called "Brutus." *c.* 300 BC. Bronze. Height 1ft ½in (31·8cm). Palazzo dei Conservatori, Rome

Another realistic portrait, called "Brutus," is a bronze head of an unknown man from about 300 BC (fig. **1.20**). He seems to encapsulate the virtues associated with distinguished Romans: that is, strength of character, vision, intelligence, and good looks. Note especially the deeply set penetrating eyes with heavy brows; the strong, slightly aquiline nose; and the determined, thin, down-turned mouth. The head was discovered in the 16th century, and soon became identified by connoisseurs as Brutus, the famed first consul of Rome and founder of the Republic, who ousted the last tyrant king, Tarquinius Superbus, from the city in 509 BC.

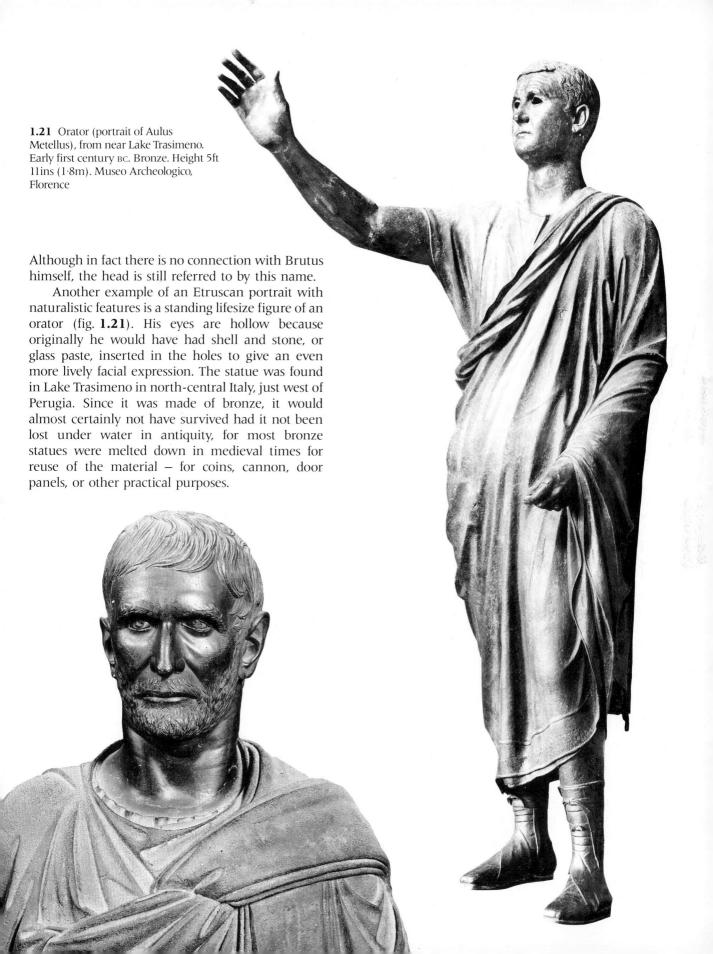

The Orator is one of the best examples to show a mixture of Etruscan and Roman influences. We know he thought of himself as an Etruscan because the hem of his toga records his name, Aulus Metellus, in the Etruscan script. On the other hand, the name itself is Roman. The laced high boots, revealed by the short toga, are characteristic of a Roman senator. And the impression of a worried face, sagging skin, and realistic, short-cropped hair seems to show influence from the Romans. In fact, the statue seems to be a transformation of a Hellenistic type into something more specifically Roman. By the early first century BC, when this statue was probably made, the Roman interest in realistic, ordinary types had begun to assert itself. In fact, the statue may have been set up on the occasion when a town near Perugia was given the title of municipium, which established a formal political and social tie with Rome.

Roman statues of politicians have often been compared with photographs of 20th-century citizens in public life because there is such a marked similarity. Like modern photography, they tend to emphasize the particular details. Indeed, the statue of an orator, with (restored) right arm raised, addressing a crowd on some public matter (using the pose of the *adlocutio*), could be any modern politician, gesturing to emphasize an argument.

Each of the types of Etruscan sculpture examined here — animals, funerary sculpture, and portraits — had an important influence on Roman art. They provide good examples of the ways in which the Etruscan objects, and the traditions associated with them, served as models to Roman artists over the following centuries.

Painting

Very little painting has survived from other parts of the ancient world except Egypt, and this makes the well-preserved wall paintings from the Etruscan tombs at Tarquinia in southern Etruria particularly important. Not only do they illustrate the Etruscan and perhaps at the same time the wider Italic traditions of central Italy, but they also provide examples on a large scale of some of the myths and themes that are otherwise preserved only in literature or on Greek vases. Specific myths are rare, but themes like banqueting, athletic competitions, and musical performances are frequent. All are undoubtedly related to the funeral rituals of the Etruscans.

The borrowing of Greek myths in Etruscan paintings, and on their small-scale sculpture and bronzes, is interesting because the Romans, too, used Greek myths from the Trojan and other cycles on their funerary sculpture. As for the Etruscans, so for the Romans the symbolic content of such myths provided a rich source for messages associated with the accomplishments of the deceased, and hopes for his or her salvation in the next world.

The painting in the Tomb of the Bulls at Tarquinia, depicting Achilles ambushing the Trojan prince Troilus at the fountain (fig. **1.22**), gives an idea of the state of the graphic arts in the region at about 540 BC. The back wall of the chamber is divided into two horizontal rectangular panels. In the lower part are several conventionalized trees, some of which are festooned with strips of cloth. This division of the wall into parts was reflected in later Roman painting, where architectural divisions played a major role.

The upper scene shows Troilus riding on a large horse, approaching the fountain, which is shaded by a date palm. The cut stone structure of the fountain has two crouching lions that project from it, and a convincing flow of water spews from the mouth of one of them. Achilles, with his foot on the fountain steps, is shown breaking out of the bushes at the left. Although placed below Troilus, his silhouette in armor is much more menacing. The artist has picked the moment just before the attack — a device for creating suspense. The narrative is primary, and the ideal proportions of the figures that were so important in the rendering of this scene in Greek vase painting are secondary here.

But if narrative was important from the point of view of the decoration of the tomb, the symbolic message may also have played a role in the very choice of this subject. Achilles, lying in wait at the fountain, is shown as a courageous hero who embodies triumphant prowess as well as careful planning and patience. There may be an attempt to equate him with the deceased, who might also have been a warrior. If so, then the suggestions implicit in

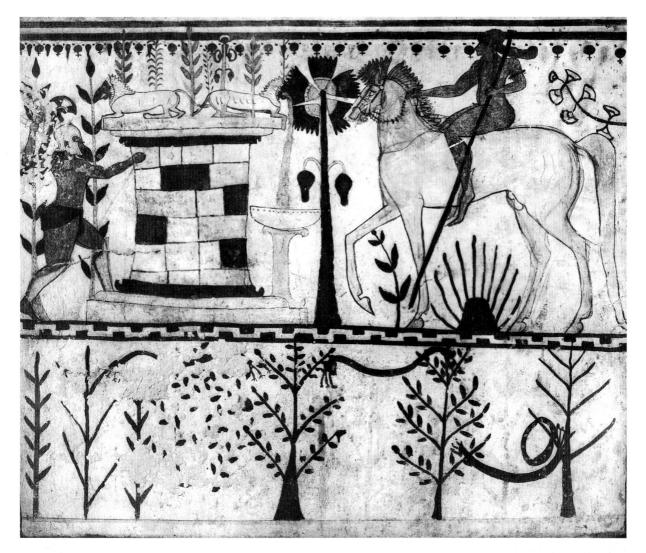

1.22 Ambush of Troilus by Achilles, from the Tomb of the Bulls, Tarquinia. Etruscan. c. 540 BC. Wall painting

the Greek myth could have easily been applied by extension to the person buried in the tomb.

The painting technique is a mixture of dark silhouettes for most of the people, and distinct outline drawing for Troilus' horse, the lions, and the blocks of the fountain structure. Most of the trees consist of a solid base in dark colors, with superimposed leaves set in pairs along the limbs. If an error was made, the artist simply redrew the

line. In general, the parts of the body are clearly separate and rather angular, although the outline of the horse shows remarkable fluidity.

The figures are large in relation to the space available, but the artist has also managed to include several indications of the natural vegetation. A feeling for the importance of the landscape is to be found in other tombs as well, and it was exploited more enthusiastically in the Italic tradition than in the Greek. In fact this interest in landscape developed into an important factor in Roman painting.

Another archaic Etruscan wall painting, from the end of the sixth century BC, decorates the so-called Tomb of Hunting and Fishing at Tarquinia. In this detail (fig. 1.23), a young boy standing on a rock at the right shoots birds with his slingshot while other boys fish from their boat. In another section (fig. 1.26), one boy climbs a steep rock as his companion dives from the top into the water. Small plants and grasses grow at the edges of the rocks. The artist showed unusual accuracy in his representation of the boy with the slingshot, the fisherman leaning over the boat's edge, and the diver. Remarkable too is the fact that the figures are small in proportion to the landscape, so that a realistic sense of scale is attained. The subject matter, with scenes from everyday life, is lively and charming, and seems to suggest a good life for the

occupant of the tomb. The bright colors – red, blue, purple, and green – for the landscape and the rocks add to the attractiveness of this painting.

A detail from the fourth century BC Tomb of Orcus, in Tarquinia, shows, in profile, the head of a beautiful woman whose name, Velia, is painted on the wall next to her. She wears a crown of leaves (fig. **1.27**, p.42) and her hair hangs loose at the sides. The rest of the hair is bound up in a piece of cloth above the nape of the neck. Although the painting decorates an Etruscan tomb, the artistic

1.23 Hunting birds and fishing, detail from the Tomb of Hunting and Fishing, Tarquinia. Etruscan. Late sixth century BC. Wall painting

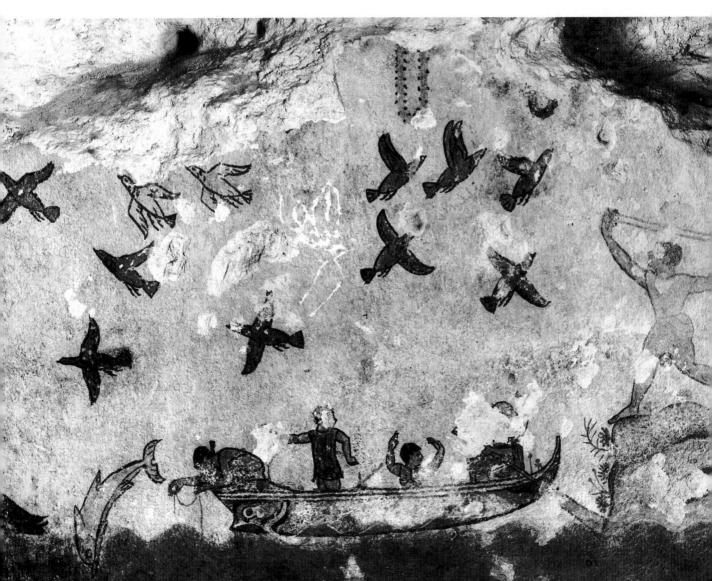

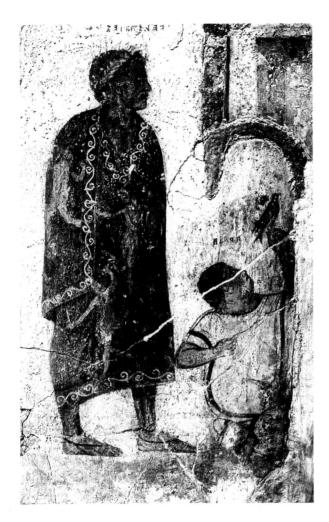

1.24 Portrait of Vel Saties, from the François Tomb, Vulci. Etruscan. Third century BC. Wall painting

features are classical Greek, and are paralleled in many examples from the Greek world. The Romans also often borrowed the ideal of beauty expressed here: the smooth line from the forehead to the tip of the nose, large eyes, full but small lips, firm rounded chin, hair parted in the middle and drawn to the sides. The practice of outlining or silhouetting the face and body was something that appealed to painters in Roman times too. They learned the practice both from Etruscan imitations of Greek prototypes, and directly from the Greeks themselves.

A third-century BC tomb in another Etruscan town, Vulci, is named for a painter, Alessandro

François, who discovered it. The tomb commemorates a certain Vel Saties, who is pictured in a long robe magnificently decorated with dancing figures (fig. **1.24**). The small figure at the right is a dwarf who accompanies him, probably in the role of a servant. He holds a bird on a leash on his left hand.

A tomb in Tarquinia, the Tomb of the Typhon, may be as late as the second century BC. Here, winged figures with snaky legs (fig. **1.25**), and females, with lower bodies that have turned into

1.25 Typhon, giant with serpent legs, from the Tomb of the Typhon, Tarquinia. Etruscan. Second century BC. Wall painting

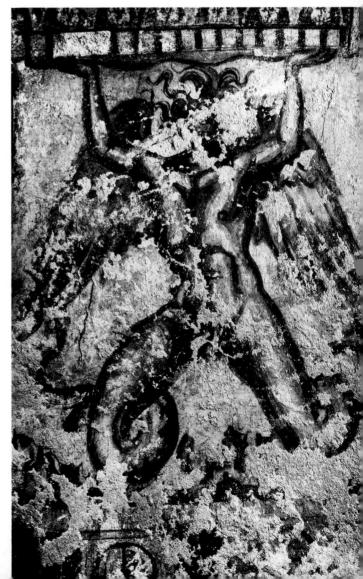

plant tendrils, act as caryatids (columns in the form of female figures) that hold up the ceiling. Typhon himself looks like some of the giants portrayed on the Greek Altar of Zeus at Pergamon (see below, fig. **2.5**). Such motifs reappeared in Roman painting as purely decorative details.

Rome, the Etruscans, and Latium

The Romans were a proud and self-conscious people who liked to think of themselves as independent. Although they emerged from the same background as the Etruscans, their language was quite different, and they resisted the idea of Rome being considered an Etruscan city, and regarded it as one of a number of Latin towns, most of which lay to the south and east. Rome was part of a region called Latium, where the people spoke the Latin tongue. Although it was not as rich or powerful in the early days as some of its Latin neighbors such as Praeneste (modern Palestrina), we learn from the historian Livy, a writer in the late Republican period, that perhaps as early as the eighth century BC a king named Ancus Martius had already begun to expand the territory and the power of Rome. At other times Rome fell under the sway of kings who were of Etruscan descent, and it was important for Rome when the last of the Etruscan kings was expelled at the end of the sixth century BC.

In the archaic period, Rome was on the fringe of the Etruscan realm, which consisted of a confederacy of twelve cities. The Etruscan culture was more prosperous at this time than the Roman. The cities were impressive, Etruscan trade was bustling, while Rome was just starting to grow into an urban center. The Romans drained a large area, and paved it over to make a forum, or marketplace. As they began to think in grander terms, and wanted to build large temples, they found it necessary to import help and expertise from the Etruscans.

But ultimately, Etruscan and Roman art and architecture sprang from similar roots. Both belonged to an Italic culture that went back to Villanovan times, and both looked to foreign influences for inspiration, whether from the Greek colonies, other parts of the Greek world, or from the Near East. Although their language was different, many Etruscan social and religious customs also passed into the Roman way of life. History and archaeology allow us to see the close relationship between Etruria and Rome, but the Romans themselves liked to explain their beginnings through myth and legend, where the Trojans and the Latins played a bigger role than the Etruscans.

Stories of Early Rome

As Rome grew, we may suppose that heterogeneous groups were attracted to the opportunities it offered. They, in turn, would have contributed to the manifold layers of stories about the origins of the Roman people and the contributions of the different kings. An example might be offered in the different stories leading up to the founding of Rome and the rivalries, hostilities, and alliances among local groups in Latium up and down the Tiber.

Virgil gives the honor of being the principal ancestor of the Roman people to Aeneas, a royal refugee from Troy, and son of the goddess Venus. He escaped from Troy with his family and the ancestral gods, and made his way to Latium in an apparently preordained progression by way of Carthage and several sites in Sicily and Italy. Virgil's epic poem, *The Aeneid*, puts this story in terms of a historical adventure, fraught with importance and signs for the future. Of course the future as foretold in the poem was the present for Virgil, whose patron was Augustus, the new ruler of Rome, who claimed to be a descendant of the house of Aeneas.

Aeneas' progress in Italy was not without setbacks, and some of the alliances he had to make with different groups may well have been a way of expressing the complications of the origins of the Roman people and the city of Rome. He had to placate various neighbors before he could settle at Lavinium, near the sea a few miles south of Rome.

1.26 Climbing rocks and diving, detail from the Tomb of Hunting and Fishing, Tarquinia. Etruscan. Late sixth century BC. Wall painting

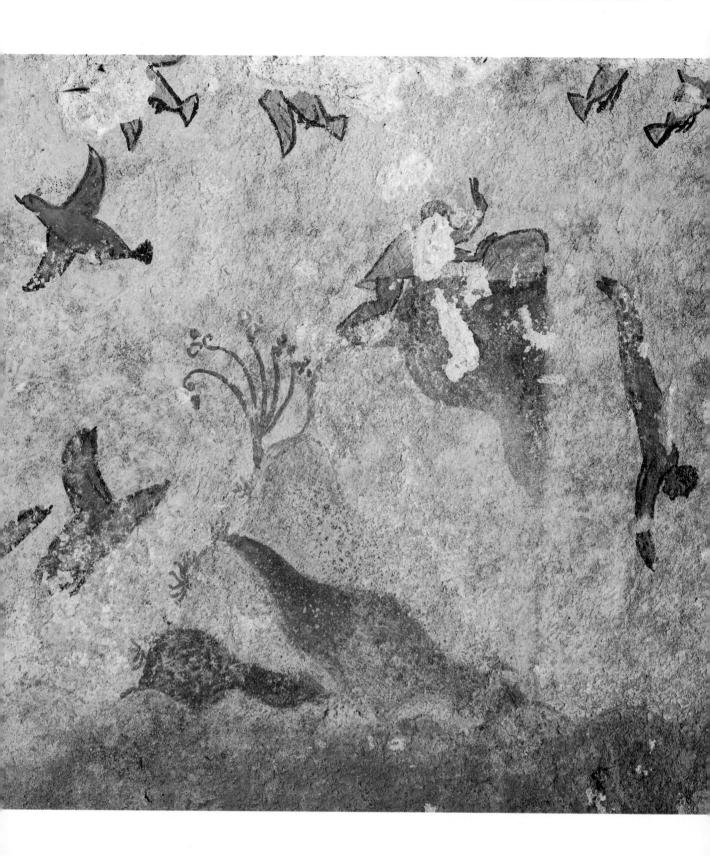

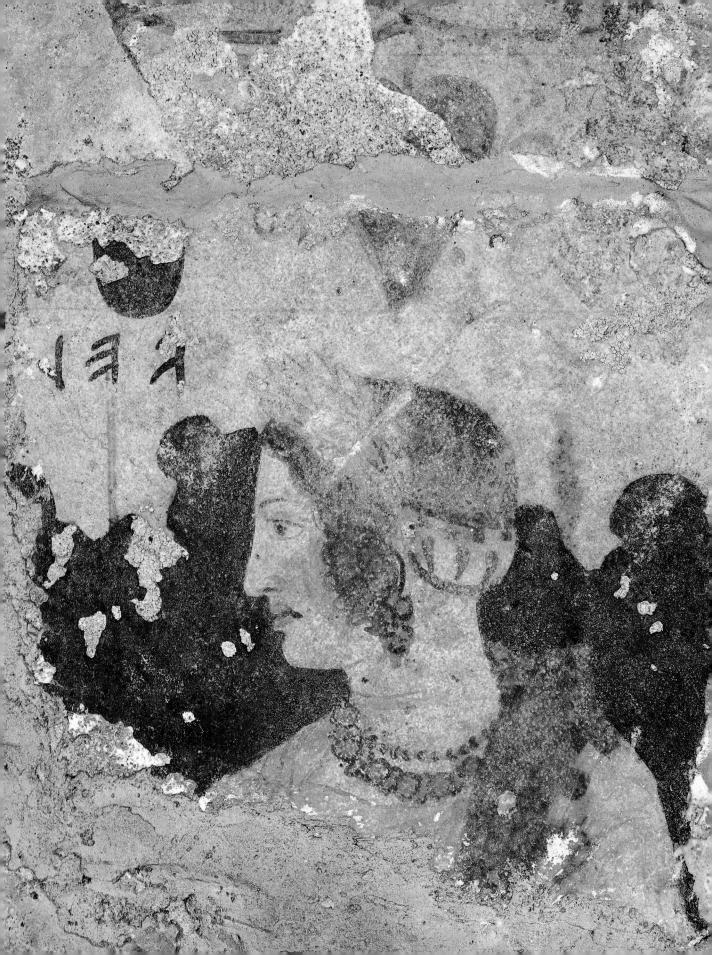

His son Ascanius later founded another town, Alba Longa, which became a preeminent Latin city in the hills about 15 miles (24km) southeast of Rome. Aeneas, Lavinium, and Alba Longa were all to play a part among the stories depicted in Roman art and propaganda, just as they did in Roman literature.

Another story, equally important, tells of the actual founding of Rome by Romulus and Remus, an event that took place, according to tradition, in 753 BC. The historian Livy [I.23.12] shows that the tale of Romulus is related to that of Aeneas. The twins, Romulus and Remus, had a human mother, Rhea Silvia, who lived in Alba Longa and was a direct descendant of Aeneas. The father of Romulus and Remus was no less than the god Mars, who had come to the woman in stealth. Their uncle, the king, feared that the boys would some day overthrow him, so he arranged that the infants should be thrown into the Tiber River; their basket, however, was left high and dry by receding flood waters.

A female wolf, coming down from the hills, noticed the children on the banks there and carried them to her den, where she suckled them until they were taken in by a passing shepherd. The boys grew up in the midst of the shepherd's twelve children,

but always shining as the leaders of the group. Eventually, they wished to found a city on the banks of the Tiber, and they chose the spot where the basket had come aground – near the foot of the Palatine Hill in Rome. In a competition to see which of them would be ruler, Romulus was the favored of the two, but Remus challenged him by jumping over the boundary wall of the city. At this point Romulus killed his brother and became sole ruler.

Whatever one makes of the story of Romulus and Remus, it provides us, as it provided the Romans, with a theoretical starting point for the history of Rome.

The effect of the Etruscans on their political successors was strong in the archaic period, but after this, they were only one of the several influences that played a part in molding the character of Roman art and architecture. We should really consider the people of Etruria and Rome as part of the same Italic tradition which combines Greek and indigenous features, and comes out with something that reflects all these sources. Thus, we can think of Etruscan and Roman developments, although sometimes hard to disentangle, as moving in tandem.

The Roman Republic 200–27 BC

Although the history of Rome goes back many centuries before Christ, there is almost nothing that has survived that we can call distinctly Roman before the second century BC; and Roman objects are very rare indeed before the first century BC. Most of our information for the earlier centuries comes from literary sources. For instance, Pliny tells us of a famous painter at Rome called Fabius Pictor (Fabius "the painter"), who lived about 300 BC. He painted battle scenes on the walls of the Temple of Salus (Health), but what his paintings might have looked like is unknown.

In the first century BC there is suddenly a wealth of material preserved that we can identify as specifically Roman. When the military leader Sulla returned to Rome from Greece, after sacking Athens, he carted with him hundreds of Greek statues which were to have a profound effect on Roman sculptors. Sulla's booty, however, was not the Romans' introduction to Greek sculpture; from previous victories, too, art from the Greek mainland

Opposite Detail of the Nile Mosaic, fig. **2.28**. Sanctuary of Fortuna, Praeneste. First century BC. Museo Archeologico Nazionale, Palestrina

(Corinth) and Magna Graecia (Syracuse and Taranto) had been brought to Rome, where it provided the inspiration for many a Roman statue. On the other hand, the Romans had a way of taking what they wanted from Greek art and putting their own stamp upon it.

An early sarcophagus

We shall begin our examination of the art of the Republic with an early sarcophagus from Rome, whose inscription puts its attribution beyond doubt. It also serves to show how Roman Republican artists borrowed Greek prototypes, but changed the manner in which the motifs were used. This is the coffin of a well-known member of the Scipio family (fig. **2.1**), datable to the early second century BC. The full name of the man was Lucius Cornelius Scipio Barbatus. He actually lived earlier, but it was shortly after 200 BC that his family built the enormous tomb on the ancient Via Appia, on the outskirts of Rome, where the sarcophagus was found. It is believed that his remains were transferred at that time into a new and elegant coffin.

The coffin, like many others, is carved out of a local volcanic stone, tufa. It is modeled on a type of Greek altar from south Italy, where some of the details were copied from Greek temples. Artists in Rome later borrowed some of the elements and reused them on Roman sarcophagi. This piece displays an unusual mix of features from the architectural motifs of two kinds of Greek temple: the Ionic, which provided the curves, or volutes, on the lid; and the Doric, the source for the square metopes (filled with rosettes) alternating with the triglyphs (the part with three verticals that recall three pieces of wood used on earlier temple construction). An inscription on the side refers to the fine characteristics of Lucius' career and personality, both of which shone with the ideals of Republican virtues.

2.1 Sarcophagus of Lucius Cornelius Scipio Barbatus, from his tomb on the Via Appia, near Rome. c.200 Bc. Tufa. Height 4ft 7ins; length 9ft 1in (1.4×2.77 m). Musei Vaticani, Rome

Sculpture

HISTORICAL RELIEF SCULPTURE

The Romans showed a great interest in depicting real events in sculpture. Historical reliefs were set up on public buildings, such as temples or monuments, often surrounded by a decorative frieze. Sometimes the dividing line between history and myth is unclear, and the two are often combined. But in contrast to the Greeks, who preferred to tell stories through the analogy of myth, the Romans liked to represent events largely as direct reporting – if sometimes rather biased toward their point of view. They also frequently included figures from the divine world together with ordinary people.

The earliest relief that can truly be claimed to represent a Roman historical event is the monument to Aemilius Paullus at Delphi, in Greece (fig. 2.2). Because we know the date of the battle depicted here, and of the general's visit to Delphi, we can date the relief to about 168 BC. Although it was almost certainly carved by a Greek sculptor, the work was dedicated to Aemilius Paullus after his victory at the Battle of Pydna.

The start of the battle was the moment when a riderless horse raced toward the Greek army, frightening the Greeks into initiating the conflict. The horse figures prominently in the center of this section of the relief. It is clearly shown as riderless, with its long body emphasized by the extended neck, and the head, seen from the back, turning sharply. Thus, the specifics of the event are included in the representation – something that is quite alien

2.2 Battle between Romans and Macedonians, detail of the monument of Aemilius Paullus, Delphi. c. 168 BC. Marble frieze

to the Greek way of working.

A historical relief of the late second or early first century BC that probably came from the Temple of Neptune in Rome (formerly known as the Altar of Domitius Ahenobarbus, fig. 2.3) shows scenes relating to the taking of the census. One of the scenes is a religious one where a bull, a sheep, and a pig are sacrificed to the war god Mars, who watches the approach of the animals as he stands beside his altar in full military regalia. The official name for this sacrifice, suovetaurilia, incorporates the Latin names of the three animals: sus (pig), ovis (sheep), and taurus (bull). Although many figures are depicted, including the priest at the right of the altar and, at the far left, the scribe who is apparently recording the census, each is clearly defined, and stands out sharply against the plain background.

The artist was interested in clarity, but did not really know how to maintain a sense of drama or interest; the figures appear rather static. In almost comic-strip fashion, they are placed in succession so that the event unfolds mechanically before our eyes. This is a characteristic feature of Roman relief sculpture which developed from the Italic traditions of sculpture, and is often referred to as the plebeian strain in Roman art. It differs considerably from a relief which came from another part of the same monument, yet both are carved in the same kind of Greek marble, and have the same overall dimensions and border.

The second relief (fig. **2.4**) shows a mythological representation of tritons and nereids (the common folk among the divine inhabitants of the sea) at the wedding of Amphitrite and the sea god Neptune. This piece seems to have been carved by an artist who was much more assured, and had been trained in the style of Hellenistic Greek art associated with an important city in Asia Minor called Pergamon (see above, fig. **0.1**). An unusual relationship existed between Rome and this city, for in 133 BC, Attalus III, the king of Pergamon,

bequeathed his kingdom to the city of Rome. Not only politically, but also artistically, this was important to Rome, for her artists often turned to Pergamene sculpture for inspiration. The famous Altar of Zeus at Pergamon (fig. **2.5**) had an enormous effect on later sculpture, and the relationship can be seen here in the relief of Neptune and Amphitrite. The curving lines of the composition are emphasized, and there is noticeable foreshortening, for instance in the left arm and chest of Neptune. The richly rounded figure of the

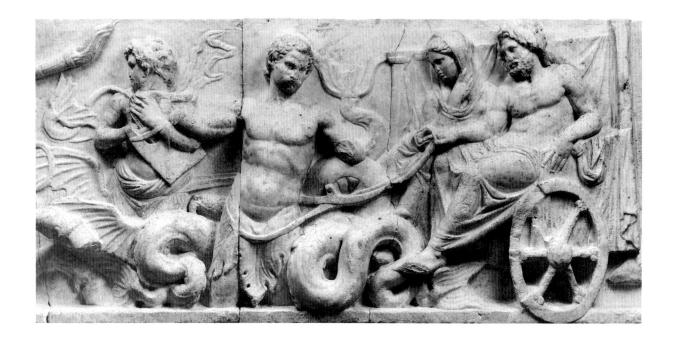

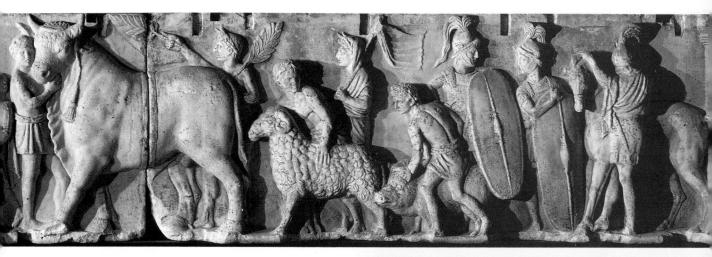

2.3 *Above* Census-taking, relief from the Temple of Neptune, Rome. Late second or early first century BC. Marble frieze. Height 2ft 8ins (81·3cm). Louvre, Paris

- **2.4** *Opposite* Wedding of Amphitrite and Neptune, relief from the Temple of Neptune, Rome. Late second or early first century Bc. Marble frieze. Height 2ft 8ins (81·3cm). Glyptothek, Munich
- **2.5** *Right* Snaky-legged giants, detail from the Altar of Zeus, Pergamon. *c*.180 BC. Marble. Height of frieze 7ft 7ins (2·31m). Staatliche Museen, East Berlin

triton blowing his shell horn and his thick coiling snaky legs are borrowed from the figure shown here on the altar at Pergamon. Furthermore, Amphitrite and Neptune are both descendants of Greek figural types going back to the fifth century BC.

It seems that the relief portraying Neptune and Amphitrite, Greek in style, was matched by a second relief, Roman in style, describing the taking of the census. There is evidence to suggest that the Greek-style relief was carved first and then cut down to fit the required size of the base. It is hard to imagine two such different approaches on one monument as we find on the reliefs from the Temple of Neptune; on the other hand, combinations of styles are not unheard of in Roman art, and different subjects called for different modes of depiction. Thus, the gods are shown in the Greek style, and the more mundane subject of the census-taking is carved in the Italic tradition.

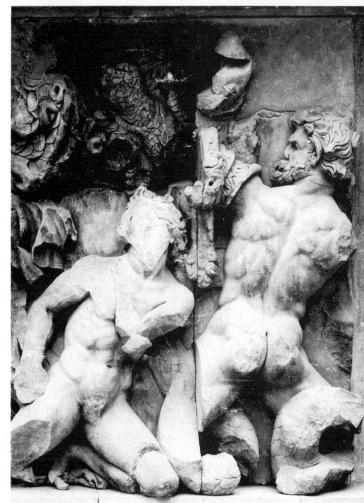

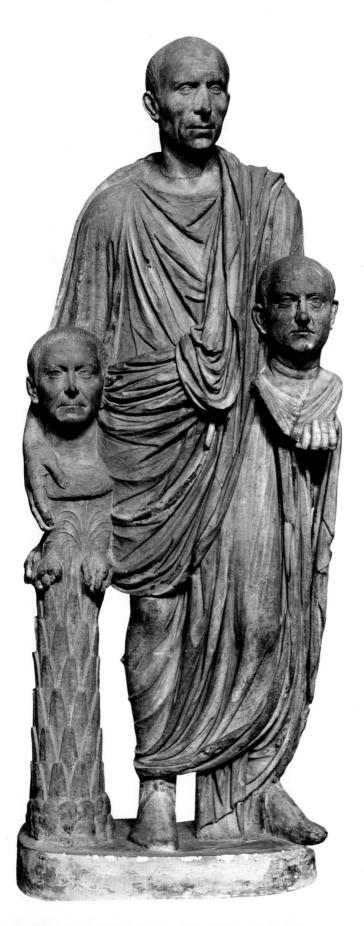

PORTRAITURE

Verism The tradition of making portraits, already firmly established in Italy, continued among Roman artists of the first century BC. Their patrons had a taste for realism, or "verism," as it is called, where the artist depicted even the smallest details of the surface of the skin with all its imperfections, including warts, wrinkles, and furrows. These details were combined with an interest in bone structure and musculature. It may have been itinerant Greek artists who first made marble heads like this for the Romans, particularly the patricians, who were the chief patrons of this style. For it was the Greeks who had developed a high level of skill in the carving of marble heads, whereas the Romans had been used to working in terracotta. It was only under Augustus, when the Carrara marble quarries were opened up on a large scale, that Roman sculptors began to acquire wide experience in the new material.

On the other hand, verism grew out of an old Italic custom, going back at least to the second century BC, of venerating masks representing the family ancestors. Although these masks, or sometimes busts, were not particularly individualized, at least they had established the principle of recalling a specific person. People of the upper classes would parade with such masks at the funeral of a relative, thus recalling not only the recently deceased but also those who went before.

A statue from the first century AD portrays a man carrying two busts of the Republican type at a funerary event (fig. **2.6**). It is a copy of an earlier statue, and it provides a precious visual record of what we otherwise know only from literary sources. The description by Polybius, a Greek historian of the second century BC, explains this ceremony:

"The portrait [of the deceased] is a mask which is wrought with the utmost attention being paid to preserving a likeness in regard to both its shape and its contour. Displaying these portraits at public sacrifices, they honor them in a spirit of emulation,

2.6 Patrician carrying two portrait heads. First century AD. Marble. Height 5ft 5ins (1·65m). Palazzo dei Conservatori, Rome

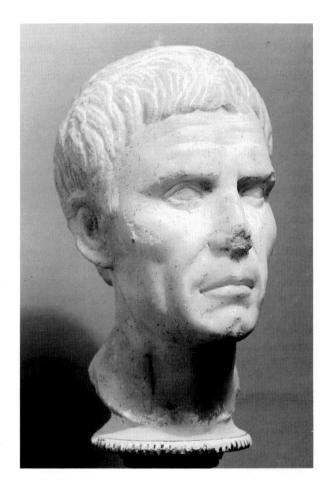

and when a prominent member of the family dies, they carry them in the funeral procession, putting them on those who seem most like [the deceased] in size and build."

[Polybius vi. 53, trans. J.J. Pollitt, *The Art of Rome c. 753 BC–AD 337 Sources and Documents* (Prentice-Hall, Englewood Cliffs, NJ, 1966) p.53]

A type of head often referred to simply as the "Republican portrait" is characterized by a stark realism that sacrifices any degree of idealization. Some were middle-aged men (fig. **2.7**), but the most frequent subject was an older type (fig. **2.8**). These men would have been prominent citizens

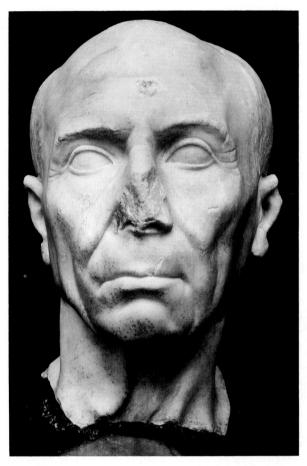

2.8 Republican portrait of a man. A later copy of a Republican original of *c*. 30 BC. Marble. Height 1ft 1in (33cm). Museum of Art, Rhode Island School of Design, Providence, Rhode Island

who had climbed high on the political ladder. Characteristic are the furrows in the forehead and along the line from nostrils to chin, and the emphasis on the prominent bone structure of the brows, cheeks, and chin. The musculature of the cheeks and the skin surfaces of face and neck are also well defined, although even some of these features seem to have become partly a matter of convention. While such physical features are emphasized, the artist also succeeded in suggesting the wisdom and experience reflected in the intelligent eyes. Heads such as these seem to sum up the Roman admiration and respect for civic leaders and elder statesmen.

Funerary reliefs In the latter part of the first century BC, during the period when the Republic was coming to a close and Augustus was establishing the empire, a type of sculptural relief developed that was confined to a specific social class. At this time it was customary for freedmen (slaves who had been freed by their owners) to order a marble slab with lifesize portraits to be set into the walls of their tombs. These tombs lined the roads on the outskirts of Roman towns. The head and bust of the deceased person was carved in relief within a rectangular frame, either alone or with other members of the family or, in some instances, with the former slave owner.

In the example in fig. **2.9**, the relief of the early Augustan period depicts a woman on the left, and two men, and we learn from the inscription that it was set up according to the provisions of the will of members of the Gessius family. Not only have shoulders with drapery been included, but also one or both hands of each figure. Each person has a serious expression and looks directly forward. These are related to the Republican heads in freestanding sculpture, in that the artist strove for realism, and emphasized individual details such as wrinkles and blemishes. On the other hand, there is a generic look to these heads. No attempt was made to associate the dead with political or mythological heroes; instead, they look at us with ordinary expressions, as if in real life, and it is not hard to imagine what the people were like.

Eminent Romans Although the subjects of many Roman portraits are difficult to identify, some are known to be famous citizens who can be securely named by comparison with coin portraits, where they are labeled. One example is the head of Julius Caesar, who was the first Roman to put his portrait on a coin during his own lifetime (fig. 2.10). His long, thin neck, sharp features (including the pointed nose and strong chin), and piercing eyes give a clue as to why he had such an impact on all who knew him. Caesar was a remarkable person: a military genius, and a civic leader with widespread talents that earned him the position of dictator in a particularly troubled time. He also reformed the calendar and the legal system, and spread Roman law far beyond the boundaries of Italy. Caesar's name lives on in the words Czar and Kaiser.

Because of a constitutional crisis, where the Senate would not agree to the demands of three influential politicians, these men formed a private contract which amounted essentially to a power

2.9 *Below* Republican tomb relief of the Gessius family. 30–13 BC. Marble. Height 2ft 1½ins; length 6ft 9ins (66·5cm×2·06m). Museum of Fine Arts, Boston, Archibald Cary Coolidge Fund

2.10 *Left Denarius* of Julius Caesar. 44 Bc. Silver coin. *c.* ³/₄in (1.9cm). British Museum, London

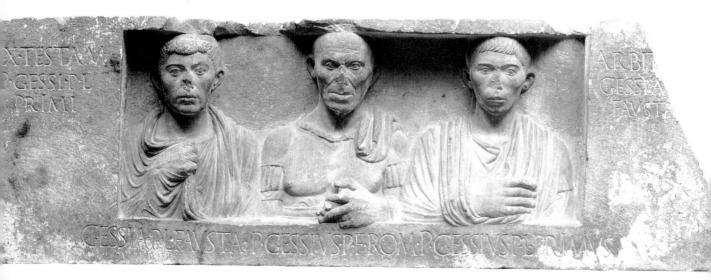

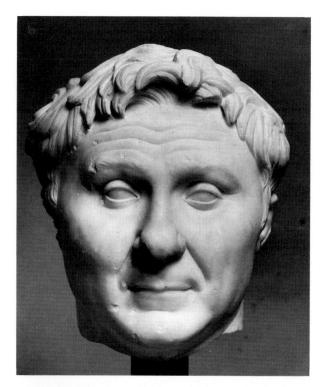

2.11 Above Portrait of Pompey. First century AD copy of an original from c.55 BC. Marble. Height 93/4ins (24.8cm). Ny Carlsberg Glyptotek, Copenhagen

2.12 Left Denarius of Pompey. 46 BC. Silver coin. c. 3/4in (1.9cm). British Museum, London

play. In 60 BC they decided to rule the state jointly in what is known as the "first triumvirate." The three men were Caesar, Crassus, who had acquired great wealth, and Pompey, who was an important general in the army. The portrait of Pompey (fig. 2.11) reveals a broad and heavy face with small, near-sighted eyes peering out from the folds of flesh. Here is an example where a coin portrait confirms the identification (fig. 2.12). His head, though realistic, is more of a character study than the veristic portrait of a man (see above, fig. 2.8), and belongs in a group of portraits that tends to attribute heroic qualities to the sitter. In fact, we know from a Greek writer of the Roman period, Plutarch, that Pompey was interested in emulating Alexander the

Great (fig. 2.13), famed for his mane-like hair. Here, Pompey's locks are similarly brushed up off his forehead, probably in hopes that viewers would associate him with the earlier leader who had also successfully led his armies toward the east. The statue may be a copy of the one in Rome in the Theater of Pompey, where Julius Caesar was murdered; he is said to have fallen at the feet of the figure of Pompey.

The head of Pompey is in fact a copy made in the first century AD of an original from the middle of the first century BC. It was common for later Romans to copy earlier statuary, and they developed an effective means of reproducing the original by a method called "pointing." An artist would take measurements from fixed points on a grid of strings,

2.13 Portrait of Alexander the Great, from Pergamon. 200–150 BC. Marble. Height 1ft 4ins (40.6cm). Istanbul Arkeoloji Müzeleri, Istanbul

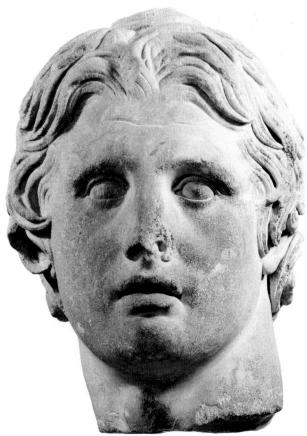

to get the depth of this or that detail of the model, and drill the prescribed depth into a new piece of marble, thus establishing the same size and proportions. Further carving and finishing in the hands of a skilled copyist would lead to a rendition remarkably close to the original.

The Romans had established a colony on the Greek island of Delos shortly before the middle of the second century BC. This flourished as a center of the slave trade until the devastation caused by the revolt of an ambitious king from Asia Minor, Mithridates VI of Pontus, in 88 BC. During this period, many of the Greek artists on the island were working for Roman patrons.

A comparison of the head of Pompey with a

2.14 Portrait of a man from Delos. Greek. *c.* 100 BC. Bronze. Height 1ft 1in (33cm). National Archaeological Museum, Athens

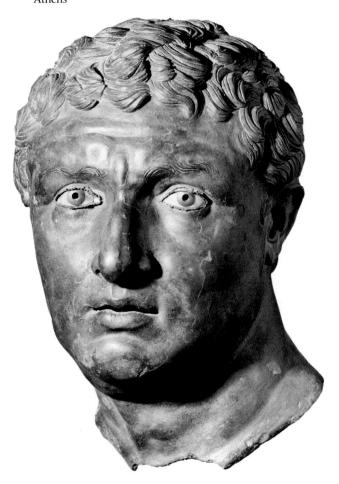

2.15 *Denarius* of the second triumvirate showing Mark Antony and Octavian (Augustus). 41 BC. Silver coin. Cornell University Collection, Cornell University, Ithaca, New York

bronze portrait from Delos (fig. 2.14) brings out notable differences. The Greek head is a little earlier than that of Pompey, and may be dated to about 100 BC. The Greek artist was also dealing with a fleshy man, but one who was younger than Pompey. The portrait from Delos is typical of the fusion of the Roman demand for naturalistic portraiture, and the Hellenistic Greek tendency to portray even ordinary citizens as heroic. Although wrestling with realism, the artist put a twist into the head, both in the neck position and by the turn of the eyes, and also allowed more interpretation in the rendering of the features. Thus they appear less as a naturalistic catalogue and more as a study of the man's personality, with the suggestion that he was some kind of a hero.

The first triumvirate collapsed after the death of Crassus in 53 BC, and civil war broke out when Caesar led his army across the Rubicon, a river in northern Italy. After several years of fighting and governmental instability, a second triumvirate was formed by Mark Antony, Lepidus, and Octavian (later Augustus), and their absolute power for a period of five years was confirmed by law in 43 BC. This event was commemorated on a coin (fig. 2.15) that showed Antony on one side and Octavian on the other, with an inscription referring to the event: tresviri rei publicae constituendae, "triumvirs for the restoration of the Republic." In effect, they were a committee of three for the purpose of restoring confidence in the orderly functioning of the political process. Even on such a small scale, and using strict profile, the coin designer was able to give life and individuality to these two heads.

Wall paintings

Wall paintings decorated both the homes of the Romans and (in common with the Etruscans) their tombs. Developments in Roman painting, and in its companion art, mosaic, can be traced over centuries from Republican times through the empire.

AN EARLY TOMB

The earliest surviving fragment from Rome is a painting from a tomb on the Esquiline Hill (fig. **2.16**) that preserves an early form of historical painting. The date of the piece is uncertain, but it was probably painted before the first century BC. It is

2.16 Meeting of the chiefs Fannius and Fabius, from a tomb on the Esquiline Hill, Rome. Second century BC? Wall painting. Palazzo dei Conservatori, Rome

2.17 Samnite House, Herculaneum. Second century BC. Wall painting

interesting that already here we can detect the Roman taste for dividing the subject into registers, or horizontal bands. There are four. At the top, only the legs of a man are preserved. Below, there is a crenellated town wall at left, and two figures, one with spear in hand, meeting each other. Both are labeled, and their names, Fannius and Fabius, are repeated more legibly in the next register, where the two men are about to shake hands while a group of soldiers watches from the right. We shall see the same kind of overlapping of figures to show a crowd in a later painting from Pompeii (see below, p.145). In the lowest section preserved there are traces of a battle scene.

What does all this mean? One of the two persons here is presumably the Fabius who was an important general in the Samnite Wars of the later fourth century BC. The painting seems to depict a battle in which one or both of the leaders may have had a hand, and perhaps the meeting when the treaty was made.

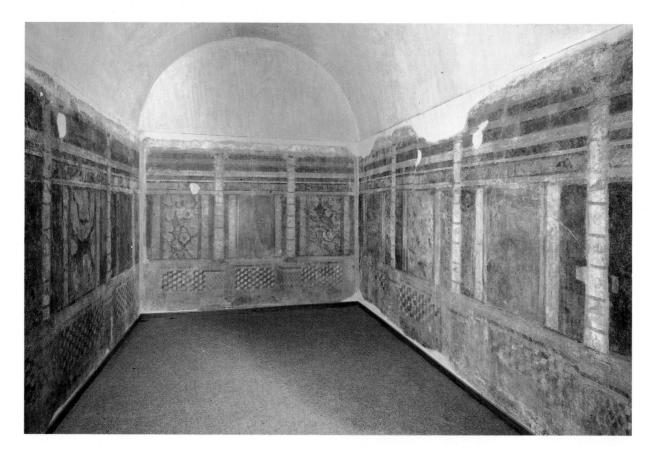

The painting is descriptive in a straightforward manner, and gives us a tantalizing glimpse of the kind of historical scenes and battle paintings of which there must have been many in early Roman times. It serves as an example in painting of the native Italic strain, also called the plebeian style, that we have already observed in relief sculpture. Although hardly a distinguished piece in itself, it is treasured as the earliest surviving fragment of wall painting from Rome, and one where the Roman interest in history is already clearly present.

HOUSE WALLS

Most surviving paintings from the Roman era were found in Pompeii and Herculaneum and other towns in the Bay of Naples, because those cities, and the surrounding settlements, were buried and preserved by the catastrophic volcanic eruption of Mount Vesuvius in the year AD 79. The ash, *lapilli* (stony particles), and mud that seeped into the

2.18 *Above* House of the Griffins, from the bedroom of a house on the Palatine Hill, Rome. 100–50 BC. Wall painting. Antiquario del Palatino, Rome

2.19 *Opposite* Peacock and theater mask before a vista with columns, in the Villa of Oplontis, Torre Annunziata, near Pompeii. First century BC. Wall painting

houses and covered the streets acted as a preservative not only of wall paintings, but also of many household and decorative objects, as well as organic materials. When first uncovered, the wall paintings had brilliant colors, as if they had just been painted; over time, with oxidation, weathering, and pollution, some have lost that brilliance, but others have been well protected from the elements.

It used to be customary to remove the best parts of large paintings from their walls, and to set them up in the palaces and museums of 18th-century kings, who regarded them as private possessions.

Many have now passed into the public collections of Italy, especially the National Museum at Naples. But some of the paintings are preserved in situ, where we can get a better picture of the individual scenes in their architectural settings.

FOUR POMPEIAN STYLES

A scholar called August Mau divided the Roman painting that survived in Pompeii until its destruction in AD 79 into four different styles. This division was based on fundamental differences in the way the artist treated the wall and painted space. The first two styles began in the Republican period, and were outgrowths of Greek wall paintings, while the Third and Fourth are found in imperial times (see below, pp.100, 121 and 143). Although this division into four styles is now sometimes questioned, it still serves as a useful way of observing differences in Roman wall painting.

The First Pompeian style In the second century BC, the most common house decoration was very simple, consisting mainly of imitations of colored marble. Pliny records the lavish use of

- **2.20** Below Bedroom of a villa at Boscoreale, near Pompeii. Mid-first century BC. Wall paintings. Metropolitan Museum of Art, New York, Rogers Fund
- 2.21 Opposite Bedroom of a villa at Boscoreale, near Pompeii, detail of rocks, birds, and garden. Mid-first century BC. Wall painting. Metropolitan Museum of Art, New York, Rogers Fund

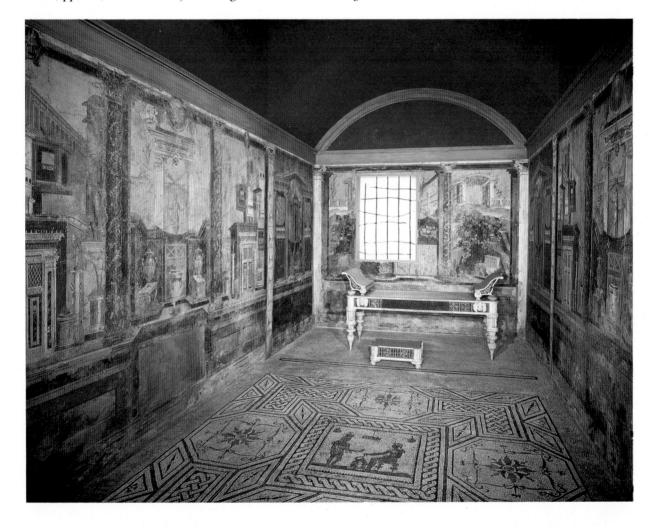

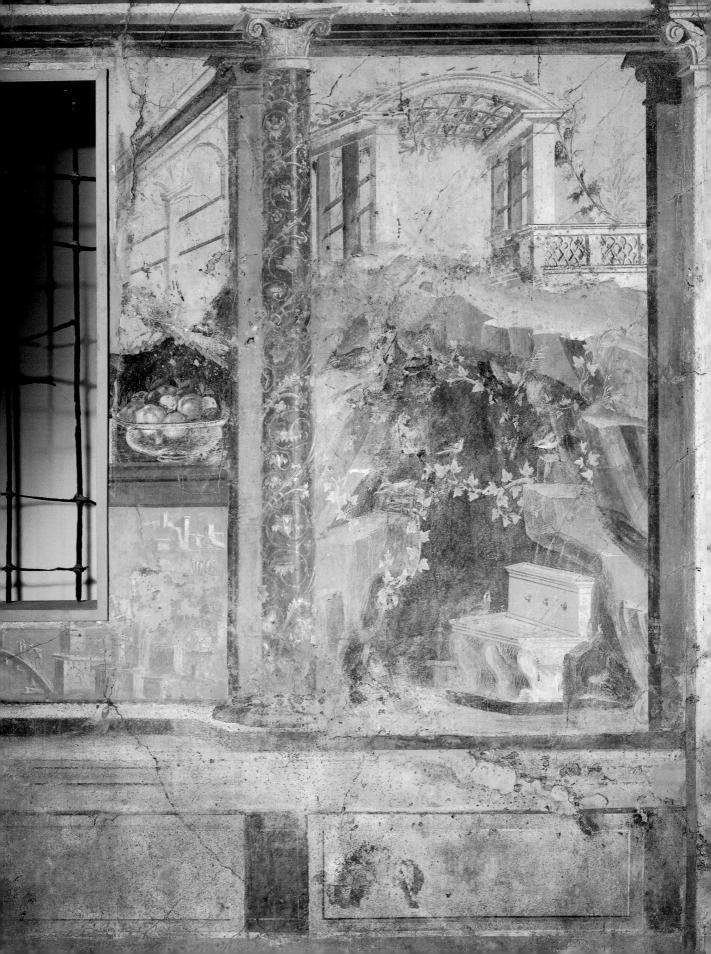

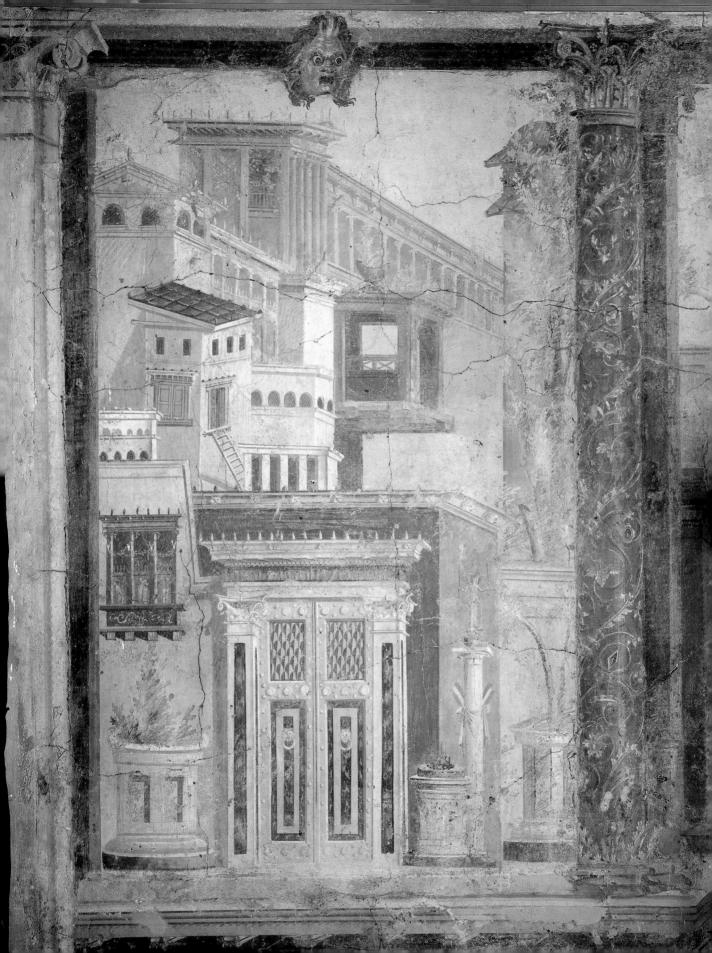

imported marble in grandiose villas at Rome [NH xxxvi. 48–50]; it would have served as the model for walls where plaster was molded and painted to look like blocks or panels of colored stones. A house owner who was not able to afford real marble, but wished to have the interior decoration look more expensive than it was, would have commissioned a painted version. Plaster was used both to emphasize the division of the painted blocks, and to make the three-dimensional cornice – the horizontal border at the top. One example is the Samnite House in Herculaneum, where we see how architectural such painting could be (fig. **2.17**, p.55). This kind of painting is known as the First Pompeian style.

2.22 Opposite Bedroom of a villa at Boscoreale, near Pompeii, architectural view. Mid-first century Bc. Wall painting. Metropolitan Museum of Art, New York, Rogers Fund

2.23 *Below* Dionysiac mystery cult, in the Villa of the Mysteries, Pompeii. Mid-first century Bc. Wall painting

The Second Pompeian style The Second Pompeian style began in Pompeii itself shortly after 80 BC, although an example from a few years earlier has been found in Rome. This style preserved a trace of the First, in that part of the wall was often still painted with the marbleized panels like those in the Samnite House; yet the whole scheme changed in that three-dimensional objects, principally architectural features like columns and ledges, were painted as realistically as possible rather than modeled in plaster.

One of the earliest examples in the Second style is from the House of the Griffins (fig. **2.18**, p.56), found on the Palatine Hill in Rome where many of the prominent citizens of the Republic lived. The flatness of the wall, which is of course literally a flat surface, is emphasized by some of the large central panels that are painted solid red; other panels have marble patterns that give the illusion of a three-dimensional surface. The illusion of columns is effected by painting them with shadows, as if they

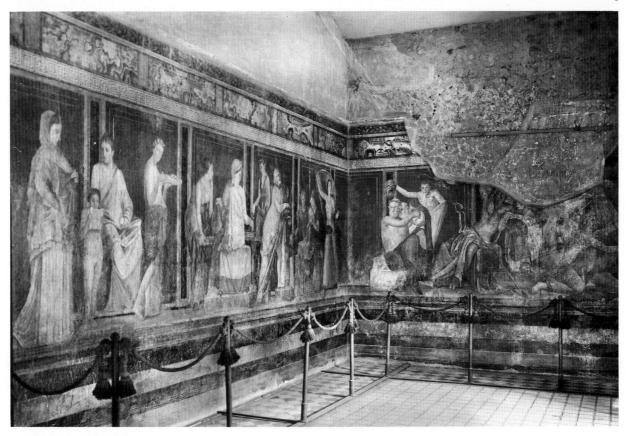

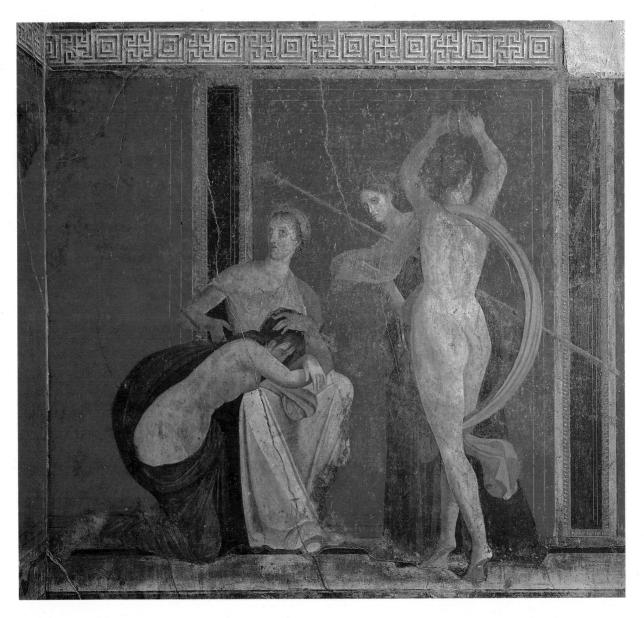

had volume and stood in front of the wall. Figural decoration had not yet been admitted.

Another splendid example to take advantage of columns to give a sense of space is seen in the villa at Oplontis. Built in the first century BC, it eventually belonged to Poppaea, wife of the emperor Nero. Discovered only recently, it has added considerably to our repertory of Roman paintings, many of them in the Second style. In one detail (fig. **2.19**, p.57) a peacock sits on a ledge near a theater mask in front of a row of receding columns with realistic shadows. Notice how the flatness of the wall is ignored, and the whole seems to be a view, above the ledge, of distant space.

2.24 Ritual passage into a mystery religion, in the Villa of the Mysteries, Pompeii. Mid-first century BC. Wall painting

Many paintings from Pompeii and Herculaneum, removed from their original wall surfaces, are now located in museums in other parts of the world. The walls of a whole room restored as a bedroom from a villa belonging to one P. Fannius Synistor at Boscoreale, near Pompeii, have been set up in the Metropolitan Museum in New York (fig. **2.20**, p.58). The painter, in the mid-first century BC, treated the wall as if it were a series of windows on the outside world. The views appear to deny the surface of the wall, as one looks out

behind a narrow ledge punctuated with painted columns, shaded and highlighted to enhance the three-dimensional effect, and ornamented by a delicate floral design. The scene with rocks, birds at a fountain, vines, and trellis (fig. 2.21, p.59), may mimic the kind of actual sight that might have been seen through the real window next to the painting.

This shift between reality and illusion is also implied in the scene on the side wall where, behind a painted portal, there is a breathtaking profusion of balconies, receding colonnades, windows, and courtyards (fig. 2.22). We can see in this detail that the artist did not use a single vanishing point to which the perspective lines lead, but rather altered the perspective from one section of the architecture to another. Thus, we seem to look at

2.25 The Laestrygonians attack Odysseus and his crew, from the Odyssey Landscapes, found in a house in Rome. Mid-first century BC. Wall painting. Height of frieze 5ft (1.52m). Musei Vaticani, Rome

the small square roof at the left from above, and at the balcony to its right from below, and the two are set with differing perspectives.

One of the most well-known examples of the Second Pompeian style, famous because of the outstanding skill of the artist, is the Villa of the Mysteries (fig. 2.23), located just outside the boundaries of the city of Pompeii. Here, in one room, the back wall is again striking in its brilliant "Pompeian" red, but flat, painted pilasters, rather than columns, divide up the space. Lifesize figures stand and move on a narrow painted ledge in front of the back wall, so that they seem to exist in real space. We may have an example here of a Roman version of Greek megalography, or painting of large-scale figures.

The figural subject matter, a feature that we have not seen before, seems to represent a kind of ritual passage into a mystery religion, that of the god Dionysus. He himself is shown in one part of the painting with several of the figures who normally

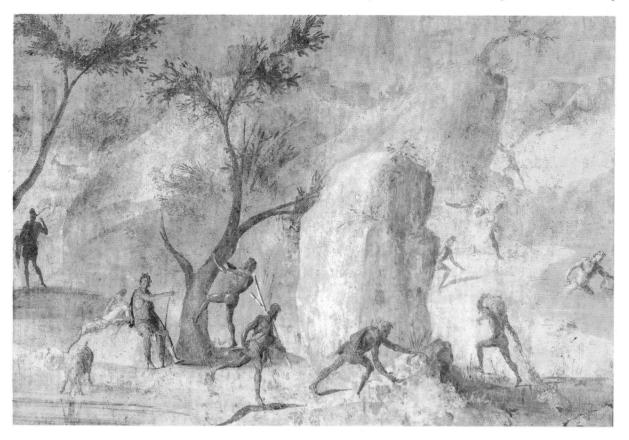

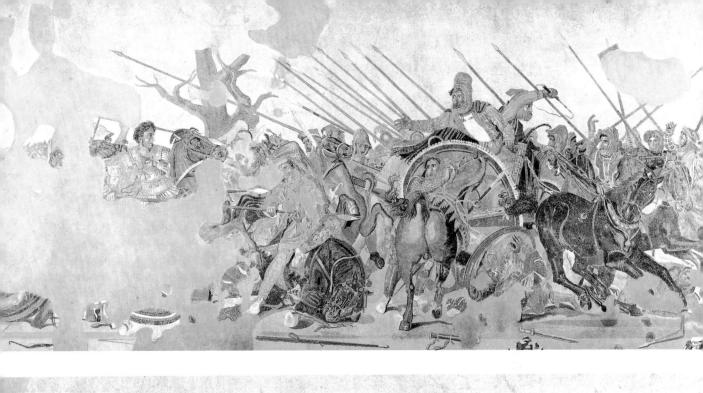

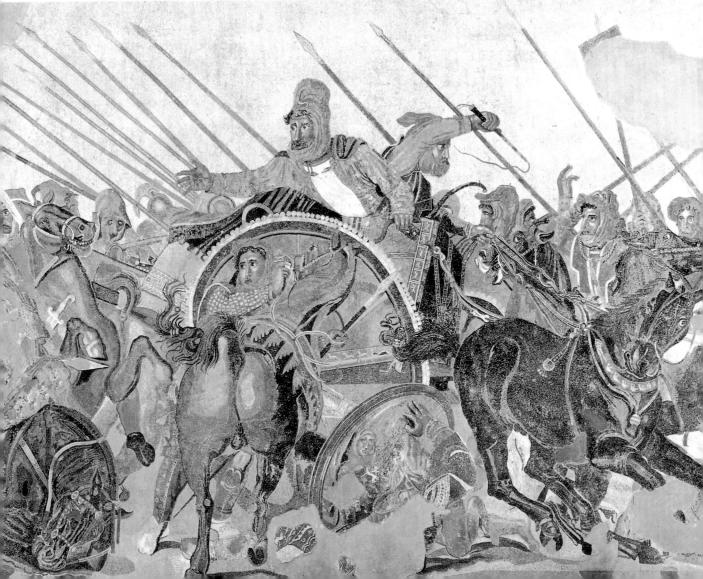

accompany him, such as Silenus and satyrs. The event portrayed seems to show how naked girls were hit with a switch as an initiation rite. In the portion shown here (fig. 2.24), a winged halfnaked female whips a young woman who cowers in the lap of another woman, perhaps her mother. Two other women are at the right. One is naked and dancing with cymbals, a twirling piece of drapery flowing from her shoulder; she is a maenad, one of the ecstatic comrades of Dionysus. The other is a fully dressed woman who seems to float past as she watches the scene. The action is carried across the corner of the room. The studies of human faces and bodies, of drapery, and of dramatic action, are particularly well drawn, and suggest that one of the finest artists of the day painted these walls for the mistress of the house.

An important set of paintings, the Odyssev Landscapes, was found in the mid-19th century in a house on the Esquiline Hill in Rome. Like other paintings of the Second style, they have a series of painted pillars in front of the main subject. This consists of a continuous landscape peopled with figures from Homer's Odvssev. The stories are taken from Books x and xi, and include Odvsseus at the entrance to Hades, his visit to Circe, and his encounters with the giant and cannibalistic Laestrygonians.

In this detail (fig. 2.25) the Laestrygonians are hurling stones and sticks at Odysseus and his crew in their ships. The men themselves, small in scale compared to the landscape, are painted in swift, confident strokes, and the landscape has a sketchy, impressionistic quality. Trees seem to sway in the breeze, and the men move with ease through a space that is clearly suggested, if not defined precisely. The artist has used a coloristic device known as atmospheric perspective to increase the impression of distance. When the more distant parts are painted in a pale color, this gives the realistic optical effect of the fading of intensity that is caused

2.26 Opposite top Battle of Alexander the Great against the Persian king Darius. First century BC Roman mosaic, a copy of a painting by Philoxenos, c. 300 BC. Height c. 9ft; width c. 17ft (2·7×5·2m). Museo Archeologico Nazionale, Naples

2.27 Opposite bottom King Darius flees from the Greeks, detail of the Alexander Mosaic

by the intervening particles of the atmosphere. Thus, blues and greens appear hazy in the distance while the nearer objects have a darker shade of the same or similar colors.

The Odyssev Landscapes are thought to be a Roman adaptation of an earlier cycle on the same theme by a Hellenistic artist. The Roman contribution lies especially in the framing of such scenes with columns or pilasters, suggesting that one is looking through an opening upon the landscape or architecture. By giving the illusion of breaking open the wall in this manner, the Roman painter relieved the impression of a closed space, thus instilling a refreshing vitality into the interior of the room.

Mosaics

The Romans liked to decorate their homes and public buildings not only with paintings, but also with mosaics that were covered with either decorative patterns or figural subjects. Mosaics were made by pressing tesserae (squarish stones) and occasional pieces of glass into a bedding of soft mortar which was squeezed into the spaces between the squares. Finally, the surface would be cleaned and polished. Beneath every Roman mosaic is a painting which served as a pattern for the mosaicist to follow. Most mosaics were intended for floors, although occasionally walls and ceilings were also decorated in this manner.

In the grand Pompeian house called the House of the Faun was found one of the most spectacular mosaics preserved from antiquity. Called the Alexander Mosaic (fig. 2.26), it covered a large area of the floor, approximately 9 by 17 feet $(2.7 \times 5.2 \text{m})$. The subject shows Alexander the Great, riding in at the left on his famous horse Bucephalus, routing the Persian king Darius III at the Battle of Issus. Darius flees in his four-horse chariot, his arm extended toward his friend who has just been run through (fig. **2.27**). Meanwhile, the fierce battle between his men and the Greeks is played out on the platformlike ground at the front.

The historian Pliny tells us that a celebrated painting of this subject was made in the late fourth century BC by the Greek artist, Philoxenos of Eretria. We suppose that the mosaicist copied that

lost original, preserving for us a close approximation of a Greek painting. He imitated not only the design, but also the illusionistic space, with figures overlapping each other. And even the notion of a polychrome mosaic, with a framed picture, called an *emblema*, in the middle, is a borrowing from Greek practice. But this is not to belittle the remarkable skill of the mosaic artist, who used tiny *tesserae* to give this work its unusually subtle gradations of colors. Figural scenes like the Alexander Mosaic were reserved for the wealthy, at least in Republican times, but it was not unusual for ordinary homes to be decorated with mosaics in black and white, frequently dominated by geometric patterns.

Another important example made during the

2.28 Nile Mosaic, in the Sanctuary of Fortuna, Praeneste. First century Bc. c. 20×16 ft (6×4.9 m). Museo Archeologico Nazionale, Palestrina

Republican period is the Nile Mosaic (fig. **2.28**), found in the sanctuary dedicated to Fortuna in ancient Praeneste. This is the modern Palestrina – the Latin town 25 miles (40 km) to the east of Rome where the musical composer of this name was born in about 1525. According to Pliny, floor mosaics were made at the bidding of Sulla, and one was set up in the shrine of Fortuna at Praeneste.

The Nile Mosaic was found near the lower part of the sanctuary in an apsed hall. Like the Alexander Mosaic, this was huge, and must have

been done in imitation of a work in Egypt, probably from Alexandria, to judge from its subject matter. In the heavily restored upper portion, exotic and sometimes imaginary animals, many of them labeled with their Greek names, dot an empty landscape, while in the lower parts, a realistic scene of the Nile in flood is portrayed. Crocodiles, hippopotami, and other animals swim and move about the river reeds, while birds, Nile boats, huts, and houses fill in other parts by the river. There is also a scene that may represent the visit of a Roman general: a group of soldiers stands in the large building with columns and a tentlike canopy that is prominently placed near the bottom of the mosaic.

The artist used the bends of the river to give a sense of recession in space, as the curves lead our eves into the distance. In this scheme, those objects that are higher up are further away. The device of atmospheric perspective, which we have already observed in painting (see above, p.65), is also used to increase the impression of depth. The artist, furthermore, experimented by giving views of the huts and temples from different angles, thus providing multiple perspectives, but without tying them together in a coherent system. Topographical interests are indulged, and there is obvious enjoyment in the study of plant, animal, and water life along the Nile. Many other Roman mosaics explored these subjects, but none on so grandiose or ambitious a scale as this.

2.29 Villa of the Papyri, Herculaneum. A plan, after the Weber plan drawn in the 18th century. Second half of the first century BC

Architecture

VILLAS AND HOUSES

Many wealthy Romans lived in sprawling villas in the countryside in the Republican period. Some of these belonged to landowners who lived in them not to entertain and relax, but to work their farms and vineyards. Others were magnificent architectural complexes decorated with sculpture and paintings, and embellished with elaborate gardens. One of these was the Villa of the Papyri near Herculaneum, named for the papyrus rolls found in its extensive library. This elegant country home was excavated by tunneling in the 18th century, with the result that drawings and plans were made (fig. 2.29), but the building itself lay buried underground. Based on reconstructions, the Getty Museum in Malibu, California (fig. 2.30) was modeled on it – not only the buildings but also the layout of the gardens and the scores of bronze statues.

The typical plan of a patrician Roman house (fig. 2.31), well documented at Pompeii, shows that the layout was frequently symmetrical. The wall facing the street front was either solid (apart from the door or windows), or in many cases there was a shop that opened directly onto the street. In Roman domestic architecture, there was much more emphasis on the interior space and decoration than on the appearance of the exterior. The entrance led into the atrium (fig. 2.32), a large space with a rectangular opening through which one looked to the sky. Rainwater ran off the roof, which was

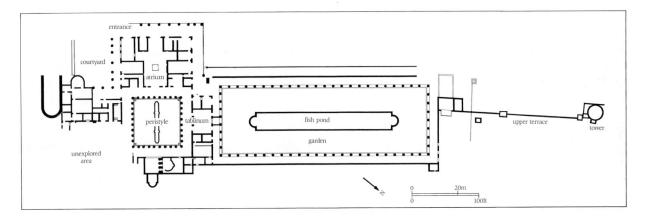

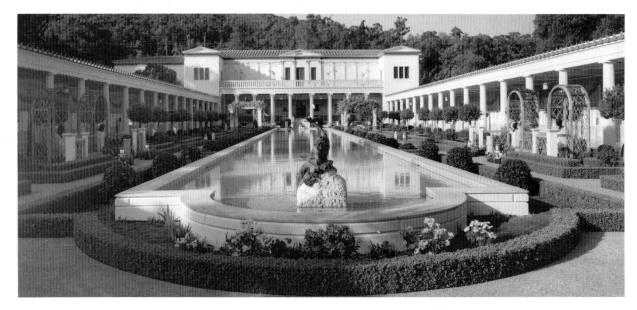

2.30 *Above* Main peristyle and garden, J. Paul Getty Museum, Malibu, California

 $\textbf{2.31} \ \textit{Below} \ \text{Roman patrician house, restoration drawing} \\ \text{and plan}$

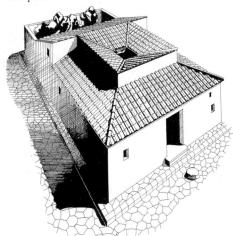

2.32 *Below Atrium* of the House of the Silver Wedding, Pompeii. Early first century AD

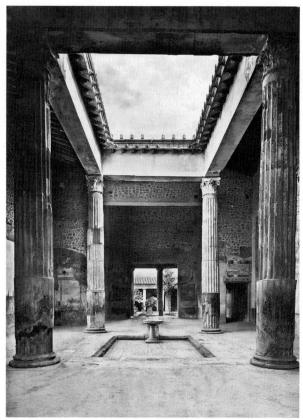

pitched inwards, and fell through this opening into a little pool called the *impluvium*. Around this space were small rooms used for bedrooms or living rooms.

Behind the atrium, on axis with the entrance, a larger room called the tablinum was used as a public reception area. The dining room, the triclinium, was normally to the left or right. It was important to the wealthy to have large and impressive rooms for conducting their affairs with clients, and in larger houses, influenced by the Greek tradition, there might also be an enclosed colonnaded garden, or peristyle. Additional small rooms were often clustered around this space as well. The open house plan was admirably suited for a climate where the weather is mostly warm and sunny: people could feel they were out of doors even when they were in the house. On the other hand, the core of the house. around the atrium, could be closed up as a barrier against cold winds when necessary.

2.33 Pont du Gard, near Nîmes. Late first century Bc. Stone. Height 162ft (49·38m)

AQUEDUCTS

The Romans are well known for their feats of engineering, among which are the enormously long and well-constructed aqueducts that carried water from the hills and mountains to metropolitan areas. Spectacular remains of aqueducts survive at Segovia, in Spain, and on the outskirts of Rome itself (see below, fig. 4.19) where miles of arches can still be traced. One of the best-preserved aqueducts, in southern France, may have been built by Agrippa in the late first century BC. It is known as the Pont du Gard (fig. 2.33), because it crosses the River Gardon about 13 miles (21 km) from the city of Nîmes, which it served. The water channel itself is at the top, while a modern roadway crosses the river above the bottom row of arches. The aqueduct is constructed of monumental stones joined without mortar or clamps. Rough stones were purposely left jutting out to allow for repair work.

The Roman builders' skill in handling the arches and vaults that are such a feature of their later buildings must certainly have been sharpened by the challenge of spanning wide valleys and deep gorges with aqueducts and bridges, built to provide

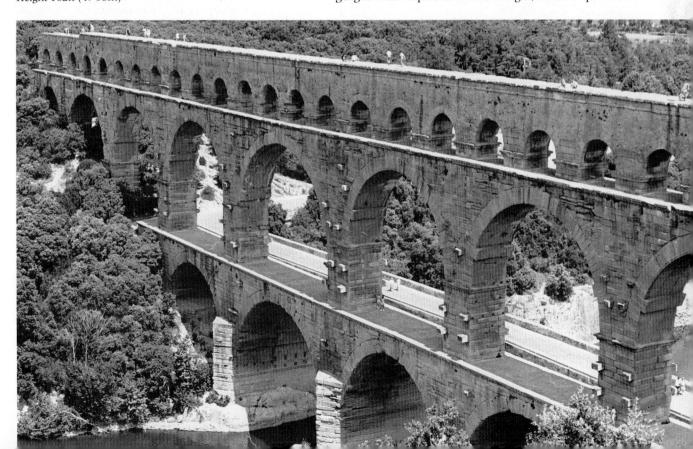

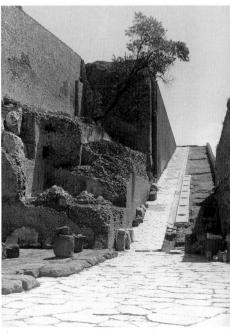

for the growing population and the administrative services that went with it. The arch itself has the functional appeal of great strength, coupled with the relatively spare requirement for building materials, in relation to its size.

But aside from the many practical points that make this such a remarkable accomplishment, there is also the aesthetic achievement. The rhythm set up by the long rows of arches is satisfying and beautiful at the same time. The two sets of larger arches are placed one above the other, whereas the small arches on the top tier are matched so that three of them make up the space of one larger one below/The central arch over the river is wider than the others, and hence required the space of four of the small arches over it. The effect of the fine proportions here is further enhanced by the reflection in the river.

SANCTUARIES

Roman architecture in the later Republican period portrays a remarkable confidence on the part of the builders in the use of new building materials and in the experimentation with new design. They had some success in carrying out grandiose religious complexes on a scale that was quite unknown before their time. Such complexes, that often included not only temples to the gods or goddesses, but also open areas for worship, sacred groves, and even secular buildings, are known as sanctuaries.

Construction of the Sanctuary to Fortuna at Praeneste would have begun around the middle of the second century BC (figs. **2.34** and **2.35**). It was built on a prominent hill, looking to the southwest over the plains of Latium. The architect took full advantage of the site, building the sanctuary on vaulted terraces that provided flat spaces for the porticoes at different levels. The actual shrine to Fortuna, an oracular shrine where the future of the

- **2.34** *Opposite top* Sanctuary of Fortuna, Praeneste, from the southwest. Second century Bc. Tufa, concrete, and limestone
- **2.35** Opposite left Sanctuary of Fortuna, Praeneste, architectural model viewed from the west. Museo Archeologico Nazionale, Palestrina
- **2.36** Opposite right Sanctuary of Fortuna, Praeneste, opus incertum at left, ramp at right. Second century BC

worshippers was predicted, was cut into the bedrock at the very top of the complex. The sanctuary exhibited a highly advanced and complicated but symmetrical design that went far beyond any known prototypes, in Italy or the Greek world.

To create the terraces past the line of the hill, the builders used a tall, vaulted substructure, seen here at the side of the model. The rows of piers were constructed of *opus incertum*, the method often used to face structures made of concrete in the second century BC (fig. **2.36**). The inside of the pier would be made of a conglomerate of rubble. Into this would be set cone-shaped pieces of tufa, a porous local stone, with the flat, irregularly shaped head of the cone facing outwards. At the corners, larger, squared blocks of limestone, known as quoins, defined the edges.

Once the Romans had put the idea of using vaults and concrete together, the possibilities were endless. Concrete was made of rubble and mortar that was composed of a kind of volcanic earth known as pozzolana. This natural material bound around the rubble and set into a hard mass, like modern cement, and its properties were responsible for much of the success of Roman architects in vaulted structures. The material provided builders with the prospect of cheaper construction because the expensive, skilled labor of making squared blocks, known as ashlar masonry, was avoided. They also discovered that a large enclosed space without supporting columns could be created by groin vaults, and eventually domes. This was a significant technological advance, and the goal of larger and larger unimpeded spaces was eagerly pursued in the imperial period. The final product eventually enabled the Romans to construct some of the most spectacular vaults ever made.

Worshippers who climbed the hill at Praeneste from the lower to upper levels found narrow passages, broad terraces, colonnades, stairs, and a ramp, before they reached the holiest part, the antrum, or cave, that was cut into the rock, and dedicated to the goddess Fortuna. They would have experienced a kind of criss-cross movement, forced upon them as they followed the paths back and forth across the sanctuary, and the views both up toward the shrine and out toward the plain below would have been spectacular.

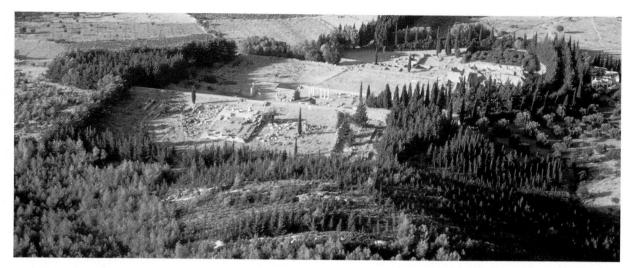

- **2.37** Sanctuary of Asclepius, Cos, aerial photograph and plan
- 1 Temple of Asclepius
- 2 Exedra
- 3 Altar
- 4 Ionic temple (Greek)
- 5 Roman building (priest's house?)
- 6 Ionic temple (Roman) for imperial cult
- 7 Clubhouse?
- 8 Fountain
- 9 Roman baths
- 10 Entry gate

An unusual feature was the ramp itself (fig. **2.36**); half covered, half open to the sky, it had a row of Doric columns down the middle that supported the roofed portion. In order to accommodate the incline of the ramp, both the capitals and bases of these columns were cut on a diagonal. The use of Greek columns at all is an interesting feature, in conjunction with the revolutionary new concrete construction mentioned above. In other words, the sanctuary exhibits a mixing of traditional Greek decorative elements and columns of cut stone, with another kind of construction in a more flexible medium that was to open a whole new way of building in the years to come.

A Hellenistic complex that reveals some of the same organization that we have seen at Praeneste is the temple to Asclepius at Cos – an island off the coast of modern Turkey. The Greek sanctuary was built to Asclepius as a kind of tribute to Hippocrates, the great medical theorist, who came from there. Its plan (fig. **2.37**) is largely symmetrical, and again we

see the stepped terraces with a central ascent toward the temple at the top. This time, however, there is no zig-zag path or covered ramp, nor the Roman technology associated with the use of concrete. The example at Cos may be the kind of architectural complex that inspired the Roman architects, but they then carried the ideas expressed at Cos even further. One can only imagine what an exotic effect the Sanctuary of Fortuna would have had on the citizens of Praeneste and other central Italic towns.

Another sanctuary of about the same time is that of Jupiter Anxur, set above the modern town of Terracina (fig. **2.38**), to the south of Rome along the ancient Via Appia. The substructure was supported by tall arches resting on squared pillars (fig. **2.39**), and the concrete of the vaulting had a kind of stone facing, *opus incertum*, similar to that seen in the Sanctuary of Fortuna. The piers and arches supported a platform upon which rested the temple and its associated buildings. By constructing this

2.38 *Above* Sanctuary of Jupiter Anxur (at Terracina). View of promontory. Second century BC

- **2.39** *Top right* Sanctuary of Jupiter Anxur, arches of foundation. Second century Bc. Tufa, concrete, and limestone
- ${\bf 2.40}~$ Bottom right Temple of Fortuna Virilis, Rome. Late second century BC. Stone

terrace, the architect was able to create a level platform on the promontory, where the sanctuary then commanded a view from all sides. The whole complex has been interpreted as both temple and garrison post.

TEMPLES

Much more conservative than these complexes is the typical Roman temple form, derived from the Etruscan prototype. A good example is the so-called Temple of Fortuna Virilis (fig. **2.40**) in the center of Rome near the Tiber River. Built in the second half of the second century BC, it has many features in common with the temple at Veii (see above, p.25).

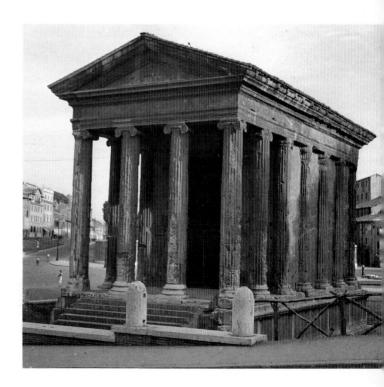

Typical are the high podium, the deep *pronaos*, and the frontal approach up a flight of steps. It also has a feature called "engaged columns," meaning that half-columns were applied to the exterior of the *cella* wall, in the manner of some Hellenistic temples. The general form of the Ionic columns is also borrowed from the Greeks, as is the use of stone to construct all parts of the building; but the tall, narrow proportions, and the Etruscan features, make this a truly Italic building.

We find this type of Roman temple all over the empire, especially in new colonies that were built in

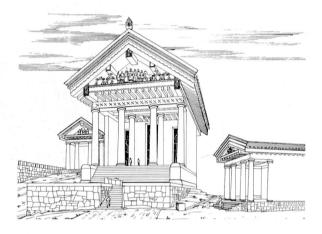

2.41 *Above* Temple at Cosa, on the Arx, reconstruction. Third or second century Bc. Stone and terracotta

2.42 *Below* Capitolium, in the forum, Ostia. *c*. AD 120–130. Brick and stone

emulation of Rome. At Cosa, situated on the coast to the northwest of Veii, the foundations of the same type of temple architecture have been preserved, and with the guidance of Vitruvius (see above, p.25), the superstructure can be restored (fig. **2.41**). It seems very likely that, with its triple sanctuaries, or *cellae*, it was modeled on the Temple of Jupiter on the Capitoline – a temple which was still standing at the time.

The temple at Cosa was built upon the Arx, or rocky citadel, and dedicated in the third or second century BC to the three gods of the "Capitoline Triad" (Jupiter, Juno, and Minerva). It also had a strong emphasis on the overhanging roof, which had gaily painted terracotta tiles. Like the earlier Etruscan temples, it rested on a high podium, approachable only from the front, and had the other typical features including the deep porch, and the walls of the *cellae* built at the edge of the podium. It was built by Roman colonists, using the form and construction of the Etrusco-Italic tradition.

Another good example, where something of the impact of the original position can still be felt, is at the site of Ostia, at the mouth of the Tiber (fig. **2.42**). One of the earliest Roman colonies, it maintained throughout its long history the elongated forum that was characteristic of early Roman towns. The word *forum* itself means an open space, out of doors, and by extension this meant a public space where people conducted business and went to market. Soon this area became favored for important temples, especially the one to Jupiter. At Ostia,

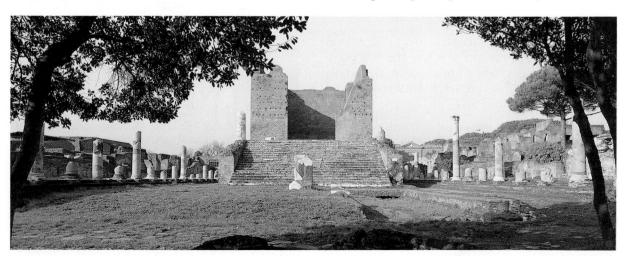

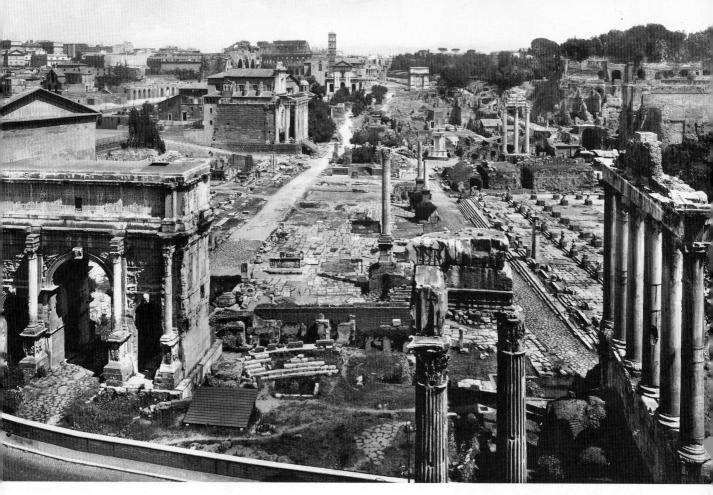

2.43 Roman Forum, view from the west end. Arch of Septimius Severus at left. Arch of Titus and Colosseum in the distance

the Capitolium (so called after the temple to Jupiter on the Capitoline Hill) was built on a podium at the back of the long, symmetrical forum, and dominated the space in front of it. Although the upper portions are now missing, the building must have looked like countless others in the centers of Roman towns.

Many public buildings and churches in Europe and the United States have façades with proportions similar to these temples, and in fact the Roman models were the chief inspiration for great architects like Palladio and Sir Christopher Wren, who in turn inspired Americans like Thomas Jefferson and Charles Bulfinch. Roman buildings became known through such works as the etchings of Piranesi (see, for example, fig. 5.8) and the engravings after Robert Adam; their publications had a great impact on both architecture and the decorative arts.

Town planning

THE ROMAN FORUM

The Roman Forum, which lies at the foot of the Capitoline Hill, was used for so many centuries that one can almost read the history of Rome in its ruins (figs. 2.43 and 2.44). In early times, at least by the eighth century BC, large parts were used as burial grounds for the "hut dwellers" who lived on the Palatine and other hills nearby. But by about 600 BC, when what had been a marshy area was drained, the ground was tamped to a firm surface and it became a public space reserved for a market and other activities. In fact, in a sense the Roman Forum became a symbol of the democracy of the Republic, being the space where civic activities took place. The Curia, or Senate building, was undoubtedly always in the spot where the late third-century AD building now stands.

The forum never was built over, although important civic buildings lined the roads that ran through it. The main roadways must have been established very early on, and one of these was always thought of as the Sacred Way (fig. **2.45**).

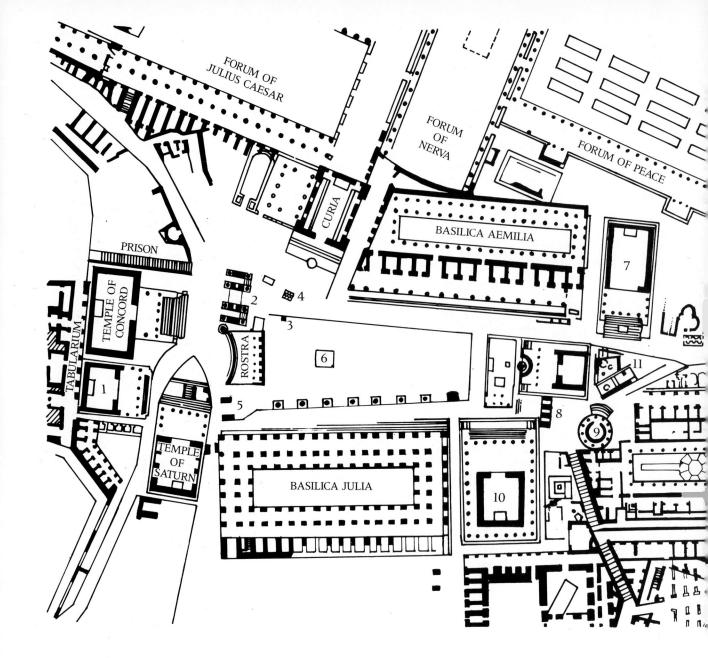

- 2.44 Above Roman Forum, plan
- 1 Temple of Vespasian
- 2 Arch of Septimius Severus
- 3 Decennalia base
- 4 The black stone (Lapis Niger)
- 5 Arch of Tiberius
- 6 Marsyas, fig tree, olive, and vine
- 7 Temple of Antoninus Pius and Faustina
- 8 Arch of Augustus
- 9 Temple of Vesta
- 10 Temple of Castor and Pollux
- 11 House of the kings (Regia)
- 12 Arch of Titus
- **2.45** *Right* Sacred Way (Via Sacra), Roman Forum. Temple of Antoninus Pius and Faustina at back left

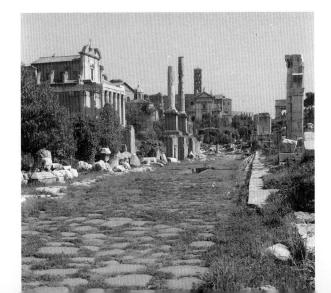

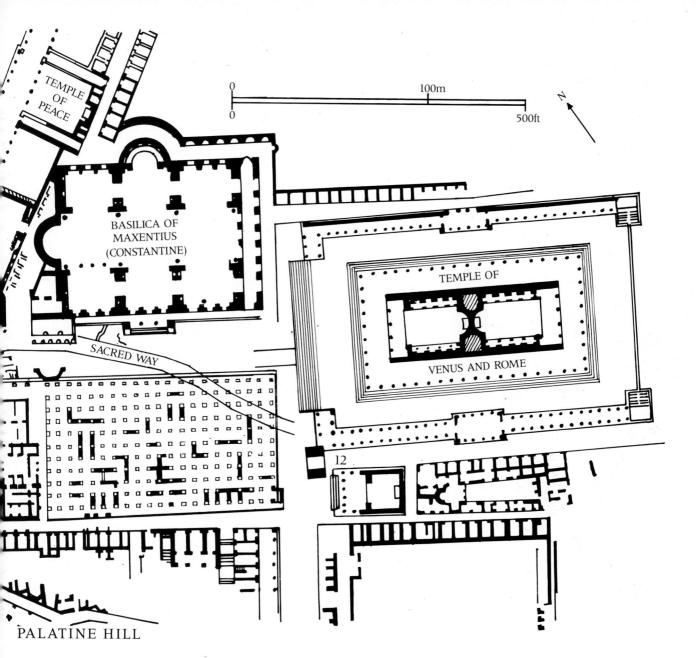

Certain early Republican spots were always honored in later times. The Lapis Niger, or black stone (no. 4 on plan), is part of a paved sanctuary with an altar dating perhaps to the sixth century BC. It may have been dedicated to Vulcan, god of the forge and blacksmiths, and marked the spot where Romulus was thought to have been killed.

The Lapis Niger was protected and considered sacred, as was the Regia (no. 11 on plan). The earliest evidence for the use of this area is a group of huts similar to those found on the Palatine, suggesting that it was occupied by hut dwellers, perhaps in the eighth century BC. The founding of the Roman Republic has traditionally been assigned

to the year 509 BC, when the Romans, under the leadership of Brutus, ousted the kings and set up an early form of the Republic. The original structure that is called the Regia may have been built at this time, in a form similar to that of the building still standing in imperial times. Although it looked like a house, it probably functioned rather as a place where the early priests and officials carried out their sacred duties after the founding of the Republic.

Two large basilicas, used for public administration like civil trials, define the north and south sides of the forum at the west end. One, the Basilica Aemilia, was originally built early in the second century BC, but was restored several times in

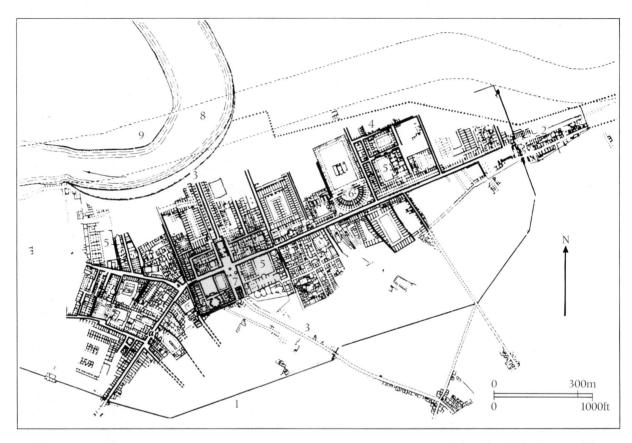

2.46 *Above* Ostia, the port of Rome, plan. The tinted area is the original *castrum*.

- 1 Defensive walls, built с. 80 вс
- 2 Decumanus maximus
- 3 Cardo
- 4 Barracks of the firemen
- 5 Bath building
- 6 Theater
- 7 Forum
- 8 Present course of the Tiber
- 9 Ancient course of the Tiber

2.47 *Left Castrum,* Ostia. Built soon after 349 BC. Stone walls. Area $5\frac{1}{2}$ acres (2·23 hectares)

antiquity. The other, the Basilica Julia, was begun by Julius Caesar, and constructed on the site of an earlier basilica. Even larger than the Basilica Aemilia, it had a double row of pillars on all four sides, and an additional exterior portico (see below, fig. **6.20**).

Another of the landmarks in this area of the Roman Forum is a raised platform where politicians delivered public speeches. It is called the Rostra, because in the fourth century BC a row of curved prows taken from the ships of defeated enemies ornamented the edge of the platform. From then on, because the prows looked like beaks, *rostra*, it was called by this name.

Excavations near the eastern end of the forum have exposed a wall that may have been an early enclosure for the area. Speculation now arises that it might be the wall around the original Roma Quadrata, a four-cornered area of the city, which was formerly thought to lie on the Palatine Hill instead of in the forum.

Over the next centuries, the Roman Forum continued to be the repository for statues and inscriptions dedicated to emperors and important civic leaders, as well as the site chosen for commemorative arches and temples to the gods and deified emperors. These monuments caused tremendous crowding that forced later rulers, from Julius Caesar onward, to build additional fora, but the original Republican forum continued to serve as one of the central nerves of Roman civic and business life until the very end of the empire.

THE CASTRUM

The Capitolium and the forum were just two of the many features that were found in any Roman town across the Mediterranean. Another common aspect was the town plan of cities that are much like Roman military camps. Wherever the army established a long-term camp, or *castrum*, it used a standard layout (fig. **2.46**), with two main streets crossing each other at right angles. Modern scholars, applying Roman surveying terms to town planning, have labeled the shorter one that ran

north–south the *cardo*, and the longer east–west road the *decumanus*. Other narrower streets ran along the same lines as the two major ones, thus making a grid-plan. A rectangular defense wall was built around the whole camp, as can still be seen at the military camp at Housesteads, by Hadrian's Wall in northern England, at the northern frontier of the Roman empire (see below, p.180).

In the many Roman towns that are similar to these settlements, the original rectangle is still clearly discernible in the enlarged town plan. At Ostia, for instance, one can see the foundations of the stone walls of the original *castrum* (fig. **2.47**). As the city grew, the streets continued along their original axes, except that the two at the south and west branched off on a diagonal just beyond the walls of the fort. Many Roman cities grew into medieval ones, and have survived as thriving modern cities. Sometimes it is not only the grid plan at the heart of the town that reflects the original military camp, but also the word *castrum*, which lives on in such names as Dor*chester* and Glou*cester*.

The effect that the *castrum* had on Roman town planning is typical of the way in which art and architectural forms that were developed during the Republican period continued to influence Roman programs in the following centuries. The format had been set, but from that point, subsequent artists and patrons took off in new directions, reacting to what had gone before, yet building upon it.

The idea that Rome was the leader and organizer in Mediterranean politics, as well as in practical matters that ranged from drainage to urban development, was set during the Republican era. Then, too, the encounter with Hellenistic arts in Magna Graecia, Greece itself, and Asia Minor, altered Roman art from a local and provincial style to the central model for the entire Mediterranean world. At first commemorative reliefs of successful generals, and buildings financed by public figures, set the stage, but soon the Romans found that they needed an art that served the state and not just the individual.

Augustus and the Imperial Idea 27 BC-AD 14

The drama of events in the second half of the first century BC changed the course of world history. Julius Caesar was assassinated on March 15, 44 BC, after which there was a bitter struggle for power that lasted for over a decade. The Battle of Actium in 31 BC left his great-nephew and adopted son, Octavian, the victor. He was given the name Augustus in 27 BC, and in 23 took over complete power. This included the right of veto over legislation, which formally signaled the end of the Roman Republic. From this point on, Roman art and architecture were to be intimately bound up with propaganda for the state as guided by the imperial family. Indeed, the purposes of public art changed.

As Rome's first citizen, Augustus fostered his image as protector of the peace and overseer of the land of plenty. Another of his

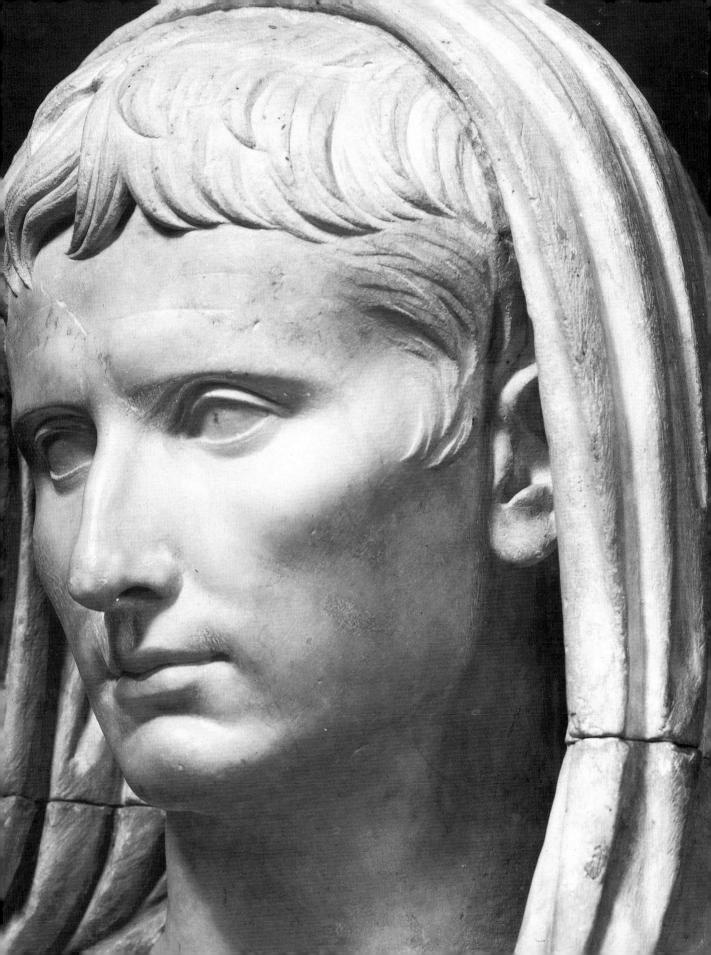

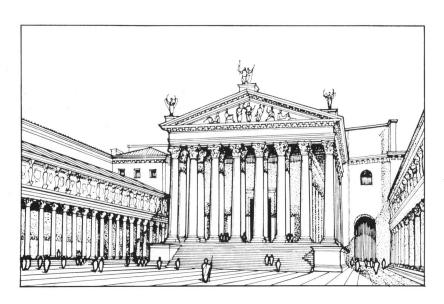

3.1 *Left* Temple of Mars Ultor, Forum of Augustus, Rome, reconstructed view

3.2 *Below* Temple of Mars Ultor, Forum of Augustus, Rome. Late first century BC. Marble facing over stone and concrete

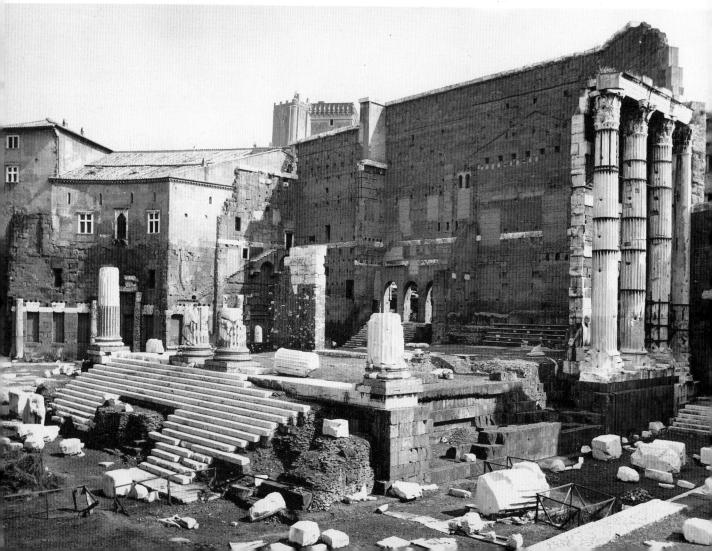

major aims was to promote the growth of the Roman population as a whole, and of his personal dynasty in particular. In this connection it was important that he confirm his right to power by association with Julius Caesar. He continued a number of Caesar's projects, such as the completion of the Forum of Julius Caesar, the Basilica Julia, and the Theater of Marcellus, and made them his own. Furthermore, he initiated a new forum near that of his adoptive father, and made the centerpiece of the complex a temple dedicated to Mars Ultor, Mars the Avenger.

Architecture

Augustus initiated a program that would bring public buildings and amenities to the populace throughout the empire. He endowed cities with theaters and aqueducts, porticoes, temples, and fora, and did not let these go unnoticed. Late in his life he wrote a famous assessment of his own accomplishments, the *Res Gestae*. The original text was inscribed in Rome, but copies of his statements were recorded all over the empire. One of the texts survives in Ankara, Turkey, inscribed on the side wall of a temple dedicated to Augustus and the goddess Roma. The emperor used much of the space to describe the many buildings for which he was responsible, and even claimed to have restored 82 temples in one year.

THE FORUM AND TOMB OF AUGUSTUS

The biographer Suetonius records the boast of Augustus that he had found Rome a city of brick and left it one of marble. One of his famous complexes, the Forum of Augustus (figs. **3.1** and **3.2**) was built like the rectangular Forum of Julius Caesar, where each side was lined by a colonnaded hall. But now, Augustus' architect added a semicircular apse, or *exedra*, behind each of the two colonnades. This was a new feature in the design of fora, and was to be used again in the Forum of Trajan in the next century (see below, fig. **6.4**), probably as a purposeful architectural reminiscence or quotation.

The Temple of Mars stood at the back of Augustus' forum, as did the Temple of Venus Genetrix in Caesar's forum, and it dominated the space in front of it in the traditional manner. Placed in the temple were statues to Mars himself, to Venus, and to Julius Caesar. The entire space was closed off at the back by a high wall that cut off the view of a poor district, full of tenement houses, that stood behind it. The wall later also served as a barrier to the flames in the great fire of AD 64.

The temple to Mars Ultor was in the first instance a way for Augustus to express filial piety, and at the same time it provided a thinly veiled reference to the fact that he had avenged the brutal death of Caesar, who meanwhile had been formally deified by the Senate. Furthermore, since Mars was the lover of Venus, a temple to Mars was particularly appropriate as a balance to the Temple to Venus Genetrix, "Venus the Mother [of the Julian clan]" that Julius Caesar had initiated. And by the time the temple to Mars was built, 40 years after the death of Caesar, there was another reason to celebrate Mars the Avenger and god of war: he had stood by the Romans in their conflict against the Parthians, and had made them victorious through peaceful negotiations.

The forum was entirely symmetrical, and emphasized the axis that passed through the center of the Temple of Mars Ultor. This axis helped to focus the viewer's attention on the center of the facade and on the space in front of the temple, where there was a four-horse chariot erected by the Senate in Augustus' honor. The exedrae behind the colonnade served as a kind of museum for statues of the great men of the past, among them the kings of Alba Longa and members of the Julian family. In the center of each exedra was placed one of the two mythical ancestors who, in Augustus' proclaimed family lineage, was a particularly important prefiguration of his own greatness: Aeneas and Romulus. Aeneas represented the pietas, piety, and Romulus the virtus, or strength, courage, and moral fiber, that Augustus now claimed for himself. This sculptural program was the visual counterpart to the literary statements regarding the divine and mythical ancestry made by the great Roman poet Virgil in his epic, The Aeneid, that had been written only a few years earlier.

Augustus also planned that his own tomb (fig. 3.3) should be a kind of propaganda statement for the Julii, and he placed there the ashes of various members of his family who predeceased him. Built in the Campus Martius ("Field of Mars"), just outside the city, he insured that it would be an impressive public monument, yet one that was in keeping with the Republican tombs that stretched along the roads outside Rome. Early in his reign he constructed the large circular building, about 285 feet (87m) in diameter, with several galleries at different levels. The first level was topped by earth, and there was a colonnade around the second. A tumulus of this sort would have reminded the Romans of the round, earth-covered tumuli in Etruscan cemeteries. Augustus, by this conscious imitation, was able to proclaim his public reverence for the Italic heritage, and reinforce his own role as a reviver of the consecrated religious and moral values that went back to Etruscan times.

3.3 Tomb of Augustus, Rome. Diameter *c.* 285ft (87m). Earth, concrete, brick, and stone

THEATERS

The provision of public entertainment at private expense was an important part of the Roman political tradition. The taste of the populace favored wild beast hunts, carried out in amphitheaters, and slapstick farces that were performed in theaters. Until the time of Pompey, these events had been held with temporary seating arrangements built for the specific occasion. Pompey gained much attention and presumably additional supporters for having commissioned the first stone theater at Rome. It was situated beyond the city limits in the Campus Martius, where little of the structure remains, but its shape may be traced in the curves of the modern buildings and streets. Furthermore, its ground plan shows clearly on a marble plan of Rome that was made during the Severan period, AD 193-235 (fig. 3.4). Pompey had to overcome considerable opposition to making permanent provision for the immorality inherent in the theater, and disguised it as a sacred precinct.

The same kind of hesitation is not apparent in the theater built by Augustus as part of the Julian

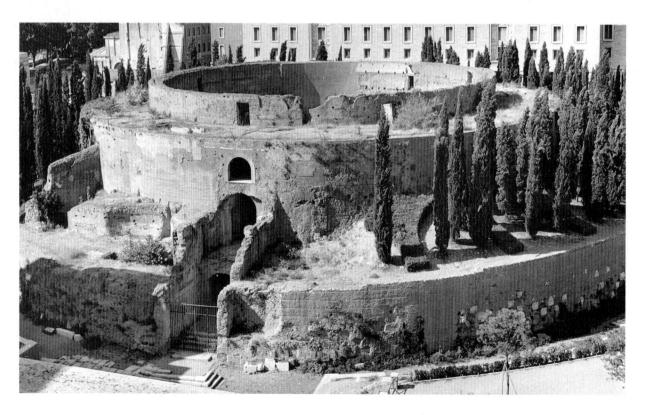

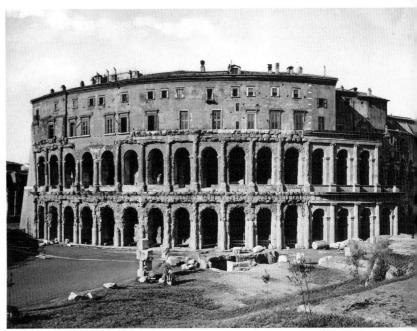

3.4 Above Theater of Pompey, on a fragment of the Severan marble plan of Rome, from the library in the Forum of Peace. Date of theater 55 BC

- 3.5 Top right Theater of Marcellus, Rome. Late first century BC. Stone
- **3.6** Bottom right The five orders of architecture: Tuscan, Doric, Ionic, Corinthian, and Composite. Engraving by Claude Perrault, 1683

building plan, although it too was just beyond the official limit of the city. Named for his son-in-law, Marcellus, much of this building still remains visible and intact because the upper parts were converted into living units and the arcaded supports were preserved (fig. 3.5). The plan is semicircular with 41 radial openings on the façade.

This theater is one of the first buildings to mix the different orders of architecture (fig. 3.6) on a facade - that is, the different kinds of standardized architectural elements largely derived from Greek practice. The columns on this building are engaged - meaning attached to a vertical surface at the back. At ground level the Doric order was used, and above this was the Ionic. The Corinthian order of the third story was later replaced by the walls and windows

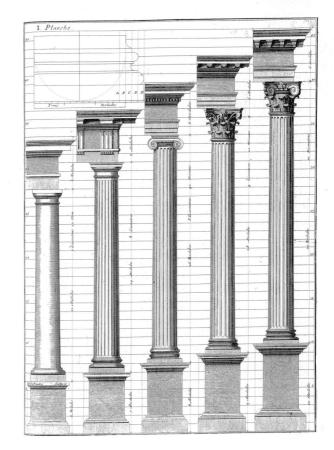

3.7 Augustus of Prima Porta. Early first century AD, after a bronze of *c*. 20 BC. Marble. Height 6ft 8ins (2·03m). Musei Vaticani, Rome

of apartments, but enough traces were found during restoration to make its existence certain. Over about 40 years three theaters were built and maintained in this area of Rome, making it a kind of theater district. Taken in conjunction with contemporary theaters in Pompeii and Herculaneum, they form a solid foundation for the development of a Roman theater type throughout the empire.

The importance of the Theater of Marcellus lies in the development of a distinctly Roman form for a theater building, where the *cavea* or seating area is semicircular, and closed by a substantial stage building with additional rooms to the sides. This is in distinct contrast to the Greek form where the *cavea* extends beyond a semicircle, and the stage area is closed off by a much flimsier structure.

Sculpture

PORTRAITS

We know what many of the famous Romans looked like because they can be identified by coins that provide both a portrait and an inscription that gives the name. By comparing the coins with sculpture, we can also identify many sculptural portraits. A large number of portraits of Augustus has survived, of which perhaps the most famous is the Prima Porta Augustus (fig. 3.7). It is called this because it was found in the villa of his wife Livia at Prima Porta, a place named for an ancient arch a few miles north of Rome. The statue, probably carved after Augustus' death, may be a copy of an earlier bronze statue made soon after his victory over the Parthians in 20 BC. In any case, it shows him as a handsome and idealized young man in his prime.

The bare feet indicate that Augustus is a hero, and even a god. Cupid, riding a dolphin at his feet, is a visual reference to the claim that the Julian family

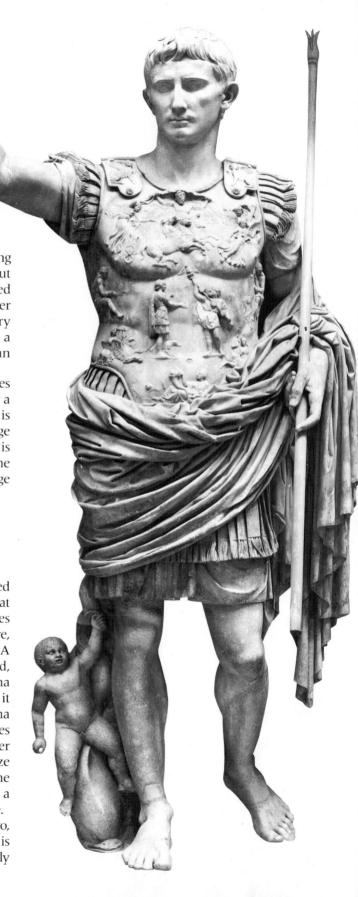

was descended from the goddess Venus, mother of Cupid. The dolphin also reminds us of the story of the birth of the goddess, who emerged full-grown from the sea. It is interesting to note that, although Augustus declined to allow himself to be represented in public as a god, he allowed the thinly veiled divine references to be used here.

Covering the breastplate of Augustus (see above, fig. **0.5**) are reliefs that refer symbolically to various aspects of the emperor's propaganda program. In the center, a Parthian dressed in baggy trousers represents the barbarian who gave back a legionary standard to a Roman soldier, who personifies the Roman army. Above this scene, the sky god holds up a canopy, signifying that the peace implied by the victory scene, and by the figure of Mother Earth holding a cornucopia full of fruit at the bottom of the breastplate, is now spread throughout Augustus' empire. Apollo and Diana at bottom left and right are paralleled by the sun god Sol and moon goddess Luna near the emperor's shoulders. Thus, the cosmic forces and passage of time are also included in this grand vision of Augustan peace.

Not only symbolic, but realistic details abound. The cloth that Augustus draws across his body, and details of tunic and sleeves, are all carefully portrayed. The artist carved the breastplate as if it were made of bronze and yet the details of the human body, including muscles, skin, and even nipples, are incorporated into the form of the armor.

This statue is a good example of Augustan classicism — by which we mean the general simplification of facial details, the smoothing of the skin, and the sharp edge to nose and brows. These characteristics, and the very term classicism, suggest that a reference is being made to the classical Greek period of the fifth and fourth centuries BC. Because these characteristics are considered to be beautiful, and indeed perfect, they suggest an idealized and godlike person who is beyond reproach.

The eyes of Augustus were carved as a smooth surface, but the irises and pupils would have been added in paint. Hair and drapery would also have been colored in this manner, following a tradition that went back to archaic Greek times. The paint on most ancient statues has worn off, but occasionally traces remain in protected places such as in the crevices of hair or drapery.

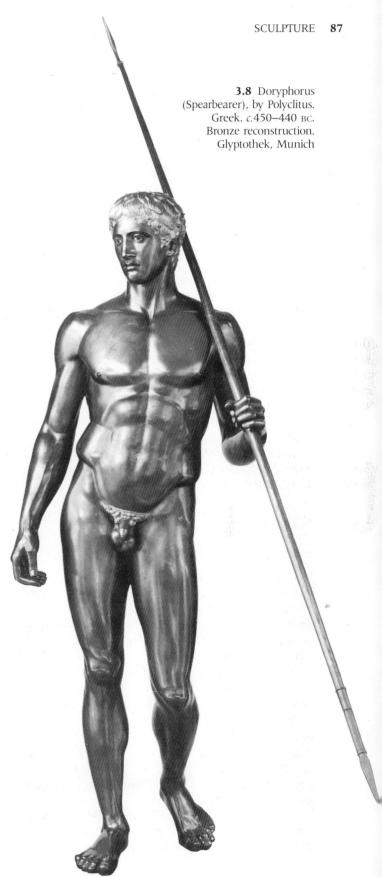

The Prima Porta Augustus is closely related to a famous Greek statue from the fifth century BC, the Doryphorus, or Spearbearer (fig. 3.8), by the artist Polyclitus. The stances are similar, with the weight resting on the right leg, and the left drawn back. Each figure, while standing in place or walking forward, turns his head to the right. Furthermore, Augustus' head, in its classicism, is closely reminiscent of Polyclitan statues, not only in the facial features – including eyes, eyebrows, nose, the line of the chin – but even in the manner in which the locks of hair are made to overlap each other, and in the very shape of the head.

- **3.9** *Below* Portrait of Augustus. *c*.AD 125. Marble. Larger than lifesize. Museum of Fine Arts, Boston, H. L. Pierce Fund
- **3.10** *Right* Portrait of Augustus as priest, from the Via Labicana, Rome. First century Ad. Marble. Height 6ft 10ins (2·08m). Museo Nazionale Romano, Rome

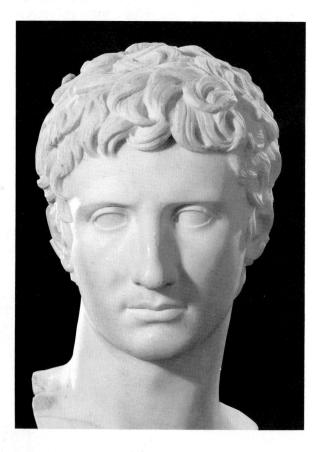

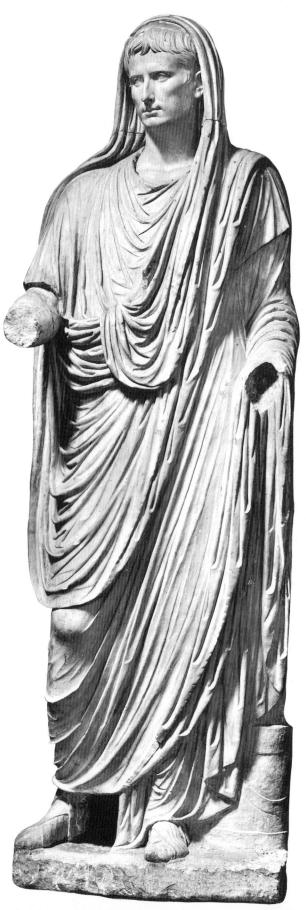

Despite the influence of this important Greek statue, changes have been made. Most have thought that Augustus, like the Doryphorus, carried a spear in his left hand, but many scholars have now come to the conclusion that the emperor may have held one in his right hand, as a symbol of authority, and may have carried a laurel branch, representing victory, in the left. The way the statues are conceived in space is also different: the Greek artist thought of his figure as moving through space, whereas the Roman artist intended that his statue be placed in front of a wall, where it would have dominated the space in front of him; indeed, the handsome, noble face and authoritative gesture of Augustus demand the viewer's attention still today.

Another statue of Augustus (fig. **3.9**) shows us how the same features that we have just seen in the head of the Prima Porta Augustus became even more idealized 100 years or more later. The facial details are similar, but there is a faraway gaze and a smoothness to skin and hair that make the emperor look less human and more godlike. Certain conventions, like the three curls that fall on his forehead, are repeated from one statue to another. We must presume a master model, made probably in the capital, and then copied several times; these copies in turn served as models throughout the various administrative centers of the empire.

Whenever a Roman is shown with his toga drawn over his head, it signifies that he is represented in the role of a priest. This is how we are to interpret fig. **3.10**, a statue of Augustus from Rome. His head and neck were carved separately, and then inserted into the draped body of the statue. The horizontal line is clearly seen on the drapery at the side of his head. Presumably, one could go down to the shop to order a statue from stock, and the head would be carved to specification.

Augustus' wife Livia, whose villa housed the Prima Porta statue, was by reputation a domineering and ambitious woman. We have a portrait of her cut in a cameo 2½ inches (6.4cm) high (fig. **3.11**). Dated to early in the reign of Augustus, 27–10 BC, it is primarily idealized and classicizing, as was the head of the Prima Porta Augustus. On the other hand, a strong personality is portrayed through the small determined mouth, the fine rounded cheeks, and the thin brows. Her hair is brushed off her

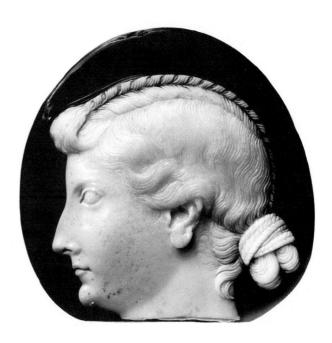

3.11 Portrait of Livia. Late first century BC. Onyx cameo. Height *c*. 2½ ins (6.4cm). Rijksmuseum, Het Koninklijk Penningkabinet, Leiden

straight forehead and elegantly braided over the top of the head to the back, where it joins a chignon at the nape of the neck. It may be a style that she herself initiated.

A head from the same period, but of another woman (fig. **3.12**), shows how the hairdo and features of a member of the imperial family can influence a portrait of an ordinary citizen. The woman probably lived in the old Latin town of Praeneste, where the head was found, but she was made to look as much like Livia as possible.

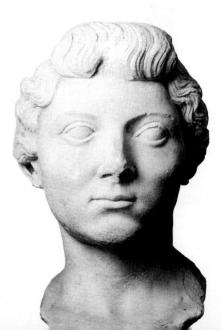

RELIEFS

Ara Pacis Augustae The propaganda program that we saw on the breastplate of the Prima Porta Augustus was reflected far and wide on relief sculpture during Augustus' reign. The most important surviving example is the Ara Pacis Augustae, the Altar of Augustan Peace (fig. 3.13). Construction took place between 13 and 9 BC, when it was dedicated on Livia's birthday. Today we see it as it was reconstructed at some distance from its original site during Mussolini's rule. The Ara Pacis consists of a grand enclosure wall encasing a smaller altar raised on a set of steps. The outer sculpted wall is about 34 feet 5 ins (10·5m) long and 38 feet (11·6m) wide, and its height is nearly 23 feet (7m). Thus, the

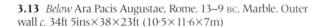

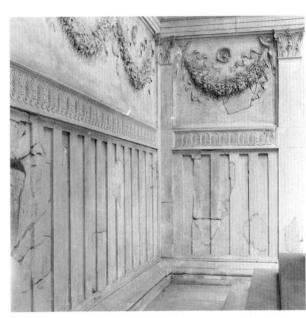

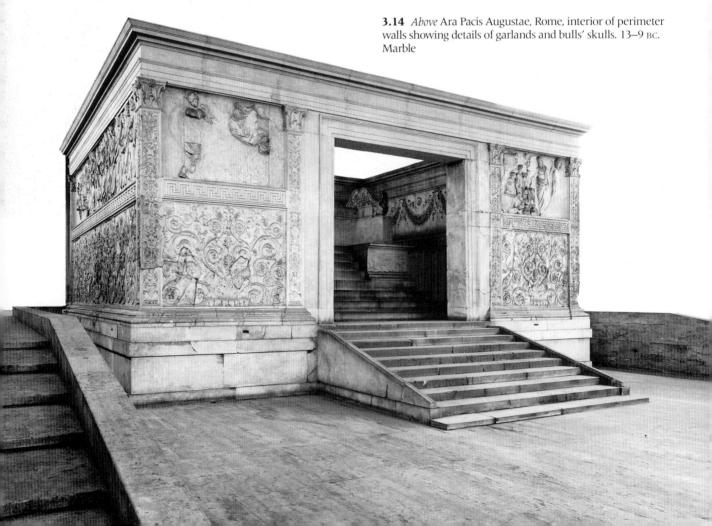

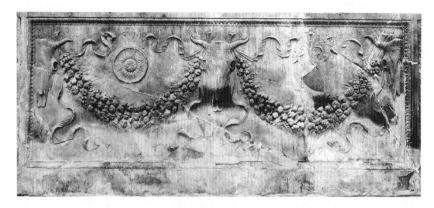

- **3.15** *Top left* Caffarelli Sarcophagus. Late first century BC or early first century AD. Marble. Antikensammlung, Staatliche Museen, East Berlin
- **3.16** *Bottom left* Mother Earth (Tellus), detail of Ara Pacis Augustae, Rome. 13–9 BC. Marble relief. Height of panel *c*. 5ft 2ins (1·6m)
- **3.17** *Below* Stele of Hegeso, from Athens. Greek. *c*.410–400 Bc. Marble. Height 4ft 11ins (1·5m). National Archaeological Museum, Athens

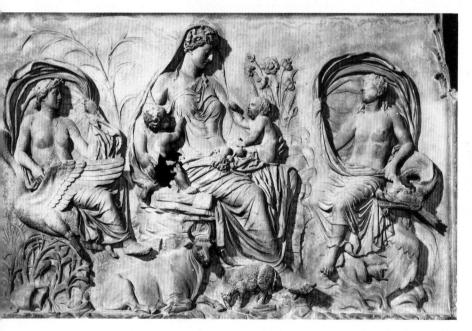

altar (*ara*) itself, inside on a raised podium, is surrounded by a wall decorated with sculpture in relief on both the interior and exterior. The interior of the enclosure wall is carved to look like wooden fence posts on which hang bulls' skulls, sacrificial bowls (*paterae*), and garlands, represented in marble as if prepared for the actual sacrifice (fig. **3.14**). The fruits in these garlands, representing all four seasons, and so magical that they all bloomed at once, were to remind the viewer that Augustus' peace spanned the entire course of the year.

A similar motif is found on the so-called Caffarelli Sarcophagus (fig. **3.15**), which must date to the Augustan period. Here too, garlands tied with

ribbons hang from bulls' skulls, and a *patera* and a jug were placed in the space above the garland. The garlands here made a permanent representation of the real flowers that would have decorated a grave at the time of burial. Sarcophagi were not common in this period, when most people were cremated; but this is an early example of a type that became popular in the second century AD.

On the outside of the Ara Pacis, the programmatic message of peace and prosperity is enhanced by mythological and allegorical imagery. A sculptural panel on the east side may portray Tellus, Mother Earth, with two babies in her lap to emphasize her fertility (fig. **3.16**). She has also been

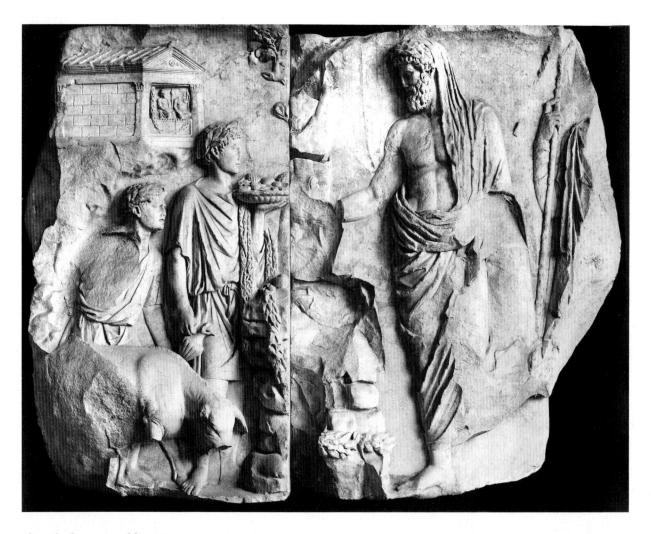

identified as a goddess (Venus or Ceres), or most recently as Pax (Peace) herself. Indeed, a peaceful and contented sheep and cow rest below her, and personifications of Fresh Water and Sea (indicated by the overturned water jug at left and waves at right) suggest that Augustan peace spread over the entire world.

In comparing the female, whoever she is, to a Greek relief of the fifth century BC (fig. **3.17**), we note how classical her face is, and how similar is the fall of drapery over her knees. The shallow carving, with a realistic suggestion of landscape, has models in Hellenistic Greek reliefs. At the same time that the figure of Tellus reflects its Greek prototypes, the Madonna-like image looks ahead to the Christian era.

Another relief on the outside walls of the Ara Pacis (fig. **3.18**) shows Aeneas sacrificing a sow to the *penates* – the household gods, and protectors of the homeland. He had brought the images of these

3.18 Aeneas sacrificing a sow to the *penates*, detail of Ara Pacis Augustae, Rome. 13–9 BC. Height *c*. 5ft 2ins (1·6m). Marble relief

gods, which can be seen in the small, well-built shrine on the rocky hill at the upper left, all the way from Troy. Aeneas, pious as always, stands before a roughly built altar, wearing the toga drawn over his head to indicate that he is acting as a priest, while two wreathed youths assist him at the sacrifice.

The sow plays an important part in one of the myths of the founding of Rome, for it had been prophesied that Aeneas would know the right spot to found his city by finding a sow with 30 piglets under an oak tree. There he founded Lavinium, named after his wife Lavinia. The relief, then, reminds the viewer of Aeneas' piety, of his connections to Troy through the *penates*, and of the foundation myth itself. All of these points were important to Augustus, pious descendant of Aeneas.

The family lineage was spelled out by Virgil in The Aeneid, where Jupiter revealed the future to his daughter Venus:

"Your son Aeneas Will wage a mighty war in Italy, Beat down proud nations, give his people laws, Found them a city... And from this great line Will come a Trojan, Caesar, to establish The limit of his empire at the ocean, His glory at the stars, a man called Julius." [Virgil 1.363ff, trans. Rolfe Humphries, The Aeneid of Virgil

(Scribner's, New York, 1951) p.12]

Of course, since Julius Caesar was the father of Augustus by adoption, as well as his natural great-uncle, Augustus could claim descent from this illustrious past.

The two reliefs just described are the best preserved of two pairs of allegorical and mythological scenes on the front and back of the Ara Pacis Augustae. The others represent the wolf with Romulus and Remus, and the goddess Roma in armor. The portrayal of the relationship of Aeneas and Romulus to Augustus was closely paralleled in the Forum of Augustus, where the statues of Romulus and Aeneas held such prominent positions in the exedrae. Thus, in both the Ara Pacis and the forum, Augustus played upon his dynastic relationship to those heroes, thereby confirming his divine and mythical ancestry.

Along the sides of the Ara Pacis, figures in two processions, one on each side, march from the back of the enclosure wall to the front. One shows mostly senators, and the other, more important side (fig. 3.19) shows the imperial family - Livia, Augustus, and his daughter's husband Agrippa, who was Augustus' chief advisor. The figure of Augustus himself, shrouded to show him in his role as Pontifex Maximus, chief priest of the Roman state religion, could not fail to evoke a parallel with pious Aeneas who was represented in the same guise just around the corner.

3.19 Imperial procession, detail of Ara Pacis Augustae, Rome. 13–9 BC. Marble relief. Height c. 5ft 3ins (1.6m)

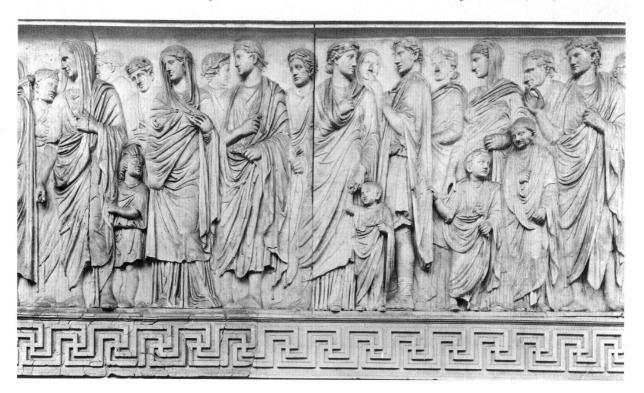

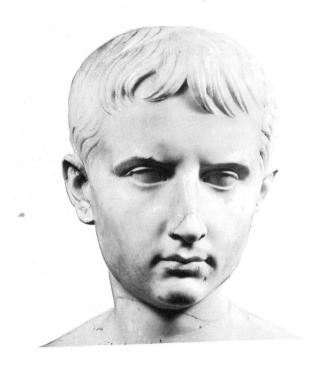

3.20 Portrait of Gaius Caesar. End of first century BC. Marble. Height 9½ ins (24·1cm). Musei Vaticani, Rome

Shown here in the two processions is the dualism of Roman rule: the Senate and the family of Augustus. For the latter, the inclusion of children had a significant role. This was partly because young people like Augustus' grandsons, Gaius and Lucius Caesar, were important members of the family, representing for Augustus the embodiment of the future and all his dynastic hopes. They are reported to have looked very much like him, and the resemblance, seen for instance in the head of Gaius in the Vatican (fig. **3.20**), is indeed remarkable.

The children were reminders, too, of that part of the imperial social program that encouraged citizens to produce as many children as they could. Augustus introduced a law that gave an advantage to men standing for office who had already fathered a number of offspring; and there were tax advantages for couples who had three or more children. Penalties were imposed on men and women of marrying age who remained either single or childless. All of these laws were intended to insure the growth of the citizen population, and Augustus' ideas are clearly reflected in the Ara Pacis, where fertility and children play an important role.

From an artistic point of view, the children

provided another service. The sculptors undoubtedly wished to alter the heights of the figures so as to avoid the monotony of too many toga-clad people with heads all at the same level. Other artistic variations were also used, such as changing the stance and direction of members of the group, and using very low-relief carving at the background level to indicate the figures behind. There was, in fact, an important precedent for many of these features: the frieze on the Parthenon in Athens.

Artistically, the Parthenon frieze provided the model for the notion of altering the positions and the directions of figures marching in a procession (fig. **3.21**). Even more important, the whole idea of a procession of Athenians, walking in a major civic and religious event, is here copied in the Augustan procession. This was a conscious effort on the part of Augustus and his artists to relate his rule and his dynasty to the greatness of Athens in the fifth century BC.

On the lower registers of the Ara Pacis, a beautiful floral pattern (fig. 3.22), made up largely of acanthus leaves and tendrils with elegant and for the most part realistic flowers, is yet another symbol of the peace and plenty nurtured by the emperor. Small animals are interspersed among the foliage, and a swan perches on top of the design at intervals; this symbol of Apollo is a reference to Augustus' claim that the god assisted him in his bid for victory at the Battle of Actium. The decorative portion of the enclosure wall, like the figural reliefs above, displays truly masterful carving. A similar virtuosity is reflected in a silver bowl (fig. 3.23), one of a pair decorated with floral ornaments, leaves, tendrils, and birds. Such beautiful objects, in expensive materials, were avidly collected by the wealthy in the late Republican and early imperial periods.

The Ara Pacis is a public monument that is a propaganda statement for the good image of the emperor. Through myth and allegory, and through representations of contemporary events, the viewer is reminded repeatedly of the greatness of Augustus. In one sense it is meant to be historical, with references to real people; and in another sense, at the same time, it carries the more abstract messages of peace, prosperity, and the divine origins claimed by the emperor.

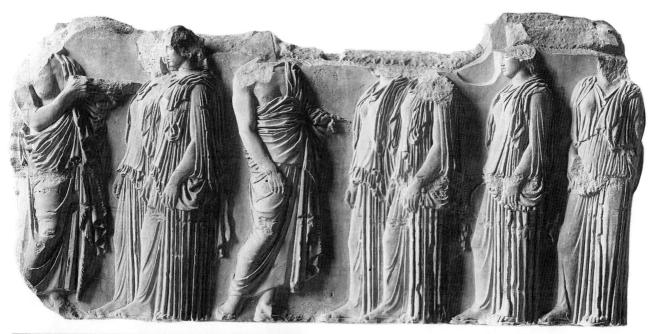

- **3.21** *Above* Maidens and youths, fragment of the Panathenaic Procession, from the east frieze of the Parthenon, Athens. Greek. *c.* 440 BC. Marble relief. Height 3ft 7ins (1·09m). Louvre, Paris
- **3.22** *Left* Acanthus and swan relief, detail of Ara Pacis Augustae, Rome. 13–9 BC. Marble
- **3.23** *Below* Silver bowl. Late first century BC or early first century AD. Height 3½ins; diameter 37/sins (8·9×9·8cm). British Museum, London

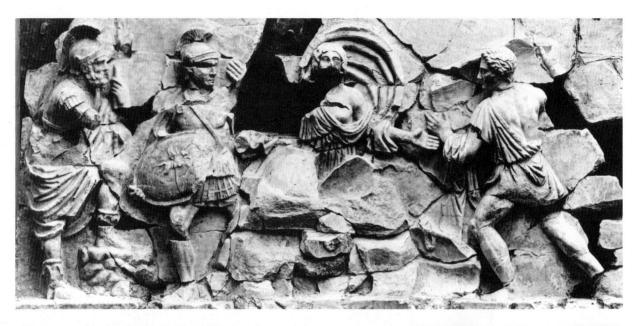

Basilica Aemilia Another example of sculptural relief from the Augustan era decorated the interior of the Basilica Aemilia in the Roman Forum (fig. **3.24**). The relief here illustrates the death of Tarpeia, a woman who turned traitor to her own city. The story tells how the young woman, tempted by the gold of the Sabine attackers, opened the city gates to them. The Sabines, who lived in the hills not far from Rome, rushed in and threw their shields upon her, killing her. This is shown, with the Sabine king, Titus Tatius, looking on from the left.

3.24 *Top* The punishment of Tarpeia, scene from the frieze of the Basilica Aemilia, Roman Forum, Rome. $c.14\,\mathrm{BC}$. Marble. Height 2ft 5ins (73·7cm). Antiquario del Foro Romano

3.25 *Bottom* Building the city wall, from the frieze of the Basilica Aemilia, Roman Forum, Rome. *c*.14 BC. Marble. Height 2ft 5ins (73·7cm). Antiquario del Foro Romano

We can see here the importance of gesture in Roman sculpture. Tarpeia herself throws her arms out in supplication, and the wind-blown cloth above her head singles her out, working to isolate her

3.26 Garden room, from the Villa of Livia, Prima Porta, near Rome. Late first century BC. Wall painting. Museo Nazionale Romano, Rome

3.27 Villa Farnesina, Rome. *c*. 20 BC. Wall painting. Museo Nazionale Romano, Rome

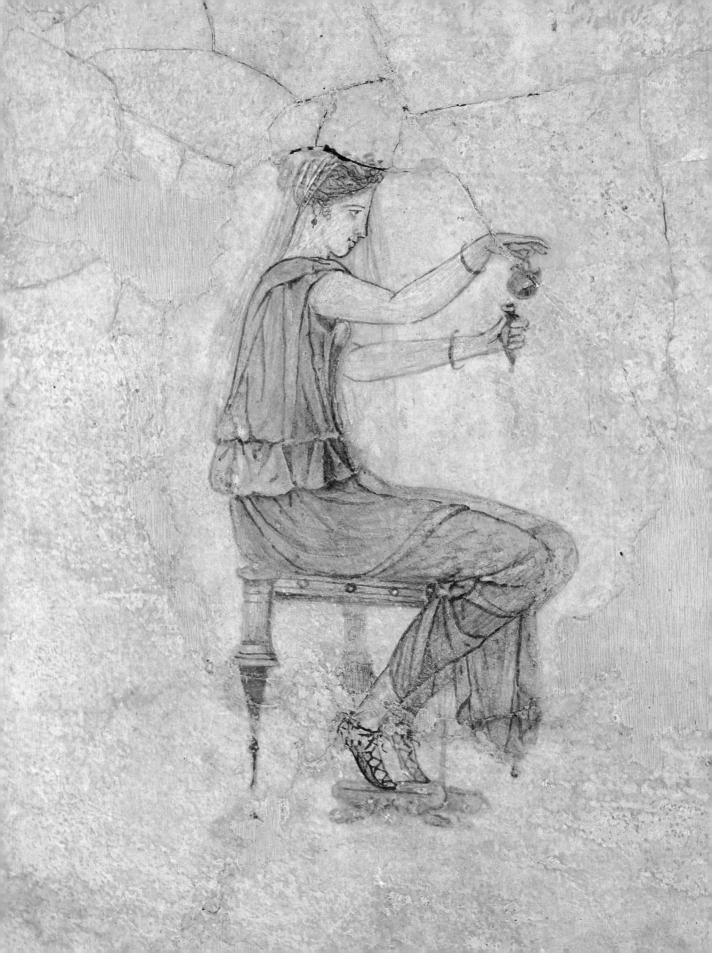

artistically almost the way a halo functions in Christian art. A similar device was used on the female figures of Wind and Sea on the Tellus relief of the Ara Pacis (see above, fig. **3.16**), and on the figure representing the sky in the top center of the breastplate on the Prima Porta Augustus (see above, fig. **0.5**).

Another scene from the Basilica Aemilia represents a group of men building a city wall, while a turret-crowned goddess watches the activity from the left (fig. 3.25). Although again fragmentary, this section of the frieze shows clearly how much the Romans were interested in the activities of everyday life. The bare-backed workers wield their tools in a realistic manner as they lay the rectangular stones in neat masonry. One of the men works from the far side of the wall, thus creating a certain depth in the scene. The symbolic meaning, that is, the strength of the defenses of Rome, is expressed by the goddess, but the chief interest seems to be the physical activity of the men.

Despite some superficial similarities, the reliefs on the Basilica Aemilia are different in effect from the sculpture of the Ara Pacis Augustae. In the Ara Pacis, figures overlap each other and depth is shown through the volume of figures; in the Tarpeia relief each person is isolated and shown crisply against the (now broken) background, and the clarity of the scene is emphasized by outline and simple, exaggerated movements. The Ara Pacis depicts space in quite a sophisticated way through details of landscape, such as the reeds and rocks in the Tellus scene, whereas the reliefs from the Basilica Aemilia are quite flat, and the one rock shown at the left of the Tarpeia scene merely serves to provide a footrest for the king. These two works exemplify two important strains in the art of the period: one idealized and elegant, and what is termed classicizing; the other, dramatic, intense, and direct, and representative of the native Italic, or plebeian style.

Wall paintings

Livia had two houses, both of which were painted in the Second Pompeian style (see above, p.61). In her villa at Prima Porta, the best-preserved room was decorated on all four walls with a garden scene (fig. **3.26**). The background is filled with fruit-laden trees, which imply once again the richness and fertility of the Augustan era. The distant portions of the garden are separated from the viewer by a series of low fences that help to define the space. The colors also aid in giving a sense of depth, especially through the use of atmospheric perspective.

The rich greens of the trees and grass, highlighted by fruits, flowers, and birds, were painted with strokes of color that look freshly applied. The Roman enthusiasm for nature, magnificently

^{3.28} *Opposite* Woman pouring perfume, from the Villa Farnesina, Rome. *c*.20 Bc. Wall painting. Museo Nazionale Romano, Rome

^{3.29} *Right* Columns, garlands, and basket, in the House of Livia, on the Palatine Hill, Rome. End of first century BC. Wall painting, Height *c.* 13ft 9ins (4·2m)

expressed here, is quite different from anything found in Greek art. The artist was no longer satisfied with providing a glimpse of the outdoors through the wall; now the whole wall became a painted "window" to reveal the landscape and space.

A house on the Palatine, where one of the rooms is painted with architectural columns (fig. **3.29**), is said to have been a second house belonging to Livia. Shaded effectively to give a sense of volume, the columns stand out distinctly against the plain white walls. Slung from these columns are garlands laden with fruits and flapping ribbons that are reminiscent of the decoration on the Ara Pacis Augustae. The fact that a fruit basket hangs from the center of the garland reminds us that these are all symbols of prosperity.

A narrow yellow frieze above the columns is painted with miniaturist scenes that display many small figures dotting a landscape filled with small shrines, trees, bridges, and statues. There is very little attempt to show the extensive space that was depicted in the villa at Prima Porta. Rather, objects and people are scattered about almost at random in what appears to be an aerial view. It seems that taste was changing and that this was one of the latest paintings in the Second style.

Another example of the late Second style is an exquisitely decorated Roman house found under the gardens of a 16th-century palace in Rome, the Villa Farnesina. It was discovered in 1878 when excavations were made in connection with the construction of the embankment for the River Tiber. The house may have belonged to Agrippa, the son-in-law of Augustus, which would give it particular significance as an example of Julio-Claudian patronage. In the alcove of the Villa Farnesina, we are given the impression of a kind of private picture gallery (fig. 3.27, p.97). In the center is a late example of a three-dimensional pavilion, within which is a mythological painting of a nymph with the infant Dionysus. To left and right, large sections of the wall are painted in red or black monochrome, and within these sections there is a square with a painting in it, giving the illusion of a framed picture. Having a collection of Greek panel paintings, or copies of them painted on one's wall, would have been a sign of prestige among the aristocratic rich.

One of these paintings within a frame shows a woman in the classical style, in profile, seated and pouring perfume from a round flask into a small pointed bottle (fig. **3.28**). The treatment of the woman, with linear outlines and a white background, is reminiscent of Greek vase paintings of the fifth century BC, and probably reflects panel paintings, now lost, of a similar nature.

The Third Pompeian style The Third Pompeian style began in the Augustan age, and grew out of the Second. It treats the wall as the flat surface that it is, rather than as a window upon distant space. With rectilinear and organic patterns against a monochrome background, it emphasizes the ornamental value of the designs. The volume of painted columns and other objects is minimized, and instead, a new type of column, or sometimes a candelabrum, wispy and thin as a reed, becomes popular. In this example, from the villa at Boscotrecase outside Pompeii (fig. 3.30), the slim columns hold up a delicate and ornamental pediment. There is no interest in showing substantial architectural structures, nor the illusion of the threedimensional.

In the center of the wall is a small vignette showing a tower, trees, statues, and human figures. This combination is known as a sacred landscape, a favorite motif in paintings in Herculaneum and Pompeii (fig. 3.31). The vista usually includes small shrines, often with gnarled trees growing up within and around them, and a landscape dotted with statues of minor divinities, bridges, rocks, shepherds' huts, and finally the shepherds themselves with the occasional goat, sheep, or cow. These paintings have antecedents in Hellenistic art, where it had been common to make the figures in a landscape small, as here, and to emphasize the picturesque qualities of rural life. Particularly Roman are the wonderfully fresh brush strokes and loose style that make the paintings seem so spontaneous.

3.30 Columns and pediment, from the villa at Boscotrecase, near Pompeii. Late first century BC. Wall painting. Metropolitan Museum of Art, New York, Rogers Fund

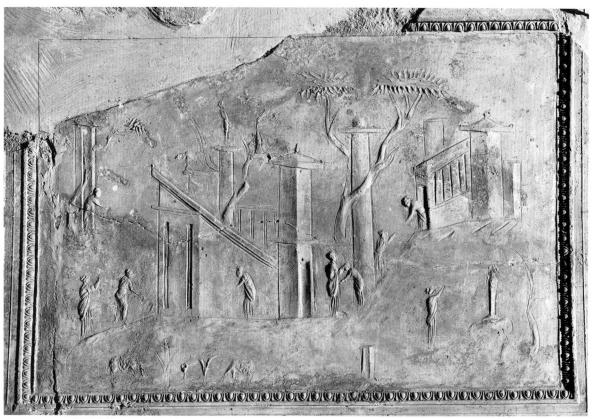

Stucco

Decoration in the elegant houses of the late first century BC included not only wall paintings, but also scenes and patterns set out in stucco on the ceiling. These might be described as relief designs in plaster. The stucco patterns on the ceiling of the Villa Farnesina are stamped with molds and finished by hand with great skill (fig. 3.32). This scene is typical, with its small shrines, sacred statues, and figures moving around in a kind of dreamlike space. Much like the sacred landscapes in paintings, the gnarled old trees growing around columns and behind the houses were favorite images that were borrowed from Hellenistic Greek prototypes.

Many of the sculptural and architectural works made in the service of Augustus had a propaganda message that was strengthened through associations with classical Greece and the golden age of Athens in the fifth century BC. Augustus also meant to remind the public of his success in fulfilling the visions of Julius Caesar, and bringing peace and prosperity to the people. He did this through the visual arts and through his statements in the Res Gestae. His style and approach became a model for subsequent emperors because he had been able to create a visual means of demonstrating the benefits he had brought to the Roman populace. He had also managed to associate himself with great movements and historical figures of the past and to use the aura attached to them for his own advantage. His successors learned from him the possibilities that rested in these fruitful associations, and they also capitalized on their associations with the first emperor himself. The charisma of Augustus served as the model and example not only for the Julio-Claudian emperors who followed him (see below, chapter 4), but, indeed, for centuries to come.

^{3.31} Opposite top Sacred landscape, from Pompeii. AD 63–79. Wall painting. Museo Archeologico Nazionale, Naples

^{3.32} *Opposite bottom* Landscape with figures, from the Villa Farnesina, Rome. *c.* 20 Bc. Stucco relief. Height *c.* 1ft 6ins (45·7cm). Museo Nazionale Romano, Rome

4 The Julio-Claudians AD 14–68

The emperors who followed Augustus always had his reputation, his taste, and his plans as a legacy. Each succeeding emperor set a new tone which gave a special character to the artistic output of his time, although the framework of images and associations that Augustus had set up remained unaltered. The value of continuity for political purposes was put above personal taste, because not all of the Julio-Claudians seem to have had the same regard for the cool classicism that Augustus had cultivated so assiduously.

Although Augustus had no sons, his daughter Julia produced two boys: Gaius and Lucius Caesar. Augustus hoped they would succeed him, and in order to expedite this, he had formally adopted his grandsons as his own children. Unfortunately, both died in early manhood, leaving Augustus without a clear heir. Although he had never been very enthusiastic about his stepson Tiberius (who ruled AD 14–37), son of Livia by her previous marriage to Tiberius *Claudius* Nero, this man

Opposite Sacrifice of a bull in the Forum of Augustus, enlargement of fig. **4.14**. Frieze from a Claudian altar. Mid-first century AD. Marble. Villa Medici, Rome

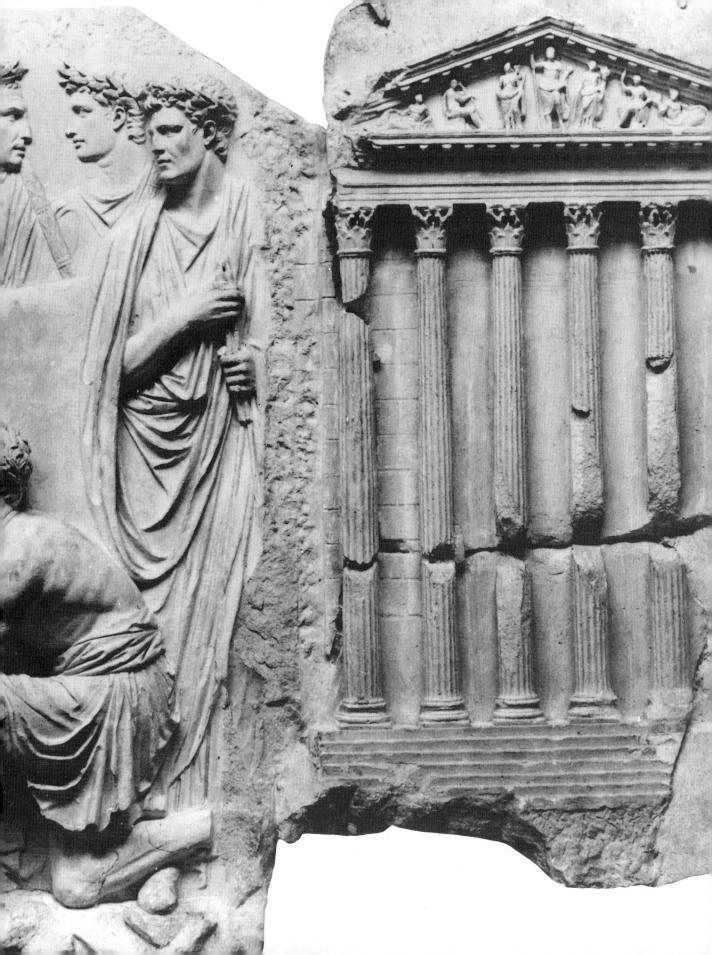

4.1 Crowning of Augustus (above) and the erection of a trophy (below), on the Gemma Augustea. Early first century AD. Double-layered onyx cameo. Height 7½ ins; width 9ins (19×23cm). Kunsthistorisches Museum, Vienna

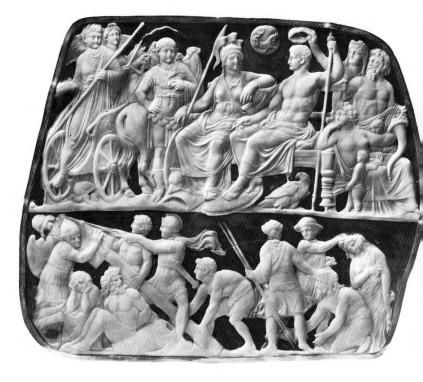

seemed to be the only suitable person to fill the need. Augustus adopted him as his son and successor. Tiberius and all the emperors until the death of Nero were part of the Claudian family; yet, they could trace their descent by adoption from Augustus and Julius Caesar. They are known as the Julio-Claudians.

The Gemma Augustea

A large gem, known as the Gemma Augustea (fig. **4.1**), anticipates the transfer of power from Augustus to Tiberius in AD 14. The figures on the sizable cameo are carved from a piece of onyx, $7^{1/2}$ by 9 inches (19×23 cm). The gem, slightly trimmed since antiquity and remounted in a modern setting, was cut from a piece that had two veins: a dark bluish color below and white on the upper layer. By controlling the depth of carving, the artist cut the figures out of the white vein, and removed the stone down to the blue layer to make the background.

Two separate but related scenes are depicted; both became conventional in Roman art. One is a scene of the real world, and the other at least partly shows the divine and symbolic realm. On the bottom, Roman soldiers erect a "trophy" composed of the arms of the enemy hung on a pole, while two sets of foreign prisoners symbolize the Roman

victory in human terms: a man and woman, with hands tied behind their backs, are waiting to be roped to the base of the trophy, and the other pair, at the right, are being pulled along by their hair. The trophy undoubtedly represents the one erected in honor of the victory of Tiberius over the Germans in AD 12. Scenes like this were repeated again and again on public and private monuments, where military strength was stressed both in narrative terms, and as a symbol of triumph.

The upper scene on the gem shows Augustus enthroned in the guise of Jupiter, as we can tell by the eagle at his feet. Sitting next to him admiringly is the goddess Roma, who seems to be represented in the likeness of Livia. The crowned female figure placing a wreath on the head of Augustus is Oikoumene, who represents the civilized world. The man in the upper left descending from the chariot is Tiberius – already designated as the next emperor. He is returning, victorious, from war in Germany. Thus the cameo acts as a kind of miniature propaganda statement on the appropriateness and destiny of Tiberius as successor to Augustus. The piece was probably made late in the reign of Augustus, rather than after Tiberius became emperor.

The stone is remarkably large for a cameo. A grand subject was chosen that has more in common with large-scale public reliefs than with private

ornaments, although it can hardly have been intended for wide circulation. A small group close to the center of power must have appreciated the nuances of the symbolism, for Augustus is here shown with overt divine pretensions that were denied in public monuments. Only his closest friends and family would have known of its existence, but later the gem had a long and illustrious history which can be traced, after the fall of the Roman empire, in the treasuries of French and Austrian kings.

Imperial patronage in the provinces

Early in the reign of Tiberius, in AD 17, there was a severe earthquake in Asia Minor that caused extensive damage in many cities. Of the 12 cities that were destroyed, Sardis in modern-day Turkey (see above, fig. **0.1**) was the hardest hit, according to the historian Tacitus [*Annals* II. 47]. The emperor gave large grants of money for the citizens to rebuild major buildings, and he cancelled their taxes for five years. For such beneficence he was thanked over and over in public inscriptions — a practice that became common throughout the empire.

The sculptors at Aphrodisias, another site in Asia Minor, were famous in antiquity for their carving skills, and indeed modern excavation has turned up an extraordinary amount of high-quality sculpture in local marble from that site. In the reign of Tiberius, an *agora* (the Greek equivalent of the Roman forum), bordered by a portico of Ionic columns, was constructed. The entablature above was carved with a lovely set of heads and theater masks connected by garlands laden with fruit and flowers (fig. **4.2**). Heads of this sort had been

4.2 Heads and garlands, from the Portico of Tiberius, Aphrodisias. Early first century AD. Marble. Izmir Museum

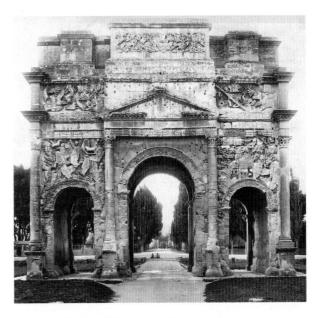

4.3 North façade of the triumphal arch at Orange. AD 26. Limestone. Height *c.* 60ft (18·3m)

known to decorate theaters, but their use on an architrave was an unusual new function for them. Recent research has shown that the heads were blocked out at the quarries, and then carved later, probably at the site. As was so often the case, some of the heads are of much finer quality than others, depending on the skill of the sculptor.

Another example of imperial patronage in the provinces under Tiberius is the triumphal arch at Orange (ancient Arausio) in southern France (fig. 4.3). It was built in AD 26 to commemorate the defeat of a rebellion five years earlier. This is the earliest surviving example of an arch with three passageways in a single massive architectural block, and seems to prefigure the great arches of the later empire. The builders were experimenting here with proportions, and this example is unusual in carrying a double-storied attic (the section at the top of the arch). The sculptural relief over the side arches represents heaps of captured armor, this time anticipating the reliefs on the plinth of the Column of Trajan (see below, fig. 6.8). The whole monument gives the impression of tremendous weightiness and at the same time is so richly decorated as to have a flamboyant effect.

Imperial architecture and sculpture

Tiberius, or possibly Nero after him, built the first imperial palace on the Palatine Hill, near the houses of many of the prominent citizens of the Republican period and also near the modest house in which Augustus had lived. He thereby started a trend that was to last to the end of the empire. Indeed, our very word "palace" originates from Palatine, or more directly from *palatium*, the old name for the hill. Little but an enormous multi-storied shell facing the forum is left, and even most of this was constructed in later periods.

In his later years, an embittered and reclusive Tiberius spent most of his time at his remote Villa Jovis on the Isle of Capri, in the Bay of Naples. He was much interested in sculpture, and is said to have had a statue of a naked Greek youth in his bedroom. He also spent time at a sumptuous villa at

Sperlonga, about halfway between Rome and Naples, and had the huge grottoes there decorated with sculpture. Dramatic figures depicting the adventures of Odysseus rested on supports in the middle of a natural pool of water and in niches in the walls of the caves. One of the statue groups represented Odysseus' encounter with Scylla, the savage female sea-monster who snatched sailors from passing boats. The helmsman was represented desperately flailing about at the stern of the faltering ship before he fell overboard (fig. **4.4**). The head of

- **4.4** *Left* The helmsman of Odysseus' ship during the encounter with Scylla, detail from a grotto at Tiberius' villa at Sperlonga. First century Ad. Marble. Lifesize. Museo Archeologico Nazionale, Sperlonga
- **4.5** Above Head of Odysseus, detail from a grotto at Tiberius' villa at Sperlonga. First century AD. Marble. Lifesize. Museo Archeologico Nazionale, Sperlonga
- **4.6** *Opposite* Head of Laocoön. Greek. Second century BC. Marble. Musei Vaticani, Rome

Odysseus himself (fig. **4.5**) expresses all the agony of the moment in the tousled hair, drawn eyes, and open mouth.

This effective group is a fine example of how the Romans adapted a style developed first by Hellenistic sculptors. There is a clear reminiscence of the presentation of the sculpture on the huge Altar of Zeus at Pergamon and of other Hellenistic groups, such as the one of Laocoön, the Trojan priest who predicted the deception inherent in the Trojan horse (fig. 4.6). In these Greek sculptural groups, the emphasis is on dramatic action. To show human expression, the eyes are cut in deeply, the mouth open, the face twisted, the hair disheveled. Deep drilling to make heavy shadows is somewhat akin to the use of make-up in the modern theater. The portrayal of deep human emotion and suffering seen in the Sperlonga sculpture is an example of the return to these devices, in what is often called "Hellenistic baroque." It is interesting that Tiberius' private taste favored this style, in contrast to the cool, detached version of the classical style favored by Augustus and continued by Tiberius himself for portraits and public monuments.

Portraits

THE OTHER JULIO-CLAUDIANS

Just as it had been important for Tiberius to establish his links with his predecessor, the other members of the family (fig. 4.7) tried to emphasize those features that might connect them to the founder of the dynasty. Tiberius was not related to Augustus by blood, since he was his mother's son by a previous marriage; nor was Caligula (who ruled AD 37-41, after Tiberius), but nonetheless he was made to look like Augustus with a similarly shaped head, straight nose, and projecting ears (fig. 4.8). Caligula's cruel personality shows clearly in the tight lips and distant eyes. The other emperors of this dynasty - Claudius and Nero - were again Claudians, and were related to each other both by blood and by marriage, for Claudius took as his second wife the mother of Nero.

Claudius (who ruled AD 41–54) was intelligent enough, according to the biographer Suetonius, and well-intentioned, but he had a weak personality. His soft features were captured in this unusual portrait

4.7 Family tree of the chief members of the Julio-Claudian

dynasty. People mentioned in the text are indicated in bold type and emperors are shown in capital letters. Numbers alongside names refer to people's first, second, third, and C. Julius Caesar = fourth marriages Aurelia (d. 85 BC) (d. 54 BC) C. Julius Caesar = Cornelia Julia = M. Atius Balbus (d. 44 BC) (d. 51 BC) Julia = Pompey Átia = C. Octavius (83-54 BC) (106-48BC) (d. 43 BC) (d. 59 BC) C. Claudius = (1) Octavia (2) = Ti. Claudius Nero = (1) Livia (2) = (2) AUGUSTUS (1) = Scribonia Marcellus (64-11 BC) (83-30 BC) (consul 50 BC) (d. 33 BC) (57 BC-AD 29) M. Marcellus Antonia L. Domitius Antonia Drusus TIBERIUS Vipsania (43-23 BC) major Julia Ahenobarbus M. Agrippa the elder (b. 39 BC) (d. AD 20) (consul 16 BC) (39 BC-(63-12 BC (36 BC-AD 37) (38-9 BC) AD 37) AD 14) Livilla Drusus Germanicus = Agrippina C. Caesar L. Caesar Julia (d. AD 31) Agrippa (13 BC-(15 BC-AD 19) the elder (20 BC-AD 4) (17 BC-AD 2) (d. AD 28) Postumus AD 23) (14 BC-AD 33) Cn. Domitius = (1) Agrippina (3) = (4) CLAUDIUS (3) = Messalina Nero Drusilla Ahenobarbus Julia the younger (10 BC Caesar Caesar (Caligula) (AD 17-38) Livilla (d. AD 40) AD 54) (AD 15-59) (AD 6-30) (AD 7-33) (AD 12-41) NERO Octavia Britannicus (AD 37-68) (d. AD 62 (AD 41-55)

of the emperor as Jupiter (fig. **4.9**), where one can only wonder whether the artist was making fun of an emperor who supposedly dribbled and was quite uncoordinated. He had the great misfortune to have been twice in the hands of manipulative and ruthless wives: first, Messalina, and then his niece Agrippina, who ultimately contrived to have her son, Nero, inherit the throne.

In portraits of Nero (who ruled AD 54–68), sculptors emphasized the fact that he was heavy, a characteristic that would have seemed more attractive to the ancient than the modern eye (fig. **4.10**). The bulbous shape of the cranium was a Julio-

Claudian family trait, and his hairdo reminds us of the locks brushed forward on Augustus' brow; but Nero's bangs give the appearance of projecting, rather than lying down against the forehead. Here he was trying to imitate the hairstyle of Alexander the Great, hoping, like Pompey (see above, p.53),

4.8 Below left Caligula wearing a toga, from Rome. c.AD 38. Marble. Height 6ft 10ins (2·08m). Virginia Museum of Fine Arts, Richmond, Virginia, Glasgow Fund

4.9 Below right Claudius as Jupiter. c. AD 50. Marble. Over

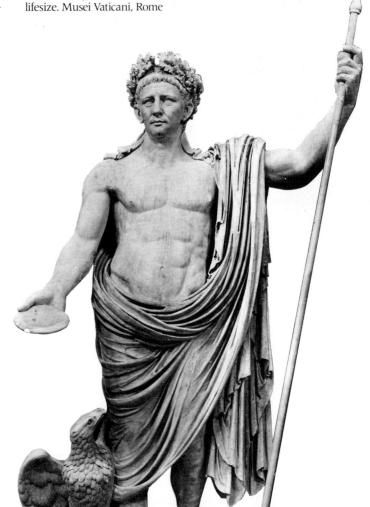

MVNIFICENTIA PII IX P.M.

4.10 Portrait of Nero, from Rome. AD 64–68. Marble. Height 1ft 3ins (38·1cm). Worcester Art Museum, Worcester, Massachusetts

that by this allusion he would incorporate some of the grandeur of his predecessor.

Although this was an official portrait that was probably not intended as a deep character study, perhaps we can read in the face the kind of person he was. Two of Nero's worst deeds were to arrange for the deaths of his mother and his stepbrother; for he feared Agrippina's domineering personality and his brother's legitimate right to the imperial throne. A reign of terror began in this way, and the emperor continued to eliminate anyone who appeared to oppose him. On the other hand, he was a popular ruler for much of his reign because he was generous in paying for games and other benefits for the public good. Only later was the unpredictable and less attractive side of his character revealed in his unreasonable participation in chariot racing and public singing contests, in which he expected ecstatic praise.

ORDINARY CITIZENS

An unusually well-preserved series of tombs was in use from Augustan times to the later years of the Julio-Claudian era. Found in the mid-19th century in a place called the Vigna Codini, along the Via Latina on the outskirts of Rome, were three columbaria, "pigeon houses" (fig. 4.11). They were so named because of the rounded or rectangular wall niches that give the appearance of a dovecote. They held the cinerary urns, that is, the urns in which the ashes of the cremated dead were placed. In this tomb, each of the four walls has nine rows of niches, with nine niches in each row. The tomb was undoubtedly first constructed in the Augustan period, for the inscriptions indicate that most of the dead had been slaves or freedmen of Livia and others of the imperial family. But it was customary to reuse these niches, and to add later family members long after the ancestors had died.

Some of the niches originally intended for urns were enlarged so as to receive portraits of the dead; three of these had survived in place when the photograph was taken in 1877. At the far left can be seen the head of a young woman (fig. **4.12**), who can perhaps be dated by her hairdo to the era of Nero; and in a niche in the wall on the right was the head of an older man (fig. **4.13**). Both were carved with great sensitivity to the textures of skin and hair, and to the muscle and bone structure. Their fine state of preservation can be attributed to the fact that they were protected in the *columbarium* until modern times.

- **4.11** *Opposite top Columbarium II* at Vigna Codini, on the Via Latina, near Rome. First century AD. Brick and stone faced with plaster. Area of room c. 20×18 ft $(6 \times 5 \cdot 5$ m)
- **4.12** *Opposite left* Portrait bust of a young woman, from the *columbarium* at Vigna Codini on the Via Latina, near Rome. Mid-first century Ad. Marble. Height 1ft 3½ins (39·4cm). Museo Nazionale Romano, Rome
- **4.13** *Opposite right* Portrait bust of an older man, from the *columbarium* at Vigna Codini on the Via Latina, near Rome. Mid-first century AD. Marble. Height 1ft 4½ins (41.9cm). Museo Nazionale Romano, Rome

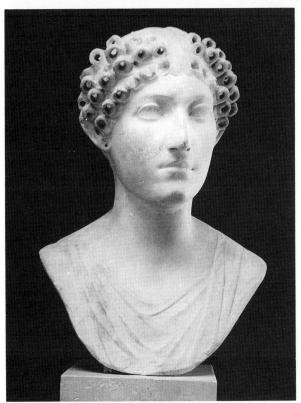

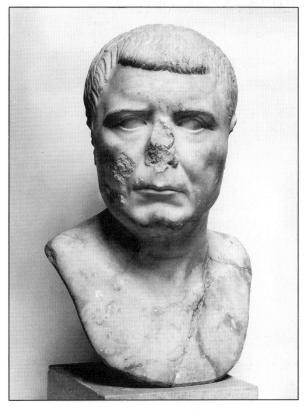

Sculpture

PIETY

The Ara Pietatis Augustae (Altar of August Piety) was planned by Tiberius and in fact voted by the Senate in AD 22, probably in honor of Livia, who was quite ill at the time. But the sculptural work was not carried out until the reign of Claudius, who took an interest in monuments commemorating piety and honor to his ancestors.

Although it is not clear that any of the surviving Roman reliefs are from the Ara Pietatis Augustae itself, sculptural panels from another Claudian altar give us examples from the period. In one part of the frieze, the sacrifice of a bull is about to take place in front of the Temple of Mars Ultor in the Forum of

Augustus (fig. **4.14**). Note the typical Roman construction, with the temple on a high podium and steps at the front, and the Corinthian capitals. The sculpture in the pediment represents, in the center, Mars, and next to him on our left, Venus.

The sculptor concentrated on the human figures, but identified the place and gave a feeling of grandeur by the addition of the imposing temple façade. A certain limited space is suggested by the variation in depth of the figures, some of whom are almost completely free of the background, while others, like those on the Ara Pacis Augustae (see

4.14 Sacrifice of a bull in the Forum of Augustus, frieze from a Claudian altar. Mid-first century AD. Marble. Height *c.* 3ft 9ins (1·1 m). Villa Medici, Rome

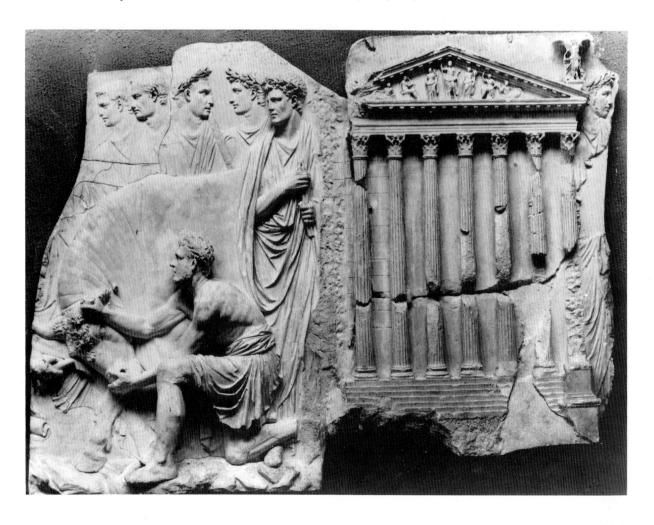

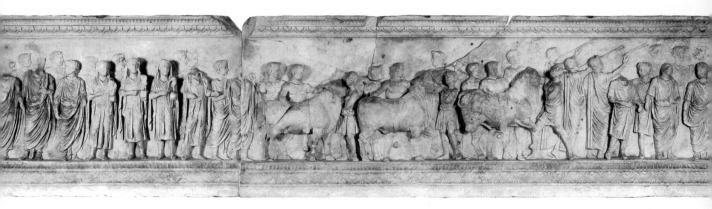

above, fig. **3.19**), are in shallow relief. A common device can be observed here: that of putting faces in profile, especially those farthest back. This allows the representation of several layers of figures, cut in a very shallow manner, and enhances the illusion of space; yet the clarity of features is maintained. The Romans learned these devices from the Greeks, who had used them to full advantage on such reliefs as grave monuments.

Another relief from the Julio-Claudian period is the one showing a procession of the *vicomagistri*, a group of freedmen who guarded the *lares*, or household gods, of the neighborhood (fig. **4.15**). The *vicomagistri* are seen on the left, two of them carrying the *lares* in their arms, and one carrying a statuette of the emperor. Near the right are the trumpeters, and in the center, a sacrifice of the sort seen on the relief from the Temple of Neptune (see above, fig. **2.3**) is again represented here.

On the relief of the *vicomagistri*, the foreground figures are mostly seen in a frontal view, while those behind are in profile. The schematic way in which these figures stand in repetitive poses seems to reflect the Italic and plebeian strain in Roman art. There is something of the static, almost cartoon-like quality that was characteristic also of the earlier relief from the Temple of Neptune.

THE IMPERIAL HERO

A different kind of monument, the monument to the hero, in this case the imperial hero, has recently been discovered far from Rome. Since 1978, a large cache of sculptural reliefs has been excavated at Aphrodisias from a building known as the Sebas-

4.15 Procession of the *vicomagistri*, relief from the Cancelleria, Rome. First half of the first century AD. Marble. Musei Vaticani, Rome

teion. This is the Greek name for the Latin Augusteum, or cult place of the emperor Augustus, his family, and descendants. It was in the interest of the Julio-Claudians to continue to vaunt their reputed family connections with Venus, and what better place for such a building than Aphrodisias, the city named after Venus (whose Greek name was Aphrodite)? Of course there would have been other such buildings commemorating the imperial family in other cities of the empire too. The Sebasteion, erected around the middle of the first century AD, was a triple-storied portico with sculptured reliefs inserted between the columns on the second and third stories. They depicted the imperial family and mythological and allegorical figures.

Augustus himself is portrayed naked, as a hero, with a circle of cloth blowing over his head (fig. 4.18). An allegorical figure at his right represents the fertility of the earth, a theme that is reinforced by the cornucopia in the emperor's hand. The snaky-tailed female sea creature at his left, as well as the oar in his left arm, represents Roman peace spread over the seas. The symbolism is reminiscent of that in the Tellus relief on the Ara Pacis (see above, fig. 3.16). The muscle-bound figures and the dramatic tension of faces and bodies are derived from Hellenistic sculpture, of the type seen on the Altar of Pergamon and the Laocoön (see above, figs. 2.5 and 4.6), but they also testify to the vivacious carving skills of the sculptors of Aphrodisias.

4.16 Birds, animals, and marine creatures, in the Golden House of Nero, Rome. AD 64–68. Ceiling painting

4.17 Landscapes and architectural motifs, in the Golden House of Nero, Rome. AD 64–68. Wall painting

4.18 Augustus, from the Sebasteion, Aphrodisias. Mid-first century AD. Marble. Height *c*. 5ft (1·5m). Aphrodisias excavation house

4.19 Agua Claudia, near Rome. c. AD 50. Stone

Public works

Augustus had set an example by repairing existing public facilities and initiating others, either at his own expense or by encouraging members of his circle to contribute. The sources retain some account of the grandiose schemes of Caligula, including a bridge across the bay from Baiae to Puteoli, near Naples; but, given his reputation for megalomania and irrational acts, this may be mere invention. It is, on the other hand, possible that the stories reflect the technical developments in Campania, the area around the Bay of Naples, which was the home of pozzolana concrete - an important building material used all over the Roman world. Claudius did in fact build a huge concrete structure (although Nero took credit for it) in a new harbor for Portus at the mouth of the River Tiber just north of Ostia.

Several of Claudius' contributions in the area of public facilities are still conspicuous in Rome today. One of his great interests was the water supply, and in fact he completed two aqueducts that had been initiated under Caligula. Parts of the Aqua Claudia, as it is called, still march across the countryside outside the city (fig. **4.19**), but the most notable

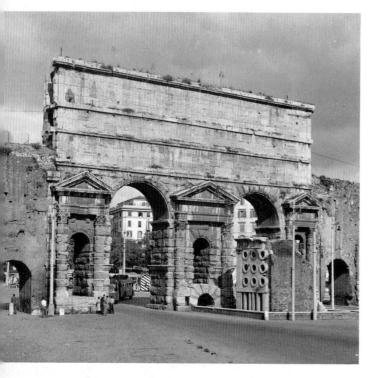

4.20 Porta Maggiore, part of the Aqua Claudia, Rome. *c*. AD 50. Stone

part that remains in Rome is the Porta Maggiore (fig. **4.20**), a section of the aqueduct distinguished by a large double archway crossing two ancient roadways, and carrying two converging water channels at different levels. The masonry on the lower sections of the arches has purposely been left in the form of rough-hewn stones, just as they would have come from the quarries; even the column shafts show this affectation, giving the impression of an unfinished work. This manner of leaving stones in the rough, called "rustication," seems to have been a feature of the architecture of Claudius, and has appealed to other builders in later eras too.

- **4.21** *Right* Underground Basilica, near the Porta Maggiore, Rome. Mid-first century AD. Concrete covered with stucco
- **4.22** *Opposite* Flying and floating figures, from the ceiling of the Underground Basilica, near the Porta Maggiore, Rome. Mid-first century AD. Stucco

Architecture

THE UNDERGROUND BASILICA

A remarkable subterranean building, known as the Underground Basilica, was found near the Porta Maggiore (fig. 4.21). Apsed at one end and with three aisles, it might have been used for some kind of secret sect during the Julio-Claudian era, but its function is not well understood. The barrelvaulted ceiling has well-preserved and beautiful stucco decorations, perhaps the finest anywhere in the Roman world. Flying and floating figures (fig. 4.22), reminiscent of the Villa Farnesina, and mythological vignettes in low relief are isolated against a plain background that is divided into a grid pattern made up of squares and rectangles. The specific message of the ceiling decoration is not clear, but because many of the small images depict rescue scenes of the successful mythological hero, the viewers may have taken heart that honor and fortitude would overcome all odds.

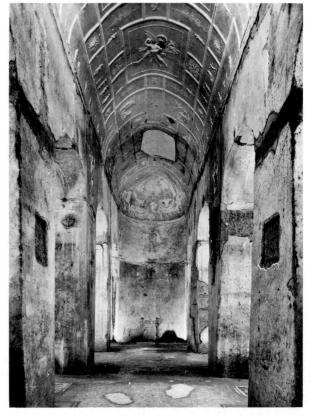

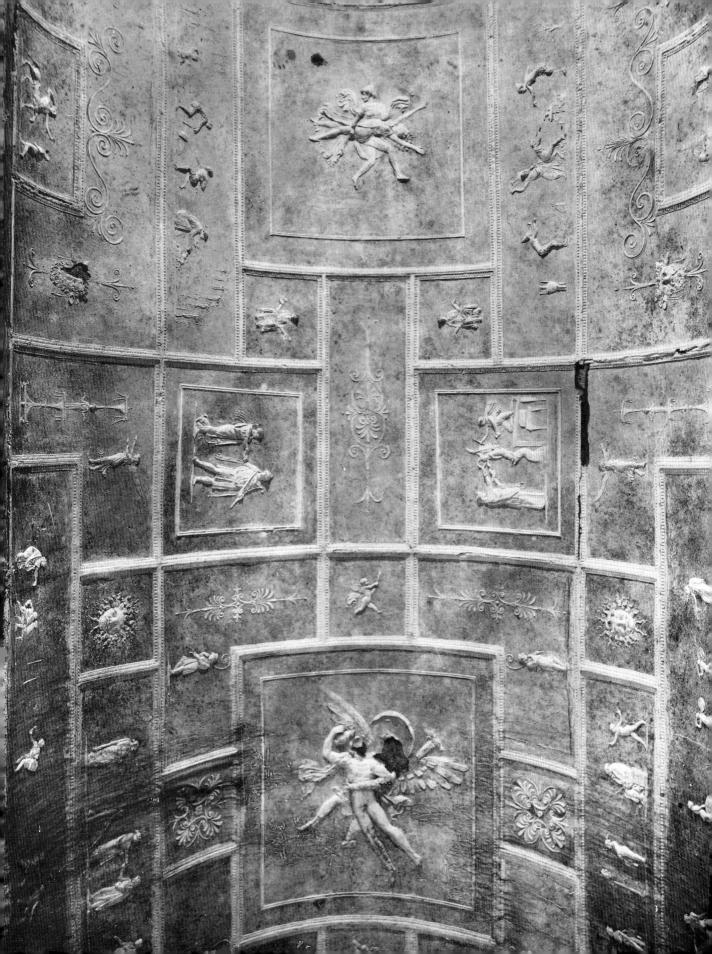

NERO'S GOLDEN HOUSE

During the reign of Nero, in AD 64, a great fire destroyed a large portion of central Rome – the famous occasion when Nero was said to have "fiddled while Rome burned."

After the disastrous fire, a huge building program was set in motion to replace the burned-out sections of the city. According to the historian Tacitus [Annals xv. 43], Nero himself insisted on certain safety measures, like the use of particular kinds of stone that were thought to be impervious to fire, and the exclusion of wooden beams up to a certain height. To house the many people who had lost their homes, many new high-rise tenements were built following safer standards, and urbanization was widespread. The overcrowding was satirized by the Roman poet Juvenal (Satire III), who deplored the noisy, dirty streets and uncouth people.

While the poor endured such conditions, Nero himself immediately seized upon the opportunity to build a sumptuous country house for himself in the center of town, in a large area that had been cleared by the fire. As it was extraordinarily lavish and in part gilded, it is called the Golden House of Nero, or the Domus Aurea. The emperor hired the best architects of the day, Severus and Celer, to construct the palace, the surrounding gardens, and the artificial lake.

One of the surviving sections, later incorporated in the Baths of Trajan that were built over it (see below, p.153), included the revolutionary architectural idea of an octagonal space with smaller rooms radiating out from it (figs. **4.23** and **4.24**). A dome with a central opening, known as an *oculus*, covered the center of the octagonal room. In addition to the light that came through the hole in the roof, there were slits that let light into the radiating rooms. This was an unprecedented and ingenious design that hid the light source from the viewer.

One wonders if this room might be equated with the remarkable dining room described by Suetonius in his biography of Nero. It was supposed to have had a gilded dome that revolved in imitation of the heavens, to the delight of the guests, and there were ceilings of ivory from which flowers and perfume could be sprinkled. Suetonius tells us in addition,

"[The palace] had a vestibule, in which stood a colossal statue of Nero himself, 120 feet high; the area it covered was so great that it had a mile-long portico with three colonnades; it also had a pool

4.23 Golden House of Nero, Rome, plan

4.24 Octagonal domed room, Golden House of Nero, Rome. AD 64. Brick-faced concrete

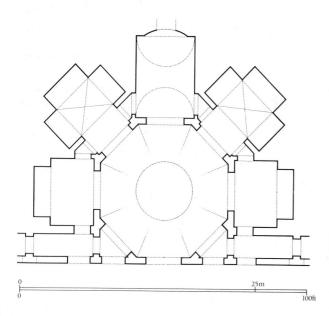

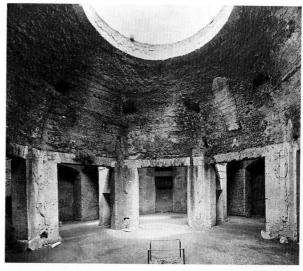

which resembled the sea and was surrounded by buildings which were to give the impression of cities. . . . All the structures in the other parts of the palace were overlaid with gold and were highlighted with gems and mother-of-pearl."

[Suetonius, Nero xxxi, trans. J.J. Pollitt, The Art of Rome c. 753 BC-AD 337 Sources and Documents (Prentice-Hall, Englewood Cliffs, NJ, 1966) p.143]

Even though it is only the lower rooms of the Domus Aurea that we have left today, there is enough to be able to see that this building represented major new ideas in construction and especially vaulting. The use of concrete to form the dome of the octagonal room and the long vaulted passages that still today lie underground show that the architects had come to realize the full potential of their chief building medium, concrete. Architecture under subsequent emperors, especially Hadrian, carried this potential even further.

The wall paintings The paintings of the Golden House were discovered in the late 15th century. A number of famous Renaissance painters, including Raphael and Giulio Romano, crawled in under the ceiling, which was then well underground, and were inspired to paint similar decorative motifs in some of their own works. Because these cave-like excavations were called grottoes, the figures on the wall were given the name grotteschi, from which comes our word "grotesque." On the other hand, the major paintings from the Golden House have not survived well, and do not therefore give us an adequate notion of the lavish decoration of this palace. Gone too are the more spectacular types of wall decoration that must have once included mosaics, stucco, and marble veneer.

The paintings that survive in the Golden House are of two different types. Some, like this example from a ceiling, are of the Third Pompeian style (fig. 4.16, p.116), with its spindly framework of rectangles, and various decorative devices that are set against a plain background. No longer is volume emphasized, nor vistas onto courtyards or gardens. The surface of the ceiling itself, rather than the illusion of space, is apparent everywhere. Small figures rest on narrow bars or fly through fields of color, somewhat like the stucco figures on the ceiling of the slightly earlier Underground Basilica at the Porta Maggiore (see above, fig. 4.22).

The Fourth Pompeian style The Fourth Pompeian style, to which most of the paintings in the Golden House may be ascribed (fig. 4.17, p.116), is in a sense a combination of the Second and Third styles. The spindly columns continue, if in a more complicated scheme, but the wall is broken up into different spatial levels with vistas upon more distant scenes. The solid architectural elements of the Second style reassert themselves but in a form that allows many more flights of fantasy and results in an unrealistic, if fabulous, rendition of space.

It is sometimes suggested that the creation of the Fourth style was due at least in part to the painter Famulus, whose name is recorded by Pliny [NH xxxv. 120]. He was said to have painted in his toga, and to have worked almost exclusively in Nero's Domus Aurea. We shall look at betterpreserved examples of this kind of painting in the next chapter.

The forced suicide of Nero in AD 68 brought to an end the period of the Julio-Claudians. The decades since Augustus had by no means had a monolithic character, but the emperors had become both in-bred (Claudius was both Nero's great-uncle and his stepfather) and an aristocratic clique. History has not looked very favorably on this group, but from the point of view of art and architecture, their accomplishments were major. In painting and the decorative arts, including stucco, they had reached new pinnacles, and something of an architectural revolution had taken place in the Golden House of Nero.

The Flavians: Savior to Despot AD 69–98

The Flavian era is often characterized as "baroque," a term that implies flamboyance and an emphasis on decorative detail.

Certainly the artists achieved enormous skill in carving, and, in portraiture, they exhibited a new sensitivity in capturing psychological representation. In architecture, the Flavians built on a grand scale, yet paid a great deal of attention to ornamental details and to sculptural relief. During this period, in AD 79, the great eruption of Mount Vesuvius took place, burying Pompeii and Herculaneum, and at the same time preserving for posterity a glimpse of life in those thriving Campanian towns of the Bay of Naples.

When Vespasian, first of the Flavian emperors, assumed the seat of power, he was looked upon as something of a savior. For, after the suicide of Nero in AD 68, there began a year

Opposite Detail of the Triumph of Titus, fig. 5.9. Arch of Titus, Rome. c. AD 81. Marble relief

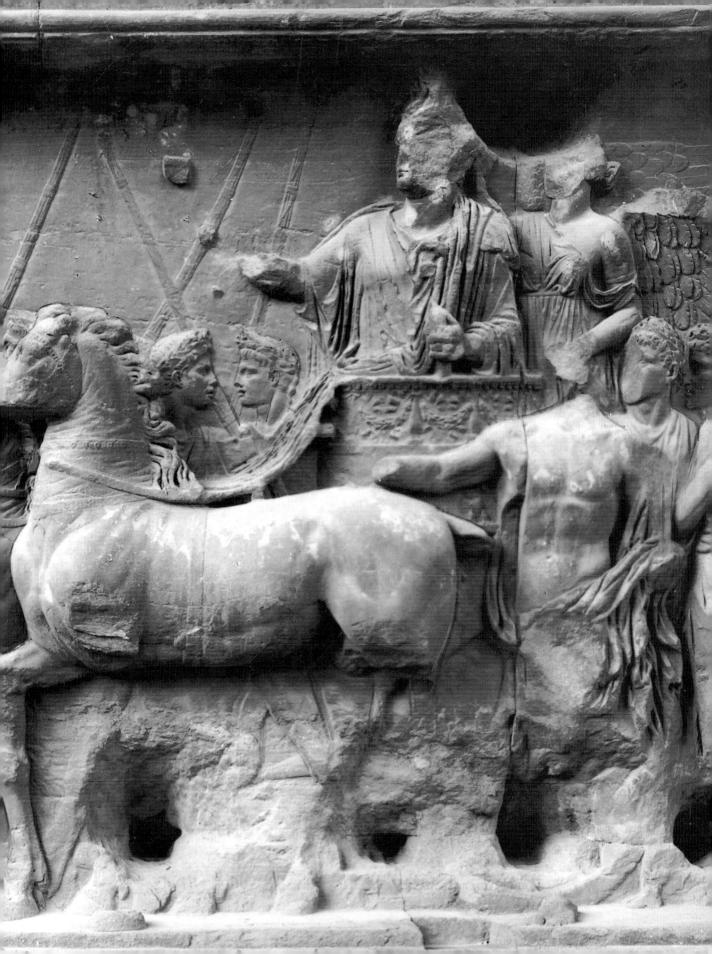

that was to see four different emperors – Galba, Vitellius, Otho, and then Vespasian – all army generals, who followed each other in quick succession. Vespasian gained political power from his military strength, having originally been appointed by Nero to put down a revolt by the Jews in Palestine. Once he had been proclaimed emperor by his troops, he handed over the command in Palestine to his older son Titus, who ended the war with the utter destruction of the Temple in Jerusalem. The Flavians began with optimism and hope, but the last of the dynasty, Domitian, deservedly earned the reputation of a despot.

5.1 Portrait of Vespasian. *c*. AD 75. Marble. Lifesize. Ny Carlsberg Glyptotek, Copenhagen

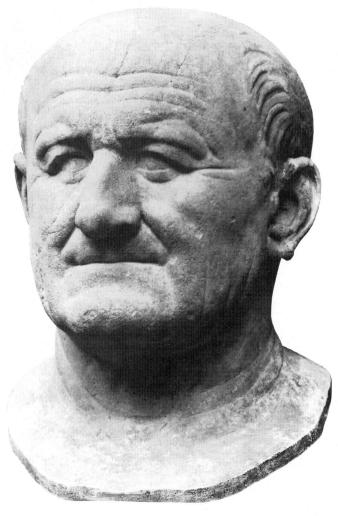

Vespasian

Vespasian (AD 69–79) belonged to a plebeian family, and cultivated the image of a plain man, in contrast to the fancy airs of Nero. His family name of Flavius is used to describe the dynasty of the next 30 years. Portraits of Vespasian emphasize a realistic, kindly-looking man (fig. **5.1**), and are devoid of the idealism that so often characterizes the Augustan and Julio-Claudian periods. The wrinkled face is appealing, if not particularly handsome.

Vespasian's portraits offer a good example of the veristic style to which sculptors and patrons of metropolitan Rome returned at this time. (In other parts of Italy, and especially Pompeii, it had never been lost.) It will not be the last time that we see the recalling of past styles, and indeed one way of characterizing the development of Roman portraiture is through the alternation between veristic and heroic representation. It is natural enough when one considers the sets of heads and busts that must have been accumulating for official display. The shelves and storerooms would have borne witness to the styles of days gone by, and offered models of every sort for copy and adaptation, especially if one wanted to establish a clear contrast to the most recent style.

Imperial architecture

THE COLOSSEUM

Coming on the heels of Nero's rule, when housing conditions for the poor had deteriorated dramatically (see above, p.120), Vespasian was welcomed as one who understood plebeians, and he made good use of this. One of his wisest political decisions was to turn back to the public domain what had been the private gardens of Nero's Golden House. He did this by building a monumental arena, known since the Middle Ages as the Colosseum (figs. 5.2 and **5.3**), on the site that had previously been a lake in the sumptuous Neronian landscape. Its main axis was 616 feet 9 inches (188m), its minor axis 511 feet 10 inches (156m), and its outer wall rose to a height of 159 feet (48.5m). The message was surely not lost on the Roman people: the Colosseum was the grandest amphitheater anywhere, and the first

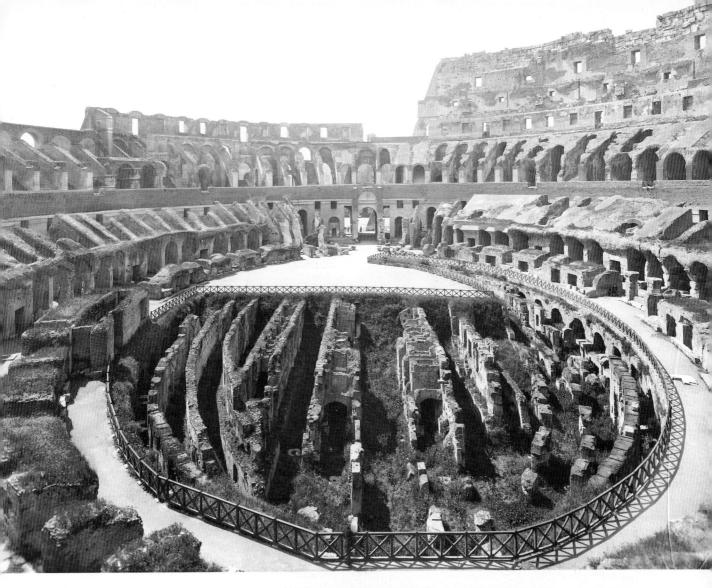

5.2 The Colosseum, Rome. c. AD 72–80. Stone and concrete. Height 159ft; length 616ft 9ins; width 511ft 10ins $(48.5 \times 188 \times 156m)$

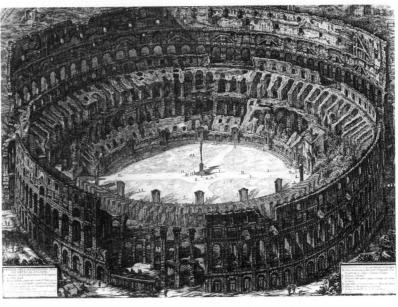

5.3 The Colosseum, Rome, etching by Piranesi from *Views of Rome*, 1776. Height 1ft 7½ins (49·5cm)

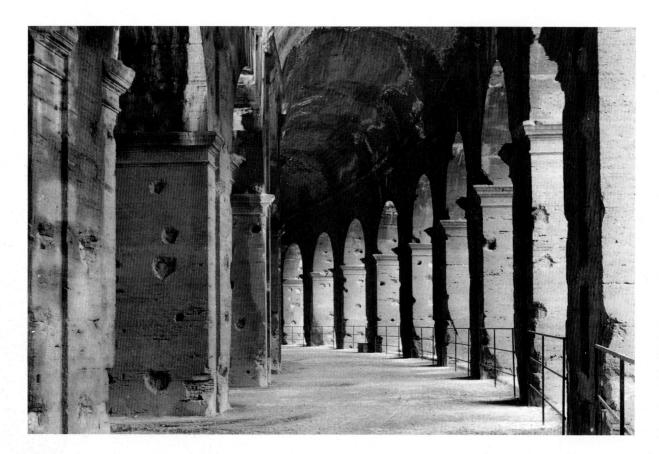

permanent one in Rome. Its purpose was to provide the setting for various kinds of entertainment, including mock sea battles, gladiatorial games, and wild-beast hunts, on the very spot where a tyrant had lived only a few years earlier.

The oval shape and steeply stepped seating arrangement of the Flavian Amphitheater, as it was actually called, enabled everyone to see what was happening in the center of the arena. The huge numbers that it could hold, with an estimated capacity of about 50,000 people, might have caused problems as the crowds came and went, but the designers anticipated them, and made 76 exits that would have allowed all the spectators to leave the building in a short time. Interior radial and circular passageways (fig. **5.4**), as well as stairways to the upper blocks, also provided good means of circulation for the massive crowds.

The structural system was based on a series of arches and arched passageways that crossed more or less at right angles to each other, making a groin

5.4 *Above* Second story interior, radial passageway, the Colosseum, Rome. *c*. AD 72–80. Stone and concrete

5.5 *Opposite* Exterior façade, the Colosseum, Rome. *c.* AD 72–80. Stone

vault (see below, glossary p.293). The arch gave the strength that was needed, without making more bulk and weight than was necessary. Even so, deep foundations had been sunk to support the enormous weight that the building required. Most of the interior was constructed of concrete, but the builders used an attractive travertine (local limestone) masonry for the exterior and the main piers. Because this stone was seen as a highly desirable building material during the Renaissance, and the blocks were ready cut, the Colosseum served as a veritable quarry for the builders of palaces and other grand buildings in that period.

The architects decorated the exterior façades (fig. **5.5**) with engaged columns of the Doric order

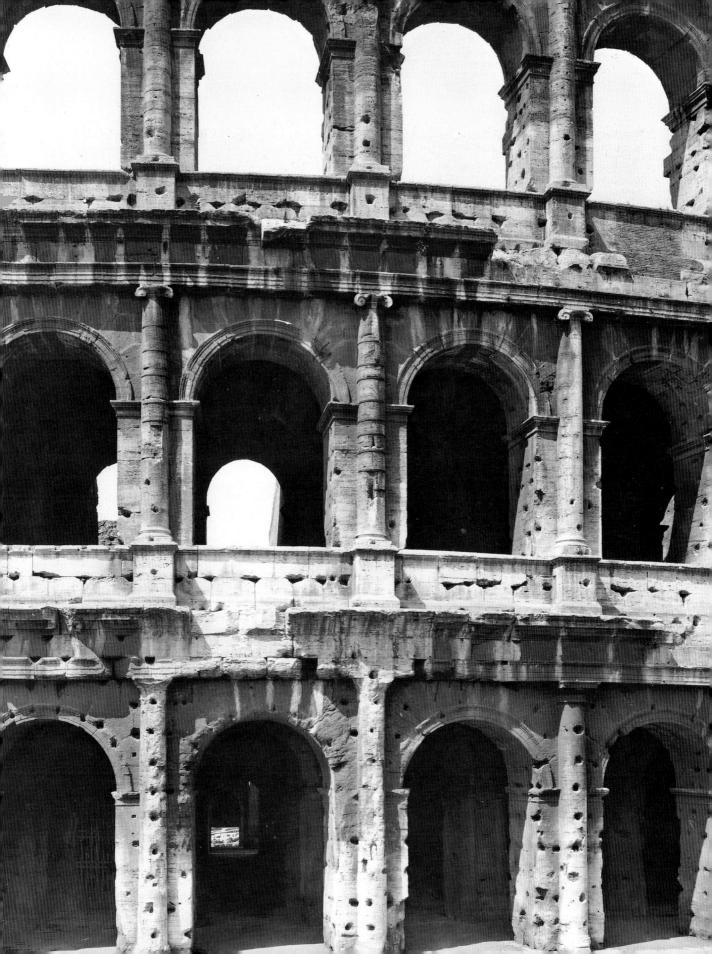

on the ground floor, Ionic on the second, and Corinthian on the third, and they used Corinthian pilasters (engaged columns that are flat instead of round) for the fourth tier. Thus, visually, the exterior is linked to Greek decorative traditions, although structurally it is a completely Roman building.

Doors at the inner ends of the oval allowed the gladiators and wild beasts to enter and leave the ring, and there was an elaborate system of passages and cages below the level of the arena to enable the animal handlers to move the lions and other beasts to an appropriate point of entry. The cages, unseen by the public, would be hoisted to a higher position, from which the animals would enter the arena. The French painter, Gérôme, made one of the famous

5.6 "Thumbs Down," at a gladiatorial contest at the Colosseum, Rome, Painting by Jean-Léon Gérôme. *c*.1859. Height 3ft 4ins (1.02m). Museum of Art, Phoenix, Arizona

reconstructions of the Colosseum (fig. **5.6**). Here we see the priestesses, known as the vestal virgins, giving the "thumbs down" gesture that indicated that the gladiator should not spare the life of his opponent. This is one of the many gruesome traditions associated with the Colosseum, the best known of which was "throwing Christians to the lions."

THE ARCH OF TITUS

Titus (AD 79–81) had the honor of officiating at the opening ceremonies of the Colosseum, in AD 80. But he is probably best known to us today for the triumphal arch (fig. **5.7**) that was erected to celebrate his victory in the Jewish War. Triumphal arches were connected with the Roman idea of victory, and a "triumph" was an honor voted by the Senate. This was celebrated by a specified ritual procession where the troops marched before the populace and exhibited the booty and prisoners-of-

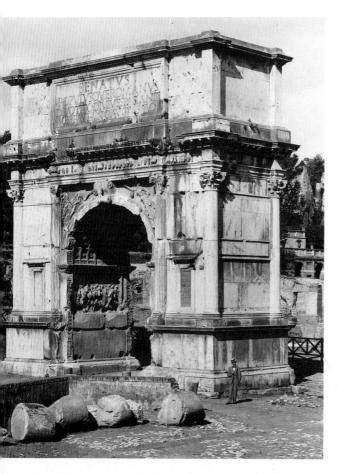

5.7 *Above* Arch of Titus, Rome. c. AD 81. Marble. Height c. 50ft; width c. 40ft (15×12m)

5.8 *Right* Arch of Titus and Frangipani Palace, Rome. Etching by Piranesi from *Views of Rome*, 1760. Height 1ft 3 ¹/₄ins (38-7cm)

war so as to confirm the success of the general and his army. Law and convention required that the soldiers had to lay down their arms outside the city walls, before marching beneath the triumphal arch.

The Arch of Titus was erected by Titus' brother and successor, the emperor Domitian (AD 81–96). It is a relatively small marble arch, with just one passageway underneath. A partially restored inscription on the attic clearly states that the Senate and the Roman People (*Senatus Populusque Romanus*, often abbreviated to SPQR) erected this monument to commemorate the deified Titus.

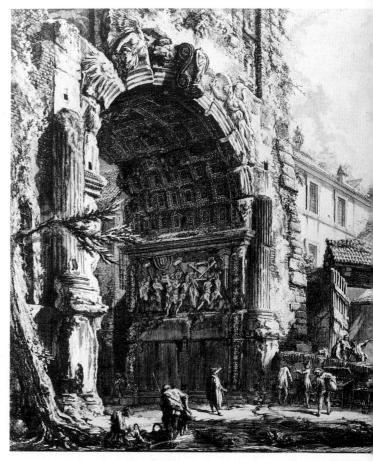

Representations of "Victory" fill the corners above the arch, called the spandrels, and two large relief panels, each with a scene from the triumphal procession, decorate the walls of the passageway. Illusionism, in this case shown by the implication of space, depth, and atmosphere, is here exploited to its fullest. Both reliefs suggest that the spectator is walking beneath the arch in the direction from the Colosseum into the forum, which would indeed be the way a procession would be moving when coming into the city center.

Heavy damage was inflicted on the reliefs when the Frangipani family incorporated the arch into its medieval fortress (fig. **5.8**). Large holes were gouged out to make room for beams, but luckily much of the relief survives relatively intact. Indeed, it is the earliest surviving sculptured arch in Rome with its reliefs still in place.

On the right, as one faces the forum, is the relief

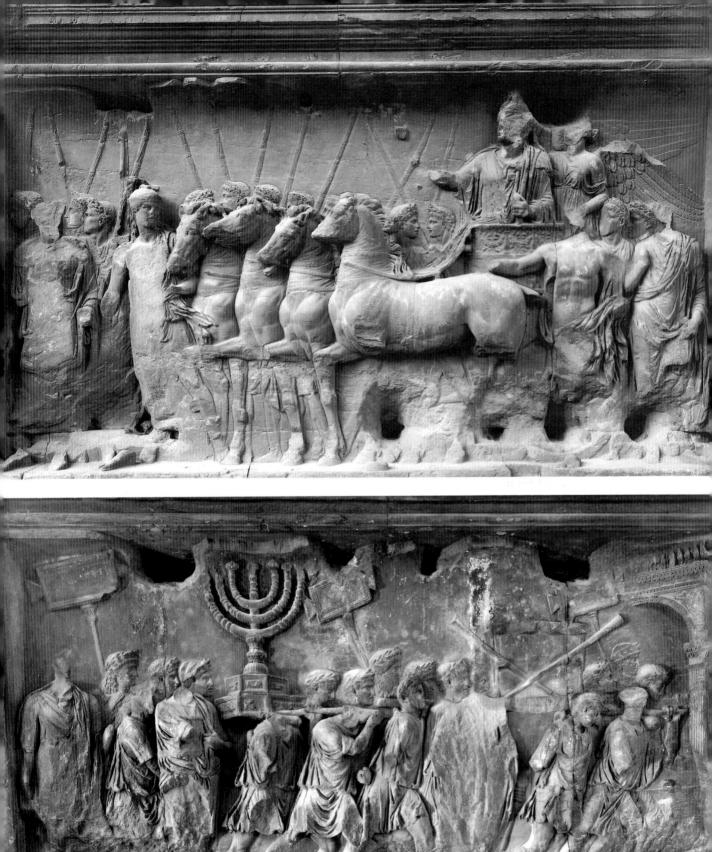

į,

depicting the emperor Titus in his chariot, led by a personification of the goddess Roma, while Victory floats behind him, crowning his head with a laurel wreath (fig. **5.9**). The head of Titus, which is now destroyed, must have been a portrait, but the members of the imperial entourage who accompany him are idealized. As on the Gemma Augustea (see above, fig. **4.1**) there is an easy mixing of the divine and human. The subject of triumph seems to have called for this fusion of the two realms.

By making the nearest figures stand out in high relief, and contrasting these with the shallow treatment of the figures in the background, a sense of deep space has been created. The sculptor also used a device to give the feeling of atmosphere: he left much of the upper portion of the background empty, save for the lances of the soldiers. The fact that they are held on the diagonal helps to give a sense of receding space. A similar device was used in the background of the Alexander Mosaic (see above, fig. **2.26**). The open space at the higher levels also gave the artist the opportunity to make Titus and Victory stand out above the other figures.

The second relief (fig. **5.10**) does not focus attention on any particular figures, but the great *menorah* (lampholder) in the center commands attention. Again, the artist has left the upper part of the frieze largely blank, giving the effect of free space. Soldiers parade by, carrying the *menorah* and other sacred objects from the Temple at Jerusalem that had recently been sacked by the Romans. They also display placards that explain the events of the military campaigns to the crowds lining the streets.

The procession, at the back end, appears, from the positions of the soldiers, to be coming towards us. The nearest figures are those carrying the litter with the *menorah* on it, and those at the front of the procession appear to be marching away from us and passing under an arch that we see projecting from the background. It must be at some distance, because the soldiers in the front rank appear too large to go through it. The implication here is that

the line of soldiers turns before our eyes, and indeed we feel that we are spectators watching the event.

The well-proportioned arch and its striking carvings represent one of the high points of the sculptor's craft in Roman relief. The notion of the "triumphator" riding in his chariot was not new, and the combination of real figures with divine and allegorical ones, such as Roma and Victory, was also known from such works as the Gemma Augustea (see above, fig. **4.1**). But on a single monumental panel, this is the first time that we find this combination — a formula that was to play an important part in subsequent Roman iconography.

THE FLAVIAN PALACE

Domitian must have become paranoid, expecting that at any moment someone might come to knife him in the back. At least that is one of the explanations for the marble-faced walls that would have served as mirrors in the public rooms of his sumptuous palace on the Palatine Hill in Rome. Tiberius, or perhaps Nero, had been the first emperor to build a grand home on the north side of

5.11 Plan of lower level of the Flavian Palace, Domus Augustana, Palatine Hill, Rome

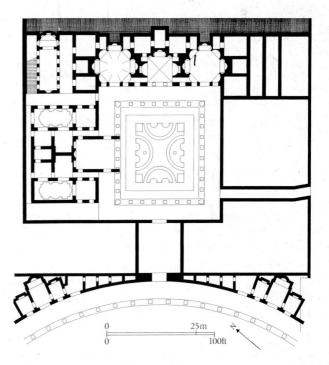

^{5.9} Opposite top Triumph of Titus, Arch of Titus, Rome. c.AD 81. Marble relief. Height 6ft 7ins (2m)

^{5.10} Opposite bottom Menorah procession, Arch of Titus, Rome. c. AD 81. Marble relief. Height 6ft 7ins (2m)

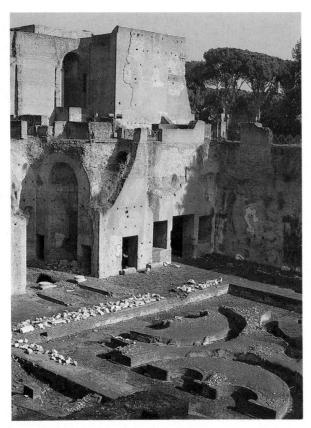

5.12 Fountain in the lower story of the Flavian Palace, Domus Augustana, Palatine Hill, Rome. *c*. AD 91. Brick and concrete. *c*. 60×60ft (18·29×18·29m)

this hill, but it was now surpassed by the palace built on the top by the last of the Flavian emperors.

As his architect, Domitian chose Rabirius, a man who loved to make rooms of unusual shape, such as octagons with circular and square niches (fig. **5.11**). He was a master in two ways: in his use of concrete, and in the innovative plan he devised for the palace. There were two distinct parts to the building: the public audience halls, known as the Domus Flavia, and the private quarters, or Domus Augustana. The palace occupied several levels between the top of the hill and the south slope facing the Circus Maximus, where chariot racing took place. Colonnades and courtyards, fountains with semicircular patterns (fig. 5.12), and octagons within octagons, make it one of the most interesting of imperial buildings. It served as the home of the emperors for the next three centuries.

Sculpture

IMPERIAL RELIEFS

Two imperial representations known as the Cancelleria reliefs were originally part of a large frieze that decorated an altar base. They were found beneath a papal palace, called the Cancelleria, shortly before World War II. One (fig. 5.13) originally showed the emperor Domitian setting out on a military expedition, guided and encouraged by a group that included the goddesses Roma and Minerva, the genius of the Senate (a personification of that body), and other allegorical figures. The head of the emperor was later recarved as a portrait of his successor Nerva, after Domitian suffered damnatio memoriae, or the official blotting out of his memory from public affairs. Recarving of the heads of emperors was not unusual. It could be done, as here, when someone had become unpopular, and it was also used as a money-saving device when a patron did not wish to pay for a whole new statue.

There is movement in the relief from right to left, aided by a series of gestures that guide the eye from one figure to the next; but overall, the illusionism and variation that we saw in the Arch of Titus reliefs (see above, figs. **5.9** and **5.10**) is absent here. There is space above the figures, and some stand in front of others, but the effect is static and mechanical. Yet the sculptors were skilled and confident in the carving of both bodies and drapery, and the gestures were part of a vocabulary familiar to all Romans, who did not need an explanation to understand such reliefs.

The second of the Cancelleria reliefs (fig. **5.14**) depicts the arrival of Vespasian in Rome. He is greeted by Domitian, as well as the *genius* of the Senate, Roma, the *lictors* (magistrates' attendants), and vestal virgins. Space is suggested by placing some figures above and behind the others and by the systematic overlapping of bodies. Domitian had this carved for his own aggrandizement, suggesting here, and elsewhere, that he had stepped aside to allow his father and then his older brother to rule before him. He also tried whenever possible to associate himself with popular relatives. Although parts of the frieze are missing, the remaining portions give us the best example of the formal

5.13 Domitian setting out, relief from the Cancelleria, Rome. AD 80-90. Marble. Height 6ft 91/2ins (2·07m). Musei Vaticani, Rome

5.14 Arrival of Vespasian, relief from the Cancelleria, Rome. AD 80-90. Marble. Height 6ft 91/2ins (2:07m). Musei Vaticani, Rome

imperial relief at the time of Domitian.

One of the finest examples of decorative sculpture by Roman artists was also produced in this era – for a refurbishing of the Temple of Venus Genetrix in the Forum of Julius Caesar (fig. 5.15; see above, p.83). The frieze shows cupids, working in the service of Venus, performing various tasks related to the goddess and her lover Mars. The treatment of the figures is tremendously selfassured, and the chubby little figures expend a great deal of energy in a convincing manner. These are the forerunners of the cherubs and amorini (representations of the infant Cupid) so beloved by Renaissance sculptors and painters.

PLEBEIAN RELIEFS

Also decorative, but stemming from a completely different tradition, are funerary reliefs of the type seen on the Tomb of the Haterii (fig. **5.16**). This is a monument commissioned by a private family, and uses the artistic vocabulary of plebeian art that has little concern for the standards of imperial reliefs. Here, minute attention is paid to the details of buildings and funerary trappings. An elaborate mausoleum, complete with ornately carved columns, bronze door, and reliefs on the side, is still under construction, as we can see by the "cherry picker" or crane, with wheel at the bottom, shown on the left. Meanwhile, the dead person lies in state.

It may be that the owner of the tomb was a builder. In any case, the sculptor shows no regard for logical spatial relationships or relative proportions. Formal imperial sculpture (like the Cancelleria reliefs; see above, figs. **5.13** and **5.14**), with its elegant drapery and slow ponderous movement, is here replaced by a kind of enthusiastic proliferation of details, as if the sculptor were trying to fit in everything, wherever it would go.

PORTRAITS

Portrait sculpture of the Flavian period dealt with new problems. Perhaps the most challenging was the elegant style of female hairdos that became popular at this time. Typical was a mass of curls piled high on the head and standing up in ringlets over the bare forehead. The style was undoubtedly **5.15** *Left* Frieze of cupids, from the Temple of Venus Genetrix, Forum of Julius Caesar, Rome. Late first century AD. Marble. Height 1ft 7½ ins (48-9cm). Museo Capitolino, Rome

5.16 *Opposite* Mausoleum under construction, relief from the Tomb of the Haterii, Via Labicana, Rome. Late first century AD. Marble. Height 3ft 5ins (1·04m). Musei Vaticani, Rome

initiated by one of the imperial wives, but it must have caught on quickly among the fashionable women of the day. The most beautiful example, and the one exhibiting the finest carving, is the head of a lady in the Capitoline Museum in Rome (figs. **5.17** and **5.18**). Her long elegant neck curves gracefully upwards as it supports the strong-chinned, heavy-browed, yet delicate face. The curls of her magnificent coiffure are drilled with deep holes in the center, providing a fine example of *chiaroscuro* — where the contrast of light and shade is used for artistic effect. Individual hairs are chiseled out on the surfaces, while defiant wisps of short hairs, escaping the ordered pattern, lie gently on the back of the lady's neck.

The same kind of Flavian coiffure is worn by the standing woman posing as Venus, clad only in a piece of drapery that falls over her legs (fig. 5.19). The treatment of face and hair does not show the magnificent subtlety of the previous example, but the high-stacked hairdo is similar. The notion of making a portrait of a wealthy woman, standing naked, having just come from the hairdresser, seems completely incomprehensible to modern taste; and indeed was not so common in antiquity either. But examples of naked men with portrait heads have survived from the Republican period, from the island of Delos. Men and women, commoners and emperors alike, appeared in this way from now onward.

Both these pieces display artistic effects through sculptural technique. The deep cutting, achieved especially through drilling, makes dark shadows that break up the surface. The design is made of abrupt transitions between light and dark areas, in imitation of the effects of painting. This is in distinct contrast to previous practice, where almost all the surface of the sculpture was visible, and the gradation of the shadows showed an even progres-

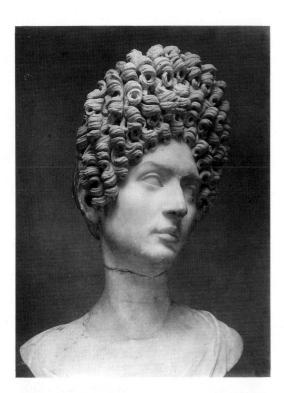

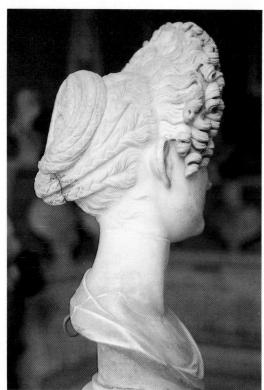

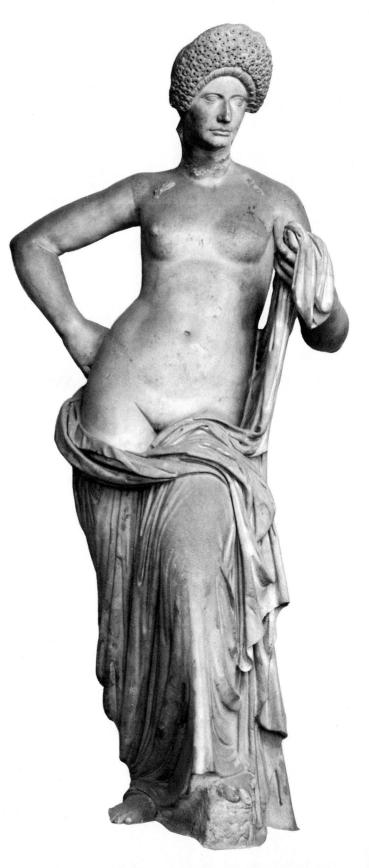

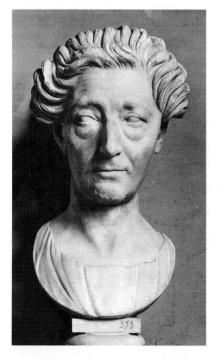

5.17 *Opposite, top left* Portrait of a Flavian lady. *c*.AD 90. Marble. Height 2ft 1in (63·5cm). Museo Capitolino, Rome

5.18 *Opposite, bottom left* Portrait of a Flavian lady, back view. *c.* AD 90. Marble. Height 2ft 1in (63·5cm). Museo Capitolino, Rome

5.19 *Opposite right* Portrait of a Flavian woman as Venus, from Porta San Sebastiano, Rome. Late first century AD. Marble. Over lifesize. Museo Capitolino, Rome

5.20 Above left Portrait of an older Flavian woman. Late first century AD. Marble. Height 9½ ins (24·1cm). Museo Laterano, Rome

5.21 *Above center* Portrait of an older Flavian woman, profile. Late first century Ad. Marble. Height 9½ins (24·1cm). Museo Laterano, Rome

5.22 *Above* Colossal portrait of Titus, or Domitian, from Ephesus. Late first century AD. Marble. Izmir Museum

sion. In the Flavian hair, the steep sides of channels made by a drill produce dark shadows, even if the channels themselves are not particularly deep. This practice continues, most obviously in reliefs of the mid to late second century AD, and in the patterns on architectural moldings.

A portrait of an older woman of the Flavian period (figs. **5.20** and **5.21**) shows her personality particularly well. Through the narrow eyes, baggy folds under the eyes, and tight lips, the artist succeeded in providing insight into this woman's strong, cunning, and intelligent character. The treatment of the rhythmical waves of her hair

makes a splendid frame to the sensitively carved face. Something of this sensitivity can also be seen in portraits of Vespasian (see above, fig. **5.1**).

The colossal portrait of the emperor Titus, or perhaps of Domitian (fig. **5.22**), is a head of a different kind. It shows to what lengths a sculptor would go to portray brute power and strength. Yet, again we see deep carving in the hair that makes effective darks and lights. The piece was found in the Flavian temple at Ephesus, in Asia Minor (modern Turkey; see above, fig. **0.1**), where the taste for dramatic treatments continued throughout the period of the Roman empire.

Pompeii and Herculaneum

Disaster struck the Campanian towns of Pompeii, Herculaneum, and Stabiae under the rule of the Flavians. Warning of trouble had come in the year AD 62, when there was a major earthquake in the region. Many of the houses had not yet been repaired, and others had been recently renovated, when Mount Vesuvius erupted on August 24 in AD 79 with such force that the ash completely buried the towns lying at its base. We have a precious eye-witness account in the form of two letters written by Pliny the Younger to Tacitus, the great historian. He told him about the death of his uncle Pliny the Elder, who was commander of the fleet stationed nearby. These letters give a feeling for what happened on that fateful day in August when

a flourishing and cultivated part of the Roman world disappeared from sight.

"[The volcanic cloud's] general appearance can best be expressed as being like an umbrella pine, for it rose to a great height on a sort of trunk and then split off into branches. ... Meanwhile on Mount Vesuvius broad sheets of fire and leaping flames blazed at several points, their bright glare emphasized by the darkness of night. ... We saw the sea sucked away and apparently forced back by the earthquake: at any rate it receded from the shore so that quantities of sea creatures were left stranded on

5.23 Centaur and youth holding a lyre, from *Antichità di Ercolano* Vol. I p. 145, 1757. Engraving after a drawing by C. Paderni. Height of engraving 1ft 1½ins; width 1ft 6½ins (34·3×47cm). The original painting, from the Villa of Cicero in Pompeii, is in the Museo Archeologico Nazionale, Naples

dry sand. On the landward side a fearful black cloud was rent by forked and quivering bursts of flame, and parted to reveal great tongues of fire, like flashes of lightning magnified in size."

[Trans. Betty Radice, *The Letters of the Younger Pliny* (Penguin, Harmondsworth, Middlesex, 1963), pp.166–7, 171. Reproduced by permission of Penguin Books Ltd]

Excavations began in the mid-18th century, after the location of Herculaneum was discovered by a man digging a well. After he unexpectedly pulled up some Roman sculpture from the hole, he investigated, only to find himself in a large cavernous underground space that eventually turned out to have been a theater. Excavations began under the auspices of the king of Naples, Charles III, who took an interest in archaeological activities. In keeping with contemporary practice, he regarded the ancient objects as his private possessions, and began a personal museum that, today, makes up some of the most important material in the Archaeological Museum of Naples. The world at large began to learn about the discoveries at the foot of Mount Vesuvius from a

5.24 Pompeii in AD 79, plan

- 1 Forum Baths
- 2 Basilica
- 3 Stabian Baths
- 4 Triangular Forum
- 5 Temple of Apollo
- 6 House of the Vettii

series of volumes begun under the reign of Charles III (fig. **5.23**), which were soon pirated in other editions in other parts of Europe. In this illustration, a detail from the center of a wall painting from Pompeii, a centaur and a youth playing the lyre seem to float through the air.

The buried cities have revealed a great deal, not only about private dwellings and public monuments, but also about daily living. From the charred remains, it is possible to learn what people ate and what their furniture was like. Organic materials such as foods and wood, so often irretrievably lost in the earth, were here carbonized, encapsulated in a prison of ash that turned to a rock-like consistency over time. Among the objects of everyday living that turned up at Pompeii and Herculaneum were lamps, door knockers, steelyards (portable balances) and scales, cups, bottles and dishes, combs and hairpins — many of them elegantly decorated, and

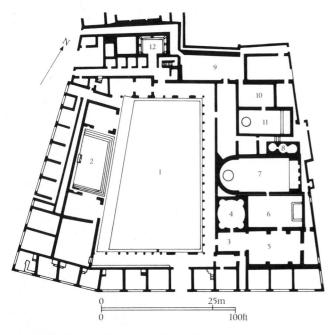

5.25 Above Stabian Baths, Pompeii, plan

- 1 Palaestra
- 5 Changing room 9 Women's dressing room
- 2 Natatio

4 Frigidarium

- 6 Tepidarium
- 3 Entrance hall 7 Caldarium
 - 8 Furnaces
- 10 Women's tepidarium 11 Women's caldarium
 - 12 Latrine

5.26 Below Caldarium in the Forum Baths, Pompeii. Early first century AD. Concrete

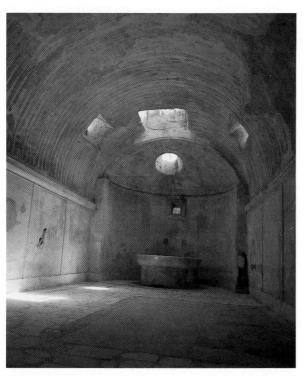

made of various materials. These cities have revealed more about the life and art of the Roman people than any other place, and they provide a rich source for confirming and elucidating what we learn from contemporary literature.

THE CITY OF POMPEII

We have already looked at a typical Pompeian house plan (see above, fig. 2.31). What about the city of Pompeii at large (fig. 5.24)? The city covers over 160 acres (65 hectares), and the wall that encircled it is about 2 miles (3.2km) long. It would have had a population of about 10,000 at its height. Like all Roman towns, it had a rectangular forum; this one, constructed in the Republican period, retains the long narrow shape typical of early examples.

There was also a triangular forum, several bath complexes, numerous temples, and exercise grounds, called *palaestrae*. The earliest of the baths, the Stabian Baths (fig. 5.25), preserves not only an early plan for this type of complex, but also an incipient dome with a hole in the roof. We see lighting through holes in the ceiling also in the caldarium, or hot room, of the Forum Baths (fig. 5.26). This construction played an important part in later Roman architecture. A large stone amphitheater, the earliest permanent structure of its type in Italy, and a theater provided space for public entertainment. Perhaps the best impression of the town in ancient times is provided by the street scene, with its large paving blocks and stepping stones for pedestrians (fig. 5.27).

Most of the buildings around the forum had still not been restored after the earthquake of AD 62 when the eruption 17 years later caused the final devastation of the city. Only the Temple of Apollo, on the west side, was nearly repaired (fig. 5.28). Since work on the Capitolium had not yet commenced, we must assume that a major restoration of this building had been planned for the future. Only a few houses in the city, the amphitheater, and the Temple of Isis had been completely restored.

5.27 *Opposite top* Street scene with stepping stones, Pompeii

5.28 *Opposite bottom* Temple of Apollo, on the west side of the forum, Pompeii, with Mount Vesuvius in the background. Second century BC; repaired AD 63-79. Stone

- **5.29** *Right* Peristyle of the House of the Vettii, Pompeii. Mid-first century AD
- **5.30** *Center* Frieze of the cupids, House of the Vettii, Pompeii. AD 63–79. Wall painting
- **5.31** *Bottom* Hercules strangling serpents, House of the Vettii, Pompeii. AD 63–79. Wall painting

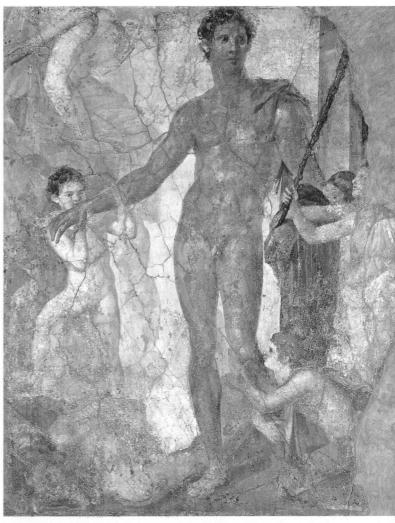

PAINTINGS IN THE FOURTH POMPEIAN STYLE

Fortunately, many of the older paintings survived the earthquake, and those that did were well preserved by the fallen ash from the volcano. To see the latest Pompeian work, we turn to one of the finest houses in Pompeii, the House of the Vettii (fig. **5.29**), which had been recently redecorated after the earthquake. In one room, small panels with black backgrounds served as host to charming scenes with cupids performing everyday tasks: making wine, playing at being pharmacists, acting as metal smiths (fig. **5.30**). The swift strokes and delightfully realistic bodies of the young cupids

5.32 *Above left* Architectural view, from Herculaneum. AD 63–79. Wall painting. Height 6ft 4½ins (1.94m). Museo Archeologico Nazionale, Naples

5.33 *Above* Theseus and the Minotaur, from the Basilica at Herculaneum. AD 63–79. Wall painting. Height 6ft 3ins (1·91m). Museo Archeologico Nazionale, Naples

make these among the most attractive of Pompeian paintings.

One of the finest rooms in the house (fig. **5.31**), the south *triclinium* (dining room), portrays, in a large monochromatic square, the young Hercules strangling serpents. To the right are two architectural vistas that are typical of the Fourth

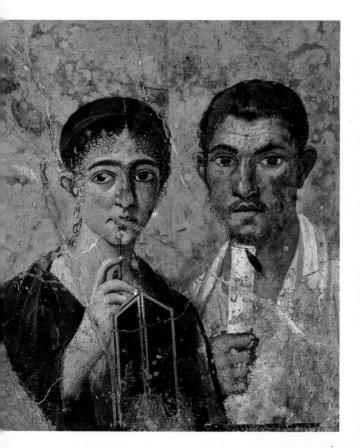

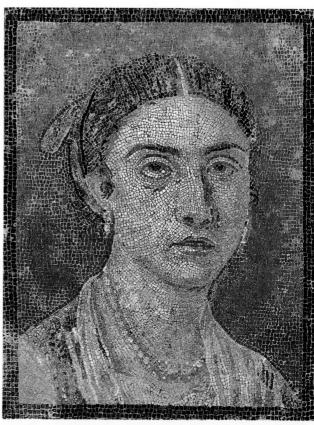

5.34 *Above* Portrait of a husband and wife, Pompeii. Mid-first century AD. Wall painting. Height 2ft 1½ins (64-8cm). Museo Archeologico Nazionale, Naples

5.35 Above right Portrait of a woman, Pompeii. Late first century Bc. Floor mosaic. Height 10ins (25·4cm). Museo Archeologico Nazionale, Naples

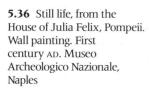

style: they revert to a greater interest in real architecture than was characteristic of the Third style, but there is a greater element of fantasy than was found in the Second.

A fragment of wall painting from Herculaneum shows the Fourth style in its theatrical and exaggerated form (fig. **5.32**). It has often been compared to a stage setting, especially because of the curtain across the top and the theater masks. Remnants of the Third style can be seen in the reed-like column at the right, but the attention to deeply receding, if unrealistic, space is characteristic of the Fourth. Through the broken pediment at the front appears a second pediment, and behind that, a still lighter and more distant building appears. This is an example of atmospheric perspective. The virtuosity of the anonymous painter demands our admiration.

Gertainly Greek wall painting influenced some of the large-scale paintings found in Pompeii and Herculaneum. A fine example from a public building in the forum of Herculaneum, the Basilica, portrays Theseus after he rescued the children of Athens from the Minotaur, who had planned to eat them (fig. **5.33**). The grateful young people kiss and hug the arms and legs of the heavy-muscled Theseus. In the crowd of onlookers at the right, the people are so close together that there hardly seems to be space for all the bodies. This device is reminiscent of the crowd in the early Roman painting from the Esquiline (see above, fig. **2.16**).

The Theseus story was a popular theme; another version appears on the wall of a house in Pompeii. The two are sufficiently similar to suggest that they are derived from the same original in much the same way that many statues of the Roman era seem to be copied from the same model.

Another mythological painting has a subject closely connected with Roman history and literature: the healing of the wounded Aeneas by the doctor Iapyx. This incident is vividly described in *The Aeneid*, Book XII, and the Pompeian artist has followed the text closely (fig. **5.37**). The composition centers on the figure of Aeneas leaning on his long spear, but there are several minor actions that are going on at the same time or occur just afterwards. We see the doctor concentrating on removing the arrowhead from the wound, while

5.37 Healing of the wounded Aeneas by Iapyx, from Pompeii. First century Ad. Wall painting. Museo Archeologico Nazionale, Naples

Venus hovers in the background with the magic plant that eventually caused the arrowhead to drop out of its own accord. The story requires that she be invisible, and the fact that Aeneas looks straight ahead while she is gazing at him confirms that this was the intention of the artist. Aeneas, who does not cry in Virgil's version, is comforting his son, Ascanius, who is weeping copiously.

The artist has used areas of contrasting color, rather than explicit outlines of the forms, to define the shapes. Changes of volume in the forms of the limbs or the folds of the drapery are handled by varying the intensity of the color, and by the addition of white pigment. The range of color is not wide; purplish brown, light blue, and a muted light green are predominant. In some parts the darker areas of shadow are reinforced by short dark lines that give the impression of hasty afterthoughts. Highlights on fabric and flesh are picked out with similar lines in white. In some places the intensity

5.38 *Opposite Lararium* in the House of the Vettii, Pompeii. AD 63–79. Wall painting

5.39 *Above* View of Mount Vesuvius from the west, from the *lararium* of the House of the Centenary, Pompeii. Wall painting. Museo Archeologico Nazionale, Naples

of the light has been indicated by areas where white has completely replaced the color. Such harsh contrasts of light and dark, and the impression of fresh brush strokes, add life to the picture.

The figures and the reference to the narrative are the only elements in this scene; there is no attempt at a landscape setting with details in the foreground and beyond. The ground and the background space are scarcely distinguished, and the bright light seems rather diffuse, so that the figures cast only vague conventionalized shadows behind them. This is in contrast to some of the presentations of grand mythological adventures derived from the Greek tradition, like those of the

Odyssey Landscapes (see above, fig. 2.25), where the setting seems almost as important as the story.

Roman houses normally had a *lararium*, a shrine to the spirits that protected the family and insured health, wealth, and male heirs to the *pater familias*, father of the family. Often the *lararium* had paintings of images of these spirits, with snakes – symbolic of the fertility of the earth – at the bottom (fig. **5.38**). In this example, the *lares* are the male figures dancing on tiptoe at right and left of the central figure, who represents the spirit, or *genius*, of the owner of the house. In his hands he holds an offering bowl and a box of incense. A snake slithers in the grasses toward an altar laden with offerings.

On the wall beside another *lararium* is the only surviving ancient painting of Mount Vesuvius (fig. **5.39**). At the left stands Dionysus with his panther, while below is the traditional snake approaching an altar. The cult of the *lares* was almost universal among the Romans, and had a history that went back to early Roman times.

Among the portraits that survive at Pompeii, none makes us feel closer to the sitters than the double study of a husband and wife (fig. **5.34**). Both look out at us with an unselfconscious gaze: hers through large, intelligent eyes as she presses her stylus to her lips in a fashionable pose, while she holds a tablet in front of her; his somewhat less intellectual, with an upper lip that rises toward his squat nose. Physiological details of both are studied carefully, and we seem to have a sensitive study of a middle-class couple.

The woman may be compared to a mosaic (fig. **5.35**), found set in a late floor, though the piece had probably been made in the first century BC. The skill of the mosaicist was quite exceptional, for he used tiny *tesserae* to make subtle gradations of light and shadow, and captured the woman's momentary expression. The open mouth and curving upper lip, combined with heavy lids, give the impression that she is in thought and about to speak. We have seen the expertise of portraitists in painting and sculpture; this piece shows what artistic heights Roman artists could reach in yet another medium.

Even specific events from daily life made their way into paintings from Pompeii. The Roman historian Tacitus recorded a riot that broke out in AD 59 between the Pompeians and their neighbors

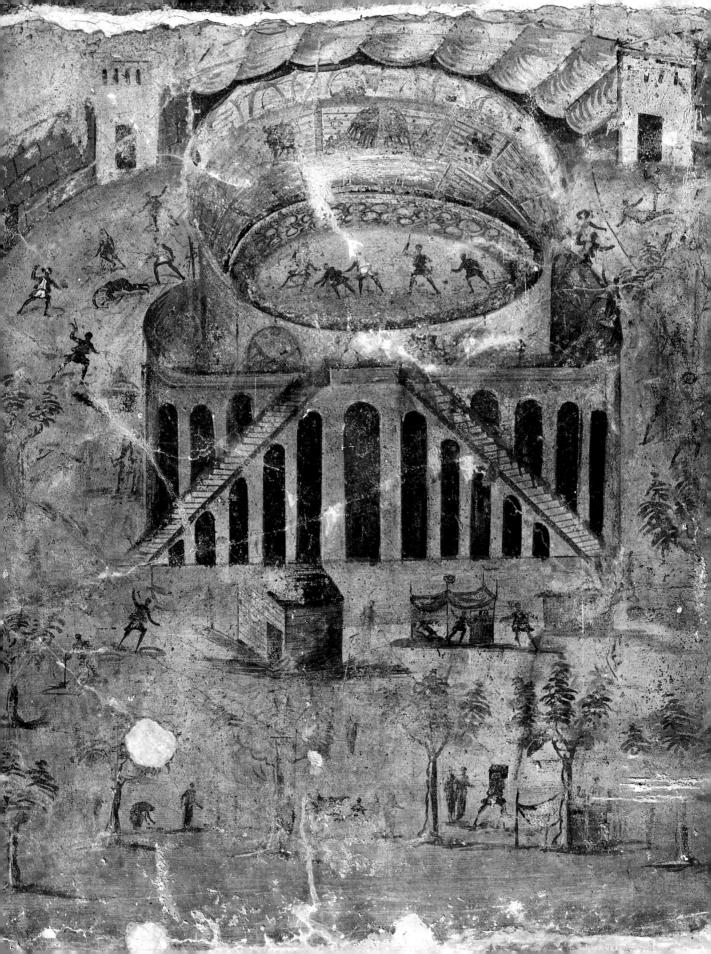

from Nuceria. The event occurred in and around the amphitheater at Pompeii, and was actually depicted in a painting from Pompeii itself (fig. **5.40**). The aerial view, looking down into the amphitheater, enables us to see the fighting taking place among figures who are made much too large for the architecture, but who vividly capture the atmosphere of a fight. Besides the immediacy and the connection with the historical record, it is a fine example of the Roman painter's skill at showing mixed viewpoints. In other words, he has shown us a direct view into the arena at the same time as a sideways view of the exterior.

Roman painters of this time had another favorite device: to decorate the walls with realistic still life paintings that often were small panels or sections in a more elaborate system of wall decoration. One of these (fig. 5.36, p.144), from the House of Julia Felix in Pompeii, shows a plate of eggs placed between a jug with spoon and a bronze jug. Hanging on the wall are small dead thrushes with spotted breasts, and, further to the right, a cloth; a bottle with a stopper leans against the shelf. The silver vessels, shown in bluish paint, are highlighted to show reflections. The textures here are smooth, but color distinctions – for example, to show shadows and the edging of the cloth, and the birds' feet - are done with careful brushwork. The artist was a master at relating the shape and volume of one object to another. The curved forms of the vessels and birds contrast with the block-like shelf, and the diagonals of cloth, sack, birds, and spoon play against each other.

PROVINCIALISM IN ART

Pompeii was a middle-class town, and a provincial center at some distance from the capital; hence, many of its inhabitants would have exhibited a taste that was artistically more conservative than what one finds in Rome. Some of the grandest homes, like the House of the Faun, would have had patrons who could afford the best, but many citizens lived here without the kind of luxury found in imperial houses or wealthy villas. Indeed, Pompeii and Herculaneum provide a fine contrast to the imperial art that tended to be better preserved in places inhabited by the emperors. Not only house types, but paintings, sculpture, and the decorative arts give us an idea of middle-class taste and abilities.

In Flavian art we have seen a dramatic break from the style prevalent under the Julio-Claudians. Although vestiges of the cool classicism of Augustus remain in some of the more formal works like the Arch of Titus and Cancelleria reliefs, the new interest in spatial relationships, textures, and ornate decoration separates such monuments and others from their predecessors earlier in the first century AD and exhibits features that we call the "Flavian baroque" style. Among the highlights of this period are masterpieces in portraiture, major building undertakings such as the Colosseum and the Flavian palace, and the magnificent reliefs of the Arch of Titus. On the other hand, plebeian works are also well represented, by reliefs from the Tomb of the Haterii and by the houses of the Campanian cities overwhelmed by the eruption of Vesuvius.

6 Trajan, Optimus Princeps AD 98–117

Trajan was the first emperor who was born out of Italy – in the town of Italica, in Spain. He distinguished himself in a military career before becoming consul. He took office in AD 98, after having been adopted by his predecessor, the old and rather frail Nerva, who had intended to gain more credibility by associating himself with an energetic and popular general; and so the transmission of power was peaceful. With Trajan's accession began an era of confidence in the greatness of the empire that had not been seen since Augustus. Trajan was to be so successful in the public eye that his era set a new standard against which subsequent Roman periods were judged.

Many portraits of the popular Trajan survive (fig. **6.2**), and he is usually easy to identify from the low brow, heavy bangs, pointed nose, and wide, thin lips. He was highly intelligent, and had an unusual combination of civic vision and military wisdom. His nickname, *optimus princeps*, or "the best chief," sums up the public's view of him.

Opposite Detail of the Column of Trajan, Rome, fig. **6.9**. Lower bands of spiral relief. Dedicated AD 113. Marble

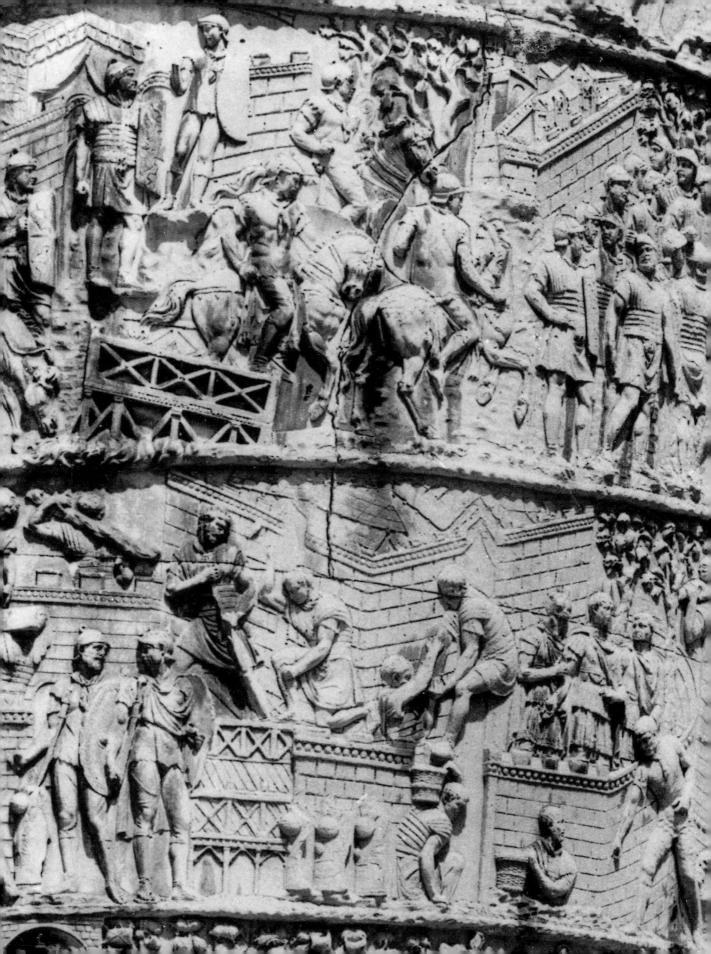

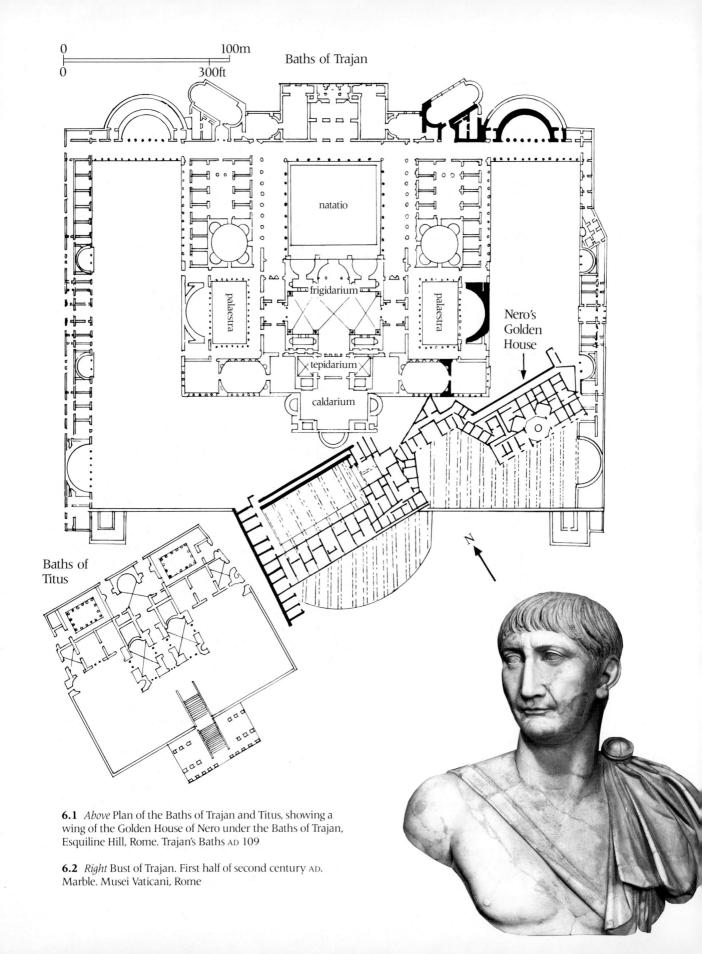

Trajan analyzed the needs of the empire, and soon began to build up the public facilities in Italy itself, such as the additional harbor at Portus, near Ostia. He also believed that the Dacians, who lived in what is now Rumania, were a significant threat to the tranquillity of the European provinces, and engaged in two important campaigns against them. A superb narrative account of these campaigns is preserved in the carved reliefs on Trajan's Column, which was set up in the complex of buildings erected to mark his victory. Typical of the art of his reign was the straightforward manner of reporting historic events, combined with a grand vision of the importance of the empire and its first citizen which was expressed in a comprehensive program of public works on a magnificent scale.

The Baths of Trajan

One of Trajan's grand projects for the city of Rome was a huge bath complex built on the Esquiline Hill (fig. **6.1**). His architect incorporated part of Nero's Golden House into the supporting platform of the new complex, thereby buttressing the hill where it otherwise sloped away. The Baths of Trajan were the first of the enormous imperial baths built in the Roman world, and although they followed in a general way the scheme that had already been established in the earlier Baths of Titus, which lay nearby, the increase in dimensions can be appreciated by comparing the two plans. The enclosure walls of the larger baths measure well over 1,000 feet (300 m) in each direction.

The Baths of Trajan consisted of a central block of rooms with different functions, surrounded by a large open area on three sides that was used for gymnastic exercises. The main elements in the central block consisted of an open swimming pool, the *natatio*, surrounded by a colonnade; in the center of the entire complex, a large vaulted chamber, called the *frigidarium*, with a cold water pool; a small room with warm water, the *tepidarium*; and a somewhat larger room with apses on three sides, the *caldarium*, with hot water. Each of these pools had been found in earlier baths, but the *natatio* had not been a standard element before this.

The ordinary Romans of both sexes would typically spend some time in each of the areas of a bath complex. But for them, the term "bathing" would also have had a much broader meaning. Gymnasia, dressing rooms, athletic fields, and lounging rooms were an essential part of the bath scheme. These establishments were important to the Roman people, as much for the entertainment and social activities that took place there as for the baths themselves. When Trajan decided to build such a lavish public building, he would surely have calculated the immense propaganda value of such a gesture. It could not have failed to impress the plebeians that the emperor had been extraordinarily generous in building the palatial baths for their benefit.

The Forum and Markets of Trajan

The complex of Trajan's forum and markets deserves attention as a whole because it displays great interest in solving the problem of multiple use; and, in the case of the markets, making usable spaces out of what are, really, foundations or retaining walls. Most of the plan looks straightforward enough, but in fact enormous spaces are involved, both open and covered. For instance, the open square of the forum was 380 by 312 feet (116×95 m). What is more, the ground was not originally flat; there was a significant hill on the eastern side. Much of this was cut away to allow for the flat space of the forum and one end of the basilica. The result must have been a towering and irregular cliff that threatened to collapse in any rainstorm. We see the solution in the form of the Markets of Trajan that appear so natural on the side of the hill, where 150 or more shops and offices on three levels were combined with a great, covered market hall.

The buildings of the markets and forum are frequently taken together, but the markets (fig. **6.4**) were actually separated from the forum and basilica complex by a high wall. That has now disappeared and the view originally would have been different; one would have seen only the upper levels of the market complex from the forum, and access would

have been quite circuitous. The Forum and Markets of Trajan were designed together by Trajan's chief architect, Apollodorus of Damascus. He must have been one of the greatest designers of antiquity, and this is his most important surviving memorial.

The basis of the design of the markets is a semicircle that seems to wrap around the exterior of a huge *exedra* on the east side of the Forum of Trajan below it (fig. **6.3**). Small shops were placed on a curve that followed this shape, and behind them, at a higher level, was a road that continued the same curve. In recent times, the road has been nicknamed the "Via Biberatica" ("Pepper Street"), after the food shops that must have carried pepper and other spices.

Attached to the complex, and at yet a higher level, was a large two-storied hall, the Aula, that had additional shops on both floors, and a large, open, vaulted space in the middle (figs. **6.5** and **6.6**). The vaulting here is unusual. Six groin vaults roof the central area, but there is a gap between this system

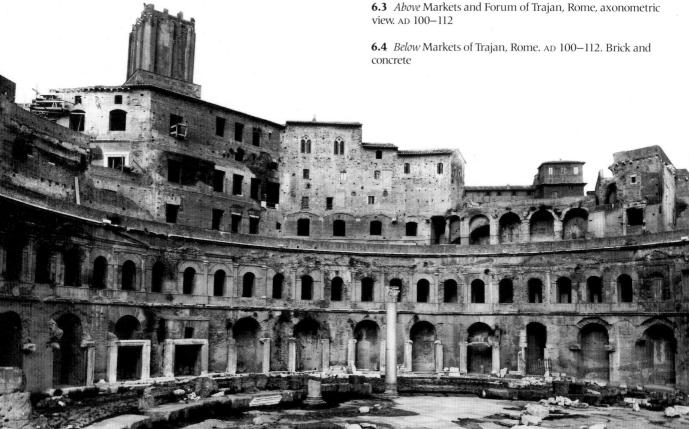

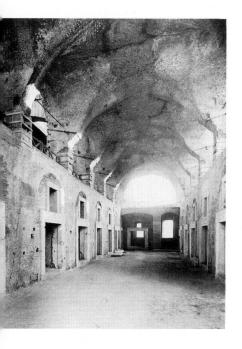

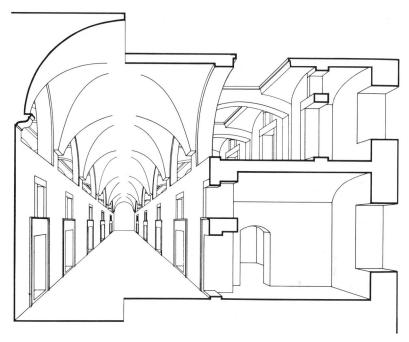

6.5 Above Markets of Trajan, Aula, Rome. AD 100–112. Brick and concrete

6.6 Right Markets of Trajan, analytical drawing of the Aula

and the barrel vaults that roof the shops at the sides; buttressing was used to bridge the gap in such a way that light could be admitted to the shops and corridors below. As in the Golden House of Nero, light-wells provided indirect lighting in a most ingenious manner.

The Aula may have been the headquarters for the imperial distributions of free food allowances or monetary payments. A large hall with individual shops and offices, and provision for the delivery of goods, would have been requirements that the designer seems to have taken care of admirably. Together with the rest of the Markets of Trajan, it provided a much-needed new area for commercial transactions, because these events no longer suited the Roman Forum, which had become more and more a public center for administrative and religious activities appropriate to the center of the enlarged empire.

The triumphal nature of the Forum of Trajan itself was immediately apparent from the design of

the entrance way; a triple arch, surmounted by a chariot group in bronze, celebrated the emperor's successes in the Dacian campaigns. In the center of the open space in front of the entrance way was a statue of Trajan on horseback. It might have been similar to that of the later emperor Marcus Aurelius on the Capitoline (see below, fig. **8.15**), but cleanshaven. Beyond the open space dominated by the statue of the emperor was a basilica, called the Basilica Ulpia, after Trajan's family name.

This huge building, 600 Roman feet long (i.e. 586 feet; 178-6m; the Roman foot is *c.* ½ inch [7mm] shorter than the modern foot), was set crosswise to the axis of the forum. It was designed in the traditional way (fig. **6.7**), with columns that surrounded the central space on all four sides, and entrances on the long sides of the building. The semicircular apses at the ends of the building repeated the shape of the large *exedrae* at the sides of the open space of the forum, and these in turn reflected the curves of the side walls in the Forum of Augustus from a century earlier.

Beyond the basilica were two library buildings, one Greek and one Latin, separated by a tall column on a square plinth (fig. **6.8**). The disappearance of the surrounding buildings has concentrated atten-

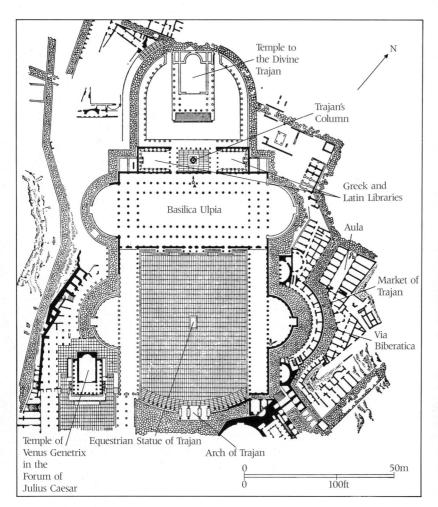

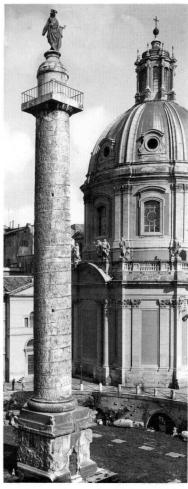

tion on the column as an isolated monument, rather than as an element in a complex, which was the original intention. And furthermore, the loss of the two buildings next to it makes it necessary to view the column, which is covered with relief sculpture, from the ground, whereas originally one could have seen the reliefs that were high on the column from close-up by looking out of the windows of the Greek and Latin libraries.

Behind the column and libraries, on a high podium, was the temple dedicated by Hadrian to Trajan after he had died, and been deified; hence it is called the Temple to the Divine Trajan. It stood until about AD 800, when an earthquake caused it to topple. Afterwards, it served as a quarry, providing building material and stone to be converted into lime.

- 6.7 Left Plan of Trajan's Forum, with Basilica Ulpia, Rome
- **6.8** *Above* Column of Trajan, Rome. Dedicated AD 113. Marble. Height 125ft (38m) including base
- **6.9** Opposite Column of Trajan, lower bands of spiral relief. Height of reliefs c. 3ft (91cm)

The Column of Trajan

Of the vast spaces and buildings of the Forum of Trajan, the only well-preserved piece is the column. The other monuments had been pillaged, and the entire complex used as a stone quarry and source of decorative marble since the sixth century AD; but the column was considered a tourist attraction in

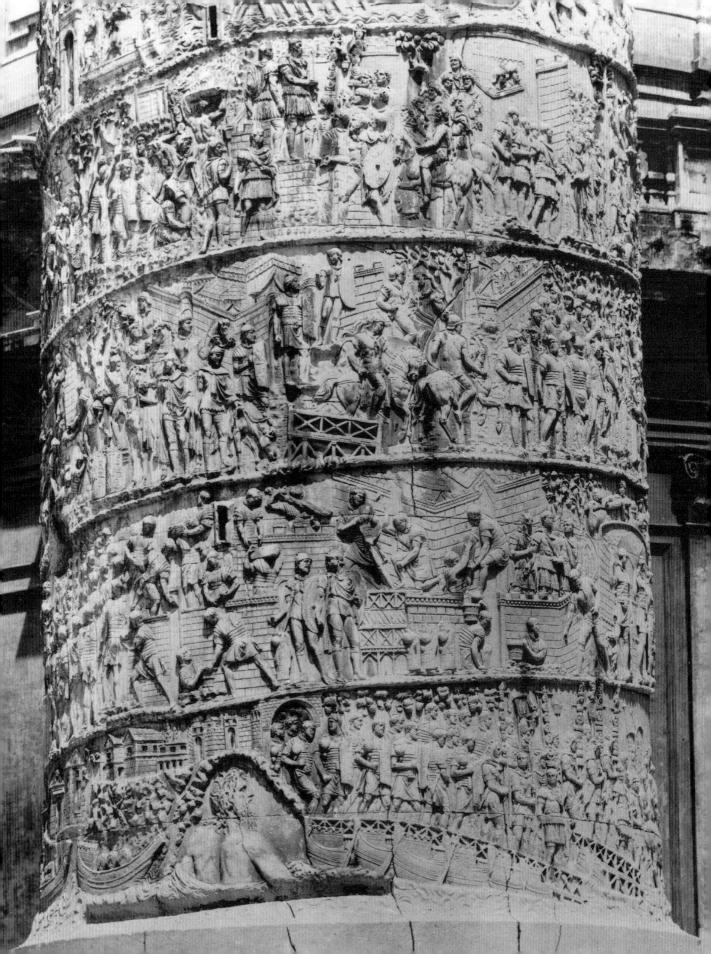

the Middle Ages, and a law was even passed in 1162, forbidding anyone to damage it, on pain of death. Indeed, it played an important part in guide books of Rome, where pilgrims were told the numbers of steps and other features regarding the column. Thus, it was always respected, and in the 16th century Pope Sixtus V had a statue of St. Peter placed on top, where once an image of the emperor Trajan had stood.

The column served several functions. In its architectural form it recorded the height of the earth dug away from the hill to the east (100 Roman feet, i.e. 97 feet 8 inches; 29·77m). And then, although it was never intended by Trajan to serve as his final resting place, the Senate decided after his death that it would be a fitting honor to deposit his ashes there. Thus, the column served both as a monument to his exploits, and as his tomb.

In its role as a showcase for Trajan's exploits, the column provided a constant reminder of his *virtus*. This meant, in the first instance, his fortitude and courage, and in the broader sense it was the summation of the multifarious glorious aspects of his character. The *virtus* of the emperor, by extension, embodied the success of the state; and

for all of this, the column provided the visual documentation.

As a sculptural document the column records the campaigns and victories of Trajan over the Dacians. We have already looked at historical reliefs on slabs, set horizontally on vertical walls like those of the Ara Pacis or the Arch of Titus (see above, pp.90 and 128). The reliefs of the column are quite different: they are carved on hollow drums of marble, placed one on top of another to form the column. The reliefs themselves are conceived in a band that winds upward in a spiral (fig. **6.9**). The height of the frieze is about 3 feet (91cm) at the

- **6.10** *Left* Watchtowers and Dacian houses along the Danube, detail of beginning of spiral reliefs on Column of Trajan; above, a Roman camp
- **6.11** *Center* The Roman army crossing the Danube on a pontoon bridge, detail of the Column of Trajan
- **6.12** Opposite River god, personification of the Danube, detail of the Column of Trajan. The beginning of the scene with Roman army crossing pontoon bridge (see above, fig. **6.11**) can be seen at right

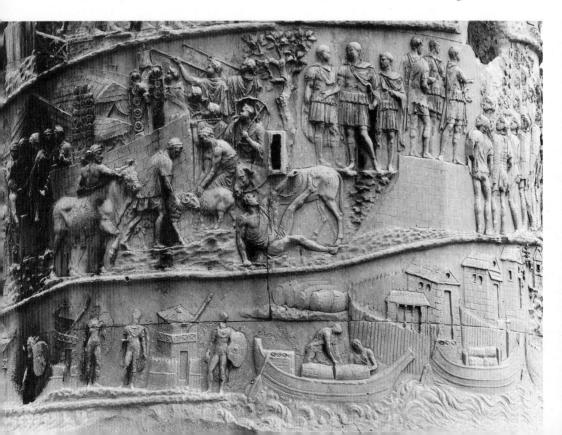

bottom, and increases to about 4 feet (1·2m) near the top, to counteract the distance and angle of vision. At the beginning the band is narrow so as to accommodate the origin of the spiral, and at the top it tapers to a point. The first sections are imaginatively used for setting the scene, describing the landscape and surroundings of Lower Dacia, where the story begins. Here we see the roughly-made houses and boats of the native peoples, and the Danube River that defined the border of the region (fig. **6.10**).

While the frieze is carved on marble drums fitted together, the action often crosses the division between them. Scenes pass from one to the next without formal framing of the different episodes in Trajan's campaigns. The figures are cut in low relief with about 2 inches (5cm) between the front plane, or original surface, and the background. The scenes would have been easier to read in antiquity than they are now, not only because the libraries next to the column allowed one to get closer, but also because the reliefs were painted to bring out the details.

The Roman liking for repetition of frequent formal scenes is particularly clear in the representa-

tions of Trajan, as he makes sacrifices, sets off on campaigns, or addresses the troops. The sculptors also indulged their love for accurate detail with regard to the setting; the army itself is frequently seen amidst woody and rocky landscapes, whether fighting, building a camp, or transporting supplies. Within the limits of the spatial conventions, the scenery corresponds well to the mountains of Transylvania.

The whole frieze is an unwound roll of enormous complexity. In the first active scene (fig. 6.11) at the bottom of the column, Roman soldiers, carrying their gear over their shoulders, cross the Danube on a pontoon bridge. The sculptors were careful to portray details of dress, and even to show the pots and pans that the soldiers carried. Just to the left of the soldiers, an allegorical image of the river god, representing the Danube, rises immense and dripping out of the waters (fig. 6.12). We see him from the back, with long hair and straggly beard – a type of river god that can be traced back to Hellenistic Greece. What is remarkable here is the ease with which the Romans could accept the mixture of the real and imaginary in one scene.

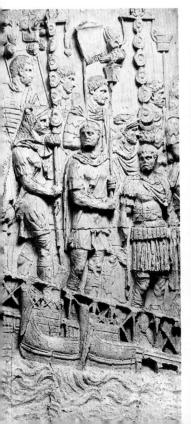

Day-to-day details abound among the 2,500 figures shown. For instance, the special insignia of individual units of the regular Roman army and the cohorts of auxiliaries drawn from all over the empire are included. These are depicted in precise and accurate detail, an indication that the sculptors drew on some kind of official record. But despite a certain insistence on accuracy, there is at the same time the use of generic or stock themes, repeated over and over on the spiral relief. We can see something comparable in Julius Caesar's written accounts of the war in Gaul during the first century BC, where the daily drudgery of the army is mingled with accounts of engagements and victories.

Certain conventions on how to portray views combining the presentation of narrative stories and spatial background had been developing in Roman art, but the combination had been more common in painting than in sculpture. Here we see both in profusion. The activities of Trajan and the army, and of the enemy, are told in a narrative that takes place in settings that are described with remarkable spatial definition. Sometimes views seen at eye level

6.13 Dacian prisoners brought before the emperor in front of a Roman camp, detail of the Column of Trajan

6.14 *Testudo* formation of the Roman army as it attacks a Dacian fortress, detail of the Column of Trajan

in the foreground are combined with a background of architectural details seen from above. Not only that, but the background features are markedly reduced in scale compared to the figures in the foreground.

Something similar is seen in the section showing a Roman soldier presenting Trajan with Dacian prisoners in front of a Roman military camp (fig. **6.13**). Note how easy it is to pick out Trajan: he is the largest figure in the group of Roman soldiers in tunics at the left, and stands in front of the others. The Roman soldier at the right pushes forward a baggy-trousered prisoner with shaggy hair and long beard. The background identifies not only the walls of the Roman *castrum*, but also the tents set up within the camp. The scale of the architecture is far smaller than the figures, but nonetheless easy to read.

In a battle scene where the Romans attack a Dacian fortress (fig. **6.14**), the humans are again as tall as the walls, yet the impression of an impenetrable barrier is effectively portrayed. The Romans here are using a particular formation suitable for protecting themselves against attackers on the wall. In a defensive maneuver called *testudo*, meaning "tortoise," they have put their shields

over their heads to make a protective casing for the men who are advancing against the fortification.

In one of the most sophisticated renderings of space on the entire column, the artist managed to do without architecture of any kind. This is the scene of *adlocutio*, where Trajan addresses his troops (see above, fig. **0.4**). Because he is standing on a high platform, the emperor is easy to identify. Furthermore, he is facing the others, all of whom look at him. Some of the army is seen from the back, some from the side, and other soldiers from the front: thus we get the impression that there is a three-dimensional crowd standing around the emperor. All this is accomplished in shallow relief and without true perspective devices.

Despite the artists' emphasis on the superiority of the Roman army, the enemy is treated with distinct respect. In the section showing the final demise of the Dacian commander, Decebalus (fig. 6.15), we find this larger-than-life hero cornered against a tree, with no chance of survival against the onslaught of the Roman cavalry. In fact, the Romans admired his death by suicide.

There is very little sign of the classicizing and elegant divinities who are familiar from earlier monuments, but Trajan himself incorporates some of this formal tradition, and there is an imposing figure of Victory writing on a shield that divides the frieze into two (fig. **6.16**). It is not that this tradition is rejected by sculptors of the Trajanic era – we can find beautiful figures in the classical mode elsewhere – but it was apparently not considered appropriate for this particular monument.

The artists who carved this milestone in Roman sculpture concentrated on a style that would make the narrative clear enough; but even more important than historical accuracy was their aim of extolling the virtues of the army and the emperor. In fact, details of events were often reduced to stock scenes that could be repeated, without historical basis, as long as the viewer was kept constantly aware of the greatness of the Roman state through its chief citizen and leader. Thus, the propaganda message took precedence over accurate details, and the Column of Trajan exemplifies in its greatest form what Roman historical relief is all about.

6.15 Decebalus commits suicide by a tree as the Roman cavalry attacks him, detail of the Column of Trajan

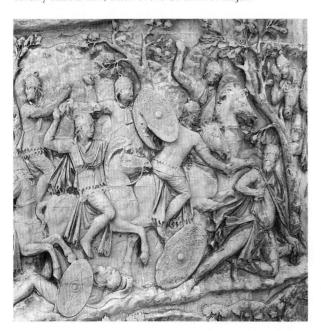

6.16 Victory writing on a shield, detail of the Column of Trajan

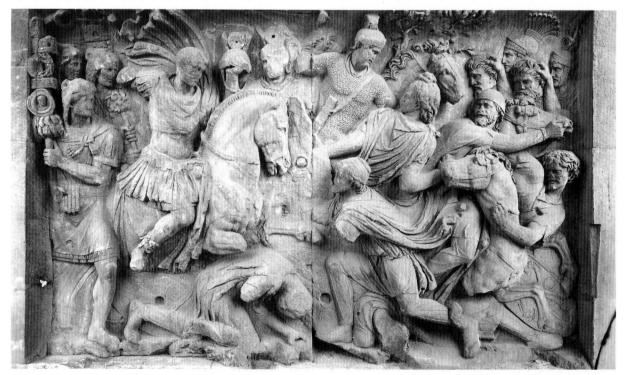

Other Trajanic sculptural relief

The Dacian war was commemorated in a second monument in the time of Trajan. In the plains of Rumania, at Adamklissi, is a huge cylindrical drum, 100 feet (30·5m) in diameter, known as the Tropaeum Traiani, or Trajan's Trophy. Constructed of rubble and faced with limestone blocks, it was decorated with 54 rectangular reliefs, each about 5 feet (1·5m) high and 4 feet (1·2m) across. One of these (fig. **6.17**) shows a Roman soldier with armor, helmet, shield, and sword, attacking two bearded Dacians who wear baggy trousers. The seated man must be a German mercenary soldier, as we can tell

6.17 *Opposite left* A Roman soldier in armor and two barbarian soldiers, relief panel on Tropaeum Traiani, Adamklissi. AD 109. Limestone. Height c. 5ft; width 4ft (1·5×1·2m). National Museum of Rumania, Bucharest

6.18 *Opposite right* Sheep and goats (Dacian booty), relief panel on Tropacum Traiani, Adamklissi. AD 109. Limestone. Height c. 5ft; width 4ft (1.5×1.2 m). National Museum of Rumania, Bucharest

6.19 *Opposite bottom* Part of the "Great Trajanic Frieze," showing Trajan riding into battle against the Dacians. Re-used on the Arch of Constantine, Rome. AD 100–117. Marble. Height 9ft 10ins (3m)

6.20 *Below* The emperor Trajan in the Roman Forum. AD 117–120. Marble relief. Height 5ft 6ins (1·68m). Antiquario del Foro, Rome

by the knot of hair tied at the side of his head. The artists clearly liked patterns, for they used ridges for folds and beard, and emphasized the patterns in the metal construction of the Roman armor.

On another of the reliefs (fig. **6.18**) the woolly curves of the sheep, and the ridges of hair on the two heraldically standing goats, make a delightful pattern. These animals represent part of the booty that would have fallen to the Romans after the battles were over. The carving is in general flat, and the style provincial; but the reliefs nevertheless are easy to read and they get their message across in a powerful manner.

Another sculptural relief from this period is the so-called Great Trajanic Frieze, taken from some monument of Trajan and re-used under the central archway on the Arch of Constantine (see below, p.268). Trajan is shown in a military tunic, led by the goddess Roma, and crowned from behind by a winged Victory. Behind him stands the Roman army, indicated by the men shown in profile, carrying lances. Farther to the right is a battle scene (fig. 6.19), where the Romans advance from the left toward the enemy, which is shown in various states of disarray: in flight, and pleading for mercy or dying.

The Great Trajanic Frieze thus combines two scenes that are completely separated from each other in both time and place: a procession, and a battle scene. How very different is the approach here from the largely down-to-earth and realistic treatment on the Column of Trajan! In the Great Trajanic Frieze we have allegorical figures, and a large-scale rendering that is heavily dependent on the classical tradition.

A relief, one of a pair called the Anaglypha Traiani, has recently been interpreted as a kind of balustrade set up by Trajan around a sacred fig tree in the Roman Forum. The reliefs were made to commemorate his burning of the tax records, thus annulling the public's responsibility for tax debts. On this occasion he made a speech from the Rostra. In the adlocutio scene (fig. 6.20) Trajan stood at the left addressing a crowd of citizens of differing ranks. Right of center is a statue showing Trajan distributing free food in an imperial act called alimentaria. At the far right is another statue, this one of the mythological figure Marsyas, whose real statue actually stood in the forum next to the fig tree. This balustrade, then, stood by the very tree represented in the relief.

The buildings in the background represent actual structures in the Roman Forum – where the relief was found. They seem to be, from left to right, the Arch of Augustus, the Temple of Castor and Pollux, and the Basilica Julia. In front of them the people stand around in groups: those listening to Trajan on the Rostra, and others near the statues at the right. The emphasis on showing a recognizable event and recognizable buildings and statues is characteristic of Roman historical reliefs, which repeatedly bring the viewers' attention to memorable moments known to the populace, and remind them of the grandeur of the imperial state.

The Arch of Trajan at Benevento

Another monument to use the grandiose approach seen on the Great Trajanic Frieze is the arch erected by Trajan, and completed by Hadrian, at Benevento. The town is well south of Rome at the point where Trajan's new road to Brindisi, a port on the eastern coast, left the Via Appia, and the arch (fig. **6.21**) stands like a gateway to the east. It was dedicated to Trajan, not primarily for the usual military victories, but because he paid for the road out of his own resources.

The form and proportions of the arch are based closely on the Arch of Titus in Rome, but at Benevento many more reliefs cover the surfaces.

There is only a single opening, and the tall attic with inscription rests on two square pylons (pillars that support an arch), with an engaged column at each corner. Once again, Victories fill the spandrels of the arch on one side, but a river god and a fountain nymph are found on the other. On the other hand, the Seasons represented below the spandrel figures make their appearance on an arch here for the first time. As the Victories refer to the emperor's triumph and glory, the Seasons symbolize the happiness of the reign throughout the year.

The 14 panels that cover the pylons, the attic, and the passageway represent subjects relating to domestic and foreign policy. Presumably someone in the court of Trajan must have decided what subjects were appropriate, and then they were designed in one cohesive scheme. The figure style is large and easy to read, and the emperor repeatedly stands out clearly from the rest of the crowd. He is depicted in all panels but two.

6.21 Arch of Trajan, Benevento. AD 114–117. Marble. Height 51ft (15·55m)

One of the reliefs on the passage under the arch makes specific reference to the citizens of Benevento: it depicts a scene of *alimentaria* – an actual event that was recorded in an inscription found nearby (fig. **6.22**). Trajan and his assistant stand at the left, and, although their heads are missing, we know that they would have been portraits. But the idealized and classical heads of crowned women with veils in the background symbolize the city goddess and other personifications. The other figures, including the children, represent the townspeople of Benevento.

In the panel showing the imperial procession (fig. **6.23**), Trajan, just left of center, is about to pass under an arch that is only slightly taller than the height of the people. Because this is a rectangular panel rather than a long frieze, the forward movement appropriate to a long narrow space has here been changed so that the motion is all but stopped. The figures seem stationary, and because people turn towards the emperor, he becomes the psychological center of the design.

The panels on the attic were carved after the death of Trajan, in the early years of Hadrian's reign. It was of course in Hadrian's interest to emphasize

6.22 *Above* Trajan distributes food to the children of the poor, relief on the Arch of Trajan at Benevento. AD 114–117. Marble. Height 7ft 10ins (2·39m)

6.23 Below Imperial procession passing under an arch, detail of the Arch of Trajan at Benevento. AD 114–117. Marble. Height 8ft 10ins (2·7m)

6.24 A personification of Mesopotamia on bended knee before Trajan, detail of the Arch of Trajan at Benevento. AD 117. Marble. Height 8ft 10ins (2·7m)

his relationship to his powerful predecessor, and thus he had himself pictured in some of these panels. One of these depicts Trajan standing before a female personification of Mesopotamia on bended knee, while others stand by to witness this symbolic event (fig. **6.24**). In the background, second from the left, is the young Hadrian.

The personification of Mesopotamia, a Roman province, symbolizes the area between the Tigris and Euphrates rivers where Parthia, one of the states defeated by Trajan, is located. Pictured in the relief, in the lower corners, are two male figures, river gods, representing the Tigris and Euphrates rivers. This scene suggests tranquillity, but the Parthians had revolted again, and although Trajan managed to control this area, it was at great expense, and he died during the preparation for one of the campaigns. Thus, this Hadrianic panel on the Arch of Trajan is more optimistic in its approach

than the facts actually warranted. In fact, Hadrian gave up the province that had been won with such effort by his predecessor.

The monumental handling of the scenes on the large panels of Trajan's arch is quite different from that on the narrow frieze that runs around the arch. just below the attic. Here is one of the numerous instances where two distinct traditions are used on the same Roman monument. This frieze follows a plebeian style, showing figures that are short and thick-set, with large heads; they do not overlap each other and most are represented in a frontal position. Even if the small frieze was planned by the same master who worked out the large panels, the workmen who executed the two styles were undoubtedly not the same. Perhaps the large panels were carved by sculptors trained in the capital, or even in Aphrodisias or Athens, while the small frieze might have been made by local craftsmen.

Timgad

Trajan established a new city in North Africa, in what is today Algeria, following the traditional form of Roman military camps, or *castra*. This town, Thamugadi, still bears the name Timgad (fig. **6.25**). It was typical of cities established as colonies for veterans. Trajan had indeed founded this town on behalf of his soldiers who served in a nearby legion of the army. His purpose was to provide them with a place to which they could retire after active duty. With the notable exceptions of Pompeii and Herculaneum, it provides today one of the clearest pictures of how a Roman city would have looked in its heyday.

Timgad was designed as a perfect square, and had a grid plan for the streets. The four corners were at first rounded, and gates were placed in the centers of the sides, where roads led in and out of the city. The shape of the forum was not long and narrow as had been the case in early Roman towns, but was square. Because Timgad has not been an urban center for centuries, but is out in the Algerian desert, it has not served as a quarry for later generations, and is thus better preserved than most Roman towns. The theater and a large arch remain almost intact. The streets, lined by colonnades and

6.25 Above City of Timgad, plan 1 Forum 2 Theater 3 Arch6.26 Below City of Timgad

walls, have the atmosphere of a ghost town, one that has been abandoned only recently (fig. **6.26**).

The idea of portraying the emperor Trajan as a benevolent provider was consistent with the optimism of his title *optimus princeps*. Public works were emphasized in this period, and much of the art adorned spaces and buildings whose primary purpose was for the gathering of municipal administrators. As the empire reached its greatest extent, Roman architects were prepared to construct large public buildings, both in Rome and in the provinces.

The expansion of Roman territories and the protection of the Roman people were major themes in this era. With an emperor steeped in *virtus*, it is no wonder that military prowess and civic administrative skills were reflected in the major building and sculptural programs that served as public statements on the glories of the Roman empire under Trajan.

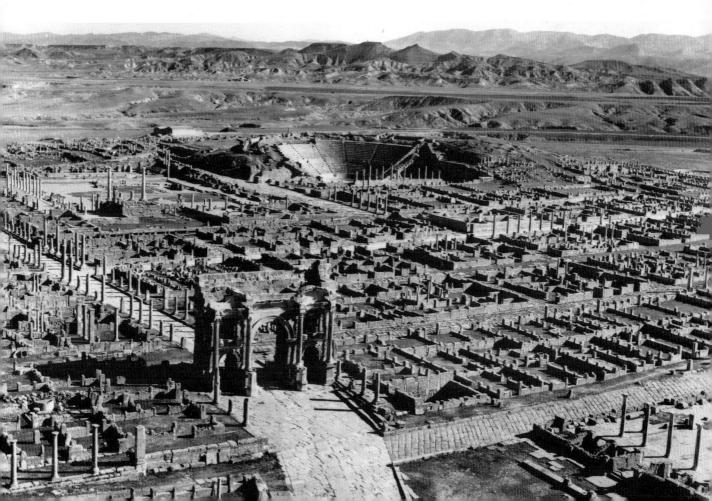

7 Hadrian and the Classical Revival AD 117–138

Roman art under Hadrian has an obvious classical flavor. The emperor himself was educated in Athens and later endowed that city with a large number of buildings, including a library. In addition he may have been a considerable force in the renewed interest in classical sculpture. He adorned much of his grand country villa at Tivoli near Rome with copies of classical masterpieces and named some of the open areas after locations in Athens and elsewhere in the Greek world. On the other hand, we should remember that an interest in classical prototypes was not new under Hadrian, and in fact many houses and gardens during the previous generations had been decorated with sculpture copied from Greek models.

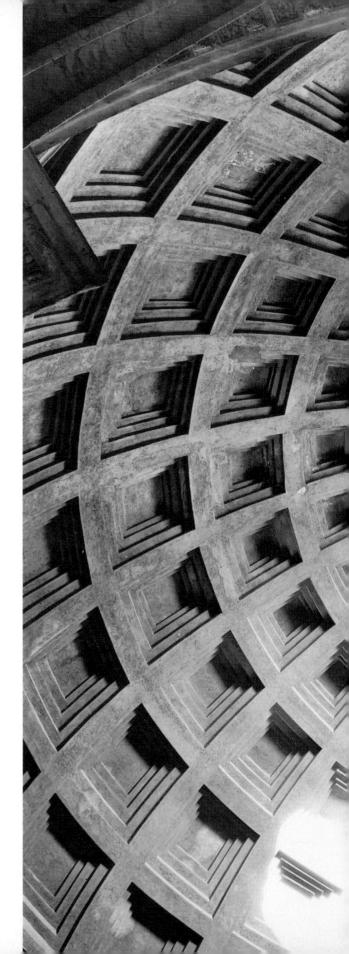

Opposite Coffering in the dome of the Pantheon, detail of fig. **7.13**. Rome. AD 125–128

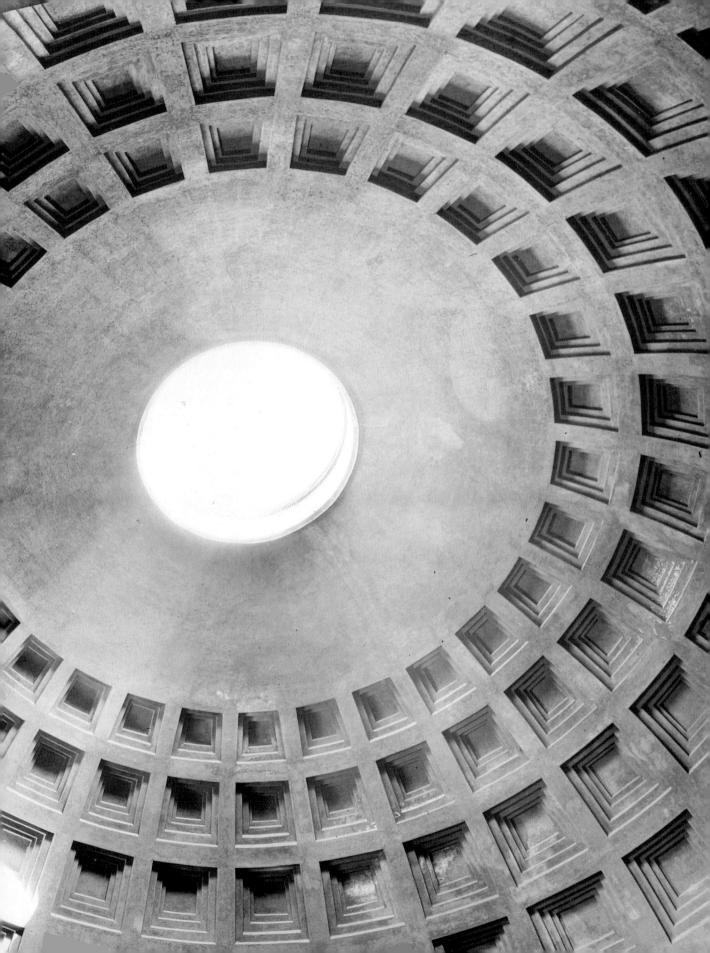

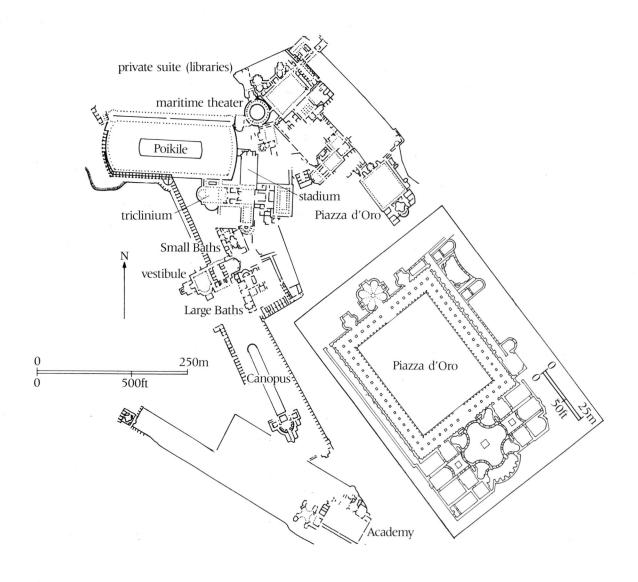

7.1 Hadrian's Villa, Tivoli, plan

7.2 The Great Baths, Hadrian's Villa, Tivoli, etching by Piranesi, from *Views of Rome*, 1770. Height 1ft 6ins (45·7cm)

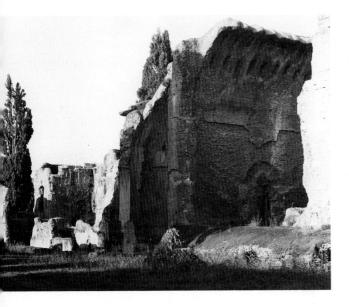

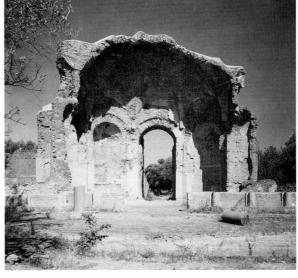

7.3 *Above* Vaulting of the Great Baths, Hadrian's Villa, Tivoli. *c.* AD 135. Concrete

7.4 *Right* Piazza d'Oro, Hadrian's Villa, Tivoli. c. AD 135. Brick and concrete

Hadrian was born in Rome of Spanish parentage. He was the second cousin of Trajan, who is said to have adopted him as his heir in his will, although this was never convincingly proven, and may well have been a ploy orchestrated by Plotina, the wife of Trajan. Indeed, Hadrian went to some pains to emphasize his relationship to his predecessor, especially in the arch at Benevento (see above, p.165), which was completed under his supervision. And furthermore, like Augustus, who built a temple to Julius Caesar, he piously set out immediately to dedicate a temple to the deified Trajan at the north end of the latter's newly finished forum complex.

One of Trajan's greatest legacies had been the military prowess of the Roman army. His column and other monuments proclaimed the superiority of the Roman command, and glorified the military expansion and consolidation of the empire that took place under his leadership. Hadrian, on the other hand, really had no wars to commemorate, and his reliefs and public monuments do not even refer to the battlefield.

Architecture

HADRIAN'S VILLA

What we know as Hadrian's Villa was in reality a series of building clusters set out on the south slope of a hill and covering an area of more than half a square mile (1·3 square km) (fig. 7.1). It was no more a unit than was Nero's Golden House, but instead of bringing a breath of country into town, Hadrian brought the town to the country. The individual units provided for the needs of a large number of people, and many of the open spaces were designed accordingly. Since there was no big city nearby (the villa lay a little way out of ancient Tibur, modern Tivoli), accommodation had to be provided for a large staff of cooks, gardeners, maids, and other kinds of servants, not to speak of a detachment of the imperial guard.

Several details within the design of individual buildings of the villa are related to the advances that had already been made in vaulted concrete spaces like those in Trajan's markets. There is a close relationship, too, between the villa's Great Baths, with its use of a central opening in the roof, and a similar device in the Pantheon (see below, p.177). This structure, as well as other parts of the villa, struck the fancy of the great 18th-century draughtsman Piranesi (fig. **7.2**), who captured

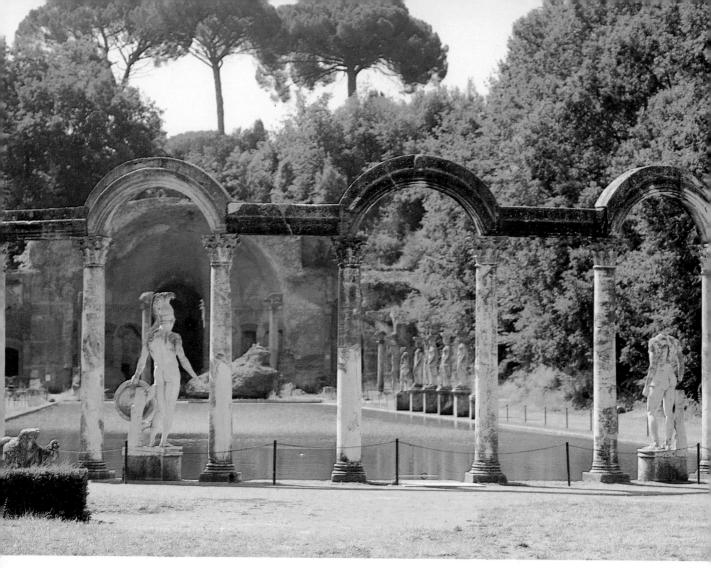

many architectural details in a series of views of the place. The vaulting of the Great Baths is a particularly good place to see the construction itself (fig. **7.3**), for, in much the same way as modern construction, wood frames were built, against which a wet concrete mixture was set. The traces of the wooden slats can still be seen on the vault.

We find the remains of a segmented dome used for a pavilion in a large colonnaded courtyard known as the Piazza d'Oro. This unusual structure (fig. **7.4**) may be the kind of pumpkin dome for which Apollodorus of Damascus, Trajan's architect, had criticized Hadrian. According to one author, Hadrian must have been present at some of the architectural conferences between Trajan and Apollodorus. He may have offered an untutored or even unwelcome opinion about some project and was told to go and play with his pumpkins — a reference to his passion for segmented domes that looked like the vegetable [*Dio Cassius* LXIX. **4**, 1–5].

7.5 Canopus, Hadrian's Villa, Tivoli. c. AD 135

At a later time he is supposed to have had Apollodorus executed, and so we may suppose that the uncomplimentary reference to Hadrian's interests in domed structures was not forgotten.

The main complexes show several distinct orientations but have a large measure of internal symmetry (see above, fig. 7.1). The landscape itself seems to have inspired the layout of the buildings, which at first sight looks haphazard. Of course a judicious amount of terracing and drainage was necessary to provide some of the waterworks that were so important a feature of many of the spaces. This is particularly obvious in the case of a long, walled area with a pool, known as the Poikile, which required substantial buttressing at the west end to provide the requisite flat area. It was a take-off of the *stoa poikile*, or painted colonnade, that Hadrian had seen in Athens.

Another long pool, the Canopus (fig. **7.5**), was named for the ancient Egyptian city that lay on the westernmost mouth of the Nile, not far from Alexandria, where Hadrian must have landed when he set out on his travels in Egypt. The statues lined up around it demonstrate how he liked to use copies of famous sculptures from elsewhere to decorate the house and grounds. Yet a third pool, this time a round one, was the core of the so-called Maritime Theater, in actual fact a place more like a private apartment (fig. **7.6**). This is where modern scholars have speculated Hadrian may have retreated for peace and quiet with his favorite, Antinous (see

- **7.6** *Right* Maritime Theater, Hadrian's Villa, Tivoli. *c*. AD 135. Marble and brick
- **7.7** *Below* Battle of the centaurs and wild beasts, from Hadrian's Villa, Tivoli. c. AD 135, perhaps based on a Greek work by Zeuxis of about 400 BC. Floor mosaic. Height c. 1ft 11ins; width c. 3ft (58.4×91.4 cm). Antikensammlung, Staatliche Museen, East Berlin

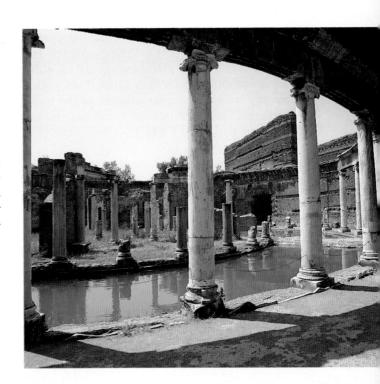

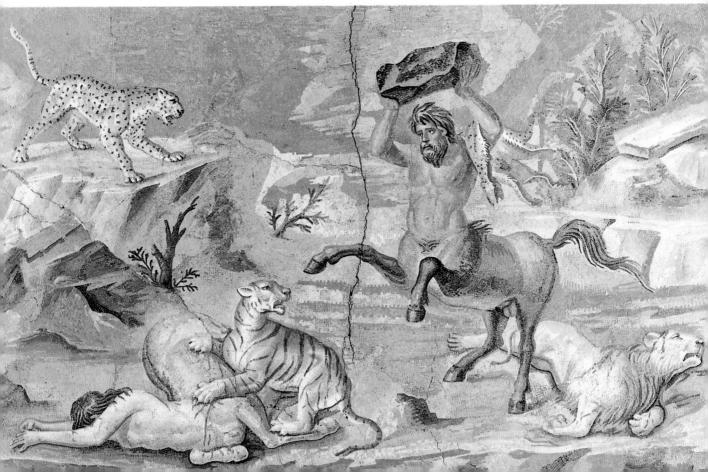

below, p.185). It had a moat around the central island, and a colonnade around the perimeter. The plan shows considerable playing with curved walls, and several rooms mirror each other. This notion had already been tried earlier in some of the room arrangements in the Palace of Domitian on the Palatine (see above, fig. **5.11**).

Mosaics Decoration within the buildings of Hadrian's Villa, from the floors to the walls to the vaults, was richly colored. Instead of concentrating on painting and stucco, which had been the practice in the early decades of the empire, Hadrian's decorators turned more to inlaid colored marble, called *opus sectile*, and to mosaics. Exotic stones were imported for the purpose from all over the empire.

One of the finest of the floor mosaics in Hadrian's Villa depicts a battle of centaurs and wild animals (fig. **7.7**). It may be related to a story painted by Zeuxis, a Greek artist who lived around 400 BC. The centaurs are said to have started the fight by attacking a lion cub. But now our sympathy

for the centaurs is aroused, especially the female mauled by a tiger who in turn is being attacked by the male centaur.

Another mosaic of the period (fig. **7.8**) covers a large floor in the Baths of Neptune in Ostia. Made entirely in black and white, the scheme is both figurative and decorative at once. Neptune rides across the center, pulled by a team of four spirited seahorses and accompanied by swimming sea creatures and dolphins, some of which are ridden by cupids. Around the edge are tritons and mythical seahorses with long twisting tails which, together, make a fine curling border effect. There are no groundlines (pictorial representations of the surface on which the figures stand) or spatial relationships, but rather a series of figural elements scattered in an orderly way over a large surface.

7.8 Neptune drawn by four seahorses, from the Baths of Neptune, Ostia. Mid-second century AD. Black and white floor mosaic. 59ft 4½ins×34ft 1½ins (18·1×10·4m)

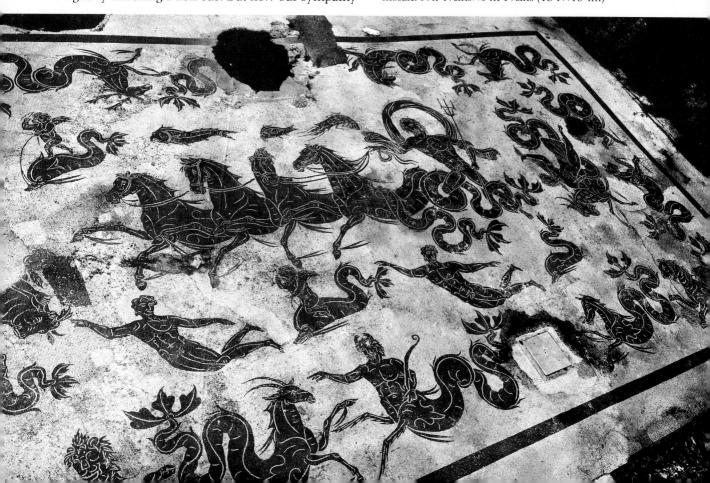

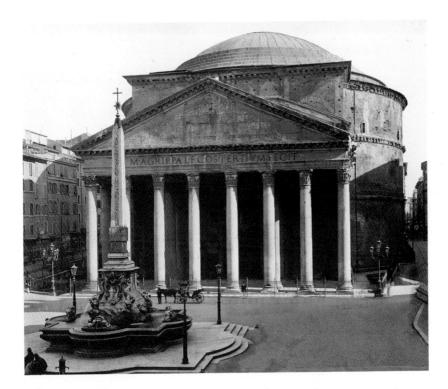

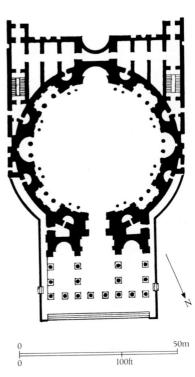

THE PANTHEON

A large temple built under Hadrian, the Pantheon, was dedicated to all the gods. It is the best preserved and most influential of all Roman buildings. It remained in such good condition because it had been turned into a church already by the early seventh century AD, and, therefore, the building was cared for and maintained over the course of the centuries.

Construction We know when Hadrian undertook the building of the Pantheon (fig. **7.9**), for the building can be dated by its bricks that were stamped to show when and by whom they had been made. A majority of them belong to the year AD 125, and show that the inscription over the porch mentioning Agrippa — the son-in-law of Augustus — is honorific rather than contemporary. There had, indeed, been two earlier buildings on the spot, for which the new Pantheon was a replacement. It was typical of Hadrian to give credit to Agrippa, who had built the original structure in 27 BC, rather than to himself; the only building on

7.9 View of the porch of the Pantheon, Rome. AD125–128. Marble, brick, and concrete

7.10 Plan of the Pantheon, Rome

which he put his own name was the Temple to the Deified Trajan.

The inscription across the front of the Pantheon says, M.AGRIPPA.L.F.COS.TERTIUM.FECIT, "Marcus Agrippa, son of Lucius, having been consul three times, built it." Another inscription in much smaller letters records a restoration by Septimius Severus and Caracalla in AD 202. The façade was originally decorated with sculpture within the pediment (the triangular area that caps the portico). The attachment holes, which are still clearly visible, indicate that there may have been a crowned eagle in this space.

The porch is supported by 16 huge, monolithic columns of granite. The design incorporates two quite dissimilar elements: a classical porch, which is rectangular in plan, and a round interior covered with a dome (fig. **7.10**). Upon entering the building

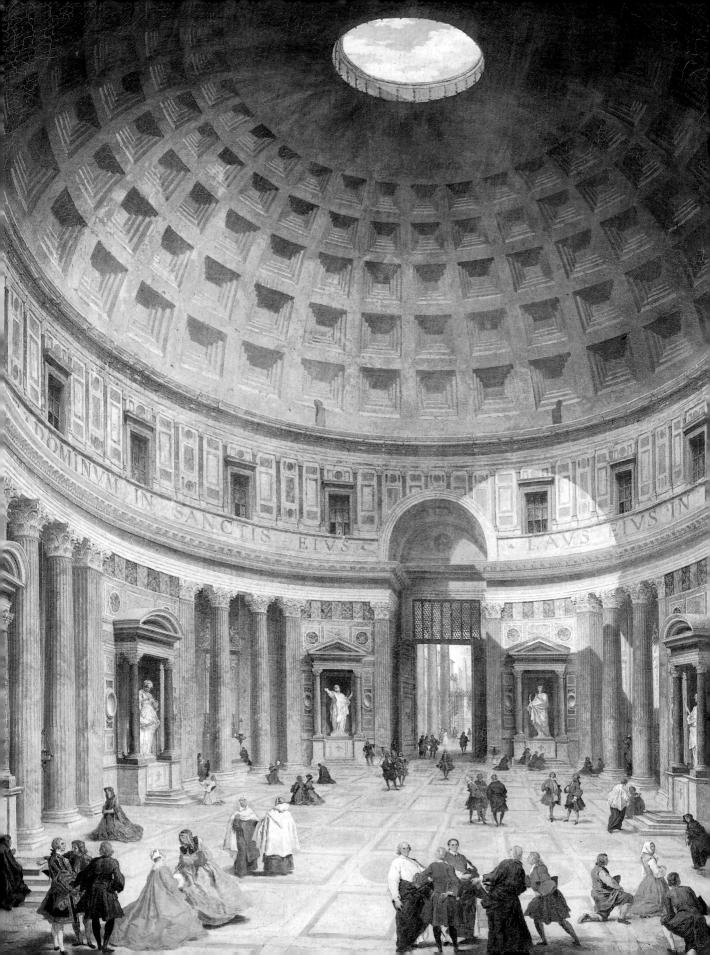

through the traditional rectangular porch one is not prepared for the enormous circular space inside (fig. 7.11). Even for those who have visited the building many times, the vastness of this space, with its marvelously imposing dome with a hole in the center, is remarkable every time.

The first impression of the interior suggests a wall held up by columnar supports in the traditional manner, but close investigation of the structure shows that this is not the case, and the real support comes from the wall of the drum and especially the thicker parts of it that function as massive piers. Eight huge arches built within the cylinder of the drum rest on these piers, and smaller arches in turn help to support the walls. These are made of brick-faced concrete.

In addition, the builders adjusted the materials, called aggregate, used in the making of the concrete: the lower parts are made of heavier matter, and, as the building rose, progressively lighter materials were used. Thus, at the bottom, the

concrete was made of heavy travertine; then came a mixture of travertine and the much lighter local stone, tufa; then tufa and brick; then brick; and finally, pumice. Another device to lighten the load of the vault was the coffering. Coffers are the square indentations that act as decoration, at the same time as making the weight lighter by reducing the thickness of the inner face of the dome.

The Pantheon should be seen as a milestone in the ongoing Roman facility in using this material and exploring its possibilities - or as another, yet more sophisticated step following the Palace of Domitian and the Markets of Trajan (see above, fig. **6.5**).

Design of the interior The contrast of the two elements – porch and drum – makes a great impact. We have here a marvellous synthesis of tradition and innovation in design, a wonder of construction and mathematical harmony. The harmony is most obvious in the way the architect used the same

7.11 *Opposite* Interior of the Pantheon, painted by G. P. Pannini. c. 1750. Oil on canvas. Height 4ft 2ins; width 3ft 3ins (1·27m×99cm). National Gallery of Art, Washington, DC, Samuel H. Kress Collection

7.12 Below Section of the Pantheon, Rome

7.13 Right Light from oculus on coffering, Pantheon, Rome

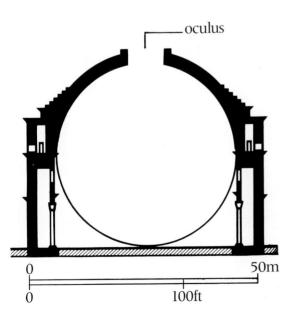

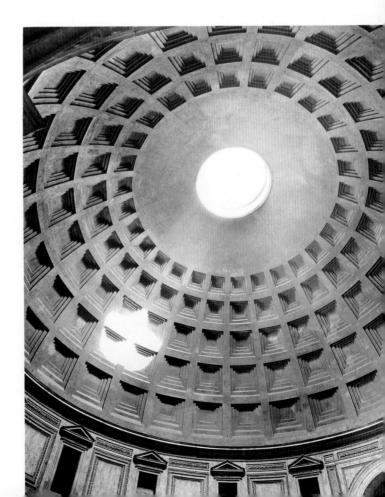

dimensions for the interior height and for the diameter (145 Roman feet, i.e. 141 feet 8 inches; 43·2m) (fig. **7.12**), which means that a sphere resting on the floor would fit inside, just touching the cylindrical walls and reaching the top of the vault.

The surface decoration of marble veneer that we see today on the interior was for the most part added later, but it preserves the general intentions of the Roman architects quite well. So does the decoration of the floor, which is composed of colored slabs that form alternating circles and squares. The Pantheon offers us a glimpse of a Roman building more or less in its original state, even though we must recreate the gilding of the ceiling decoration that may have made the dome look like the heavenly sphere of all the gods that the name Pantheon evokes.

The *oculus* As one stands inside the grandiose space of the Pantheon, the light circle entering the building through the *oculus* moves perceptibly around the dome as the earth turns, and makes the viewer aware of the cosmic forces. And, of course, when there is rain, it comes straight in the building, trickles down the drain holes in the floor, and is carried away in the still-functioning Roman drainpipes underneath.

The *oculus*, 27 feet (8·3m) wide, is the only source of natural light in the building (fig. **7.13**) except for the huge double entrance doors. Making an opening of this size in the roof was a piece of engineering that was daring in the extreme. There had been earlier examples of holes in the center of a dome, but none had approached this size. Today, the bronze sheathing around the *oculus* is still the original Roman bronze. In contrast, the original bronze roof tiles on the exterior of the dome have had to be replaced several times since antiquity, and are now made of lead.

Until recently, it has been possible to climb up the ancient stairways in the walls, and out onto the roof of the dome. One proceeded around the outside to the back of the building, and mounted the steps that can be seen even from ground level. A truly great experience is to lie down on one's belly, and look through the *oculus* at the ant-like people below.

7.14 Temple of Venus and Roma, Rome, seen from the Colosseum. Dedicated AD 135. Concrete, granite, travertine, and marble. Width $325 \mathrm{ft}~(99 \mathrm{m})$

7.15 Plan of the Temple of Venus and Roma, Rome

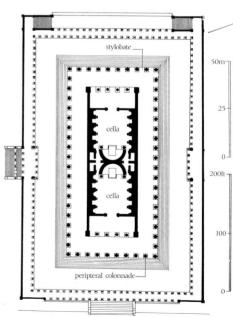

OTHER HADRIANIC BUILDINGS

Monuments in Rome Hadrian built another unusual and important temple in Rome, the Temple of Venus and Roma (figs. 7.14 and 7.15). Located between the Roman Forum and the Colosseum, it sits on a small hillock at the foot of the Palatine Hill. It has two cellae which back onto each other: one is dedicated to Venus and the other to the city goddess Roma. Perhaps Hadrian himself who, as we have already seen, fancied himself as an architect, had a hand in designing the building. Certainly we may attribute to his interest in things Greek the fact that many Greek features were incorporated in its design. For instance, instead of having a deep porch with columns just in front of the building, it has columns encircling the whole temple, making it what we call peripteral. Also, instead of standing on the usual podium, the Temple of Venus and Roma rests on a stylobate, that is, the top platform of a series of steps, as was typical of Greek temples (see above, p.27). It must have seemed quite unusual at the time for a temple dedicated to the goddesses Roma and Venus, chief protectors of the city, to be

7.16 Mausoleum of Hadrian, Rome. Completed AD 140. Tufa faced with marble. Diameter 214ft (65·23m). The Roman bridge in the foreground was also built under Hadrian

designed in a manner that was both unorthodox and contrary to Italic traditions.

Hadrian also built a huge mausoleum for himself across the River Tiber from the Campus Martius (fig. **7.16**). The shape is like an enormous drum on which earth was originally piled high in imitation of the Mausoleum of Augustus. It became a fortification in the Middle Ages, and is still called by the name Castel Sant' Angelo — named for the bronze angel that wields a sword on the top. This is the dramatic setting where the final act of Puccini's opera *Tosca* takes place.

Provincial works We have concentrated so far on Hadrian's buildings in and around Rome, but in addition, there were other dedications and constructions in his honor all over the Roman provinces. He took considerable interest in the empire as a whole, and visited many of the

7.17 *Aureus* of Hadrian, Rome. Shows emperor at left, greeting a female personification of the province of Africa. AD 136. Gold coin. Diameter *c.* 3/4in (1-9cm). British Museum, London

provinces, even those at the fringes of the empire. Indeed, he spent many years of his reign away from the capital, a fact resented by the people in Rome. We can see the record of his travels to some extent in a series of coins that have symbolic figures of the provinces on the reverse (fig. **7.17**). Perhaps these travels helped to spread the classical revival; and conversely, the emperor surely learned a great deal about the Greek world by traveling in it himself.

The Romans put a good deal of effort into military architecture in the form of walls and forts on the frontier. There was a particularly elaborate system in Germanic lands, stretching from Mainz to Vienna, and another for the defense of Syria and Palestine. One of the best known of the many projects around the empire that were dedicated under his name was Hadrian's Wall in the province of Britain. It was not just a wall, but a strategic

defense line crossing the country from the west coast to the east, with a small fort every mile, and 12 substantial garrison posts across the 80-mile (130-km) span of the frontier. One of these is Housesteads (fig. **7.18**), the ancient Borcovicium,

7.18 Plan of Roman camp, Housesteads, one of the forts along Hadrian's Wall in northern England. Second century AD. Stone

7.19 A section of Hadrian's Wall near the fort at Housesteads

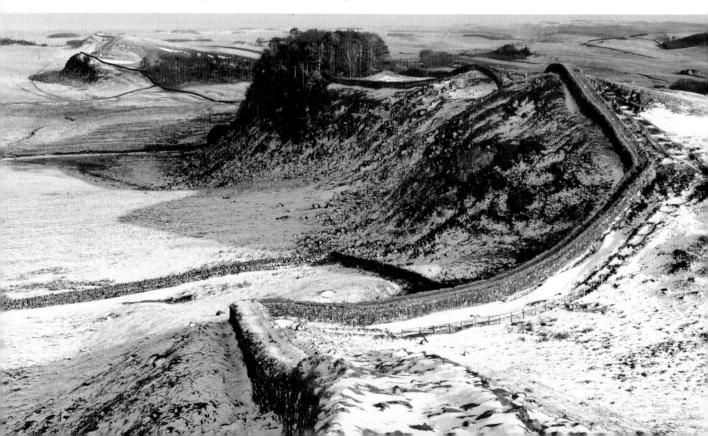

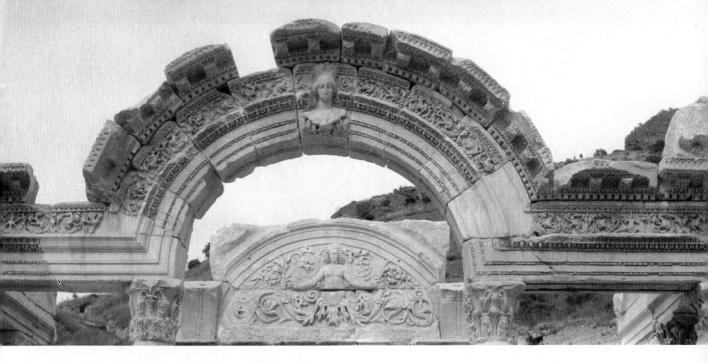

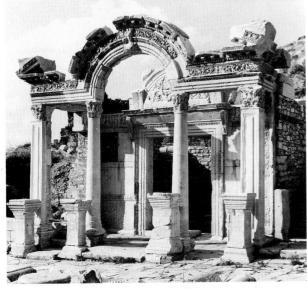

built near a particularly well-preserved section of the wall itself (fig. **7.19**). Like the *castrum* at Ostia and the town of Timgad (see above, pp.79 and 166), its plan is a rectangle with a main north—south and east—west street, ending in gates through the outer defense walls. The four corners were rounded, and there were towers at principal points around the edges. Inside was a large meeting hall for all the soldiers (*principia*), a granary, a bath, a hospital (*valetudinarium*), and barracks. The commander of the unit had his own house, the *praetorium*. In spite of its amenities, duty at a fort such as this must have been a hardship post for Romans brought up in a Mediterranean climate.

7.20 *Top* Detail of "Syrian arch" on entrance colonnade, Temple of Hadrian, Ephesus. Behind it, the ornamental relief over the doorway. AD 130–138. Marble

7.21 Left Temple of Hadrian, Ephesus. AD 130–138. Marble and other stone

7.22 Above Temple of Hadrian, Ephesus, reconstruction

A small but decorative temple on one of the main streets of Ephesus is a good example of the kind of building dedicated to Hadrian in cities around the empire (figs. **7.21** and **7.22**). The ornate frieze that runs across the façade (fig. **7.20**) rises up into an archway that rests upon two Corinthian

columns, and spans the entrance of the porch. A pediment, no longer surviving except at the corners, closed the space over the arch. This combination of an arch within a pediment was a feature of Roman architecture that originated in the Near East, and that became popular later in the imperial period. Another doorway behind the outer so-called Syrian arch leads into the temple proper. Above the door is a curved space filled with a relief of a female figure emerging out of ornate acanthus leaves and tendrils.

Another building at Ephesus, dedicated to Hadrian late in his reign, is the Library of Celsus (fig. **7.27**). It is identified by an inscription and has been reconstructed in recent years by Austrian archaeologists working at Ephesus. The Romans of the eastern parts of the empire loved the kind of undulating façade seen here, with projecting pavilions capped by round and pointed pediments. A favorite device was to alternate the projecting portions (those pairs of columns that have an entablature above them). Notice that each of those on the second story spans the space between two lower pavilions. Not only do the pavilions themselves give the impression of a façade that projects and recedes, but also the niches in the walls, usually filled with sculpture, add to the three-dimensional effect.

7.24 *Below Insula*, Ostia, reconstruction. Second century AD. Brick and concrete

7.25 *Right* Apartment houses built next to the slope of the Capitoline Hill, Rome. Reconstruction. First half of second century AD. Brick, concrete, and travertine

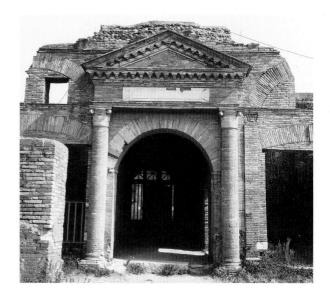

7.23 Horrea Epagathiana, entrance to the warehouse, Ostia. Mid-second century Ad. Brick

Domestic and commercial architecture Near Rome, at the port city of Ostia, can be seen some of the best-preserved ancient houses and commercial buildings in Italy. Because Ostia had grown so rapidly within a relatively small space, apartment buildings had sprung up to house the swelling throngs. We call these *insulae*, literally "islands," or blocks (fig. **7.24**). They had courtyards in the middle, and apartments of up to four or five stories around the outside. Part of such an apartment building was also found in Rome, built into the Capitoline Hill (fig. **7.25**). Here, the ground floor had the usual

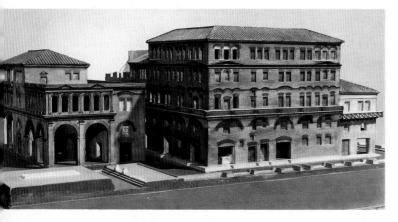

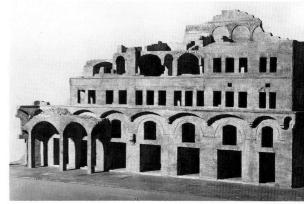

large doors and smaller square windows above that were characteristic of shops, while the upper floors were reserved for living spaces.

At Ostia, as at Pompeii and Ephesus and Timgad, one gets the impression of a real Roman town by walking down the stone-paved streets lined with buildings on both sides. Some of these buildings at Ostia were warehouses, built especially to house the excess grain that was shipped to the harbor from Sicily, and held here before distribution to Rome. These warehouses, or horrea, are named after the owners: this one is called the Horrea Epagathiana et Epaphroditiana (fig. 7.23). There is an impressive arched entrance way constructed out of brick, bordered at left and right by engaged columns with Corinthian capitals and capped by a pediment. Shops faced the street on either side of the entrance, while the grain itself would have been stored in the rooms around the central courtyard. husband's handsome and thoughtful face. She was more aloof than he, and stood as a kind of distant ideal suitable for the empress. In a relief carved after her death (fig. **7.29**), she rises from her funeral pyre to heaven on the back of a scantily-clad winged female figure. Hadrian watches the ascent, and the male figure at left symbolizes the Campus Martius, where the funeral took place. A scene like this is called an *apotheosis*, meaning that the deceased person is being deified. The whole effect is a little like an Athenian grave relief of the fourth century BC, but the iconography is typically Roman.

Hadrian had a lover, Antinous, from Bithynia in northwest Asia Minor, who lived and traveled with him and shared his highly cultured pursuits. When

7.26 Portrait of Hadrian wearing an oak wreath. AD 117–138. Marble. Over lifesize. Archaeological Museum, Khania, Crete

Portraits

Hadrian was the first emperor to wear a full beard (fig. 7.26); it soon found its way into general fashion and the standard portrait. He did this, perhaps, to look more like the Greek heroes he admired so much, but also probably because he was persuaded that the beard enhanced his imperial image. It offered sculptors the opportunity for additional exploitation of the possibilities of light and shade in male portraits. The potential of chiaroscuro has already been noticed in the sculptural renderings of several Flavian women (see above, figs. 5.17 and 5.19), but this fashion had not been taken up very often for men; at that time a combination of the starkly realistic interests of the Flavians and a general tradition of clean-shaven faces had made it inappropriate for male portraits.

Another change in the portraiture of the period was the definition of the eye by incising the ring of the iris and drilling two shallow circles in the pupil to show the reflection of light. This practice was to continue in most heads until the end of the empire. Previously, such details had been painted directly on the smooth stone.

Hadrian's wife Sabina (fig. 7.28) had a quiet beauty and dignity that seemed to match her

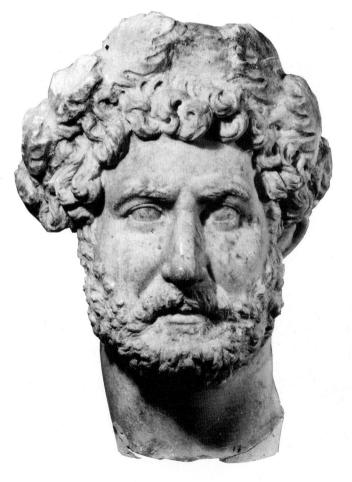

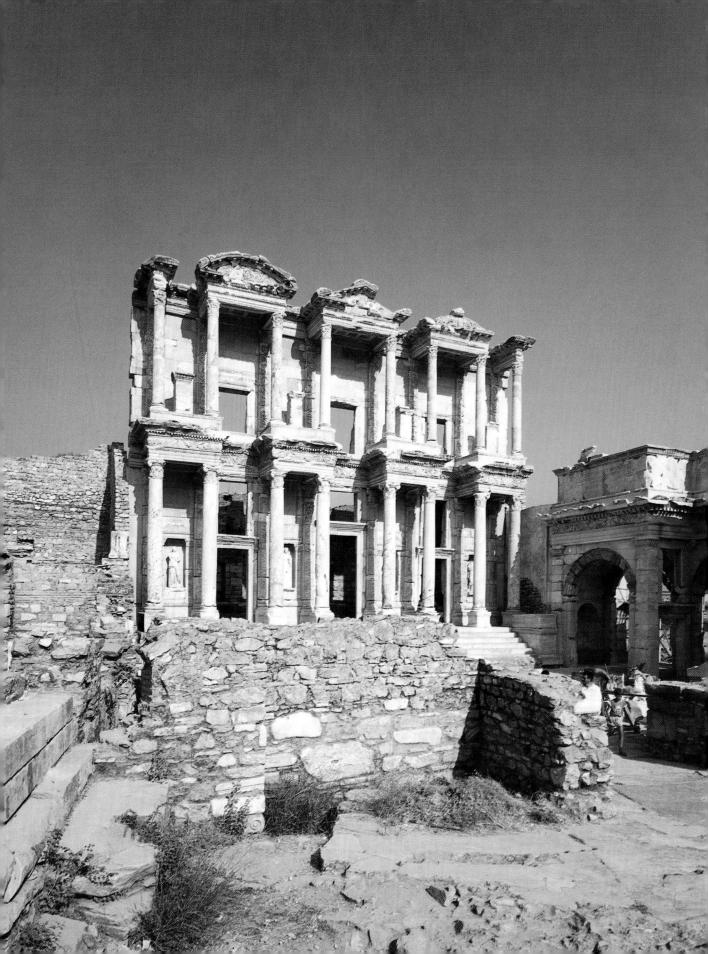

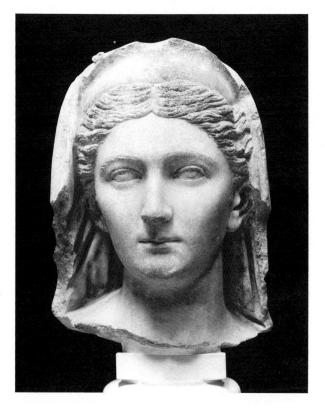

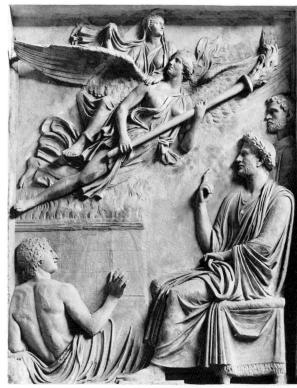

7.27 *Opposite* Façade of the Library of Celsus, Ephesus. AD 135. Marble

7.28 *Above* Portrait of Sabina. AD 117–134. Marble. Height *c.* 1ft 2ins (35·6cm). Museo Nazionale Romano, Rome

7.29 *Right* The *apotheosis* of Sabina, Rome. AD 136–138. Marble relief. Height 8ft 9½ins (2·68m). Palazzo dei Conservatori, Rome

Antinous drowned in the Nile in AD 130, Hadrian went into deep mourning. He founded a new city, Antinoöpolis, had his young lover deified as if he were a family member, and initiated the cult of Antinous.

Statues of the young man survive in large numbers. He is shown with unusually beautiful classical features; in a sense he sums up the Hellenic ideal of male beauty in the Roman period better than anyone else. However, because he was idealized as a god, we do not know how he actually looked. A relief (fig. **7.30**) shows him in the guise of the minor deity Silvanus, god of uncultivated land. The lovely face and figure of Antinous suit the

7.30 Relief of Antinous as Sylvanus, signed by Antonianos of Aphrodisias. AD 130–138. Marble. Height 4ft 8ins (1·42m). Banca Nazionale Romana, Rome

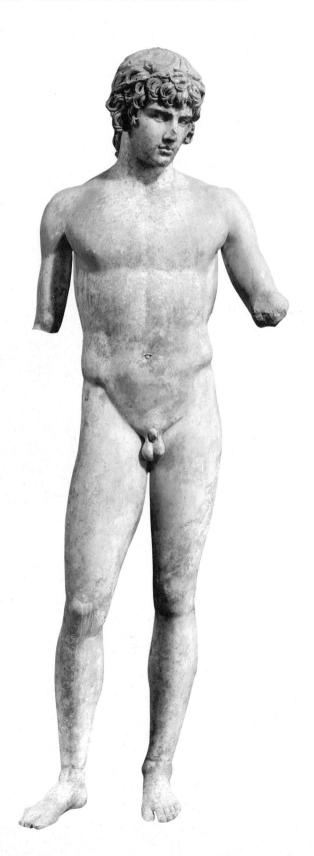

bucolic mood of this quiet subject, as he stands with his dog before a small altar and tree. The piece is signed by Antonianos of Aphrodisias, who was probably working in Rome, where the relief was found. A statue of Antinous, standing naked (fig. **7.31**), again captures the thoughtful and sensitive face, its fine features framed by pretty curls.

Reliefs

On the Arch of Constantine, built over a century and a half after the reign of Hadrian, is a set of large roundels, 6 feet 6 inches (2m) in diameter, that had been removed from a monument of Hadrian. How they were originally used on Hadrian's monument is not clear, but the theme of the reliefs was the emperor at the hunt. Three of the eight roundels show an actual hunting scene: the boar hunt (fig. 7.32), and a bear and a lion hunt. One shows the departure scene, and four represent sacrifices to the gods – including the newly deified Antinous. In the scene illustrated, the emperor, followed by two comrades, chases a hairy boar on a narrow horizontal groundline. The tree at left serves as an effective border, in the style of Hellenistic prototypes.

These scenes served not just to show that Hadrian liked to hunt, although that was true. Rather, the hunt symbolized the emperor's *virtus*, because it required courage and strength of character. Similarly, the sacrifice scenes served to point out his *pietas*, just as the sacrifice scene with Aeneas on the Ara Pacis Augustae (see above, p.92) had shown the same thing. These propaganda messages had been the original intent on Hadrian's monument. Then, when the roundels were transferred to the Arch of Constantine, they carried the same message, but applied at that time to the new emperor.

7.31 Left Portrait of Antinous. c. AD 130–138. Marble. Height 5ft 10^{3} /4ins (1·8m). Archaeological Museum of Delphi

7.32 *Opposite* A boar hunt, Hadrianic roundel, re-used on the Arch of Constantine, Rome. AD 130–138. Marble. Height 6ft 6ins (2m)

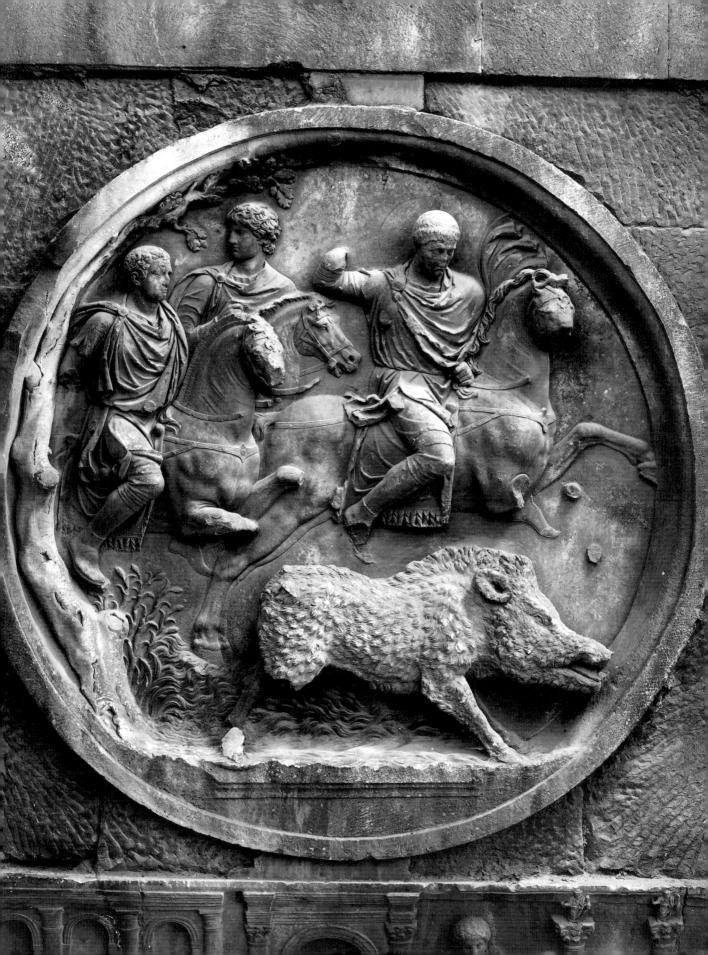

Sarcophagi

Cremation had been the standard, though not exclusive, method of burial in later Republican and Julio-Claudian times, but inhumation and in particular the use of carved stone sarcophagi seems to have gained more acceptance in the time of Trajan. For reasons that are not well understood, some people must have decided that it was preferable to be buried in a coffin than to be cremated, thus reverting to practices that went back to the earlier Republican period. There are no other obvious changes in religious practices, but the presence of stone sarcophagi that can be dated to the early second century stand as testimony to the new custom.

ATTIC SARCOPHAGI

Under Hadrian these new burial customs became established, and people began to use sarcophagi all over the Roman empire. Artists must have leaped at the chance of having a rectangular space suitable for pictorial scenes, and presumably their enthusiasm would have encouraged the use of sarcophagi even further. The front and the two ends of the sarcophagus were carved, while the back was usually left plain, because the normal practice in Italy was to place the piece against the wall or in a niche of the tomb. The lids, too, were carved with scenes on a narrow band across the front. This type

is called the Attic sarcophagus, because the home of the tradition seems to have been in Athens, and many were actually carved there.

The reliefs on sarcophagi, from the time of Hadrian until well into the Christian era, provide one of the best opportunities for observing stylistic changes, as well as the development of subject matter in a long series. Although some sarcophagi were decorated with garlands, like those on the Caffarelli Sarcophagus (see above, fig. 3.15), it soon became common to carve figural scenes that were of two types: either a theme depicting moments in the life of the deceased — scenes of marriage, sacrifice, warfare, or public office; or mythological scenes that often had something to do with death and the after life. Some of these latter themes were gruesome, to say the least, but that did not seem to offend the Roman patrons.

One of the violent tales to appear on sarcophagi is that of Orestes (fig. **7.33**). Three successive scenes are shown. At the left, two Furies sit by the grave of Agamemnon, father of Orestes. He is the man whose death Orestes avenges in the next scene, where he carries out the murder of his mother, Clytemnestra, and her lover Aegisthus – the killers of his father. Clytemnestra lies at Orestes' feet, and

7.33 The myth of Orestes, sarcophagus. AD 130–138. Marble. Height 2ft $7\frac{1}{2}$ ins; length 6ft $11\frac{1}{2}$ ins ($80\text{cm} \times 2 \cdot 12\text{m}$). Cleveland Museum of Art, Cleveland, Ohio, gift of the John Huntingdon Art and Polytechnic Trust

Aegisthus lies distorted and upside down. Orestes is assisted by his friend Pylades, who holds up a piece of cloth, while the horrified nurse turns her head and covers her face from the dread deed. Two Furies come up behind another piece of cloth to pursue Orestes for the crime he has just committed. This second scene takes up most of the area of the front of the sarcophagus. The third, at the right, shows Orestes stepping over one of the Furies as he leaves the tripod at Delphi (far right) to seek forgiveness from Athena in Athens. This series of events, though gory, would have represented for the family of the deceased the expiation of guilt as a way of gaining salvation.

All the figures are carved in low relief. Although there is a certain amount of overlapping, each person stands out clearly, and the whole story

7.34 The dragging of Hector around the walls of Troy, sarcophagus, Rome. *c*. AD 190. Marble. Height 4ft 7ins; length 7ft 8ins (1·4×2·34m). Museum of Art, Rhode Island School of Design, Providence, Rhode Island

is easy to read. The two cloths, each making a shallow arc, act as a repeated compositional element, and separate the foreground from background figures. The Fury in the lower left is placed to fit the corner, and the tripod acts as a border at the right-hand edge. The composition was carefully thought out, but perhaps not by the artist of this particular sarcophagus; for there is a second surviving one with the same story and many of the same details. There must have been certain stock types of sarcophagi, repeated often, even from one

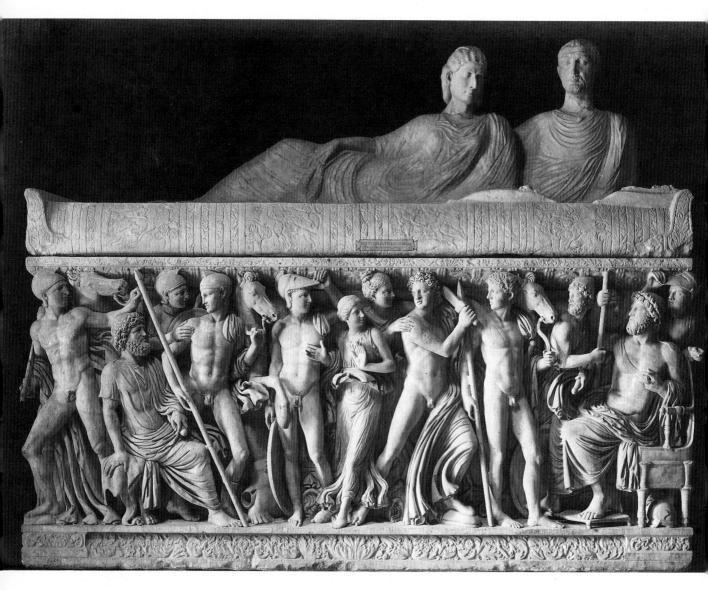

workshop to another. Indeed, many of the types that we know exist in several versions.

Attic sarcophagi were widely disseminated to western clients in many parts of the empire, but were excluded from areas where there was well-organized local competition, or where other imports had a strong hold on the market. They were made of the fine, white Pentelic marble that was easily available in the quarries near Athens. Some lids were carved to look like a roof (fig. **7.34**), slanted, covered with tiles, and bordered by *antefixes* – the decorative tiles lining the edge of the roof; others

7.35 Achilles at the court of Lycomedes, sarcophagus. *c*.AD 250. Marble. Height 4ft 3ins (1·3m); lid 3ft 5¾ins (1·06m). Museo Capitolino, Rome

looked like a funeral bed upon which the dead person reclined (fig. **7.35**). Figures on the vertical faces were thought of almost in three dimensions, and thus projected far from the background surface. Mythological themes usually supplied the subject matter, and the scenes continued across the whole panel of the front or sides.

ASIATIC SARCOPHAGI

The Attic sarcophagus, carved with a relief across the front, and usually on the ends too, was preferred in Italy and in Greece. In eastern parts of the empire, however, sculptors carved all four sides of sarcophagi, although the back was often less carefully finished than the other faces. These pieces were set up in cemeteries along the roadside and in other places – such as the center of a mausoleum – where all sides would have been visible. This kind is called the Asiatic sarcophagus, because the main centers of production were located in Asia Minor.

Asiatic sarcophagi, too, were shipped over wide areas of the empire, but were largely excluded from Greece, where the Attic sarcophagi had a kind of monopoly. Asiatic lids are similar to those on Attic sarcophagi, but the sides are distinctive in that they

7.36 The labors of Hercules, sarcophagus. AD 210-250. Marble. Height 3ft $10\frac{1}{2}$ ins; length 8ft $2\frac{1}{2}$ ins $(1.18 \times 2.5 \text{m})$. Archaeological Museum, Konya

are divided by a series of columns all the way around the sarcophagus (fig. 7.36). There is normally one scene placed between each of the columns. Sarcophagi of this type are usually much more elaborate and ornate than the Attic variety. The relief is higher still, and limbs of the figures are frequently cut free of the background. The architectural details show deep cutting for the patterns of the moldings, which are exaggerated far beyond what we see in full-size architectural examples.

Both Attic and Asiatic sarcophagi have been found in shipwrecks. They confirm the fact that, despite their size and weight, these objects were transported over wide areas. Another way of confirming their broad distribution is through a study of the different kinds of marble used. Many were exported only partially carved, leaving to a sculptor at the final destination the job of finishing the garlands, figures, portraits, and other details. Sometimes the artists from the place of origin of the sarcophagi traveled to faraway places so as to do the finishing job themselves for the final patrons.

STRIGIL SARCOPHAGI

A common type of sarcophagus has curved fluting on the front and sides, giving the effect of rippled patterns or an elongated S (fig. 7.37). These are called strigil sarcophagi, because the patterns are reminiscent of the bronze body scrapers, called strigils, that were used by athletes after strenuous exercise. These were sometimes embellished with Seasons or other figures, and a central medallion into which the dead person's portrait was carved to order. In other words, they could be mass-produced, and were available for easy personalization. Indeed, the sarcophagus of the ordinary person would not have been decorated at all; only the wealthier people could have afforded the kind of ornamental and figural carving that we have seen in the above examples.

Sometimes sarcophagi that were partially carved at the quarry were finished with a different kind of decoration from that which was originally intended. For instance, many strigil sarcophagi had lions' heads on the front (fig. 7.38). When leaving the quarry, this type would have had a large protrusion which was to be carved at the final destination: however, sometimes these protrusions would be carved into something else, such as draped female figures.

The reign of Hadrian was one of extraordinary activity, especially in the realms of architecture and sculpture. It produced the Pantheon and the villa at Tivoli, the defensive wall in the north of England, fine classicizing portraits, and a burst of activity in the making of sarcophagi. Hadrian's personal interest in Greek works was reflected in both the architecture and sculptural decoration of his villa, and in other buildings, such as the Temple of Venus and Roma. Although the emphasis on Greek models was not new, it took on a new importance in this era of classical revival.

^{7.37} Opposite top Strigil sarcophagus, decorated with portrait medallion and Mercury (left) and Bacchus (right). Second half of third century AD. Marble. Height 3ft; length 7ft 3ins (91·4cm×2·21m). Camposanto, Pisa

^{7.38} Opposite bottom Strigil sarcophagus with lion heads. First half of third century AD. Marble. Height 3ft 11/2ins; length 7ft $8^{1/2}$ ins (95·3cm×2·35m). Camposanto, Pisa

8 The Antonines AD 138–193

In the period of the Antonines, and especially toward the end of this era, we begin to see signs that Roman art was changing in dramatic ways. The contrast of styles inspired by the Greek and Italic traditions continued, but the importance of the native, plebeian strains in imperial art increased. There was a new interest in frontality (where figures face us directly), and spatial relations were analyzed in ways that emphasize pattern and schematic arrangements. The practice of showing one figure behind another to imply depth began to give way; instead, we find examples where the figures that are meant to be standing behind have been placed, instead, above the ones in front. Furthermore, the taste for monuments that exalted the Roman army found a new expression in sarcophagi, while imperial monuments under Marcus Aurelius show a new sensitivity for the plight of the enemy.

The rule of the Antonines, together with that of Trajan and Hadrian, was later looked upon as the Golden Age. It was a time when the empire was at its largest, and there was relative peace in both internal and external affairs, despite the fact that there were constant skirmishes and foreign threats at the borders. The prosperity of the Romans was at its height in the mid-second century AD.

Opposite Commodus as Hercules, detail of fig. **8.36**. *c.* AD 190. Marble. Palazzo dei Conservatori, Rome

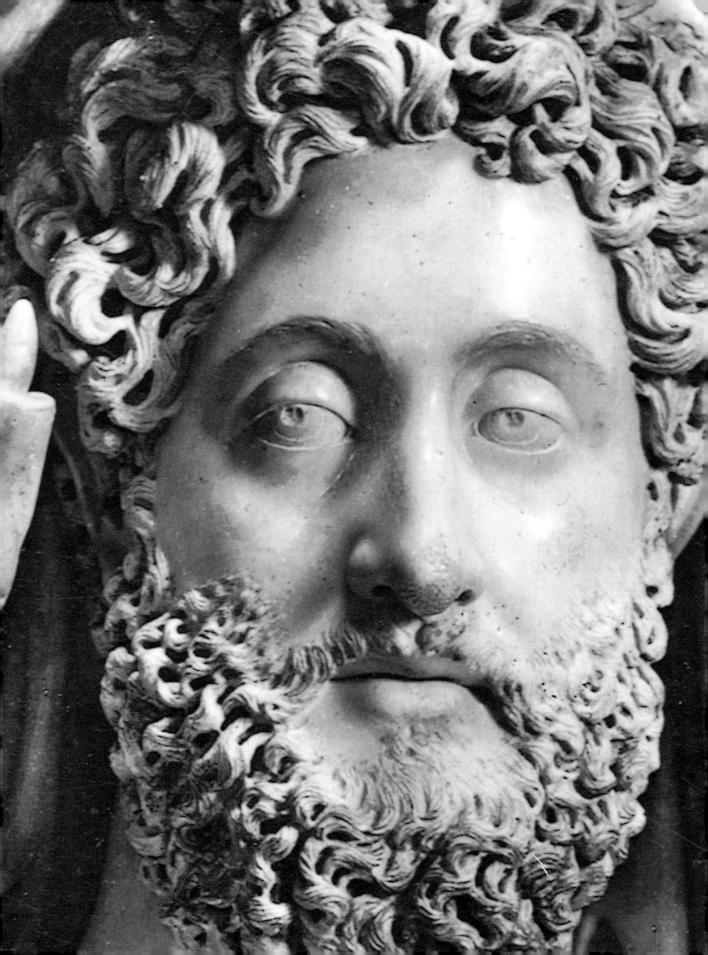

The Antonine family

The group of rulers who followed Hadrian had a complicated family connection that only just allows them all to be called by the family name, Antoninus. Antoninus Pius, the first of the group, had been adopted by Hadrian late in his reign, shortly before he died; at the same time, Antoninus Pius adopted Marcus Aurelius (his wife's nephew) and the young Lucius Verus to be his sons.

After the death of Antoninus, Marcus Aurelius and Lucius Verus shared the imperial seat for eight years (AD 161–169), until Lucius died. It must have been a strange combination, for Marcus Aurelius was philosophical, thoughtful, and intelligent, while Lucius Verus, clearly the junior member, was apparently more frivolous and self-centered. The *Meditations* written by Marcus Aurelius reveal a person who cared deeply for his people, and abhorred the wars he found it necessary to fight.

And finally, Marcus Aurelius took his ill-deserving son, Commodus, as a co-ruler, and was then succeeded to the throne by him. This was only the second time since the beginning of the Roman empire that an emperor was succeeded by his natural son. Titus had followed Vespasian, but all other transitions had been orchestrated to give the appearance of legitimacy to the next emperor.

The reign of Antoninus Pius

PORTRAITS

Antoninus (AD 138–161) had been given the honorary title, Pius, that had something of the ring of "augustus" to it. After all, the hero Aeneas was also frequently called by the term *pius* in Virgil's great poem, and the reference would not have been missed by a Roman citizen. It suggested that the emperor was mindful of doing his duty in persuading the Senate to vote divine honors for his adopted father Hadrian. He is portrayed by an enthusiastic biographer as a placid and agreeable man, and his reign seems to have been mostly peaceful. In appearance, he followed the style that had been

initiated by Hadrian - a thick, curly beard, and a frame of hair around the face (fig. **8.1**).

Antoninus Pius married Faustina the Elder, a woman who shared a certain amount of imperial honor with her husband. The head of a huge statue of her (fig. **8.2**) was found in the Temple of Artemis

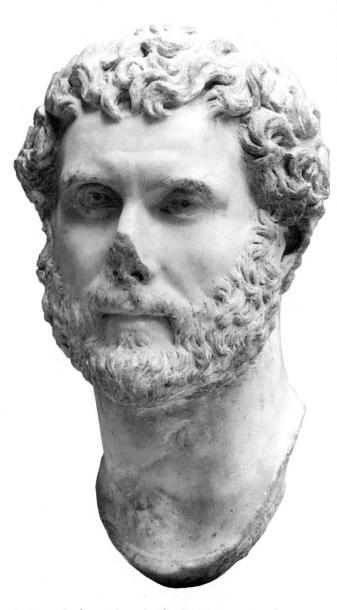

8.1 Portrait of Antoninus Pius, from Rome. *c*. AD 140–150. Marble. Height 1ft 3ins (38·1cm). Bowdoin College Museum of Fine Arts, Brunswick, Maine, gift of Edward Perry Warren

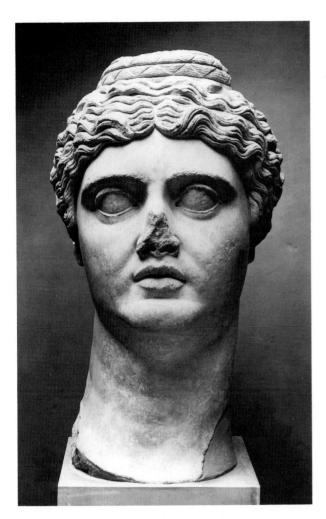

8.2 Portrait of Faustina the Elder, from Sardis. *c*. AD 140. Marble. Height 4ft 9ins (1·45m). British Museum, London

at Sardis. The temple, which had colossal statues of Artemis and Zeus in Hellenistic Greek times, was re-dedicated in the second century AD to include the emperor and his wife, on the occasion of a new honor for the city during his reign. The head alone, chin to top, is almost 3 feet (91cm) high, and one can imagine how impressive the whole statue must have been. Faustina's hairdo, with a central part, wavy locks drawn to the sides, and a bun on the top of her head, became the typical style of the period.

ARCHITECTURE

Antoninus Pius did not sponsor many buildings, despite his relatively long reign; nor did he put up heroic monuments. But when Faustina died young, in AD 141, she was deified, and the emperor erected a temple to her in the Roman Forum. Later, when the emperor died, the name was changed to include him too. This temple of Antoninus and Faustina (fig. **8.3**) is today one of the better preserved buildings standing in the forum because it was turned into a 17th-century church. The baroque façade and the church walls are surrounded by the ancient temple columns made of *cipollino* — a gray marble with a natural grain that looks something like the pattern of a sliced onion.

The new emperor dedicated a temple to the divine Hadrian in AD 145. This has been identified as the temple now housing the stock exchange in

8.3 Temple of Antoninus Pius and Faustina, Roman Forum, Rome. After AD 141. Marble

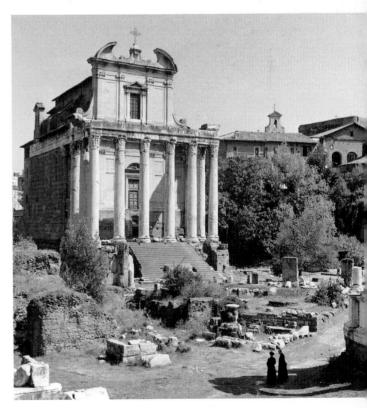

Rome (fig. **8.4**). A number of free-standing columns from the peristyle at the side and part of the *cella* wall still survive, and the entablature has ornate decoration above the Corinthian columns. Between the columns at the base of the temple were reliefs representing trophies and personifications of the provinces (fig. **8.5**) that were so important to Hadrian.

One of the major achievements of Antoninus Pius' engineers was the construction of a defensive wall in faraway Scotland, named for him as the Antonine Wall. This was to insure the security of his forces as they pressed northward. Since there was already the great wall built by Hadrian, it seems remarkable that Antoninus decided to extend the frontiers even farther. A coin (fig. **8.6**) commemorates the Roman victories in Britain during his reign. It shows his portrait on one side, a figure of Victory on the other, and the label BRITAN[nicus].

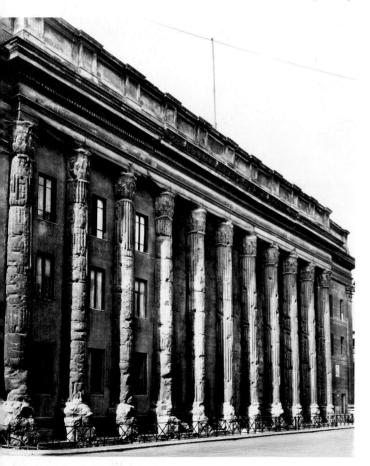

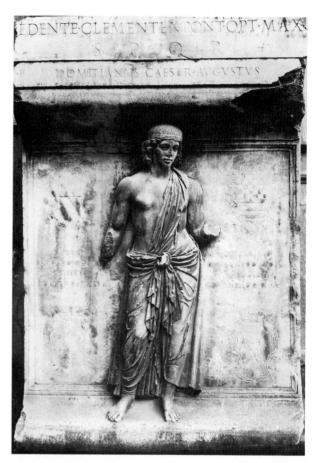

- **8.4** *Left* Temple of Hadrian, Rome. Dedicated AD 145. Marble and stone. Height of columns 48ft 9ins (14-86m)
- **8.5** *Above* Personification of a province, from the Temple of Hadrian, Rome. AD 145. Marble. Height 6ft 10ins (2·08m). Palazzo dei Conservatori, Rome
- **8.6** *Below Sestertius* of Antoninus Pius, Rome. Head of Antoninus Pius and Victory. Brass coin. AD 142–144. British Museum, London
- **8.7** *Opposite* Battle scene, Great Antonine Relief, Ephesus. *c.* AD 140. Marble. Height 6ft 9ins (2·06m). Neue Hofburg, Vienna

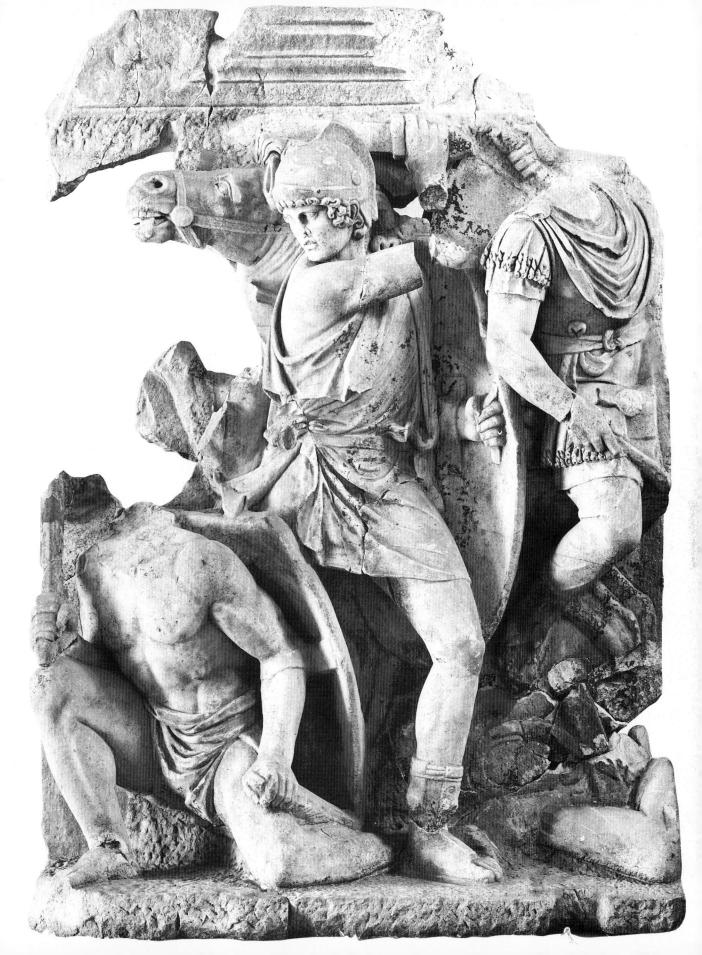

RELIEFS

During the Antonine period, and perhaps near the beginning of it, a monumental altar was set up at Ephesus to honor the gods and the imperial family. The purpose may have been to confirm the succession of Antoninus Pius as the ruler destined to follow Hadrian. Only fragments of the rectangularshaped altar have survived, and their order is uncertain, but the general arrangement can be made out. It seems that at the lower levels, bulls' heads and richly rounded garlands decorated the high base, and the figural frieze, of which many fragments have been preserved, would have been at the next level. One of the fragments (fig. 8.7) depicts a Roman soldier in tunic and helmet attacking a nearly naked barbarian with a sword. Behind the Roman, a horse with tongue hanging

8.8 Members of the imperial family, from the Great Antonine Relief, Ephesus. *c*. AD 140. Marble. Height 6ft 9ins (2·06m). Neue Hofburg, Vienna

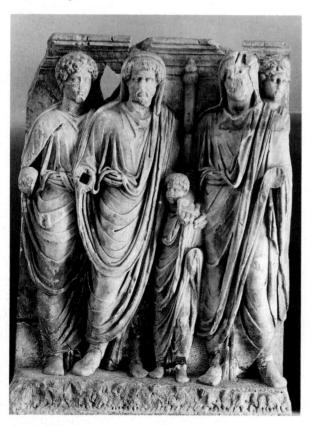

out rears on its hind legs while, at the right, another Roman soldier rides into battle. The action sways to both right and left: the Roman soldier moves right, but looks back over his shoulder; the barbarian moves left, but probably looks up at his assailant to the right.

Violent scenes such as this alternate with ponderous standing figures, some of whom are imperial portraits. Hadrian and the Antonine emperors and their wives each appear at least once. The emphasis on the transition of power from Hadrian to the Antonines comes to a climax in the group portrait showing, left to right, Marcus Aurelius, Antoninus Pius, the child Lucius Verus, Hadrian, and perhaps Faustina II, wife of Marcus Aurelius (fig. 8.8). Instead of a moving procession, such as the one on the Ara Pacis (see above, fig. 3.19), the figures here are stationary, and face out toward the viewer. Other Antonine reliefs also favor this arrangement.

The carving here is very deep, so that each figure stands out sharply from the background. The whole must have been wonderfully impressive, when the alternation of dramatic military scenes and formal portraits reminded viewers of the involvement of their rulers with the military prowess of the empire. It was a grand statement, where the battle scenes were based on Hellenistic prototypes, but the standing figures were more closely tied to the tradition of Roman imperial processions.

The reign of Marcus Aurelius and Lucius Verus

PORTRAITS

The portraits of Marcus Aurelius and Lucius Verus make them look something alike, although in fact they were not related (figs. **8.9** and **8.10**). Probably it is the heavy deeply drilled locks and the similar beards that point up the resemblance. Marcus Aurelius has heavy upper eyelids and a somewhat sad expression that fits well with the character we can observe through his writings. On the other

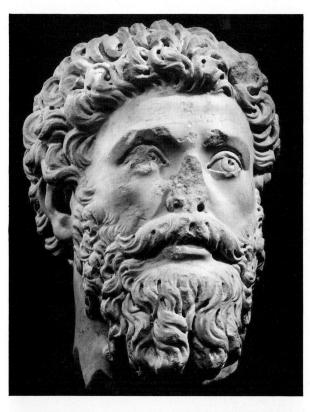

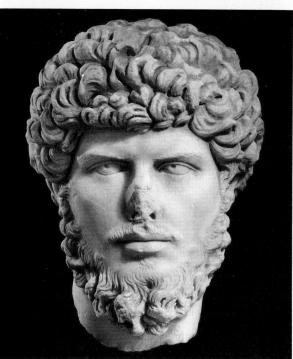

- **8.9** *Left* Portrait of the emperor Marcus Aurelius. c. AD 170, or later. Marble. Height 1ft 2^{1} /4ins (36·2cm). Kimbell Art Museum, Fort Worth, Texas
- **8.10** *Bottom left* Portrait of the emperor Lucius Verus, from Asia Minor. AD 160–169. Marble. Height 1ft $2^{1}/4$ ins ($36\cdot2$ cm). Toledo Museum of Art, Toledo, Ohio, gift of Edward Drummond Libbey
- **8.11** Below Full-length naked portrait of Lucius Verus. AD 160–169. Marble. Over lifesize. Musei Vaticani, Rome

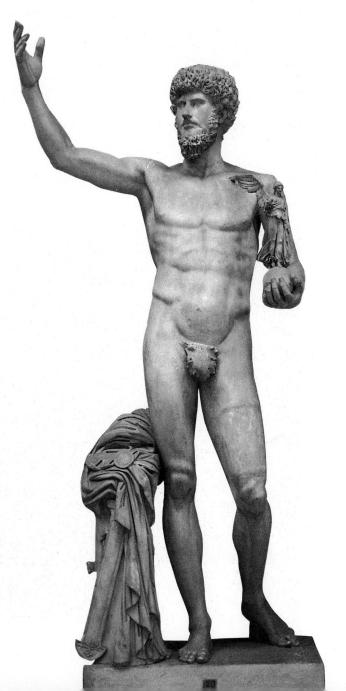

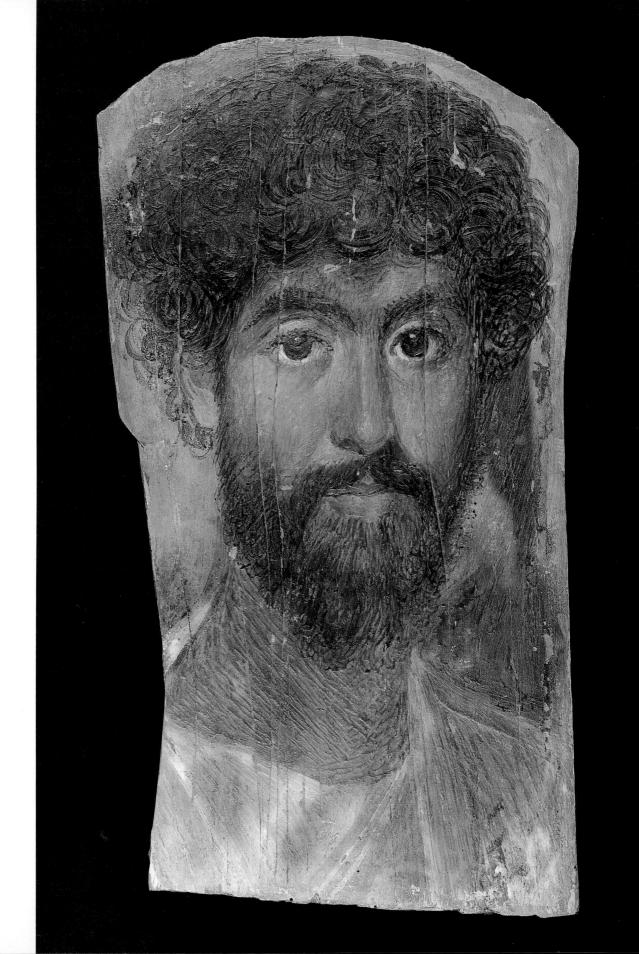

hand, the colossal head of Lucius has an empty expression. The facial features and the long narrow face are unusually handsome, although almost too delicate for the florid curls that nearly overwhelm the face.

Another statue of Lucius Verus (fig. **8.11**) shows him in the nude, as an athlete or hero. He makes a grand gesture with his right hand, and holds a Victory standing on an orb in the left. The notion of portraying the emperor naked may seem unusual to the modern eye, but grows out of the Greek practice of performing athletic activities in the nude. Thus, Lucius Verus is shown in the tradition of athletes and Hellenistic kings, and his pose is more formal than the modern equivalent of publishing photographs of the President of the United States in his bathing suit or running shorts.

8.12 *Opposite* Painted portrait of a young man, from the Fayum. AD 160–170. Encaustic painting on wood. Height 1ft 2ins; width 8ins (35·6×20·3cm). Albright-Knox Art Gallery, Buffalo, New York, Charles Clifton Fund, 1938

8.13 *Below* Painted portrait on a mummy, from the Fayum. Third quarter of second century AD. Linen, and encaustic painting on wood. Museum of Fine Arts, Boston, gift of the Egyptian Research Account

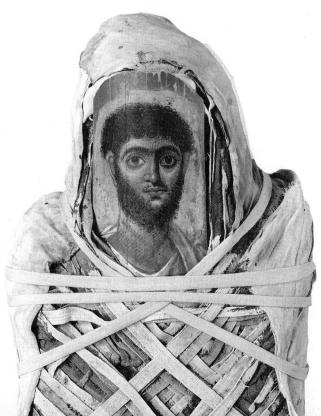

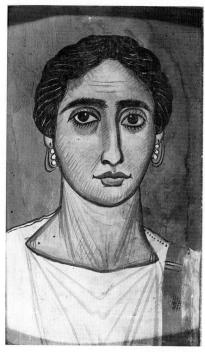

8.14 Portrait of a young woman, from the Fayum. *c*. AD 300. Encaustic painting on wood. Height 1ft³/4in; width 7¹/2ins (32·4×19·1cm). Arthur M. Sackler Museum, Harvard University, Cambridge, Massachusetts, gift of Mrs John D. Rockefeller

On the other hand, it was not common to make nude statues of the emperor in Italy, but was, rather, a practice usually reserved for the Greek parts of the Roman empire.

Painted portraits from Egypt have been well preserved, especially in an area near the Nile called the Fayum. A wooden board was painted with the head of the deceased in colored pigments mixed with beeswax. The board was placed on the mummy and wrapped in the linen cloth that encircled the body in such a way as to leave the painted face showing (fig. 8.13). Both facial type and hairdo show a good deal of careful observation. so much so that the time period when the person lived can frequently be ascertained by comparing the style of the coiffure to other dated works. Thus, although Fayum portraits were made from the mid-first century AD to the fourth century, we can tell that the young man in this portrait (fig. 8.12) must have lived in the time of Marcus Aurelius and Lucius Verus, to judge from his hair curls. Another, of a young woman (fig. 8.14), can be dated to about AD 300. The young faces and penetrating eyes are typical of Fayum portraits, but each one has its own character.

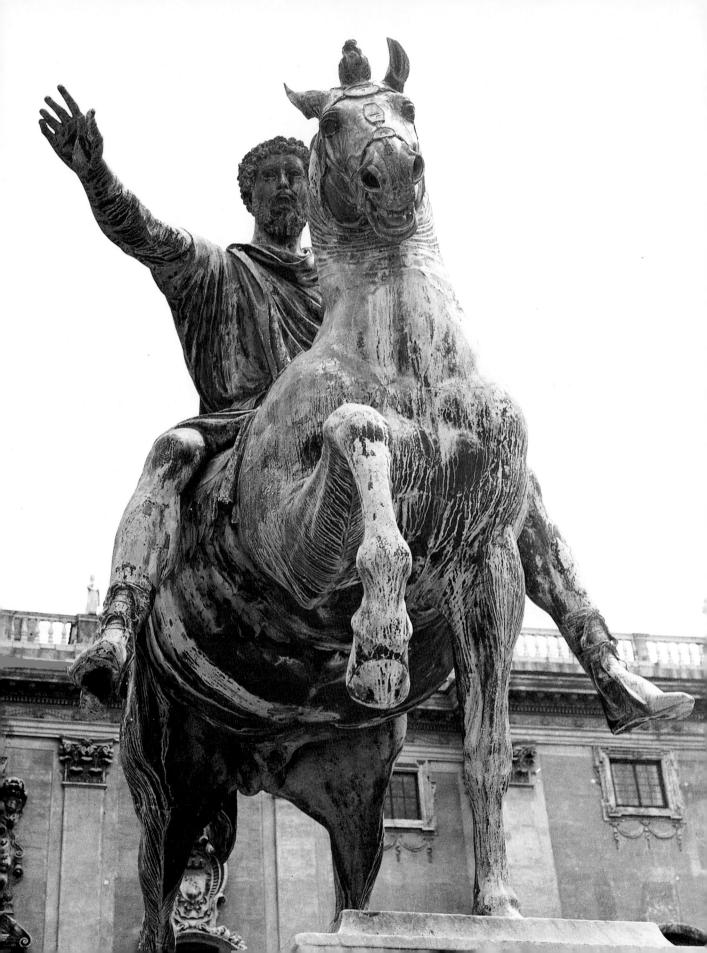

The only bronze equestrian statue to survive from antiquity is the over-lifesize figure, 11 feet 6 inches (3·5m) high, of Marcus Aurelius on horseback (fig. **8.15**). The reason it was not melted down for re-use of the metal is because it was believed, throughout the Middle Ages, to be a statue of Constantine, the first Christian emperor. But a comparison of the head with other portraits of Marcus Aurelius confirms the proper identification. The head is a fine example of naturalism, and reveals the sensitive personality through careful modeling of the face. Hair and beard provide effective contrasts of texture.

The statue was originally gilded, and traces of the gold leaf remain on the surface. The emperor wears a tunic and a heavy cloak associated with the leader of the army. He is shown with one hand extended as he addresses a crowd. The noble horse is large, but does not overpower the strength of its rider. Even though this is a military statue, the philosophic turn of mind of the emperor is portrayed through the thoughtful and compassionate expression.

The statue was used by the great Renaissance sculptor Michelangelo as the central focus of his square, the Campidoglio, on the summit of the Capitoline Hill (fig. **8.16**). He raised the statue on a high base, and designed the pavement to draw attention to this famous and influential piece. In recent years, the horse and rider were removed for restoration and preservation since they were suffering badly from the heavily polluted air of Rome.

THE BASE OF THE COLUMN OF ANTONINUS PIUS

Early in the reign of Marcus Aurelius and Lucius Verus a column was erected to honor the dead emperor Antoninus Pius. The granite shaft, which was devoid of sculptural relief, no longer survives, but the base is intact in a courtyard of the Vatican in

8.15 Opposite Marcus Aurelius on horseback, Rome. AD 164–166. Gilded bronze. Height 11ft 6ins (3·5m)

8.16 *Right* Overall view of the Campidoglio, a Renaissance square designed by Michelangelo on the ancient Capitoline Hill. The statue of Marcus Aurelius on horseback stands in the center. Designed 1537

Rome. Three of the four sides are carved with figures in relief, while the fourth has a dedicatory inscription from his sons. The three sculptured sides of the pedestal provide a fascinating mixture of styles. On the front, the subject is the apotheosis of the emperor and his wife (fig. 8.18): they are rising to heaven, in this case, on the back of a huge winged male god, accompanied by the eagles of Jupiter. A personification of the Campus Martius in Rome holds an obelisk - one of the several that marked important squares in the city. The other figure is the goddess Roma, personification of the city itself, who presides over the whole scene. As on the Arch of Titus relief (see above, fig. 5.9), she wears a helmet and has one breast exposed. The shield (fig. 8.17) is decorated with an emblem showing the wolf with Romulus and Remus.

The scale of figures is altered in an unusual way, leaving the emperor and his wife relatively small. Yet, the scene is classicizing in its treatment; it fits into the tradition of those imperial monuments following Greek prototypes, in the sense that figures are rounded, and there is a feeling of space. Indeed, the relief is reminiscent of the one commemorating Sabina, wife of Hadrian (see above, fig. **7.29**).

It therefore comes as a surprise to look at the sides of this monument, which are identical (fig. **8.19**). They represent a military review (perhaps part of the funeral exercises), where the horses and horsemen are riding in a circle around a

group of infantrymen who stand on a narrow ledge representing a groundline. Each horse, looking as if it belongs to a lead soldier, also has a small ledge on which to stand. The figures appear rather short and stubby, and are in sharp contrast to the classical proportions on the *apotheosis* scene.

We have seen before the tendency to make figures more squat, and to isolate them against a background; it has been singled out as a characteristic of the plebeian style, as opposed to the more formal imperial tendencies. Instead of showing space in the way it was done on classical reliefs, where those figures that stood behind are understood to be farther away, this relief deals with the problem in another way: the cavalrymen who are farther away are shown *above* the other figures. There is also little alteration in the size of the background (i.e. upper) figures, who must in fact be at some distance. They round the corners of the

8.17 *Above* Detail of the shield of the goddess Roma, from the base of the Column of Antoninus Pius, Rome. Shield emblem shows Romulus and Remus. *c*. AD 161. Marble. Musei Vaticani, Rome

8.18 *Below Apotheosis* of Antoninus Pius and Faustina, on the base of the Column of Antoninus Pius, Rome. *c*. AD 161. Marble. Height 8ft 1½ins (2·47m). Musei Vaticani, Rome

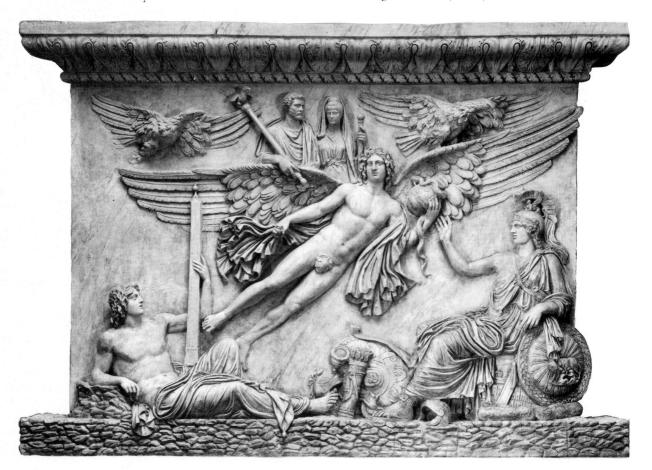

8.19 *Right* Military review, on the base of the Column of Antoninus Pius, Rome. *c.* AD 161. Marble. Height 8ft 1½ins (2·48m). Musei Vaticani, Rome

8.20 *Below* Submission of the barbarians to Marcus Aurelius, relief panel from a triumphal arch. *c*. AD 176–182. Palazzo dei Conservatori. Rome

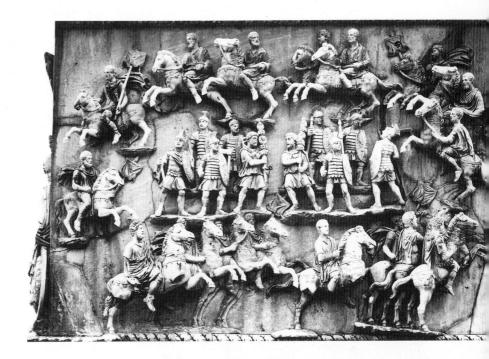

circle simply by facing in different directions. The artist has used two mutually inconsistent viewpoints: looking down on the scene as in a bird's eye view, at the same time as looking straight on at the figures. Although visually illogical, the relief reads easily, and we have no difficulty in understanding the message. The clarity comes, perhaps, from the way that the relief acts almost as a diagram.

The fact that this way of looking at space appears on a major imperial monument signals a change. But we have seen this kind of representation on a number of earlier reliefs, including the one from the Temple of Neptune and the *vicomagistri* relief. In the pictorial arts we can point to the Nile Mosaic as a prototype of this convention, in the sense that there, too, higher objects were intended to be farther away. Thus, the origins for this kind of representation go back at least to the Republican period, and maybe to the second century BC when the Italic, plebeian tradition was well established in sculpture and painting.

PANELS FROM A TRIUMPHAL ARCH

Marcus Aurelius found himself fighting during much of his reign although he claimed that he would have preferred to be peacefully at home. He endured two campaigns of several years each in the north along the Danube. These wars were commemorated in at least two monuments, a triumphal arch and a sculptured column.

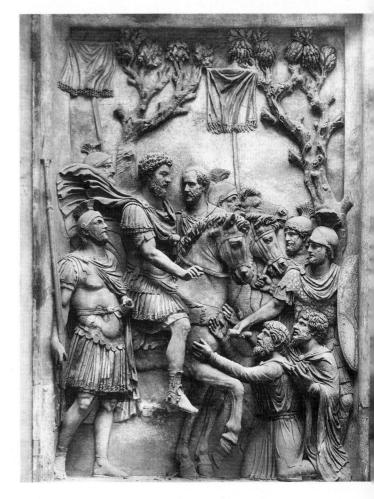

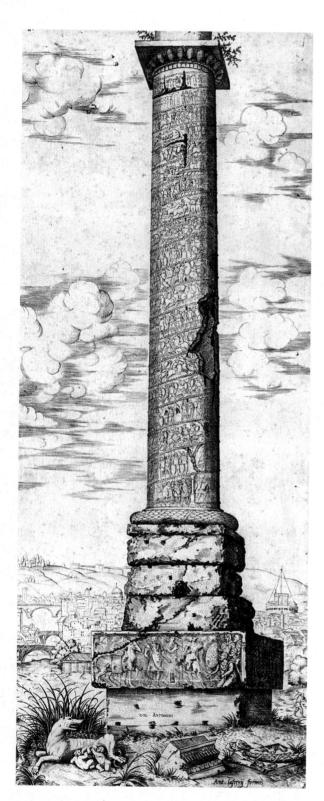

Although the triumphal arch no longer stands, several of the sculptural panels survive. One (fig. **8.20**) shows the emperor on horseback, surrounded by members of the army, who are indicated by a few soldiers in military dress, and by the placards being waved about among the trees. The enemy is shown by only two figures; they kneel in the lower right corner. But with such economy of sculptural means, the artist indicated the full story: the emperor, gentle-faced and riding in with cloak billowing behind him, is pardoning the enemy in an event called *clementia*. His pose is similar to the bronze equestrian statue in the round (see above, fig. **8.15**).

THE COLUMN OF MARCUS AURELIUS

Whether the reliefs on the Column of Marcus Aurelius were begun late in his reign or early in that of his son Commodus is open to dispute, but they took a long time to carve, and were not quite completed when Commodus died in AD 192. It was left for Septimius Severus to dedicate the column the next year. The column (fig. 8.21), seen here in an imaginary view of Rome after a work by the Renaissance artist Enea Vico, is closely modeled on the Column of Trajan (see above, fig. 6.8). It is the same height, and again has reliefs set out in strips that wind in a spiral around the column, but with far fewer scenes (fig. 8.22). Here, the border dividing one strip from another is heavier and thicker, and the figures stand out farther from the background than on the Column of Trajan. The reliefs depict the two campaigns conducted by Marcus Aurelius against the German tribes along the Danube.

The Column of Trajan is by and large an example of straight reporting, and describes the day-to-day activities of the army. On the other

- **8.21** *Left* Column of Marcus Aurelius, Rome, shown on its original base. The view of Rome in the background is imaginary. Engraving by Nicolas Beatrizet after Enea Vico. Mid-16th century
- **8.22** *Opposite* Three levels of the spiral reliefs showing scenes from the German wars, on the lower part of the Column of Marcus Aurelius, Rome. AD 180–192. Marble. Height of spiral bands 4ft 1 in (1.24m)

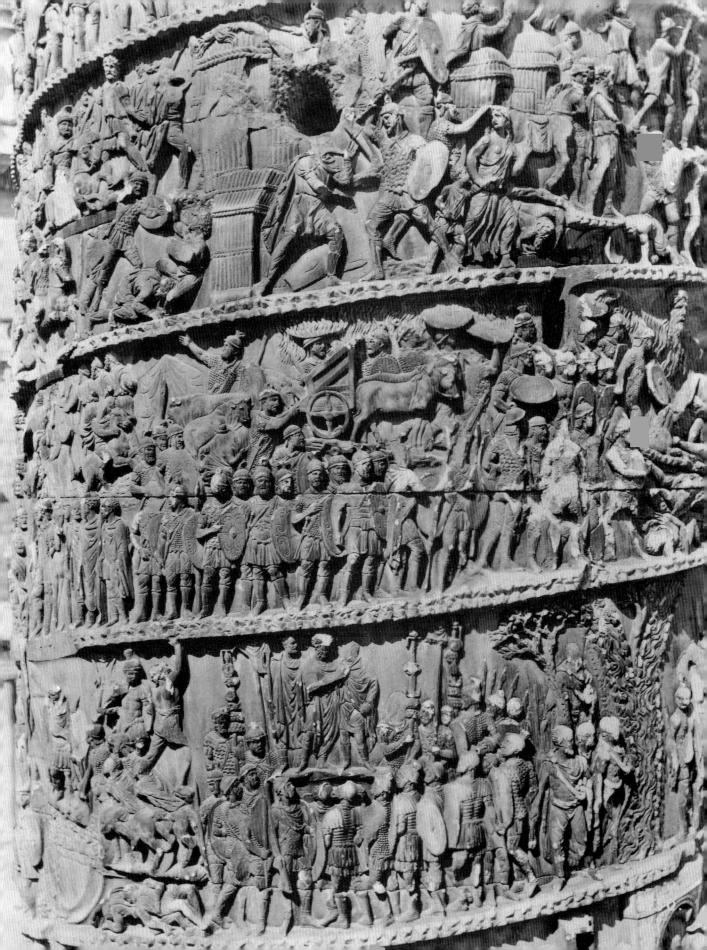

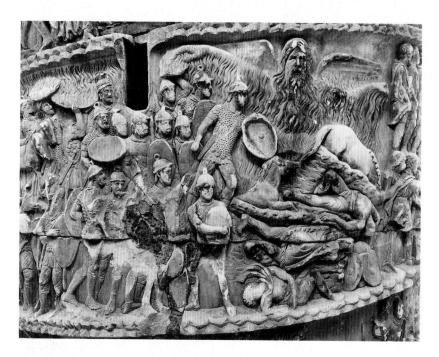

8.23 *Left* The miracle of the rain, detail of the Column of Marcus Aurelius, Rome. AD 180–192. Marble. Height 4ft lin (1·24m)

8.24 Opposite top Captive women and children and Roman soldiers, detail of the Column of Marcus Aurelius, Rome. AD 180–192. Marble relief. Height 4ft lin (1·24m)

8.25 Opposite bottom A massacre of barbarians, detail of the Column of Marcus Aurelius, Rome. AD 180–192. Marble relief. Height 4ft 1in (1·24m)

hand, there is a clearly-shown admiration for the enemy, as for instance at the moment when Decebalus committed suicide (see above, fig. **6.15**). This admiration tends to shed reflected glory on the Roman army. In other words, if the enemy is so worthy of praise for its courage and military prowess, how much more will the Roman people have pride in their own soldiers who have managed to vanquish this enemy?

The Column of Marcus Aurelius handles the situation somewhat differently. Many of the scenes portray the brutality of war, and there is overall a strong representation of the pain and suffering of the enemy. The sources for this emphasis may lie in Hellenistic reliefs, such as those from Pergamon, which capitalized on emotive human expressions. But there were also contemporary reasons to show so much distress and agony, especially as Marcus Aurelius himself felt torn between his deep concerns about the inhumane aspects of war, and his duty as emperor and commander to defend the empire.

Many individual scenes are related in one way or another to those on the Column of Trajan. Both use personifications: we saw earlier the representation of the Danube in the form of a river god (see above, fig. 6.12); on the Column of Marcus

Aurelius, there is a rain god (fig. 8.23) looming large beside the smaller-scale human figures. But here, the personification does more than identify the place; he partakes in the story in an active way, and helps to determine the outcome. The event portrayed is a battle where the Roman soldiers, overwhelmed by the much larger forces of the enemy, are saved by a torrential downpour that floods the river and drowns many of the enemy soldiers and their horses. Thus the god, winged and bearded so that the hairs blend in with the rain that pours down from his outstretched arms, brought about the defeat of the barbarians. The intervention on the part of a superior being in the representation of victory may reflect a breakdown in the more rational approach to events that had been characteristic of the Column of Trajan. In other words, the reliance on miraculous salvation on the Column of Marcus Aurelius suggests a growing mysticism among the Roman people.

Another scene (fig. **8.24**) shows the capture of barbarian women and children when the Roman army passes through a village. The peasants are begging for mercy, while the soldiers, ugly and mean, are taking a poke at one of them. The barbarian woman is represented in a particularly

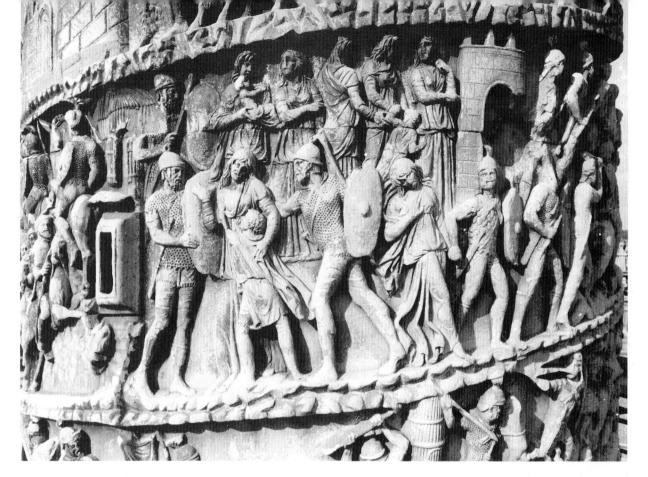

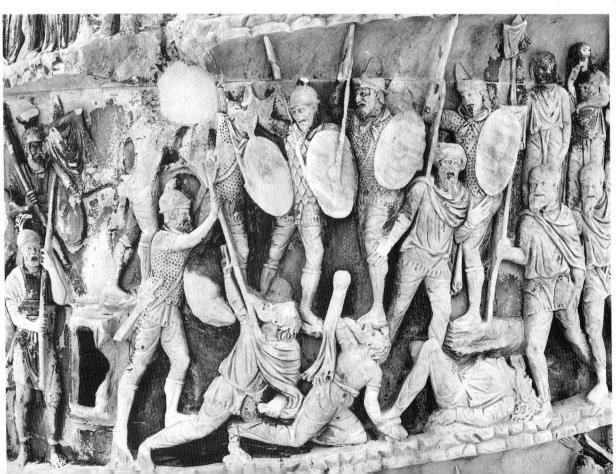

classical manner, and it is ironic that the Roman victors appear rougher and less civilized than the enemy. This is one of the most graphic examples where the artist, in accord with the philosophy of Marcus Aurelius, takes a sympathetic view of the vanquished, and records their plight with humanity. Similarly, in a scene showing the massacre of barbarian soldiers, wearing typical baggy pants (fig. **8.25**), the viewer easily feels empathetic to the unarmed enemy; they clearly have no chance against the armed Roman soldiers. Again, this seems to reflect a growing uneasiness or crisis of confidence in the rational order of the army and the state.

The *adlocutio* scene on the Column of Trajan (see above, fig. **0.4**) shows a masterful treatment of space. The emperor, in profile, addresses a crowd of soldiers who stand around him in gradually changing positions of frontal, side, and back views. In the *adlocutio* scene on the Column of Marcus Aurelius (fig. **8.26**), the emperor and his lieutenants, standing on a narrow ledge, face us directly. The soldiers are still understood to surround the emperor, and some are seen from the front, sides.

8.26 The emperor addresses his troops, detail of the Column of Marcus Aurelius, Rome. An 180–192. Marble relief. Height 4ft 1in (1·24m)

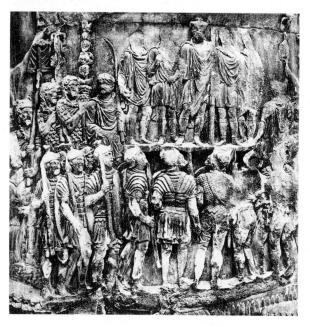

and back, but the emphasis is now on the frontal view of the emperor. This development is but one step along the steady progression toward increasing frontality in Roman art.

SARCOPHAGI

Battle scenes Perhaps in answer to the new surge in military activity, wealthy Romans began to favor a new subject on their sarcophagi: the battle scene (fig. 8.27). As on the Column of Marcus Aurelius, the Romans are shown as a superior force. and in uniform. The barbarians in this case are mostly naked, but their long, unkempt hair and the torque (band of twisted metal) worn around the neck of some of them identify them clearly as foreigners. The scene is violent and shows the horrors of war, and yet there is artistic order: a seated captive frames each of the lower corners, and a series of diagonals helps to link the tangle of active figures. As on the Column of Marcus Aurelius, the emphasis on the psychological and emotional effects of the battle scene suggests an increased uneasiness in the public outlook.

Much more complicated, but somewhat in the same spirit, is another battle sarcophagus, this one showing the combat between Roman soldiers and the German cavalry (fig. **8.28**). What at first looks like a terrible jumble soon comes into focus as one understands the system. The Roman military leader, on horseback, rides in at the very center. All around him the combat rages, with the diagonals of swords providing some of the organization of the composition. At far left and right prisoners, some with their hands bound, provide a visual border for the relief. Above them, Roman trophies complete the vertical definition.

Everyday life We stated above that some sarcophagi depicted scenes from the everyday life of the deceased. One such example is the sarcophagus of a Roman general (fig. **8.29**). The section in the middle shows the general in front of an altar, making a sacrifice in which a bull is about to be slain by his assistants. At the right he is shown at his marriage, shaking hands with his wife while attendants look on. A child in front symbolizes the fruits of the marriage, and at the same time balances the child on the left who accompanies his

8.27 *Above* A battle between the Romans and Gauls, sarcophagus. AD 160–170. Marble. Height 4ft 1in; length 6ft 11ins (1·24×2·11m). Museo Capitolino, Rome

8.28 Below A battle against barbarians, sarcophagus. c_{AD} 190. Marble. Height 3ft 9ins; length 7ft 10ins $(1\cdot14\times2\cdot39\text{m})$. Museo Nazionale Romano, Rome

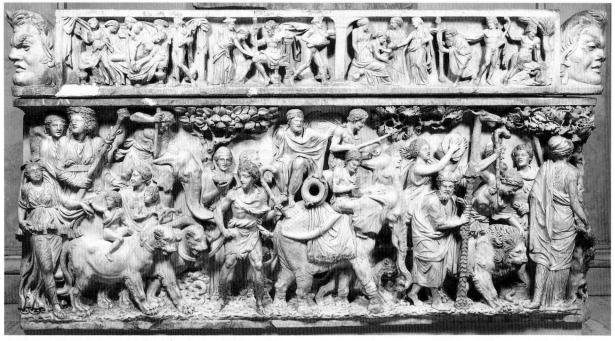

mother and father – barbarians who beg for mercy from the general. The general himself stands on a little platform, accompanied by a figure of Roma and a Victory at the far end. This is reminiscent of public monuments commissioned by the emperors, and is a good example of art in the service of an ordinary citizen that imitates the iconography of imperial monuments. Sarcophagi like this are biographical in nature, and are programmed to show the virtues of the deceased. They rely on an increased sense of morality, a private sense of morality that grows out of the expectations of *virtus* in the emperor.

8.29 *Top* Scenes from the life of a Roman general, sarcophagus. Late second century AD. Marble. Height 2ft 9½ins (85·1cm). Museo di Palazzo Ducale, Mantua

8.30 The Indian triumph of Bacchus, sarcophagus. *c.* AD 180. Marble. Height 3ft 3ins (99·1cm). Walters Art Gallery, Baltimore, Maryland

Dionysiac themes A group of ten sarcophagi was found together in 1885 in two chambers of a large tomb belonging to the family of the Calpurnii Pisones in a cemetery on the Via Salaria, north of Rome. One of these (fig. **8.30**) portrays Dionysus,

the god of wine, subduing the land of India. He rides in at the left, drawn by a pair of panthers, accompanied by elephants, a lion, *maenads* playing the cymbals, and others of his followers. Barbarian prisoners ride on one of the elephants, and, in a remarkable *tour de force*, at the center the horn of the trumpet faces directly toward us. Sarcophagi with dionysiac themes of revelry offered a kind of escape from the troubles of everyday life, and suggested that the deceased would go on to a better world.

Large sarcophagi A remarkable example of an Asiatic sarcophagus (see above, p.191) is one found near Melfi, a town southeast of Benevento. The piece (fig. 8.31), now housed in the cathedral of Melfi, can be dated to the reign of Marcus Aurelius by the style of the hairdo of the woman lying on the bed on the lid. Unusually large (with a height of 5 feet 6 inches; 1.7m), it has aediculae, or pavilions, on all four sides with seated or standing figures within each of them. The tops of the aediculae alternate between triangular pediments and round caps with shell shapes. At the end is a door, completing the effect of a house or temple. The column shafts that separate one figure from another are fluted in spiral grooves, and the ornamentation is deeply carved, as are the figures. Each of these is a type inspired by earlier Greek examples, many of them recognizable gods or goddesses such as Apollo and Venus. They have here been combined with a distinctly Roman kind of funerary setting.

Another grand sarcophagus of this period is the Velletri Sarcophagus (fig. 8.32), found in 1956. Its lid was made to look like the pitched roof of a temple, from which three-dimensional garlands are slung. The divisions of the decoration are reminiscent of a theater stage, and indeed the whole subject may be representative of the theater of life – and of death. The exterior is covered with figures taken from different myths, divided into two registers. The upper one, with scenes portraying the labors of Hercules, is capped by alternating rounded and triangular pediments, each filled with mythological figures such as the sun god, Sol, and the moon goddess, Luna. The lower register portrays different scenes connected with the underworld, including the myth of Proserpina who is carried off in a chariot by Pluto – but who will return each spring. We see the pair enthroned here in this detail (fig. **8.33**), with the sky god overhead, much as on the breastplate of the Prima Porta Augustus (see above, fig. **0.5**). The theme of rejuvenation is inherent in the myth of Proserpina, and, as on so many sarcophagi, it conveys the message of victory, and ultimately of salvation.

This sarcophagus has many features in common with the Asiatic type, but the style of carving figures and decorative features shows that it was made in Italy. It is an interesting example of the effect of Roman art from one area on that in another; in this case, the influence travels in the opposite direction from what we tend to think of as the usual flow.

Garland sarcophagi One of the favorite types of sarcophagus is the garland sarcophagus which, like its predecessor the Caffarelli Sarcophagus (see above, fig. **3.15**) and the more common funerary altars of the early empire (fig. **8.34**), is decorated

8.31 Asiatic sarcophagus, from near Melfi. After the middle of second century AD. Marble. Height 5ft 6ins (1·7m). Melfi Cathedral, Melfi

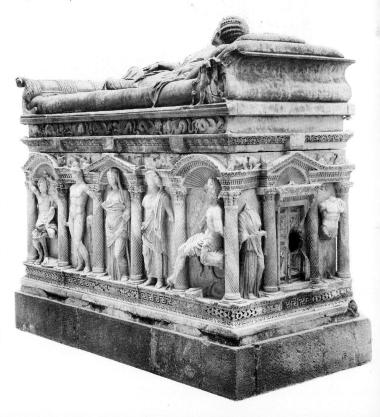

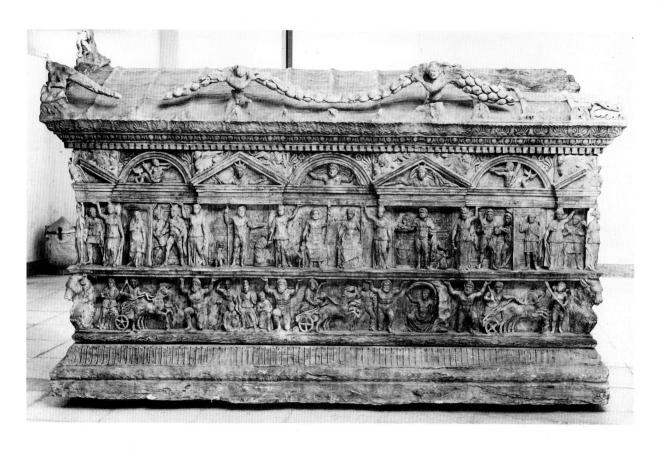

8.32 Above Velletri Sarcophagus, from Velletri. After the middle of second century Ad. Marble. Height 4ft 9ins (1·45m). Museo Civico, Velletri

8.33 *Below* Pluto and Persephone with sky god overhead, detail of front of Velletri sarcophagus. After the middle of second century AD. Marble. Museo Civico, Velletri

with garlands slung across the front side. Fruits and leaves tied into a graceful arc are supported by ribbons, and often held up by figures as well (fig. **8.35**). The standing figures on garland sarcophagi — usually cupids or Victories — carry an encouraging message of life after death. On this example, cupids not only hold up the garlands on the three decorated sides, but they also compete in a chariot race on the lid. Here they seem to represent the four seasons, anticipating the common use of cupids in this role on later sarcophagi.

The reign of Commodus

With the death of Marcus Aurelius, a long period of stability in the Roman empire – a period that had begun with Nerva – came to an end. Although at the age of 16 Commodus had been named co-ruler with his father, and had already sat on the throne for three years, when he took over sole command he initiated a new era of decadence. He was clearly deranged, and fancied himself as the incarnation of Hercules (fig. **8.36**) and later Jupiter. In the portrait shown, we recognize the similarity of features to those of Marcus Aurelius – especially the heavy

8.34 *Left* Funerary altar of A. Fabius Diogenes and Fabia Primigenia. Mid-first century Ad. Marble. Metropolitan Museum of Art, New York, Fletcher Fund

8.35 *Above* Garland sarcophagus with cupids, from Capranica, near Viterbo. Mid-second century AD. Marble. Height 2ft 7ins; length 7ft 1¾ins (78·7cm×2·18m). Metropolitan Museum of Art, New York

8.36 Below Bust of Commodus as Hercules. c. AD 190. Marble. Height 3ft $10^{1/2}$ ins ($1\cdot18$ m). Palazzo dei Conservatori, Rome

eyelids – and the continuation of the deep drilling to elaborate the curls of hair and beard. In fact, this portrait brilliantly contrasts the textures of the lion head and paws, symbolizing Hercules, with the smooth skin of the emperor.

Commodus led a life of boundless excesses, in which he catered exclusively to his own pleasures and depravity. Among his numerous decrees was one where he insisted that the names of the 12 months should be altered so that each one was called by one of his various titles or nicknames. He had no interest in foreign affairs or protection of the borders, and so the military gains made by his father were more or less wiped out, and Commodus left the state in sad disarray. His megalomania caused him to be murdered in AD 192.

The Antonine period had begun with the peaceful era of Antoninus Pius, who inherited the relatively calm state of affairs from Hadrian. Marcus Aurelius had led the empire through brutal and difficult battles that began to tear apart the fringes, and that were commemorated in his great spiral column. And then, when the era came to an ignominious end under Commodus, it was for someone from a new dynasty to repair the damage.

9 The Severans AD 193–235

The Severan period is marked by a rich array of architecture and architectural sculpture that drew attention to the continued glory of the imperial house. No matter that the house was so riddled with intrigue and hatred that family members had begun to kill one another; on the exterior, all was a picture of harmony and friendship that was created by triumphal arches and public buildings. It is remarkable that imperial patronage in this period was able to sustain such a steady program of construction, when the internal struggles threatened to undermine all sense of morality. From major changes in city planning to large-scale monuments, the Severans sponsored some of the more flamboyant architecture of the Roman era.

Artistically, in many ways, this period belongs to the Late Empire. Frontality became more and more common. The dependence on deeply drilled channels to define drapery and hair, reminiscent of hair and beards of the Antonine period and the hairstyle of some Flavian women, is characteristic. What had previously been modeled by subtle gradations and chisel work was commonly expressed in the Severan period in a more linear fashion,

9.1 Victories carrying trophies, in the spandrels of the Arch of Septimius Severus, Roman Forum, Rome. The Arch of Titus can be seen in the background. AD 203. Marble relief

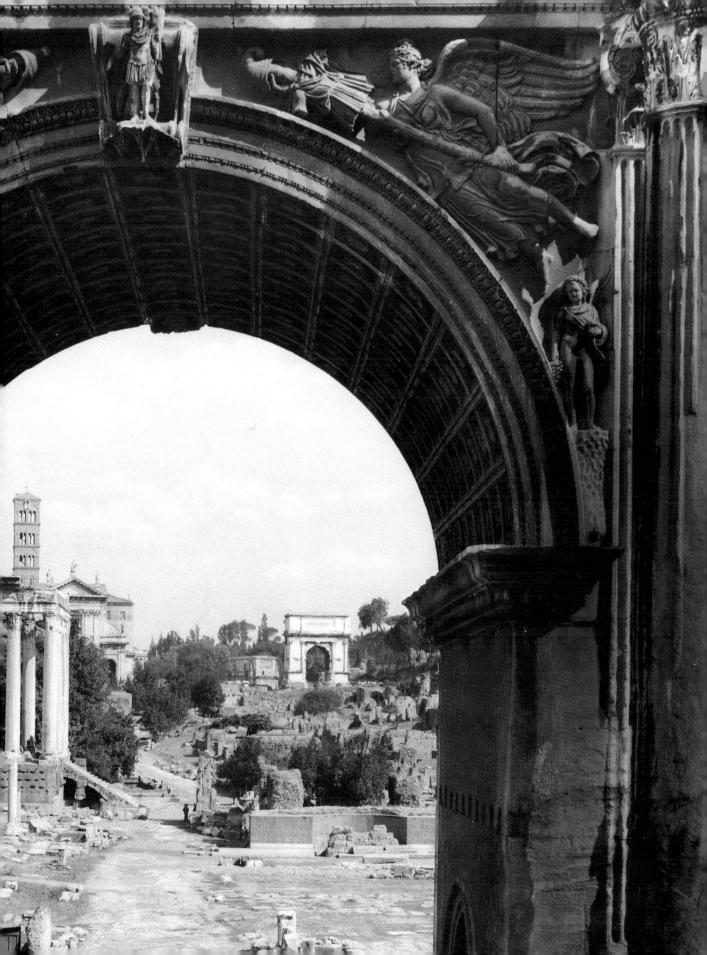

9.2 Portraits of Septimius Severus, Julia Domna, Caracalla, and Geta (Geta destroyed), from the Fayum. *c*.AD 199. Painted on wood. Diameter 1ft 2ins (35·6cm). Antikenabteilung, Staatliche Museen Preussischer Kulturbesitz, West Berlin

using harsher contrasts. The interest in outline rather than volume was further developed by the increased use of simplified and deep-cut architectural ornaments. How well these artists knew how to take advantage of the strong Mediterranean sunlight can be seen in monuments extending from North Africa to Syria.

The reign of Septimius Severus

After Commodus, last of the Antonines, was murdered, there was an uneasy struggle for power that must have been reminiscent of the atmosphere after the death of Nero. Septimius Severus was the army general who emerged victorious in AD 193, after a successful stint in the provinces and particularly as governor of Illyria and Pannonia (modern Yugoslavia and Hungary). He began a new

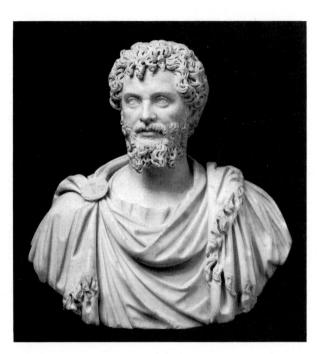

9.3 *Above* Bust of the emperor Septimius Severus. AD 200–210. Marble. Height 2ft 6½ins (76·8cm). Indiana University Art Museum, Bloomington, Indiana, gift of Thomas T. Solley

9.4 *Right* Full-length naked portrait of Septimius Severus. AD 200–210. Bronze. Height 6ft 9ins (2·06m). Cyprus Museum, Nicosia

dynasty known as the Severans. He was not a native Roman, but was born in Leptis Magna on the coast of North Africa, in what is now Libya; his wife, Julia Domna, was from Emesa in Syria. He gives the impression of a down-to-earth military type, somewhat in the mold of Vespasian, although he had a fine education in Greek and Latin literature.

PORTRAITS

An unusual number of portraits of Septimius Severus has survived, allowing for more detailed comparisons of technique than is possible for most of the other emperors. The portraits advance his claim to have been the adopted son of Marcus Aurelius, although this was actually an invention. It remained common for later emperors to appropriate the reputations of earlier ones in their adoption of names and titles.

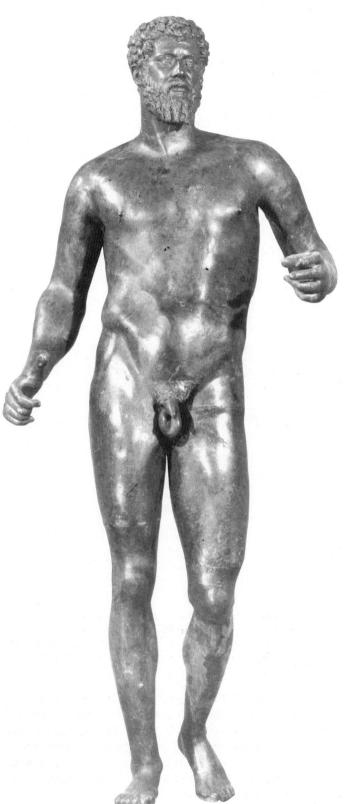

Characteristic of one of Septimius' portrait types (fig. **9.3**) is a row of curls hanging down his forehead, and a split beard with two large corkscrew curls at the bottom. The tradition of heavy drilling that had been initiated under the Antonines continued. An unusual bronze portrait among those surviving is the over-lifesize statue of the emperor (fig. **9.4**). Here is a good example of the naked figure, made in the eastern parts of the empire, where the people were brought up on the Greek notion of beauty residing in the naked body. Found in Cyprus, the statue seems to bespeak the brute strength of a man whose head seems too small for

9.5 Portrait of Julia Domna, from Syria. *c.* AD 205. Bronze. Height 1ft 2ins (35·6cm). Arthur M. Sackler Museum, Harvard University, Cambridge, Massachusetts, gift of C. Ruxton Love, Jr.

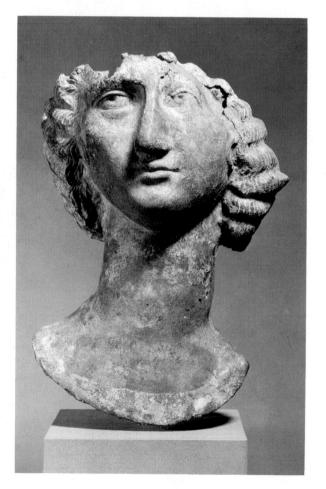

the enormous body. The stance is reminiscent of classical Greek statues, but the specific features, and the expressive arms, are typically Roman.

The only painted portrait of an imperial family to have survived from all of antiquity is a roundel depicting the Severan family: Severus himself, Julia Domna, and their sons Caracalla and Geta (fig. 9.2). Severus, with gray hair, is easily recognizable. Julia Domna, too, looks just like the marble and bronze portraits of her (fig. 9.5); her scheming, wicked personality is just as evident in both. She initiated a new hairstyle with large, rippled waves cascading in heavy locks down both sides of her head, and then curled under at the bottom. The chubby boy at the right, looking spoiled and unappealing, is Caracalla, who was to succeed his father. At the bottom left is a head that has clearly been scraped off. This was Geta, the unfortunate son who was murdered after the death of Septimius Severus by his jealous brother, and some say with the connivance of his mother. Caracalla then proclaimed a damnatio memoriae, the abolition of his memory, which meant that all statues and other representations of Geta were to be destroyed. Very few representations or inscriptions have survived this decree.

Each of the figures in the family portrait looks outward, although only the eyes of Julia Domna engage ours. Septimius Severus wears an imperial crown with jewels and wreath, and is a little larger than the rest of the family. The technique used for his features is finer and more careful than that for the others, but they also wear crowns, and Julia Domna's earrings and necklace stand out prominently.

TRIUMPHAL ARCHES

Rome During his reign Septimius Severus had to take to the field against the Parthians. Military honors included two triumphal arches, one in Rome and the other in his birthplace, Leptis Magna. The arch in Rome is one of the best-preserved landmarks in the Roman Forum (fig. **9.6**). Much larger than the Arch of Titus, it has three archways instead of one: a huge central one and two smaller ones at the sides. Sculptural relief covers the exterior on both sides, and huge columns set on bases reach from the bottom to the attic, which they appear

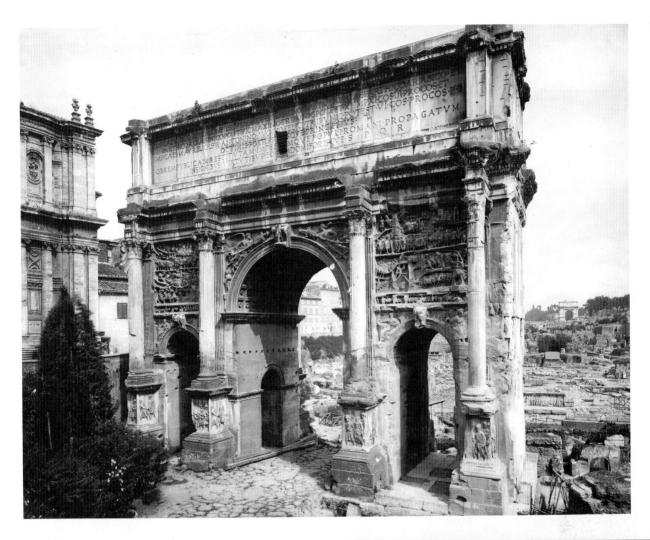

9.6 *Above* Arch of Septimius Severus, Roman Forum, Rome. AD 203. Marble. Height *c.* 67ft 6ins (20·6m)

9.7 *Right* The emperor Septimius Severus addresses his troops, from the Arch of Septimius Severus, Rome. AD 203. Marble relief

to support. The bases are elaborated with expressive reliefs of captive soldiers. Representations of Victories fill the spandrels on one side (fig. 9.1, p.218), and river gods on the other; small boys representing the four Seasons stand just below. These flying Victories, carrying trophies on long sticks, are descendants of those on the Arch of Titus, but the effect of body, drapery, and wings is becoming less gently modeled in the old classical style, and rather more harsh and linear.

The large, square areas over the smaller arches at the sides provide spaces for the four main

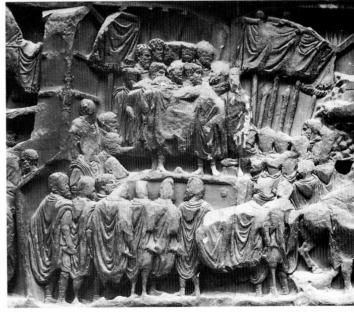

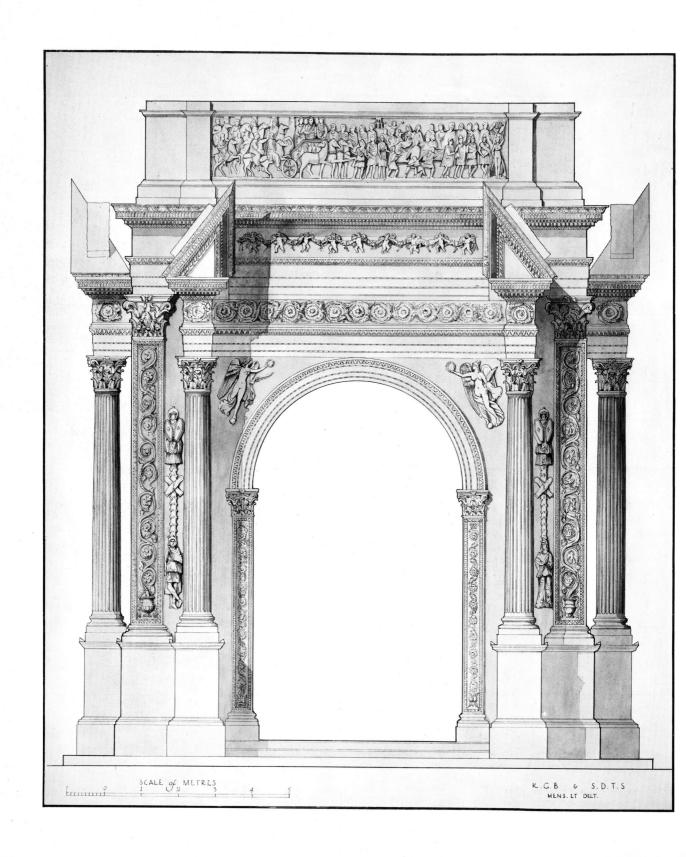

narrative scenes, each of which centers, of course, on the exploits of the emperor. The inscription on the attic records that he fought against the Arabs and the Parthians. These reliefs are today badly worn, but it is still possible to get the general effect. In the relief showing the emperor addressing his troops (fig. 9.7), he is flanked by his two sons Caracalla and Geta. The arrangement is closely modeled on the same motif as on the Column of Marcus Aurelius (see above, fig. 8.26), but the figures are shorter and stubbier, and the folds have become more schematic. The overall scheme of the sculpture is a kind of aerial view of towns, rivers, and landscape into which individual recognizable scenes, such as military engagements, have been incorporated.

Leptis Magna The triumphal arch at Leptis Magna, erected in AD 203, has a completely different effect (fig. **9.8**). It is what is called a *tetrapylon*, meaning a four-way arch at the intersection of two roads – in this case, the crossing of the *cardo* and one of a number of *decumani* (see above, p. 79). Thus, its location was one of the most important points in the city. Two intersecting colossal archways crossed the two streets at right angles. On each of the four sides there was a so-called broken pediment. This means that the lower two corners of the triangle are represented, but where the middle of the pediment should be, there is, instead, the normal attic of an arch. Its rectangular space was filled with relief sculpture rather than an inscription.

The architectural decoration is flamboyant, with deeply drilled floral motifs, columns, and ornamented pilasters. In the spandrels of the arches are Victories holding wreaths (fig. 9.9). These figures were descendants of classical types, as may

- **9.8** *Opposite* Reconstruction of the four-way triumphal arch, or *tetrapylon*, of Septimius Severus, Leptis Magna. AD 203–204. Marble. Reconstructed and drawn by Denys Spittle
- **9.9** *Top right* Victory on the spandrel, from the Arch of Septimius Severus, Leptis Magna. AD 203–204. Marble. Tripoli Museum
- **9.10** *Right* Half section through the Arch of Septimius Severus, Leptis Magna. Reliefs show Romans besieging a city. AD 203–204. Marble. Reconstructed and drawn by Denys Spittle

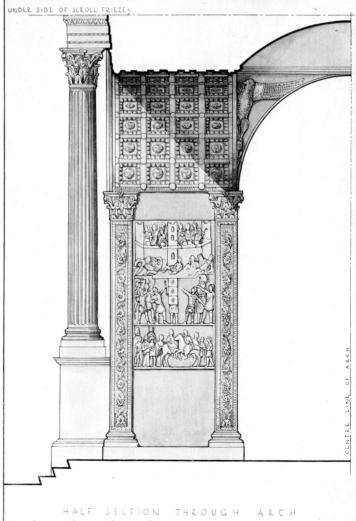

9.11 *Above* Triumphal procession of Septimius Severus and his two sons, from the Arch of Septimius Severus, Leptis Magna. AD 203-204. Marble. Height of relief 5ft 6ins (1·68m). Tripoli Museum

9.12 *Below* Sacrifice of a bull before Septimius Severus and Julia Domna, from the Arch of Septimius Severus, Leptis Magna. AD 203–204. Marble. Height of relief 5ft 6ins (1·68m). Tripoli Museum

be seen by comparing them to those on the Arch of Titus. While the bodies and drapery are superficially following classical conventions, they nonetheless give a rubbery and unanatomical rendition that shows a lack of basic understanding of the models.

The arch was richly decorated with relief panels, some of which adorned the inside of the pylons (fig. 9.10). Here the Romans besiege a city and dead soldiers lie at the foot of a city wall. The event in the lower panel is probably to be associated with the triumph of Caracalla. Other reliefs were placed on the attic, where the carving had to be strong and definitive so that it could be seen from the ground. The bright sunlight was used to produce the effect of dark lines in the deeply drilled grooves, tracing the outlines of the figures and such details as drapery folds. One of the subjects is the imperial chariot in a triumphal procession (fig. 9.11). Severus stands in the carriage and supervises the shaking of hands of his two sons who stand on each side of him. Geta is at the left, where the face was intentionally smashed away by Caracalla's order. The scene represents concordia, but suggests by implication (as often, when this sentiment occurs) that there may have been some earlier "discordia" between them.

Each member of the imperial family stands looking straight toward us, despite the fact that the imperial carriage itself is seen in profile. The retinue of attendants at the right also stands frontally, but the four horses, and the horseman on the left, are in profile. The figures do not overlap except that there are two rows at left and right; we are to read the back rows as farther away, not literally above the others.

Farther to the right on the same relief, a sacrifice is taking place with Julia Domna officiating (fig. 9.12). Her hair is delineated in a pattern of deep drilling that makes sense only from a distance. Here we can see, too, that the folds in her robe are deeply carved in what look like straight gouges from close up; but again these take on a more natural and effective appearance from a distance. The flatness of the sculpture does not interfere with its clarity because the images come across through linear definition and emphasis on outline.

9.13 Part of the arcade decorated with heads of Medusa and sea nymphs, Severan Forum, Leptis Magna. Dedicated AD 216. Marble

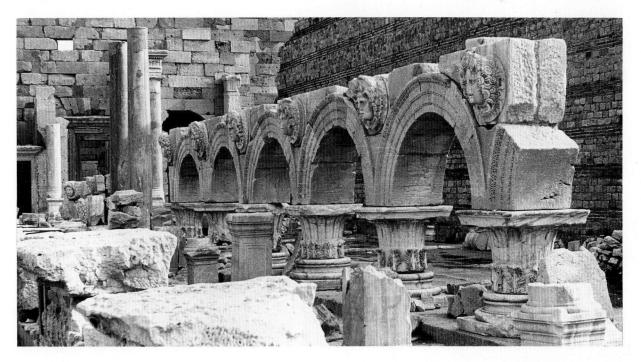

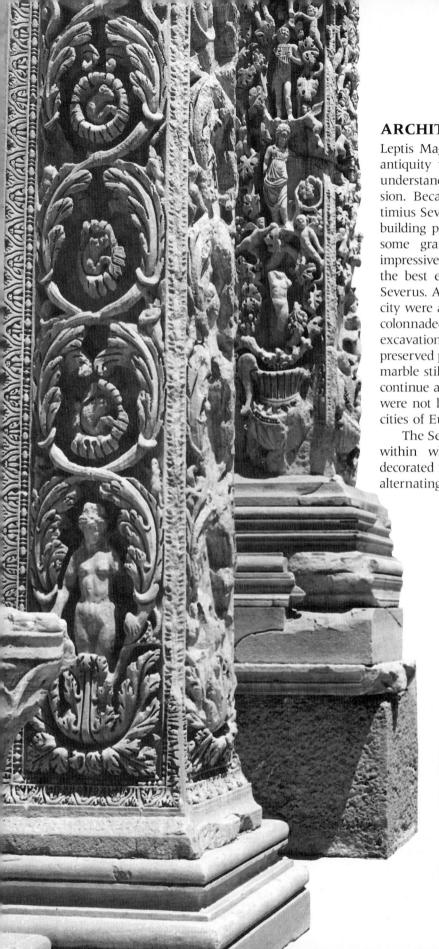

ARCHITECTURE

Leptis Magna had a much better water supply in antiquity than it has now - an essential fact for understanding its potential for wealth and expansion. Because this town was his birthplace, Septimius Severus lavished a great deal of money on a building program there. Although there had been some grand architecture earlier, including the impressive Baths of Hadrian, the city became one of the best endowed of the empire in the reign of Severus. Among the emperor's contributions to the city were a huge new forum, a basilica, and a long colonnaded street that led to the harbor. The excavations here have uncovered remarkably wellpreserved portions of these places, with much of the marble still lying around; because the area did not continue as a city in later times, the ancient stones were not looted in the way they were in so many cities of Europe.

The Severan Forum was enclosed by high walls within which ran a portico. Its arches were decorated in the spandrels with large female heads, alternating between sea nymphs and Medusa — the

- **9.14** *Left* Pilasters with peopled scrolls, in the Severan basilica, Leptis Magna. *c*. AD 216. Marble
- **9.15** *Below* Hunting Baths, Leptis Magna. Late second or early third century AD. Concrete. Length *c.* 86ft (26·2m)

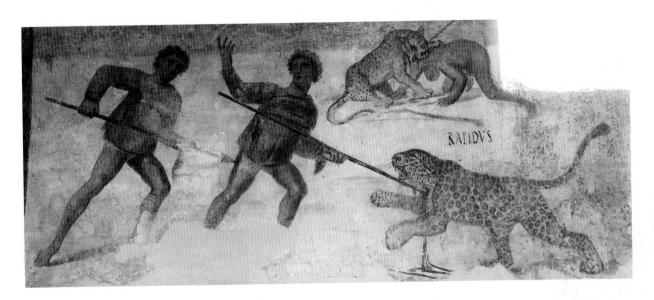

snaky-haired monster who turned men to stone (fig. 9.13). At one end of the forum was a large temple raised on a podium in the traditional manner, and at the other end was the huge apse-ended basilica. Its rich decoration includes reliefs known as "peopled scrolls" (fig. 9.14). Deeply carved acanthus leaves curl around in a rinceau of vines, while human and animal figures in high relief fill the spaces between the curves of the stems and leaves. The carving techniques on these reliefs again take advantage of deep drilling to make

9.16 A leopard hunt, detail of painting on the south wall of the Hunting Baths, Leptis Magna. Late second or early third century AD. Wall painting. Height of whole painting 5ft 3ins (1·6m)

dark shadows in the intense North African light. Inscriptions indicate that some of the sculptors came from Asia Minor, and these have sometimes been connected with Aphrodisias, one of the outstanding centers of sculpture in this period.

Another set of buildings at Leptis, this time from the late second century AD, is the Hunting Baths (fig. 9.15). Well preserved because they were buried under the sand, they are an excellent example of the extensive use of concrete to make a multiple series of vaulted spaces for the different baths within the complex. There seems to have been no attempt to ornament the exterior with columns or other classical decoration, but the interior had wall paintings (fig. 9.16). Hunters are attacking a leopard, nicknamed Rapidus ("Swifty"), while a man is mauled by a leopard in the background. Here we have a scene from the arena, but such hunts would have been important for the purpose of obtaining wild beasts for the competitions that took place in the Colosseum and other amphitheaters. Leptis may well have been one of the collection and shipping points in this important trade.

Funerary portrait reliefs Another town to have benefited from the largesse of Septimius Severus was Palmyra, located at the edge of the Syrian desert. The fact that the emperor's wife was a Syrian may explain his interest in the area; but, in addition, he would have had practical concerns of a strategic and economic nature regarding Palmyra itself. What had previously been a largely mudbrick town was now given many new public buildings in marble. Long colonnaded streets and a huge triumphal arch still stand as testimony to the building program (fig. 9.17).

The art of Palmyra reflects a mixture of Roman and Parthian styles. It reached the height of its splendor under Queen Zenobia in the third century AD, but had been within the Roman sphere since Julio-Claudian times. The best-known works of art from Palmyra are the funerary portrait reliefs carved in limestone to adorn large family tomb chambers. The most elaborate of these tombs have walls covered with relief portraits set in an architectural frame. The figures are normally identified by the names of their fathers, as well as their own.

One such funerary relief shows a man called Yarkhai, son of Ogga, and his daughter Balya; the identification comes from the inscription carved into the background (fig. **9.18**). This example is dated in the second half of the second century, but the type continued through the third century. Both figures stand out in high relief, so much so that the

9.17 Panoramic view of Palmyra, taken from the northeast, engraving by Thomas Major from *The Ruins of Palmyra* by Robert Wood, 1753, after Borra. A: Temple of Bel; H: monumental arch; colonnade is to the right of monumental arch. Width of engraving 4ft 10½ ins (1.48m)

forearm of Balya is quite free of the background. Both face the viewer directly, although they do not engage our eyes. The poses are typical, with hands drawn up near the heads, either tucked into the cloth or holding it (in the case of the woman).

9.18 Funerary relief of Yarkhai, son of Ogga, and his daughter Balya, from Palmyra. Second half of second century AD. Limestone. Height 1ft 10ins; width 2ft $8\frac{3}{4}$ ins $(55.9\times83.2$ cm). Portland Art Museum, Portland, Oregon, gift of Aziz Atiyeh

Palmyrene artists were distinctly interested in pattern, as seen here in the emphasis on the folds of clothing and the cloth hanging behind the figures; and also in the border fringe of Balya's robes and the hair patterns. Even the pattern of extended fingers is repeated. Jewelry interested these people too, undoubtedly both for the decorative effect and because it showed a person's wealth. Here, the woman wears a necklace with hanging pendant in the center and two bracelets.

The heads are in a certain sense portraits, as seen especially in the strong nose and mouth, and the wrinkles, of Yarkhai. On the other hand, there is a similarity among Palmyrene reliefs that gives them all something of the same feeling. Perhaps it is the repeated frontality, the long oval eyes, and the repetition of pattern. Some of these features contributed to the formation of the Byzantine style.

Severan baroque in Syria At another site in Roman Syria, Baalbek, a small gem of a temple, perhaps dedicated to Venus (fig. **9.19**), has survived despite the ravages of medieval and modern warfare. It stands near a colossal temple in the sanctuary known as Heliopolis, which is the Greek equivalent of the sanctuary of Baal. The walls of the Temple of Venus themselves are circular, with niches in the exterior. Surrounding the *cella* is a portico of Corinthian columns set on a high base. The most notable features are the entablature and base, both of which curve in to the *cella* walls

between each of the portico columns. Thus, the concave walls of the entablature, mirrored in the curving base and the niches, play against the convex walls of the *cella*. In many ways this seems to be the ultimate example of the kind of Severan baroque style seen in Leptis Magna.

9.19 The Temple of Venus, Baalbek. First half of third century AD. Marble

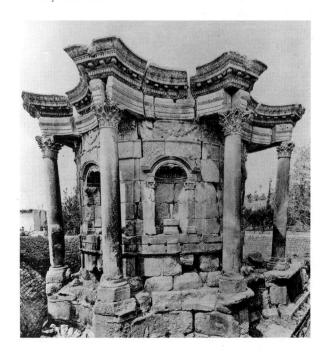

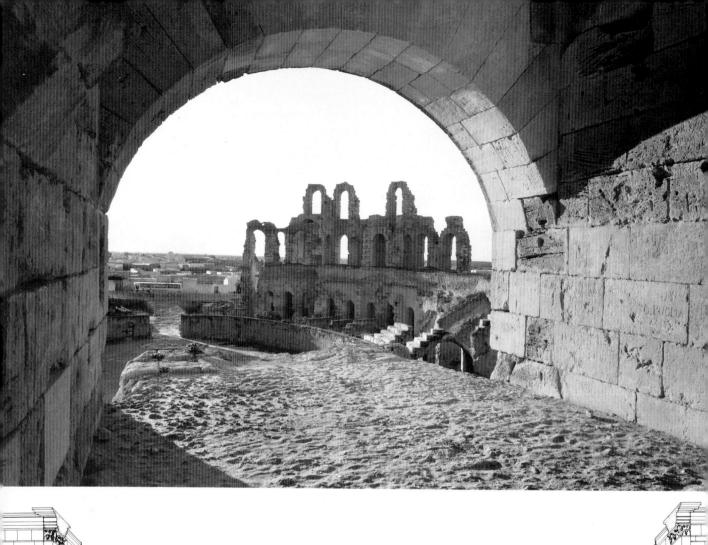

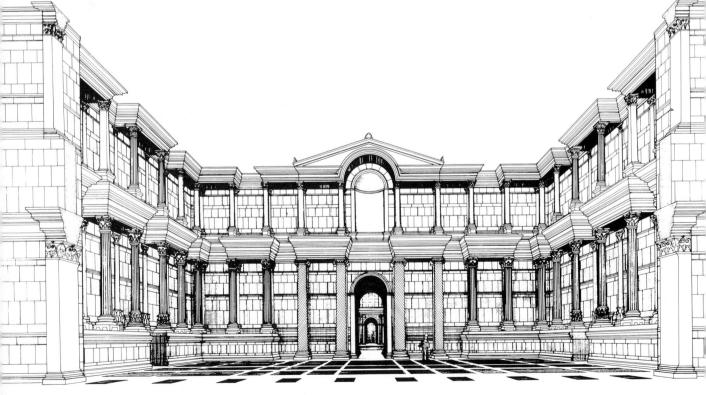

9.20 *Opposite top* The amphitheater at El Djem (Thysdrus), with the desert in the background. *c*.AD 238. Stone and concrete. Length *c*. 484ft (147·52m)

9.21 *Opposite bottom* The Bath-Gymnasium Complex (Marble Court) at Sardis, reconstruction by D. DeLong based on an earlier study by F. K. Yegül. AD 211–212. Marble. Height *c.* 65ft (19·8m)

9.22 *Right* Laughing satyr decorating a capital from the Marble Court, Sardis. AD 211–212. Marble. Height 1ft 3ins (38·1cm). Manisa Museum

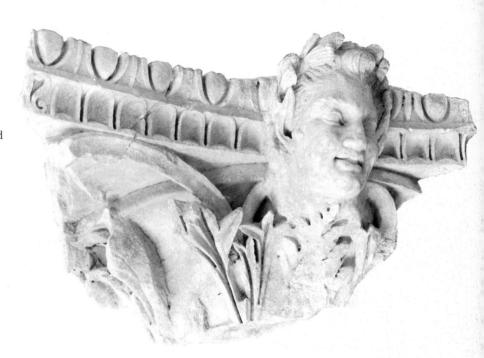

Later Severan buildings Palmyra and Baalbek are only two of the many cities at the fringes of the Roman empire that dominate the surrounding landscape. Another example, in what is now Tunisia, is El Djem (ancient Thysdrus). The amphitheater there rises dramatically out of the surrounding desert (fig. **9.20**), reminding us of the way in which Roman towns made their mark all around the Mediterranean shores.

Citizens in Roman towns of the empire would typically dedicate public buildings to the imperial family and would indicate it by inscriptions and statues. One such example is a large bath complex in the city of Sardis in Asia Minor. The gymnasium portion had originally been dedicated to Lucius Verus, but a grand entrance hall (fig. 9.21), perhaps for the imperial cult, was added in the latter part of the reign of Septimius Severus. The actual dedication was to the family of Julia Domna, Caracalla, and Geta, showing that the opening was after the death of Septimius in AD 211. The date can be fixed even more precisely because the name of Geta is erased from the family group, and he was not murdered until AD 212. Thus, we have a very narrow time span, 211-212, for the dedication of this monument and a precise date for the ornament found on it.

The ornate style of decoration that was characteristic of the arch at Leptis Magna is found here too. Some of the columns on the colonnade in front of the grand entrance hall at Sardis have leafy Corinthian capitals with heads projecting from them. One of these (fig. 9.22) has the head of a laughing satyr, derived from the Hellenistic tradition. The notion of putting heads and busts on architectural pieces was not completely new, but it became popular in the Severan era.

The way in which the architectural bays and niches at Sardis project and recede is also typical of the period. They may be compared to another Severan building, a theater (fig. 9.23), in a town in North Africa that is down the coastal road from Leptis Magna: Sabratha. Again, there are bays, and the capitals on the columns are carved in the same manner as those at Sardis.

Another building project of Septimius Severus that still survives is the so-called Porta Nigra in the German city of Trier, the ancient Augusta Treverorum (fig. **9.24**). (Some have considered it to be a work of the later third or early fourth century.) Constructed of a blackish sandstone that gives the gate its name, it is one of the later examples of the use of the arch combined with the pilaster. Unlike the decorative motifs on the Colosseum, these

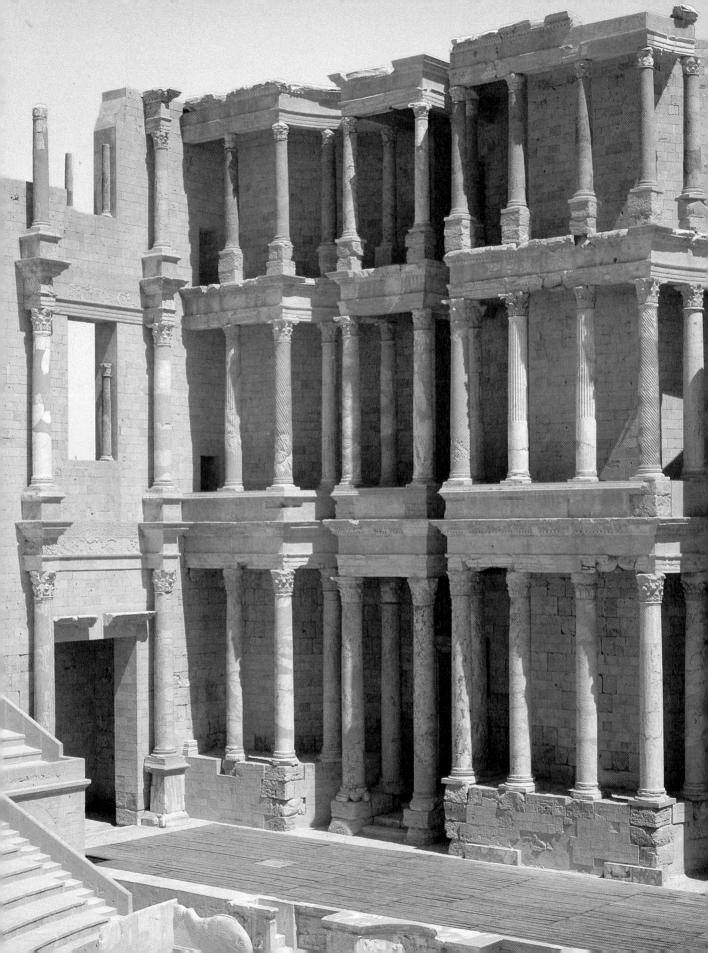

- **9.23** *Opposite* Theater, Sabratha. Late second century AD. Marble
- **9.24** *Right* Porta Nigra, Trier. Late second century AD. Sandstone. Height 98ft 5ins (30m)

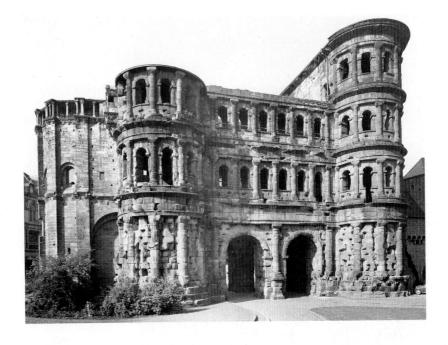

pilasters have simple Tuscan capitals at all levels. Two massive, rounded towers flank the thick gate through which there are two arched openings. The rhythmical continuation of smaller arches across the entire façade draws the full width of the gate together, making it into an impressive and elegant architectural masterpiece rather than simply a fortification. On the other hand, the Porta Nigra continued to serve as just that, a fortification, for several centuries.

The reign of Caracalla

With the advent of Caracalla began a new era of cruelty, such as had not been witnessed for over a century. One look at his portraits (figs. 9.25 and 9.26), all of which indicate at least a measure of the brutality of the man, will give a good sense of the character that lay behind so much evil. He typically has a threatening scowl and a sidelong glance, such as we see in the first of the two illustrations. The second, carved in Egypt in a hard red granite, captures something of the same scowl, transposed almost into an abstraction. The head, 1 foot 8 inches (51cm) tall, seems even larger than it is because of the power of the features. The chubby boy of the

9.25 Portrait of Caracalla. Early to mid-third century AD. Marble. Height 1ft 2¹/4ins (36·2cm). Metropolitan Museum of Art. New York, Samuel D. Lee Fund

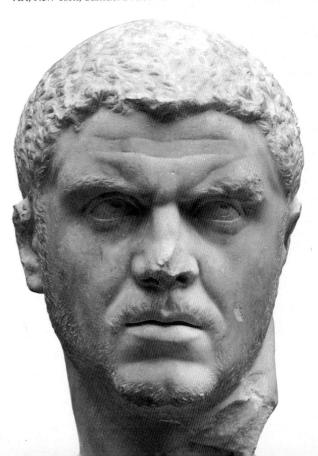

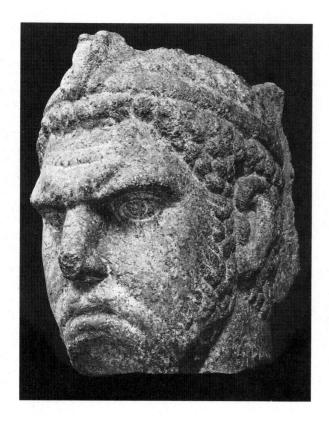

9.26 Portrait of Caracalla, from Egypt. Early third century AD. Red granite. Height 1ft 8ins (51cm). University Museum, University of Pennsylvania, Philadelphia, Pennsylvania

painted roundel turned into a heavy-jowled man with protruding, wrinkled forehead. The face is a believable one for a man who was capable of killing his younger brother, and instituting a new reign of terror.

On the other hand, he had administrative skills, and broadened the base of citizenship throughout the empire. Was this a form of philanthropy, or to broaden the tax base? More likely it was the latter, for he had problems with enormous inflation that was exacerbated by the development of a new coin, the *antoninianus* (fig. **9.27**), that was supposed to be worth two silver *denarii*. In fact the coinage became

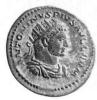

9.27 Debased silver coin of Caracalla, an *antoninianus*. AD 214. Diameter 7/sin (2·9cm). British Museum, London

debased, and copper coins washed with silver were then considered silver coins. This situation continued to worsen until the reforms of Diocletian at the end of the third century, but even they were largely unsuccessful at dealing with the problem of a huge imperial deficit. It remained for Constantine to restore faith in the value of money with the inauguration of the *solidus*, a gold coin.

PUBLIC BATHS

The most important public project sponsored by Caracalla was the completion of the great baths in Rome that had been initiated by his father, and which are known as the Baths of Caracalla. The plan (figs. 9.28 and 9.29) shows a basically rectangular and symmetrical arrangement. As in all Roman baths, at the core were the three essentials: the frigidarium, the tepidarium, and the caldarium (see above, p.153). There was also the swimming pool open to the sky, the natatio, and small "plunge baths." What is new here, and what is typical of late imperial bath complexes, is the fact that the central block with the different pools was surrounded on all sides by open spaces for gymnastic exercises, whereas previously (see above, fig. 6.1), this block ran into one side of the surrounding enclosure walls. Although the complex was so large, the general arrangement was typical of smaller bath buildings all over the empire. Every town could be counted on to have one or more of these establishments, and going to a public bath was part of everyday life in the Roman world.

It used to be possible to get some sense of the size and grandeur of the *frigidarium* by going to the old Pennsylvania Railroad Station in New York City (fig. **9.30**). This building, now demolished, was modeled on the Baths of Caracalla, and its vaulting recreated the Roman construction that had been carried out in concrete.

At the Baths of Caracalla, the enclosed area for running and games was huge, measuring 1,076 by more than 1,315 feet (328×400m). There were even libraries and gardens within these walls. As with the earlier imperial baths, a magnificent building of this nature, built by the emperor for the public good, could not have failed to reflect well on the image he wished to create as one concerned for the welfare of his people.

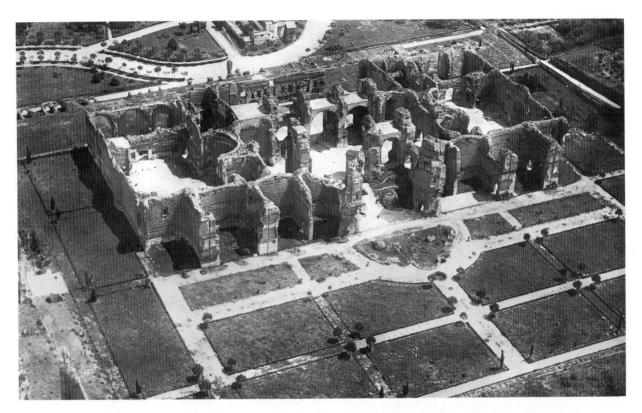

9.28 Above Aerial view of the Baths of Caracalla, Rome. c. AD 211–217. Marble and concrete

9.29 Below Baths of Caracalla, Rome, plan

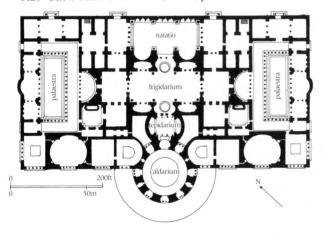

9.30 *Right* Interior view of the waiting room of the old Pennsylvania Railroad Station, New York City. 1906–1910. Travertine, marble, and plaster. A copy of the Baths of Caracalla by the architects McKim, Mead, and White. Now demolished.

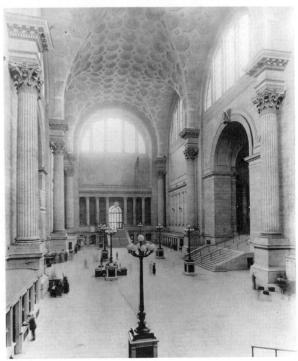

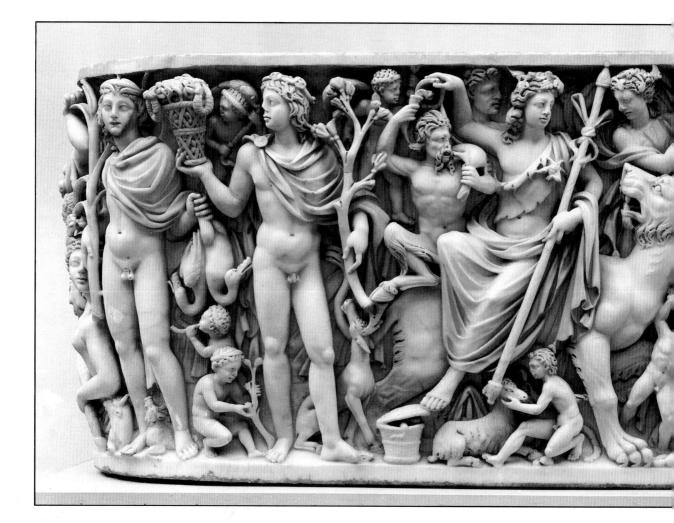

SARCOPHAGI

The figures on sarcophagi in the late Severan period continue to show a dependence on classical models, and yet the sculptors no longer had the same interest in individual details of anatomy and drapery as their predecessors. Like the artists who carved the figure of Victory on the arch at Leptis Magna (see above, fig. **9.9**), with her sinuous grace that is disconcerting at first glance, so the sculptors of sarcophagi had a new way of looking at figures.

A good example is the Season Sarcophagus (fig. 9.31), sometimes called the Badminton Sarcophagus after the home of its former British owners. It is a tub-shaped marble coffin that reminds us of a wine vat; suitably, the subject matter here is the triumphant Dionysus, shown

9.31 Bacchus and the four Seasons, the so-called Badminton Sarcophagus. *c*. AD 220. Marble. Height 3ft 3ins (99·1cm). Metropolitan Museum of Art, New York, Joseph Pulitzer bequest

together with naked youths representing the four Seasons. Each Season stands with his weight on one leg, and the other one relaxed in front of him; but the weight distribution is not convincing. The musculature looks somewhat out of condition.

Dionysus in the center rides a panther, and is surrounded by various types of followers: satyrs, animals, and small children who are derived from representations of Cupid. Associations with the cult of Dionysus are shown, including *maenads* clashing cymbals, music, dancing, and wine. Trees and vines,

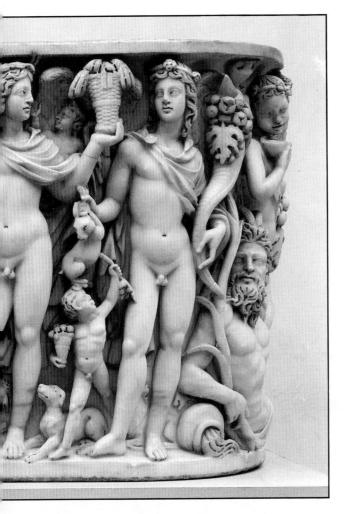

latter (fig. 9.32), who came to the throne at the age of 14, we see a similarity to the youthful portraits of Caracalla, probably because it was important to emphasize the relationship so as to back his claim to the throne. Characteristic of this latest Severan style is the hair that lies close to the surface of the head, and the emphasis on the hairy eyebrows, in contrast to the very smooth skin. The eyes look off to the side, but unlike the scowling expression of Caracalla, they have a more soulful look. In some ways this head presages the expressionistic heads of the mid-third century, but in others, Caracalla's portraits served as the model for the next generation. His tough, fierce expression and reputation must have appealed to the soldiers who were to become emperors over the following decades.

9.32 Portrait head of Alexander Severus. *c.* AD 220. Marble. Height 2ft 6ins (76·2cm). Museo Capitolino, Rome

characteristic of the countryside, are interspersed between the figures. The whole gives a rich impression of people, animals, and vegetation, and yet the effect is quite different from the sarcophagus described above which also had a dionysiac theme (see above, fig. **8.30**). There, the sculptor seemed to have better control of bodies, drapery, and plant forms.

After Caracalla's assassination in AD 217, there was a brief rule by the military prefect who had arranged for the murder of the emperor, but then, through the intrigues of some of the female members of Caracalla's family, two more Severans came to power: first, the much-hated Elagabalus, and then his cousin Alexander Severus. In this portrait of the

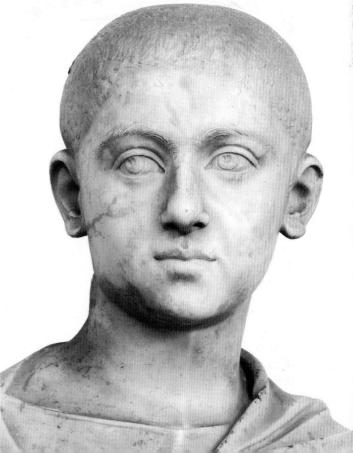

10 The Soldier Emperors AD 235–284

Between the assassination of the last of the Severans in AD 235 and the beginning of Diocletian's reign in 284, more than 25 men bore the title of emperor. Most were not elected by the Senate but proclaimed by the army. Perhaps more than anything else, the age of the soldier emperors is epitomized by the portraits that record a series of frighteningly aggressive faces. The rulers were almost without exception fierce army men, and this shows clearly in both sculpture and coinage. It is not only the emphasis on military types that leaves such a vivid impression on the viewer; equally important is the new style in portraiture. Sharply defined faces, and an emphasis on the shape of the cranium, are characteristic of the period. There are also new techniques for defining short hair, which is now articulated through the use of punches and chisels. It is as if the coarseness (and brilliance) of the technique helps to capture the brutality of the age.

Opposite Battle between Romans and barbarians, detail of fig. **10.14**. Ludovisi Sarcophagus, from near Rome. *c.* AD 250. Marble. Museo Nazionale Romano, Rome

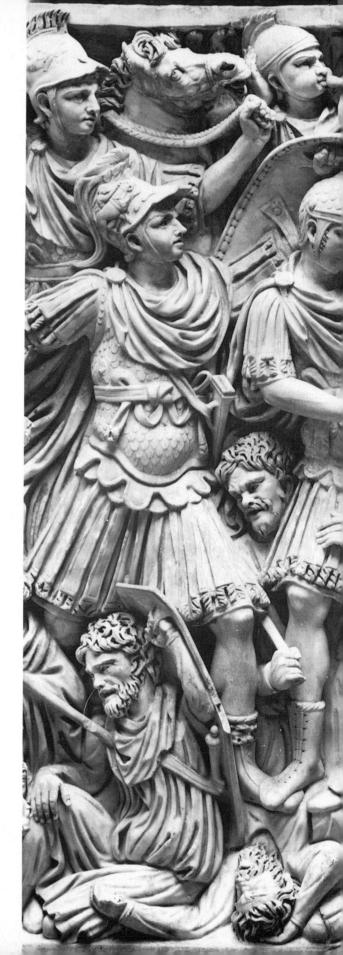

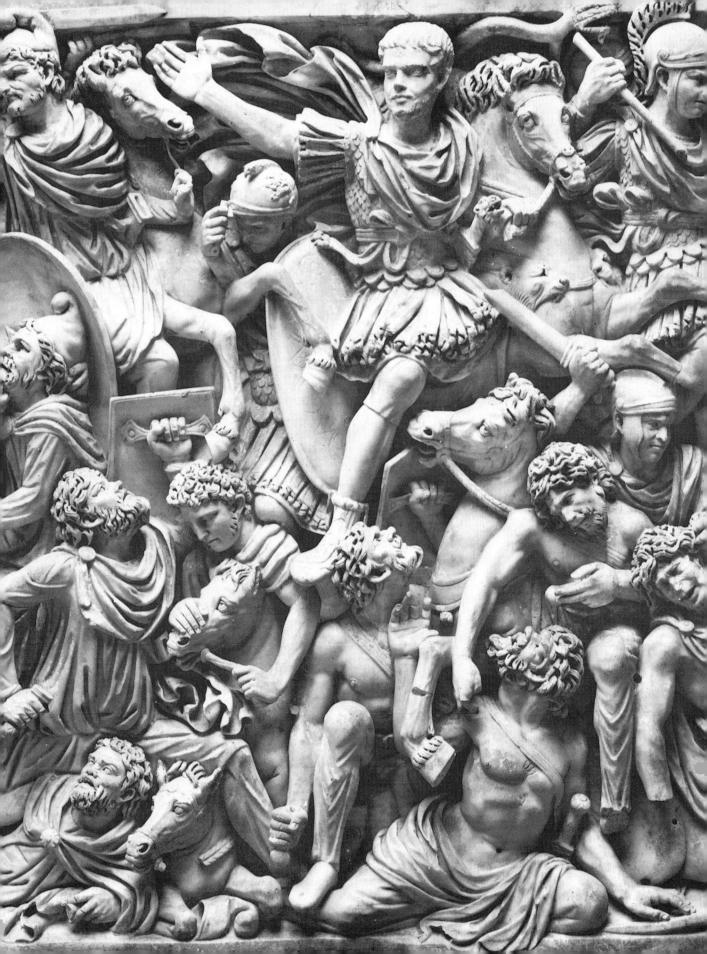

Such changes in style and technique reflect a new emphasis on a psychological approach to portraiture. There had been a move in this direction under the Antonines, and to a certain extent in the later Severan period, but portraits under the soldier emperors tend to be even more expressive. The causes for these stylistic changes lie in a fundamental new anxiety that plagued not only the emperors, but the people as a whole. The old order had broken down, and confidence in the system had reached a new low point. Many people turned at this time to new doctrines such as mystery cults that held out hope for salvation. Furthermore, those who adopted the Neoplatonic philosophy which became popular in the mid-third century were more interested in the spiritual than the physical aspects of portraiture. All of these forces combined to create a new style that emphasized the inner qualities and concerns of the sitter.

Throughout the middle of the third century AD, for about 50 years, no emperor could hold the reins of power without the force of the army behind him. On the other hand, military politics enabled one or another of the generals or other usurpers to come to power abruptly. In this period no one could maintain his position for more than a few years, and some emperors lasted no more than a few months. Almost all, having taken power upon the murder of the preceding emperor, came to a premature and violent end. Meanwhile there were constant wars at the borders of the empire. Under these conditions, political stability was non-existent, and there was little time or interest in embellishing cities with fine sculpture or architecture, or decorating private and public places with paintings and mosaics. Hence, during these years there was not much in the way of building projects; the army corps of engineers was off fighting, and had no time for construction. Most areas of artistic output in this era were thin, with three notable exceptions: coins, portrait sculpture and sarcophagi.

Coins

The coins are more important than in previous eras for giving us a series of official images that helps us identify the likenesses of even those emperors with very short reigns, whose three-dimensional portraits are very rare. The coin series also gives us representations of pretenders to the imperial throne, whose other portraits were almost certainly suppressed. Besides their iconographic interest for identification, they are useful as a datable and independent standard of stylistic changes.

Portraits

To a greater or lesser degree, Roman portraitists had always been striving toward a true likeness of the individual. Divergences had depended upon how much idealism or generalizing or specificity was desired in one period or another. Now, in the third

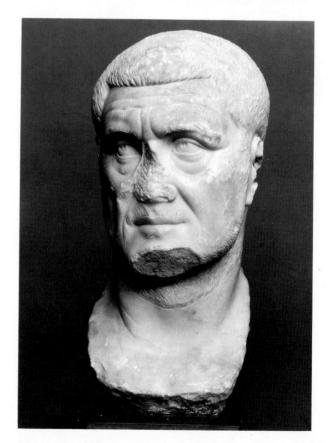

10.1 Portrait of Maximinus Thrax. *c*.AD 235. Marble. Height 1ft 5ins (43·2cm). Ny Carlsberg Glyptotek, Copenhagen

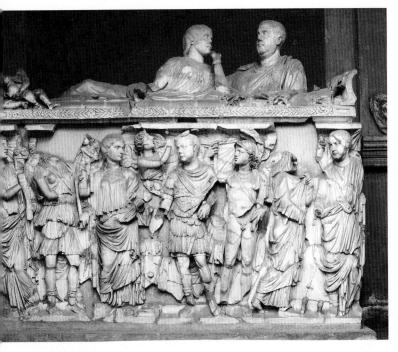

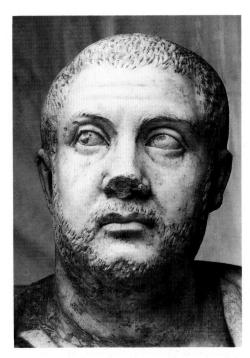

century, new elements became important: abstraction, and an increased interest in psychological depth. Realism in portraits was still important, in some ways even more so than earlier, but there was also a tendency to emphasize abstract lines in the face and the general shape of head or hair. In addition, the brow was often wrinkled as if to indicate anxiety, and the eyes were given the impression of gazing into the future.

MAXIMINUS THRAX

Maximinus Thrax (AD 235-238), an army general from Thrace in northern Greece, took over after the murder of Alexander Severus. He was a fierce and uncultivated peasant of great stature, with a talent for wrestling but no interest in any aspect of government other than support of the army. In his portraits (fig. 10.1), which emphasize his violent and brutal character, he glowers from under the heavy brows. The deep lines of forehead and cheek on the squared face emphasize the scowl that had been introduced in the portraits of Caracalla.

Here, hair was treated in a new way: instead of giving an impression of volume by drilling, the sculptors carved the hair nearly flat. Peck-marks give the idea of texture in what is almost exclusively

10.2 Left Sarcophagus of Balbinus. c. AD 238. Marble. Height 6ft 7ins (2m). Catacomb of Praetextatus, Rome

10.3 Above Head of Balbinus, detail from sarcophagus of Balbinus. c. AD 238. Marble. Lifesize. Catacomb of Praetextatus, Rome

a surface treatment. The close-cropped hair projects slightly and evenly from the level of the skin, and upon this wig-like surface numerous short chisel marks give the impression of real hair.

Only three years after ascending to power, Maximinus Thrax was himself overthrown and murdered by his own soldiers. In that year, AD 238, there was a total of five emperors: after the death of Maximinus, a father and son, both called Gordian, ruled together; and then two men, Pupienus and Balbinus, were elevated to the throne by the Senate. But their joint reign lasted only about three months before they too were murdered by the army.

BALBINUS

A sarcophagus thought to be that of Balbinus and his wife (fig. 10.2) includes portraits carved on the figures who lie on the lid as well as in relief on the front, where their wedding and a sacrifice are represented. The custom of putting reclining figures on the top may ultimately look back to the Etruscan tradition, but it may have come more directly from the practice used on the lids of some Attic sarcophagi. This realistic but unflattering portrait on the lid (fig. 10.3) shows that Balbinus was overweight and had a wide face and double chin. His hair has even less volume than that of Maximinus Thrax, and the shape of his cranium is emphasized. The style is reminiscent of several late Republican heads. Short chisel marks define the moustache and short stubbly beard, as well as the hairstyle that had been made fashionable by Caracalla. But what had in his case been carved in three-dimensional volumes was now cut just into the surface.

PHILIP THE ARAB

Among the most dynamic of the portraits of the soldier emperors is that of Philip the Arab (AD 244–249) (fig. **10.4**). He was a native of Syria who, when appointed prefect of the Praetorian

10.4 Portrait bust of Philip the Arab. AD 244–249. Marble. Height 2ft 4ins (71·1cm). Musei Vaticani, Rome

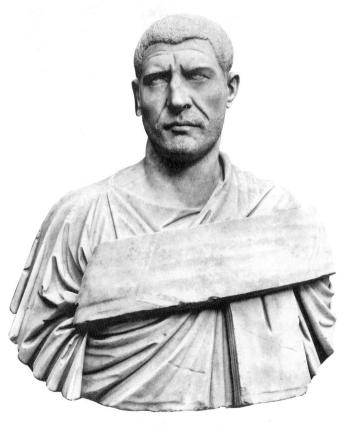

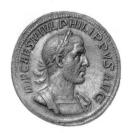

10.5 Medallion of Philip the Arab. AD 244. Silver. Diameter 1½ins (3·8cm). Museum of Fine Arts, Boston, gift in memory of Zoe Wilbour

Guard, promptly began plotting against the emperor. Success was short-lived: five years later he was himself overthrown and murdered. His portraits show the harsh reality of the subject, and yet reveal a remarkable sensitivity in the artist. His worried eyes peer expressively from under the protruding brows. The turn of the head seen here had been introduced as a formal device in portraits of Caracalla, and repeated in those of Maximinus Thrax. But now the eyes look upward, as if for divine inspiration, rather than downwards and aside as had been the practice for Caracalla.

Philip's strength of character is also expressed through the long, bony, Semitic nose, thick-lipped mouth, and by the deeply lined face. Perhaps most remarkable of all is the way the artist was able to capture here a moment in time, as if Philip's face were moving, and the particular, fleeting expression had been caught in stone. Such skill is one of the great accomplishments of third-century portraiture.

Philip wears a different kind of garment, the trabeated toga, which has a broad, flat band drawn across the chest; this was to become the typical dress of the late empire. It was made of a heavy material, and normally had only a few rather stiff folds that added to the feeling of formality of these later portraits. His hair is also severe, almost like a cap from which short flecks of stone have been removed. We see all of these features repeated on one of his coins (fig. 10.5).

TREBONIANUS GALLUS

Another of the short-lived emperors was Trebonianus Gallus (AD 251–253), who was the first in a long time to come from an old Italic family. We may have a portrait of him in the large bronze statue, measuring 7 feet 11 inches (2·43m), in the Metropolitan Museum (fig. **10.7**). His raised right hand would have held a lance. This is the only more or

10.6 *Below* Trebonianus Gallus, detail of head. AD 251–253. Bronze. Metropolitan Museum of Art, New York, Rogers Fund

10.7 *Right* Full-length naked portrait of Trebonianus Gallus. AD 251–253. Bronze. Height 7ft 11ins (2·43m). Metropolitan Museum of Art, New York, Rogers Fund

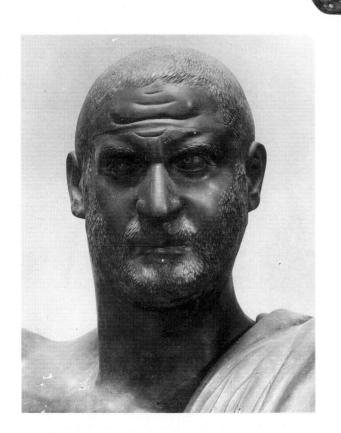

less complete bronze statue of an emperor (put together from many fragments) that survives from the period. At least, it appears to be an emperor, because, so far as we know, no ordinary citizen would have been honored by such a large statue. The identification is based on the similarity of the head to coin portraits.

The figure is naked, save for a single piece of cloth slung over his shoulder and left arm, and an elaborate pair of sandals. The effect of the huge naked figure, with long legs and arms, but short, squarish torso and a head that seems much too

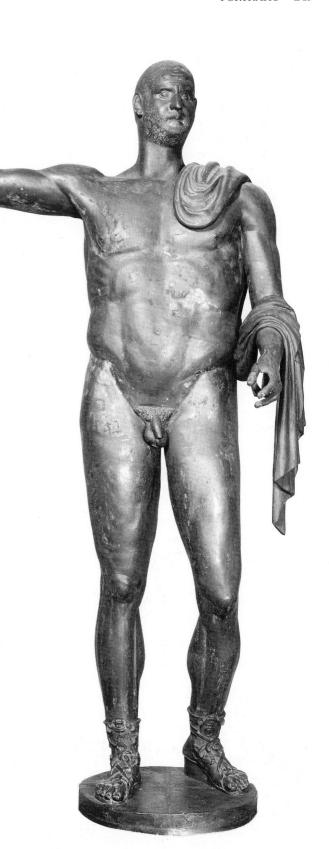

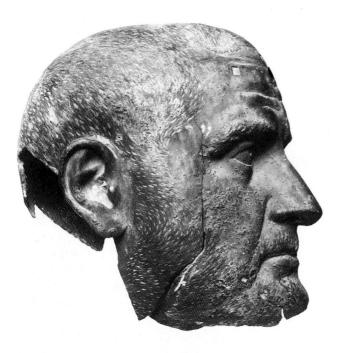

10.8 Portrait of Trebonianus Gallus. AD 251–253. Bronze. Height 10½ins (26·7cm). Museo Archeologico, Florence

small for the body, can only be described as grotesque. There is no interest here in the ideal body proportions of classical statuary. The surface of the head, nicked to show the texture of hair, does not rise above the surface of the skin (fig. 10.6). The artists had by now developed a crude, if effective, technique for indicating surface textures. This can be seen even more clearly in a bronze head (fig. 10.8) that may represent the same emperor. The marks in the beard and hair are applied in a pattern that seems to reflect the growth of hair.

A FEMALE PORTRAIT

A fine example of a female portrait from the period of the soldier emperors (fig. **10.9**) shows something of the psychological observation that characterizes so many of the male counterparts of this era, but without the same tension. The heavy hair, parted in the middle and falling behind her ears, is a coiffure that developed from that of Julia Domna (see above, fig. **9.5**), but that had become somewhat altered by some of the empresses who followed. The sidelong

glance, and the slightly smiling mouth, give this face an uneasy expression, and at the same time a certain liveliness.

GALLIENUS

The emperor Gallienus (AD 253–268) brought about not only a new portrait style, but he also encouraged a spirit of learning and culture that had not been seen for a long time. He instituted a kind of renaissance of old Roman values, and a resurgence in interest in the arts. He was the son of the emperor Valerian, and had been co-ruler with his father until the latter was taken captive by the Persians in AD 260. Gallienus' total reign, both as

10.9 Female portrait and half-body bust. First half of third century Ad. Marble. Height 2ft 1½ins (64·8cm). Marble. Metropolitan Museum of Art, New York, Rogers Fund

10.10 Portrait of Gallienus. AD 253–268. Marble. Height 1ft 2½ins (36·8cm). Antikensammlung, Staatliche Museen, East Berlin

partner and as sole emperor, lasted about 15 years, which was longer than anyone had ruled since Septimius Severus.

His portraits (fig. **10.10**) show a handsome man, whose hairdo is clearly intended to remind the viewer of Augustus. Note the way the divided locks fall on the forehead. The emphasis here is on Gallienus' sensitivity and intellect instead of on brute strength – the hallmark of his predecessors. The artist's attention to the thoughtful eyes and sensitive mouth may be not only a reflection of the man himself, but also a public statement about his suitability to take over the reins of power from his father.

In the time of Gallienus, Neoplatonic philosophy became important under the leadership of the great philosopher Plotinus. His beliefs minimized the importance of physical likeness in portraiture, and put more weight on the spiritual content and the inner emotions. These beliefs were in direct opposition to the ideals of Greco-Roman classicism, and must have had an important effect on the changes witnessed in the second half of the third century and thereafter; for Neoplatonism was to be highly influential in the Middle Ages and the Renaissance.

We may have a portrait of Plotinus in this head, one of three of the same person preserved at Ostia (fig. **10.11**). In contrast to the techniques used for the military emperors, the carving here is done in a way that emphasizes the soft textures of face and skin. There is a timelessness to the expression, and a

10.11 Plotinus, from Ostia. c. AD 260–270. Marble. Height 1½ (33.7cm). Ostia Museum

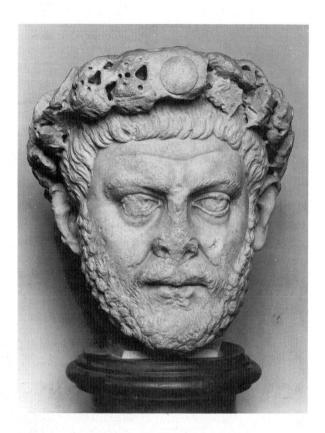

10.12 Portrait of Aurelian (or Diocletian) with an oak leaf crown. AD 270–275. Marble. Height 1ft 3½ins (39-4cm). Istanbul Arkeoloji Müzeleri, Istanbul

deep thoughtfulness, characteristic of philosopher portraits that go back to the fourth century BC; and yet the head seems to anticipate the distance and abstraction of portraits that came a few years later, at the end of the third century AD.

AURELIAN

Gallienus was done away with in an army coup in AD 268, at least partly instigated by Aurelian, who became emperor shortly afterwards. We may have a portrait of him crowned with an oak wreath (fig. 10.12), although this is sometimes thought to be one of his successors, Diocletian. The eyes here seem to stare off into space, and the face is symmetrical and even immovable; yet the treatment of flesh, muscles, and hair is far more plastic than had been common until the time of Valerian and Gallienus.

The Aurelian Wall

In his five-year reign Aurelian proved to be one of the most successful of the soldier emperors, especially in his efforts to ward off the enemies at the borders of the empire and even to chase them from Italy itself. Indeed, this incursion from the north was sufficiently threatening for him to build a great defense, known as the Aurelian Wall, around the city of Rome (figs. **0.3** and **10.13**). This was the first time it had seemed necessary to fortify the capital since the Gallic invasions of the fourth century BC; previous defenses had been in far-flung corners of the empire, but not in the homeland. The Aurelian Wall anticipates the medieval fortifications that would encircle towns, both large and small, in the following centuries.

The circuit was put up with remarkable speed, in many cases using the walls of existing buildings or enclosed spaces, and incorporating many bits of disused or neglected monuments, often of marble that contrast oddly with the even tone of the red. coursed brick used for most of it. The circuit had a length of 12 miles (19.3km), with square towers erected every 100 feet (30m) to serve as artillery platforms and to offer the possibility of crossfire against an approaching enemy. Its original height, which was increased during several renovations, was about 25 feet (7.5m) and it was probably thought of more as a screen than as protection from a serious or prolonged siege. The general organization is comparable to the frontier walls in Britain and Germany (see above, p.180). The colossal effort of making such a grand wall, which is still one of the most imposing monuments in Rome, and the widespread taking of private property for the purpose, shows the determination of the frightened Romans to defend the city against the northern hordes.

10.13 Aurelian Wall, near Porta San Sebastiano, Rome. AD 271–275. Brick and concrete. Height 24ft 6ins to 32ft 9ins (747–9·98m)

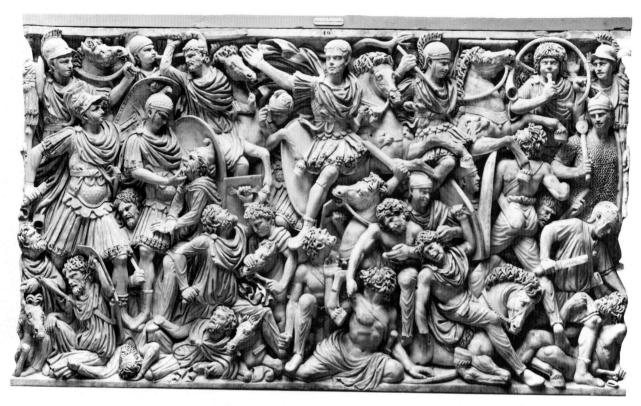

Sarcophagi

Ever since the mid-second century, inhumation of the dead in elaborately carved stone sarcophagi had been growing in popularity, at the expense of the more traditional custom of cremation. Figural subjects of many kinds were popular on sarcophagi, especially dionysiac scenes and generalized battles. In spite of the variety of subject there is a unity of purpose in the search for salvation. These themes suggest the triumph over death or offer access to a life hereafter. Some of the allusions are much more obvious than others, but the spirit of the age is shown in the increasing devotion to religions or mystery cults that promised a better life after death.

Perhaps the most impressive sarcophagus of the period is the Ludovisi Sarcophagus (fig. 10.14), so called for the cardinal in whose collection it belonged after its discovery in the early 17th century. Dated to the period after the middle of the third century, it is the last of the great battle sarcophagi — a type which had been popular for some time. The person being honored here rides the

10.14 Battle between Romans and barbarians, detail of the Ludovisi Sarcophagus, from near Rome. *c.* AD 250. Marble. Height *c.* 5ft (1·52m). Museo Nazionale Romano. Rome

horse in the top center of the relief as he ostensibly leads his troops into battle against the barbarians. His head, distinctly a portrait, must have been sculpted by a specialist.

The central hero rises out of the mass of figures below him, but seems to have nothing to do with them; he looks off into the distance, and makes a grandiose gesture that does not apparently relate to the suffering portrayed everywhere else. All around him the battle rages, and two men, one near each of the upper corners, accompany the noises of battle with sounds of the trumpet. Overall, the effect is one of deep undercutting and writhing movement, with a pattern of arms, legs, and heads – not always attached to an obvious body. Roman soldiers, easily distinguished by their helmets, breastplates, and tunics, attack the enemy, who wear long, baggy pants, and sport heavy beards. In general, the Roman figures seem to hold more prominent

positions, but our attention and our sympathy are drawn, rather, to the faces and expressions of the barbarians (fig. **10.15**).

Another sarcophagus of the period, perhaps from about AD 270, is the one from Acilia, which lies about halfway between Rome and the coast (fig. **10.16**). The shape, rather like a tub, was used at this time for several men of senatorial rank, who are typically shown in a procession associated with their assumption of duties. On this example the best preserved portions are at the left, where men with deeply carved hair and intellectual faces walk in the procession with the senator.

The youthful figure, probably the son of the senator, is clearly a portrait. His pupils are deeply drilled, as are the inside corners of his eyes, and, in contrast to the others, he wears his hair very short. All the figures are carved in high relief, and appear to be quite free of the background – although they are not. They wear long togas, whose loose folds are used to make connecting patterns between the figures. The young boy stands out from the company of older philosophers not only because of his age, but also because of the different style of carving. His thoughtful, if distant, expression, is a foretaste of the kind of extreme abstraction that would come into vogue at the end of the century.

10.15 Head of a dying barbarian, detail of the Ludovisi Sarcophagus, from near Rome. c. AD 250. Marble. Height c. 5ft (1·52m). Museo Nazionale Romano, Rome

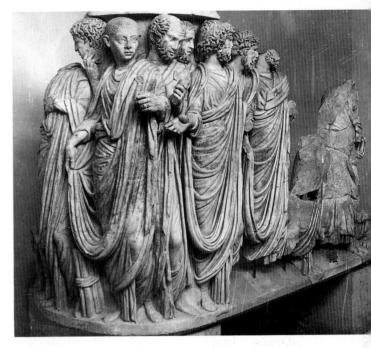

10.16 Members of the senatorial rank pointing to the son of a senator, detail of a sarcophagus from Acilia, near Ostia. *c*. AD 270. Marble. Height 4ft 10½ins (1·49m). Museo Nazionale Romano, Rome

The age of the soldier emperors had been marked by civil strife and a lack of security. The ruthlessness of both the army and a string of emperors had meant that state-condoned murders were not unusual. In such an unsettled time, one of the most outstanding artistic developments was the emphasis on frank portraits that revealed the tensions of the era, and harsh portrayals of the emperors are found in both sculpture and coinage.

The sculptors also produced numerous sarcophagi, many of which refer to real or imagined battles. The successful generals portrayed on reliefs of this kind indicated not only that the deceased had been a military hero, but implied too that he would be victorious in achieving a happy afterlife.

Men who ruled during the half century known as the period of the soldier emperors had little time, money or interest in sponsoring large-scale building projects. But the threat of invasion from marauding barbarians forced the emperor Aurelian to build the impressive city wall that still stands as one of the great monuments of Rome.

11 The Tetrarchs AD 284–312

Since Republican times, Roman rulers had been using art as a means of serving the state, and of promoting their own aims. The possibilities were never exploited more powerfully than under the rule of the Tetrarchs, those groups of four rulers who shared top responsibility in the government. The distance of the emperors from the populace was increased through much elaboration of the court ceremony in ritual and dress, mentioned in the biographical texts and seen in the arts and buildings.

In monumental new buildings and in sculpture, they made sure that their message of joint power, firmer and more stable than what had gone before under the soldier emperors, was clear to the people. In portraiture, individuality became almost totally obscured in abstractions that were carried to new heights. The impression of power was more important now than the specific features of the person who wielded it.

The unsettling turnover of emperors came to an end in AD 284, when Diocles, a general from what is now part of Yugoslavia, was declared ruler in the town of Nicomedia (modern Izmit). His rule was to bring profound

11.1 Santa Maria degli Angeli, converted by Michelangelo from the central hall of the Baths of Diocletian, Rome. Baths AD 298–306; conversion to a church 1563–1566. Height $\it c.$ 90ft (27-4m)

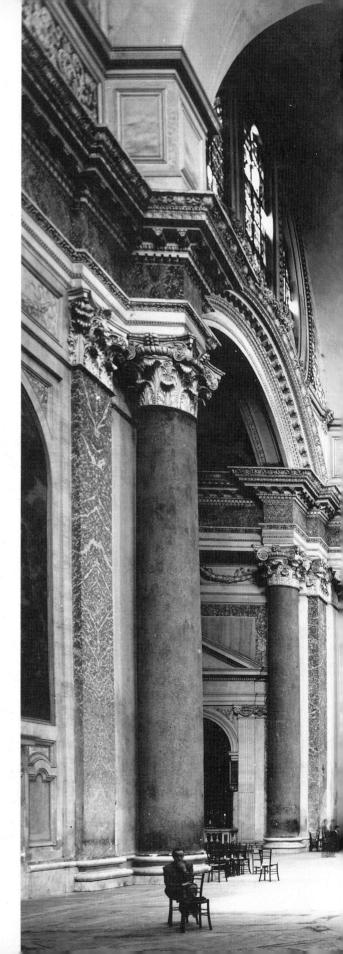

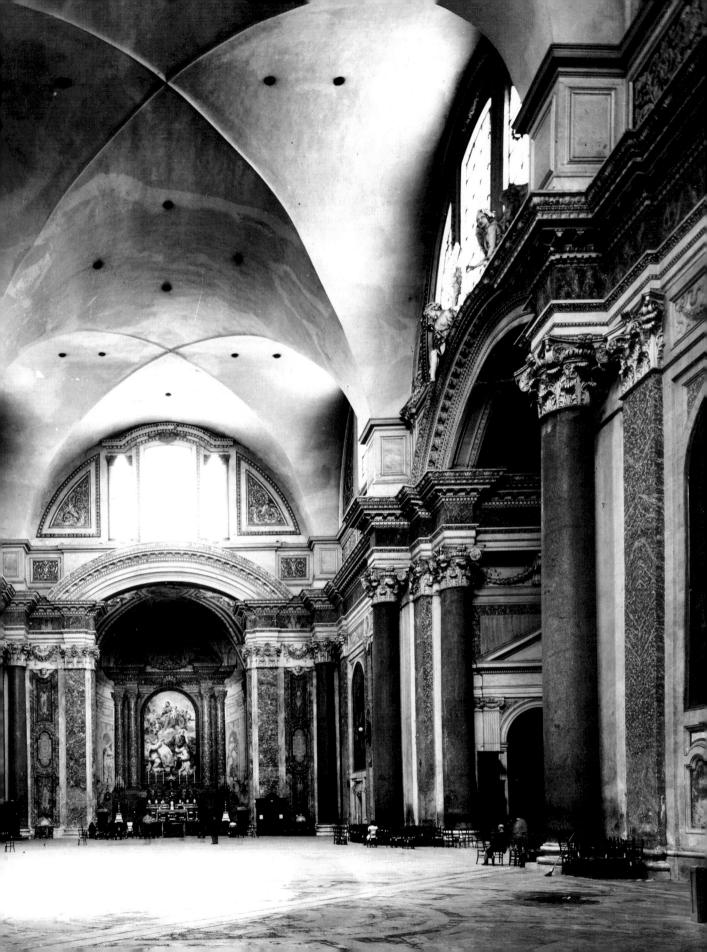

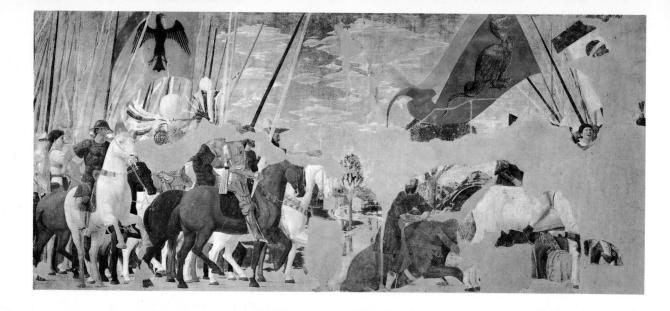

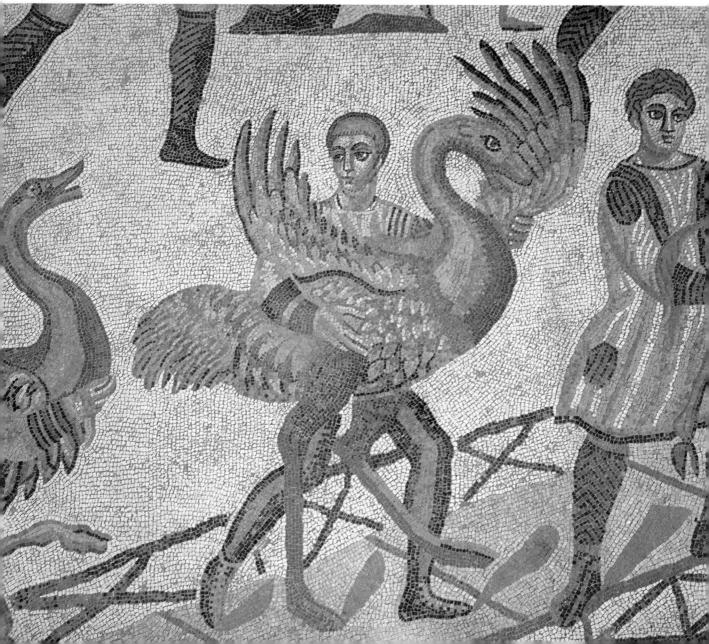

changes to Roman culture and would produce an art even more obviously at the service of the state than had been seen until then. His reign illustrates clearly how the organization of the state and the purposes of its rulers were reflected and projected by works of art and architecture.

The establishment of the tetrarchy

Diocles, who quickly took the name of Gaius Valerianus Aurelianus Diocletianus, to enroll himself in the families of his predecessors, inherited the same problems as they had, but he took immediate steps to deal with them. Many of his solutions were simple - perhaps over simple - and caused much hardship, even for those supposed to benefit. The decisions that had the most effect upon the arts were in the realm of political organization.

Soon after being proclaimed emperor, he invited a colleague, Marcus Aurelius Valerius Maximianus, to be co-ruler as Augustus. Subsequently (AD 293) Gaius Galerius Valerius Maximianus and Gaius Flavius Constantius, known as Constantius Chlorus, were appointed Caesares, junior members of the team. The titles and the association of colleagues as helpers or likely successors were not new, but the official recognition of authority over different territorial domains within the empire was a radical departure. The empire was by this arrangement governed by four administrators, two Augusti and two Caesares (junior colleagues and heirs apparent), each with his own geographical area, army, and administrative center.

Thus, Diocletian controlled the eastern part of the empire from Thrace to Egypt, and had his capital at Nicomedia; Maximian saw to Italy and Africa, and indeed the entire Roman west, from an administrative center at Milan, rather than Rome:

11.2 Opposite top Constantine pursues Maxentius across the Tiber River. c. 1460. Wall painting by Piero della Francesca. Height 11ft; width 24ft $(3.35 \times 7.32 \text{m})$. San Francesco, Arezzo

11.3 Opposite bottom Detail of the great hunt, in the villa at Piazza Armerina, Sicily. Early fourth century AD. Mosaic

Constantius Chlorus ruled at Trier, and Galerius at Sirmium (Sremska Mitrovica in Yugoslavia, not far from Belgrade). Diocletian was under the protection of Jupiter, and Maximian under that of Hercules - connections which are significant for understanding much imperial iconography on the coins or on historical reliefs.

Each of the Tetrarchs initiated a major construction program for suitable palaces, offices, and public buildings that were appropriate to the dignity of the Roman state. Like many of their predecessors, they used these for propaganda, and hoped to show through huge and lavish buildings that the greatness of Rome had been renewed after the stresses of the past decades. This gave rise to a great deal of building and a need for much decorative and commemorative sculpture. And because the reorganization was not confined to the upper echelons of government, smaller and more numerous units of government were created, and this gave rise to additional building and aggrandizement in many provinces.

Architecture in Spalato

After 20 years in power, Diocletian retired to the villa he had built at Spalato (now called Split) in his native Illyricum, in Yugoslavia. It is clear from its exterior form (figs. 11.5 and 11.6) that he was expecting hostile attempts on his life, or perhaps just general unrest in the countryside. The layout was rectangular, slightly deeper than it was wide, approximately 650 by 550 feet (200×170m), and one side faced the sea. The other three sides were provided with a high wall with a small gate in the center of each, and square towers at the corners with smaller towers in between. The gates themselves were framed and protected by octagonal towers, and on the north side the surround was decorated with a columnar arcaded façade and niches for statuary. The narrowness of the actual entry ways and the existence of a second gate beyond a sizable courtyard give the impression of a fortified camp, and emphasize the preoccupation with the safety of the owner. The notion of a fortified villa prefigures the medieval castle.

Besides general provisions for his daily life and

11.4 *Right* Peristyle, Palace of Diocletian, Split. *c*. AD 300

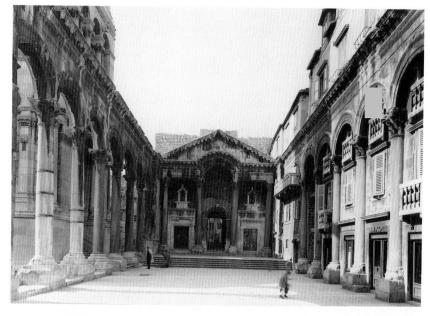

11.5 *Below* Plan of the Palace of Diocletian, Split. *c*. AD 300. *c*. 650×550ft (200×170m)

11.6 *Below right* Palace of Diocletian, Split. *c*.AD 300. Artist's impression of an architectural reconstruction by E. Hébrard

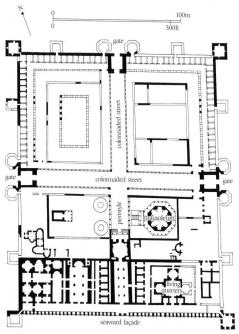

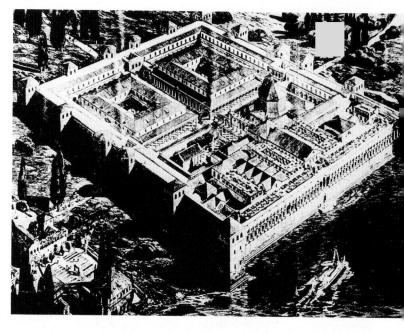

that of the staff, Diocletian, even as an ex-emperor, required some accommodation appropriate to his station. This included a colonnaded court (fig. 11.4) with a ceremonial doorway at one end where the "emperor" could make a formal appearance. The court, called the peristyle, uses arches springing directly from the column capitals without inter-

vening architraves (the horizontal architectural elements that surmount the columns). Constructions like this became popular in the aisles of Early Christian basilicas. The grand doorway brings into prominence for ceremonial uses a motif that had been utilized in architectural façades for many years; here it acts as a translation of a triumphal

arch with all its attendant associations. It makes literal the implications of many architectural forms and ceremonial situations, and gives focus and status to the one-time guardian of the Roman state.

Following the tradition of a number of previous emperors, Diocletian made preparations for his death and the perpetuation of his memory in the form of a mausoleum that was built within his palace complex. It later became the cathedral, an ironic turn for the grave monument of somebody who had been one of the worst offenders in the persecution of early Christians. The octagonal building, surrounded by a row of columns, nestled within a courtyard off the central peristyle. The whole was roofed by a cupola decorated with mosaics.

The size and facilities of Diocletian's palace are remarkable; in the 18th century most of the town of Spalato was contained within the walls. We can attribute its preservation to the ongoing adaptive use of the well-built structure.

11.7 Baths of Diocletian, Rome. 16th-century etching by E. Du Pérac. Height 9ins; length 1ft 3½ins (22.9×39.4cm)

Architecture in Rome

In Rome the most notable monument to have survived from the period of Diocletian's rule is the bath complex that bears his name (fig. 11.7). Its scale and layout are equivalent to the Baths of Caracalla (see above, figs. 9.28 and 9.29). Much of it still stands, and it is used today as the Museo Nazionale Romano delle Terme (National Roman Museum of the Baths). The frigidarium was converted by Michelangelo into the church of Santa Maria degli Angeli, and because of his renovations in 1563, before the central part of the building had fallen in, another grand vaulted interior has been preserved that gives us a real feel for Roman roofed spaces (fig. 11.1, p.252). In fact it would have been grander still because the floor has been raised about three feet and the ceiling is missing its rich decoration.

Much building activity and the restoration of older buildings are attributed to Maxentius. The son of Maximian, he became one of the "second generation" of Tetrarchs. He had control of Italy from AD 306 to 312, when he was defeated and killed outside Rome by the forces of Constantine the

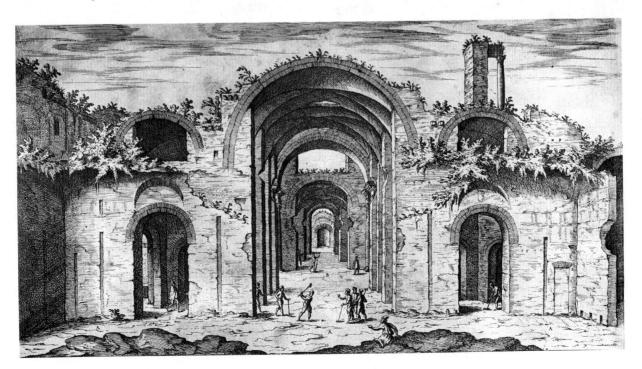

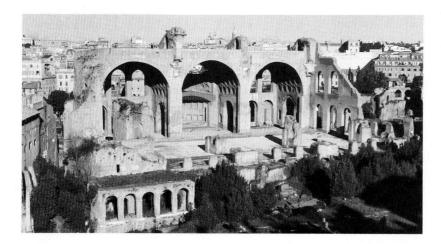

11.8 *Left* Basilica of Maxentius and Constantine, Rome. *c*. AD 306–313. Brick and concrete

- **11.9** *Below left* Basilica of Maxentius and Constantine, Rome, plan
- **11.10** *Below* Basilica of Maxentius and Constantine, Rome, architectural reconstruction. Platform 328×213ft (100×65m)

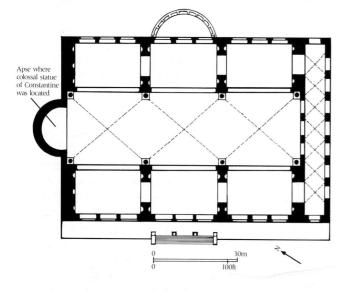

Great at the Battle of the Milvian Bridge. This event was commemorated in a grand fresco painting by the Renaissance artist Piero della Francesca (fig. 11.2, p.254), who painted a whole cycle of pictures celebrating the victory of Constantine and the triumph of Christianity.

Maxentius' main contribution was perhaps the Basilica of Maxentius, also known as the Basilica of Constantine, in the Roman Forum (fig. 11.8). The construction of the building was clearly a political statement, reaffirming the primacy of Rome against the new political centers organized by Diocletian. The purpose of this great hall – a public space for civic affairs – was significant in these circumstances; and its grandeur was a requirement for an

emperor who was dispensing imperial judgments.

The form that the basilica took was a major departure from earlier examples of the type, such as the Basilica Ulpia in Trajan's forum (see above, fig. 6.7). Traditionally such buildings had several aisles formed by rows of columns; a central open area, called the nave; and apses at the ends. The ceilings of civic basilicas were timbered, and flat. The Basilica of Maxentius (figs. 11.9 and 11.10), instead, was roofed by huge vaulting over the central space, and was flanked on each side by three enormous bays whose vaults were lower. The so-called groin vaulting of the nave had precedents in the Aula of Trajan's Markets (see above, fig. 6.5) and in the vaults of Roman public bath complexes.

This was the first time such constructions were used on a basilica.

The Basilica of Maxentius, erected on a colossal concrete platform measuring 328 by 213 feet (100 ×65m), was finished and altered by Constantine, to whom it was rededicated in AD 313. He created another entrance with steps on the south side and a matching apse at the north end of the central bay, thus introducing some confusion into the orientation of the building. The apse at the west end, on the long axis, had previously been the focus, and, curiously, the fragments of the colossal seated statue of Constantine (see below, fig. 12.12) were found here. It is generally supposed to have been an acrolithic statue - one where marble is used for head. arms, and legs only, and the rest is made of wood. It may be, then, that the head of Constantine was in fact a substitute for an earlier statue of Maxentius, and that most of the statue was given a new identity a few years later.

The Basilica of Maxentius was the last great administrative building at Rome, although there were other important and inventive structures like the Temple of Minerva Medica and the Mausoleum of Constantia, preserved for us as the church of Santa Costanza (see below, chapter 12). There was no real cause for another building of that size in Rome after Constantine created his New Rome, or Constantinopolis (Istanbul), and the center of gravity in Italy itself shifted to the north, to the new capital in Milan.

Architecture in northern Greece

The administrative requirements of the tetrarchy also produced a monumental complex in Thessalonica in northern Greece, the city chosen as the capital for the Tetrarch Galerius when he became *Caesar*. The actual plan of his palace is not precisely known but a large, round building, probably intended as his mausoleum, survives as the church of St. George (fig. 11.11). The mausoleum is a large, circular, brick-faced building with a central dome, set within an octagonal courtyard. It seems to have been turned into a church before AD 400 and was

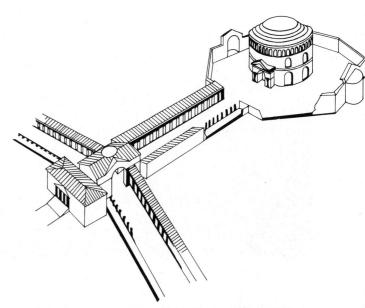

11.11 Reconstruction of the Mausoleum of Galerius and the Arch of Galerius across the main colonnaded street, the Via Egnatia, Thessalonica. Early fourth century AD

decorated with fine early Byzantine mosaics of martyred saints.

Galerius also built a splendid triumphal arch (fig. 11.12) set across the Via Egnatia, which was the main east-west road between Italy and the eastern provinces. It was connected to the mausoleum complex by a roofed portico and a broad avenue. Begun in AD 296, the arch was quite different from its predecessors in Rome and elsewhere on the Italian peninsula. It was built of brick, but the lower parts were faced with marble slabs carved in relief. The main façades had triple openings, one large and two smaller, on the main street. There was also a passageway on the short sides to provide for traffic on the cross street leading to the palace on one side, and the mausoleum on the other (see above, fig. 11.11). This makes it more of a civic four-way arch or tetrapylon, like the one at Leptis Magna (see above, fig. 9.8), than the ceremonial arches at Rome. The design also had the effect of producing a substantial vaulted space at the main crossing; the beginning of the curve of the arch still survives although there is relatively little left compared to what was standing in the 19th century.

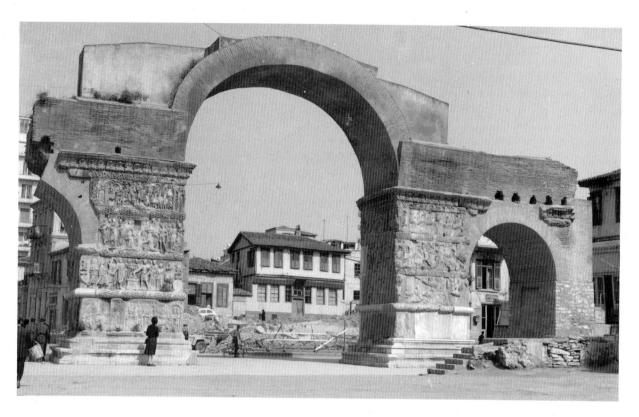

11.12 *Above* Triumphal arch, or *tetrapylon*, of Galerius, Thessalonica. *c*. AD 300. Brick and marble

11.13 *Below* Battle scene with an elephant, detail of the Arch of Galerius, Thessalonica. c. AD 300. Marble

The sculpture on the arch celebrates the successes of Galerius' campaigns against the Sassanians – successors to the Parthians in Mesopotamia – on the eastern border. As far as the subject is concerned, the usual military and triumphal motifs dominate, and there is some local color, like representations of camels and elephants (fig. 11.13). On the other hand, it is even more difficult to make out any narrative progression than on the Arch of Septimius Severus in the Roman Forum (see above, fig. 9.7). In one panel we can see that victory is, as it were, shared by the whole group, who are all present with their divine attributes in a formal and frontal presentation.

The reliefs on the piers of the arch have been set out almost as if they were on sarcophagi, and it has been suggested that sculptors from that branch of the trade were enlisted to help with the grandiose project. It is certainly plausible, for many of the scenes have their ends closed as part of the composition, much like the battle sarcophagi from the time of Marcus Aurelius (see above, figs. **8.27** and **8.28**), and the proportions are appropriate.

Some of the sculptors of the reliefs of the Arch of Galerius carved narrow channels around the figures so as to emphasize their outline. This technique had also been used on some earlier sarcophagi. Furthermore, in practical terms, it is hard to see what other group of artisans would have been ready or competent to execute this project.

Mosaics

Figural painting and mosaics of this period and the era following show a simplification of forms; flat, frontal presentations were preferred. This preference was, of course, not new. We have already seen its beginnings in sculpture in the reliefs of the arches of Septimius Severus (see above, figs. 9.7 and 9.11).

A good example of the attitude toward representation and narrative can be seen in the mosaic from a villa at Hippo Regius (Bône), in Tunisia (fig. 11.14). The mosaic is called the Hunt Chronicle because it shows a series of events related to the capture of beasts. At the left, hunters set out after antelope and ostriches, and in the center, men armed with shields and torches drive wild beasts into a temporary netted cage. One of the men has been forced down by a leopard.

The artist has used different vantage points within the same field of vision. At the left, each figure is seen as if at eye level, although one is placed above the other to show depth. But in the center, we seem to be looking down on the scene and into the netted area. Beneath some of the figures there is a shadow that acts also as a groundline. The impression is of a collection of cutouts that might pop up from a card, rather than an integrated pictorial whole.

This mixing of viewpoints is also seen in many scenes from a villa in Piazza Armerina, Sicily. It was probably built in the early fourth century, using artists or designers from Africa for the acres of mosaics that decorate the floors. Again there are hunting scenes (fig. 11.15), perhaps representing the urgency of capturing animals to be exhibited in the amphitheater. In the detail shown, a lion hunt takes place in the upper sections. Men in capes, and armed with shields and spears, attack a lion, which turns on one of its assailants. At the lower left is perhaps a representation of the owner of the villa. He is, in any case, a well-dressed man, with elegantly embroidered costume and a hat typical of

11.14 The Hunt Chronicle, from a villa at Hippo Regius. Early fourth century Ad. Height 12ft 4ins; width 22ft (3·75×6·7m). Bône Museum

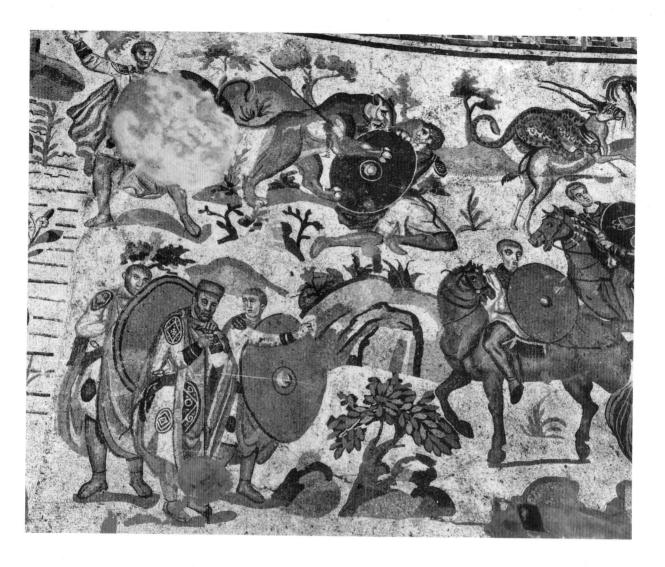

11.15 Detail of the great hunt, in the villa at Piazza Armerina, Sicily. Early fourth century Ad. Mosaic. Height 16ft 8ins (5·08m)

the day, and he seems to be surveying the scene accompanied by two of the hunters. The landscape has been reduced to schematic elements: small trees, rocks, a cave, and horizontal groundlines. The individual figures are important, and the general activity connects several scenes, but they are not linked in terms of landscape or unified space.

In another section of the hunt scene, men guide a series of enormous ostriches across a loading plank for a boat (fig. 11.3, p.254). As in the mosaic from Hippo Regius, the legs have their own schematic shadows that make a pattern of wedge-shaped diagonals across the yellow of the plank. Although in some ways the scene has been treated as a flat pattern – as, for instance, in the railing of

the gangway and the shadows – in other ways, there is a remarkable sense of volume. Perhaps most effective are the feathers on bodies, wings, and tails of the ostriches. A great deal of attention was also paid, in a difficult medium, to the curly hair of one of the men, to his costume, and even to the facial type. The owner of the villa must have had the very best talent of the day available for his elaborate villa.

The artistic outlook that produced these changes was the result of a much reduced interest in corporeality or in rendering the actual surface appearance of objects, people, or landscapes. Creating the illusion of volume in the folds of a toga or the recession of space in a hunt was no longer a goal for most artists. The folds can be seen, largely through pattern, but they are not mimicked in a realistic way. Space is indicated almost entirely by schematic mechanisms.

Portraiture

Much of the official sculpture of this era can be regarded as a distinct stylistic manifestation of the ideas that Diocletian and his colleagues wished to propagate. In particular we should look for the following characteristics: clarity, uniformity, simplicity of organization, and distance from the observer. In the tetrarchic style it is difficult to tell one emperor from another on coins or in statuary, although the names on inscriptions tell us that the persons are different. Personality is subdued in pursuit of the uniform government and administration of the state. There are some individual features that cannot be hidden, like Constantius Chlorus' nose (fig. 11.16), but in general, the simplified block-like presentation does for all. Some of the descriptive devices, like the stippled hairstyle, have been seen before, but never in so extreme a form, or cultivated in conjunction with what amounts to imperial ideology.

The uniformity seen in connection with the portraits on coins can also be seen in a statuary group of the four Tetrarchs in high relief. Carved out of porphyry – a dark reddish-purple Egyptian stone used particularly for imperial statuary – the group was probably part of the imperial palace in Constantinople, and was later rebuilt into the exterior of St. Mark's Cathedral in Venice (fig. 11.17). Since the use of porphyry for statuary or sarcophagi was reserved exclusively for the imperial family, these must be official representations of the emperors.

Some of the same rules that applied to the coinage are at work here too. The four men on the corner of St. Mark's are indistinguishable, save for the fact that, in each pair, the one at the left is bearded – presumably to represent the older

11.16 Portrait of Constantius Chlorus.Gold medallion, minted at Trier, AD 296–297. Diameter c. lin (2·5cm). Musée Municipale, Arras

11.17 The Tetrarchs. *c*. 305 Ad. Porphyry. Height 4ft 3ins (1·3m). Exterior corner of St. Mark's, Venice

Augustus with his adopted son. This is as it should be, if the office of emperor is the important thing and the man holding it only secondary. The Romans called this *similitudo*, and there is literary confirmation of the fact that it was considered desirable that there should be no visible differentiation between the leaders. Not only the lined foreheads and other facial features, but also clothing, weapons, and even gestures are repeated exactly. The artist was clearly interested in pattern, and played with the repetition of folds in the capes, sleeves, and skirts, and with the jewel-bedecked sword handles and sheaths. The fact that the men stand with their arms around each other is symbolic of their *concordia*.

One of the most compelling and instructive portraits of this era is a porphyry bust now in Egypt's Cairo Museum (fig. 11.18). It serves as a tangible example of many of the ideas set out above. When one looks at this head, the first impressions are of power, distance, and intensity, and the least important thing is individual identity. How has this effect been achieved? First, the material is extremely hard and responds better to grinding and polishing than to chiseling or drilling. Secondly, there are hardly any particular details, and the eyes, enormous and conventionalized, are not really set

11.18 Bust of a Tetrarch. Early fourth century AD. Porphyry. Height 2ft 5½ins (74.9cm). Egyptian Museum, Cairo

back sufficiently into the head. Those creases that there are in the forehead and cheeks combine to give a sense of concern and tension rather than individuality. Add to this the effect of the rhythmic stippling in cleverly articulated rows for the hair and beard, and the artistic accompaniment of the political change becomes clear.

Even the folds in the toga are conventionalized and rhythmical. We cannot say that Egypt, where the head was found, produced the abstracted tetrarchic style, but we can see that it was perfectly suited to the hard stones that the Egyptians had worked to such effect for 3,000 years. The igneous rock is not, however, a requirement for the style; we find it also in marble and bronze. The same characteristics are found in miniature as well as colossal sculpture, and on coins of bronze, gold, and silver.

Decennalia relief

After the young Caesares had completed ten years of joint rule, together with their older colleagues the Augusti who had ruled for 20, the Tetrarchs set up a monument in the Roman Forum to commemorate the anniversary called the decennalia. This was in AD 305, around the time when Diocletian abdicated the throne and retired to his palace in Spalato. The monument consisted of five columns, which were pictured in the subsequent relief on the Arch of Constantine (see below, fig. 12.4). A plinth at the foot of one of the five columns survives in the Roman Forum, showing on one side two Victories holding up a clipeus, or shield, inscribed with a notice about the event (fig. 11.19). This was a very old motif, one that had appeared on the spandrels of Roman triumphal arches (see above, figs. 5.7, 9.1, 9.8 and 9.9).

The treatment of the Victories here is linear. Both the folds of drapery and the wing feathers are drilled in such a way as to suggest the lines in a drawing. The same holds true for the weapons and trophies at the far right and left. Figures that were plastically modeled during the earlier empire are here treated in a flat manner, which nonetheless serves to define the intent of the artist.

Power seems to be the message of tetrarchic art, in particular the power of imperial authority embodied in the Tetrarchs themselves. The simplified forms allowed no distraction in the way of elaboration or ornament; the direct message gave no room for ambiguity or nuance.

The four-way division of power seems to have intensified the activity of builders and stone masons, as the power of the state had to be reflected in several sectors of the empire. All the while tax

11.19 Two Victories holding a shield, from the decennalia base, Roman Forum, Rome. c. AD 305. Marble. Width 5ft 10ins (1·78m)

revenues were being channelled into administrative and residential buildings, rather than productive public works like bridges or road repair. Yet architects in this period continued to explore vaulted structures; and the need for uncluttered interior space for public assembly — whether for bathing or the administration of justice — drove the grandiose architectural forms.

In the early fourth century, one of the Tetrarchs distinguished himself as particularly energetic and forceful. This was Constantine, son of Constantius Chlorus. Powerful, though ruthless, he came to be known as Constantine the Great. We now turn to him as the last pagan emperor, before he himself converted to Christianity.

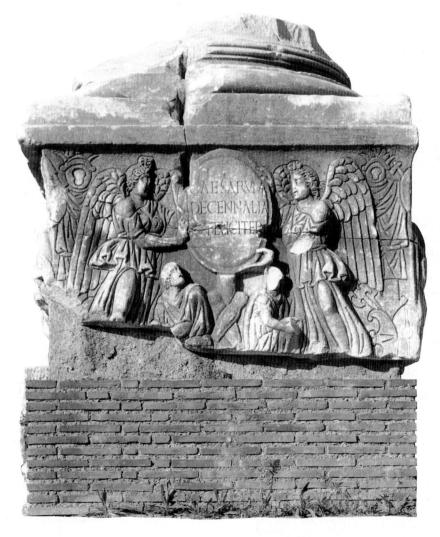

12 Constantine AD 307—337 and the Aftermath

Just as the Tetrarchs had known how to manipulate the message projected through art and architecture, so Constantine turned to works of art, many of them colossal, to proclaim his own importance. But he also initiated a practice that had not been seen before: that is, he began to remove sculptures from the monuments of his predecessors and to put them up on one of his own monuments. By this action, he hoped to acquire for himself some of the honor and appeal of those whose sculptural panels he re-used. He chose reliefs from monuments of the most revered of second-century emperors – Hadrian, Trajan, and Marcus Aurelius – to decorate his own new commemorative arch, and probably took them from monuments that were still standing at the time. These acts would have implied that the emperor had absorbed some of the glory associated with the earlier monuments.

The portrait style favored by his artists grew out of the abstraction of the tetrarchic period, sometimes called tetrarchic cubism; yet surely there is more individuality and even a hint of classicism to be seen in the portraits executed

Opposite Detail of the great dish from Mildenhall, fig. 12.28. Mid-fourth century AD. Silver. British Museum, London

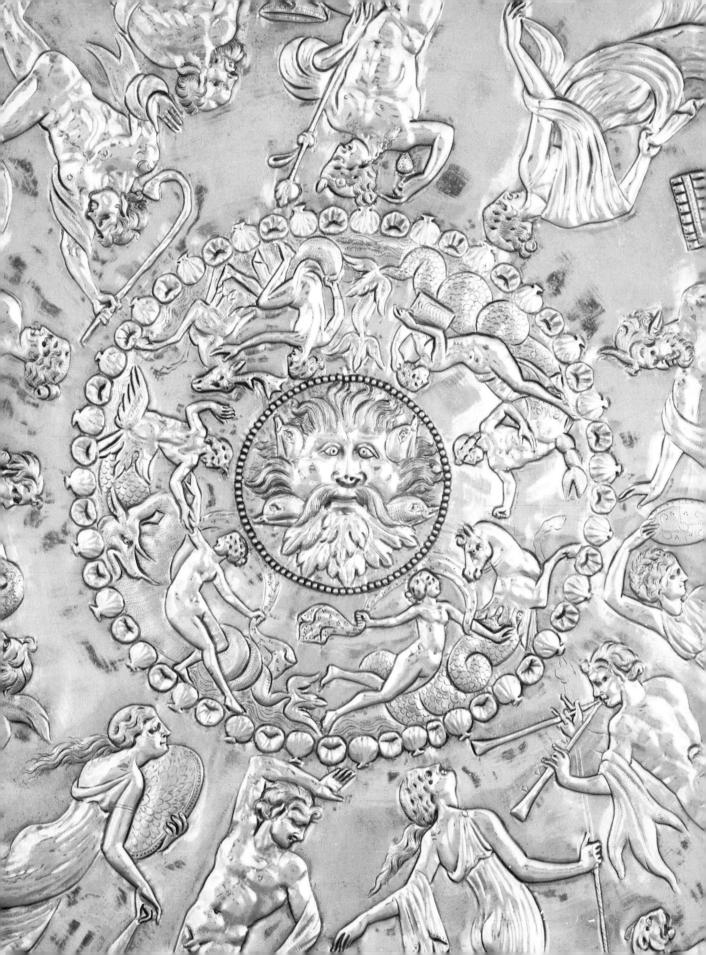

under Constantine than under his predecessors. Bold new steps were taken in architecture, many of them in the service of the new, approved religion, Christianity. Constantine's own conversion began the trend where official art, up to that point always pagan, started to lend its aura to the glory of the Church.

Late Antique art

During the third and fourth centuries AD, the approach to representation in the figurative arts was much less concerned with traditional issues of spatial depth and corporeal reality than previously. Different aims, like the clarity of organization, hierarchy of position, or indications of power, took precedence over the representation of volume or consistent proportions. This attitude shows in portrait sculpture and in historical reliefs as well as in paintings and mosaics. The outlook and requirements of the patrons were changing, and even temporary revivals of more classical elements could not reverse the tide.

This period is sometimes known as Late Antique, and in a certain way serves as a bridge or transition between the classical tradition and the medieval world. A partiality for frontal representation and heavy, square proportions, and for clearly outlined human figures, is often seen as the key to this period. But these and other artistic preferences arose from a changing mental attitude, a changing set of requirements, and a changing political and religious system. We should not minimize the role of Christianity in de-emphasizing the naturalistic aspects of the classical tradition, and in exalting the spirit over the body. These new expectations joined the requirements of clarity and hierarchy, typical of this period, that were carried over into the art of Byzantium and the early medieval period.

The division between the art of the tetrarchy and that of Constantine's time is no more clear-cut than the political division. Constantine became sole ruler in the west by defeating his colleague, the Tetrarch Maxentius, at the Battle of the Milvian Bridge in AD 312. On the other hand, he did not challenge Licinius, who had gained control over the

east, until AD 324. We have therefore to accommodate the coexistence of two traditions. One was a continuation of the explicit confirmation of the governmental system that originated with the tetrarchy. The other was a purposeful turning away from its harsh, compacted forms without any loss of the authority that tetrarchic images had been so successful in generating.

Imperial monuments

THE ARCH OF CONSTANTINE

The Arch of Constantine (fig. 12.1) is the most accessible public monument of this era, and it, too, presents us with a conflicting mixture of styles and traditions. According to the inscription on the arch, it was set up by the Senate to commemorate Constantine's victory over the usurper Maxentius. The architectural format and, in fact, the main dimensions are familiar from the triumphal arch of Septimius Severus at the other end of the Roman Forum (see above, fig. 9.6).

The sculptural arrangements are quite different, and yet we can read in both monuments a record of military campaigns, even if we cannot pin them down to precise events. The sculptural program of the Arch of Constantine is made up largely of panels appropriated from much older monuments which are combined with a small-scale historical frieze narrating contemporary events: the struggle with Maxentius and the establishment of Constantine's government at Rome. The large panels which had originally had contexts relating to Hadrian, Trajan, or Marcus Aurelius could now be understood together with the Constantinian frieze as generalized ideas in relation to Constantine's successes or personal qualities.

- **12.1** *Opposite, top left* Arch of Constantine, Rome. AD 312–315. Marble. Height 70ft; width 85ft 8ins (21·34×26·11m)
- **12.2** *Opposite, bottom left* Figure of Victory, from the Arch of Constantine, Rome. AD 312–315. Marble
- **12.3** *Opposite right* A Dacian from the time of Trajan, on the attic of the Arch of Constantine, Rome. Early second century AD. Marble

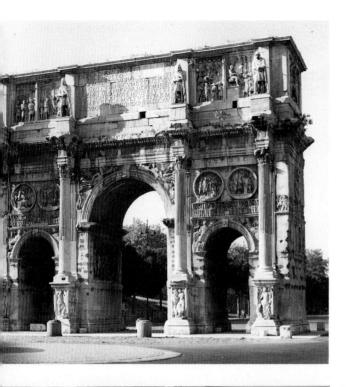

As one looks at each face of the Arch of Constantine, groupings within the organization of the sculptural decoration become apparent. The dedicatory inscription on the attic is flanked by two pairs of framed panels illustrating the success and formal military role of the emperor. The reliefs had originally been on a monument of Marcus Aurelius, and were re-used here. Those main elements are separated and enclosed by standing figures of Dacian prisoners in an attitude much like that on the battle sarcophagus (fig. 12.3). These Dacian statues are also re-used, and come from a Trajanic monument. They stand on plinths that continue the architectural framework all the way down to ground level. All three sides of the lower plinths, at the base of the arch, carry sculptured decoration: at the front, Victories, and on the sides, more prisoners.

Victories fill the spandrels of the central arch (fig. 12.2), and river gods occupy the same spaces over the smaller side arches. The Victories are still later descendants of the types seen on the arches of Septimius Severus at Rome and Leptis Magna (see above, figs. 9.1 and 9.9). Here they have become flatter and even, one might say, unattractive. Their drapery billows out behind them in what is at best a nod to classical prototypes. But if one thinks of them in their own right, they are powerful women whose symbolism is absolutely clear, and, in that sense, the sculptors succeeded in their mission.

The focus of the sculptural program seems to be on the spaces over the side arches. At the top, they are filled with two pairs of large roundels with classical associations (see above, fig. **7.32**). They function in the same way as the panels in the attic, in that they refer to abstract qualities to be associated with Constantine, with virtues transferred by implication from Hadrian (for whom they had been made) to the current emperor. Similarly, the battle scene and crowning of Trajan by Victory on the frieze under the arch (see above, fig. **6.19**)

must have seemed to Constantine and the people of his era a kind of generic victory that could apply to him as well as to any predecessor.

There was an important practical result of Constantine's borrowings of sculpture from earlier monuments. These reliefs, put before the public eye in a new setting, reminded the people through subsequent centuries of the old classical style, and they served as models for the classicizing strain that continued into the Christian era, in tandem with new styles that were, if anything, anti-classical.

Below the roundels are two long, narrow panels showing the events leading to Constantine's victory and his first official acts in Rome: the *oratio* (fig. **12.4**), and the *donatio* (fig. **12.5**), both of which were performed in the Roman Forum. The first was a public speech he gave; and the second was a gift of money to the people of Rome at the emperor's expense. These small-scale friezes depict contemporary events, but they actually continue practices that were shown often in Roman historical reliefs, and that had been well established over the course of the empire.

These panels would have been carved by artists from local workshops who were probably used to making sarcophagi and other sculptural reliefs for the middle-class population of Rome. Certainly they were not trained in the classical mode of the reliefs taken from the second-century monuments that were used to adorn the same arch.

In the *oratio* scene Constantine stands on the raised platform, the Rostra, in the Roman Forum, with his ministers standing around him. His head is missing. The members of the imperial party wearing togas face toward us but their heads turn aside, either to look at the emperor or, more rarely, to converse with a neighbor. At either end of the platform is a majestic seated statue looking straight ahead. One is identified as Marcus Aurelius and the other as Hadrian.

At the side stand two rows of Romans in short tunics, one behind the other, although the method of portraying them places one *above* the other (fig. **12.7**). The device of having the occasional head turned away from the central focus for the sake of variety was employed here too, although the emphasis is clearly directed toward the middle. A few children serve the same function, but they are

^{12.4} *Opposite top Oratio* of Constantine, and the Hadrianic roundels above, on the Arch of Constantine, Rome. AD 312–315. Marble. Height of frieze 3ft 4ins (1·02m)

^{12.5} *Opposite bottom Donatio*: the emperor Constantine distributing gifts, from the frieze on the Arch of Constantine, Rome. AD 312–315. Marble. Height 3ft 4ins (1·02m)

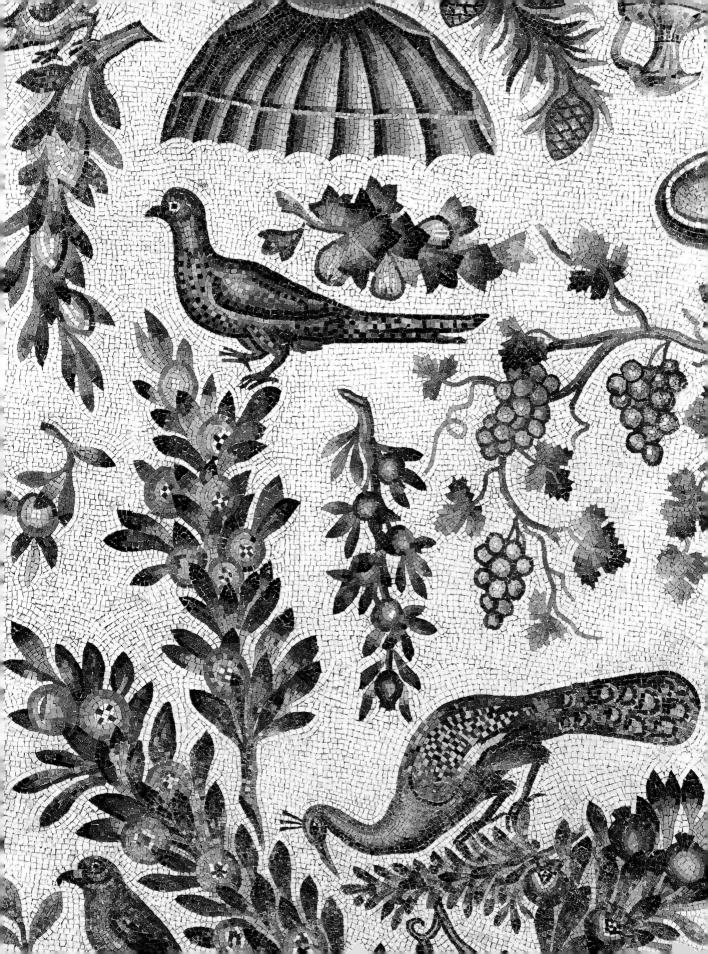

nothing like so animated or involved in the action as their counterparts on the Ara Pacis (see above, fig. **3.19**). The scene is quite site-specific, and shows, in addition to the Rostra and the five-columned monument of the Tetrarchs behind it, three other major monuments in the forum: at the left, the Basilica Julia, and the Arch of Tiberius (now destroyed) that commemorated his successes in Germany; and at the right, the Arch of Septimius Severus.

The relief portraying Constantine's largesse, or the *donatio*, is, if anything, even more abstract and formal. Constantine sits in the center, enthroned, and again his head is missing. It is clear here that it

12.6 Peacocks, grapevines, and other fruits, detail of mosaics in Santa Costanza, Rome. Mid-fourth century AD

12.7 *Above* Left side of the *oratio* frieze, on the Arch of Constantine, Rome. AD 312–315. Marble

12.8 *Below Donatio*, detail from extreme left, from the frieze on the Arch of Constantine, Rome. AD 312–315. Marble

had been made of a separate (and probably finer) piece of marble, and it must have either fallen or been removed at some later date. His ministers surround him, once more in two rows. Beyond the central group are four window-like divisions with balustrades on the upper level, within which are small scenes where one man is distributing the bounty while another, with a scroll, keeps records (fig. 12.8). Immediately below is a row of standing men, each with one hand raised, and his head turned upwards to view the emperor. Interspersed here and there are young children or babies. These are the common folk, the recipients of Constantine's generosity.

In both friezes the human heads take on inordinate importance. It is only by a head count that one can really read the relief at all, and space is defined, such as it is, by the positions of the heads, one behind the other. The emphasis on the head prefigures Byzantine icons, where the importance of the face is if anything even more pronounced. Little attention is paid to the bodies, all of which are covered by drapery with deeply drilled linear grooves. These make a distinctive pattern, easily readable even at such a small scale and at the height that these reliefs sit on the arch. The overall treatment is flat, and little effort is made to differentiate one figure from another. The message is clear: the multitudes turn adoringly toward their emperor who, superior and triumphant, dominates each scene.

12.9 Base of the Obelisk of Theodosius, Istanbul. *c.* AD 390–393. Marble. Height *c.* 13ft 11ins (4·2m)

THE BASE OF THE OBELISK OF THEODOSIUS

The sculptured base commissioned in AD 390 by Theodosius to support an Egyptian obelisk in the hippodrome in Constantinople (fig. 12.9) is a much later monument where the formal requirement for frontality is quite clear, and the organizational scheme noted in the small panels on the Arch of Constantine has been taken much further. On one face Theodosius can be seen standing behind the railing of the imperial pavilion with a wreath in his hand. On either side of the pavilion there are officials holding *mappae*, the cloths used to signal the beginning of the race. They have been placed beneath the emperor, although the scale of their bodies is similar.

The whole composition was placed above two rows of people whose repeating frontal heads are their most noticeable feature. An official presentation is shown and all the participants are gazing outwards with frontal faces. Some indication of the place and occasion is given in the form of railings and wreaths. The program here is rather like that on the small friezes of the Arch of Constantine, but the people are more rounded and less like cut-out shapes than on the Constantinian example, and the back row is not so obviously reduced to disembodied heads. The whole scene has suffered rather from the effects of the weather, which has unfortunately probably toned down the impact of the strict emphasis on frontality.

Portraits

No more dramatic example survives of the importance to Constantine of visual propaganda than the fragments of his colossal seated statue installed in the apse at the end of the Basilica of Constantine in the Roman Forum (see above, pp.77 and 259, and figs. **12.10** and **12.12**). Its size alone, over 30 feet (9m) in height, would have made it extraordinarily impressive. The hand placed near the head in the courtyard of the museum in Rome where it is now displayed gives a good sense of the overwhelming size.

But there is no parallel to the psychological power of the colossal head, 8 feet 6 inches (2·6m) in

height (fig. 12.11). The enormous eyes look upward, and are emphasized by the deeply drilled, bean-shaped pupils. In addition, the grandiose treatment of specific features like the huge nose, and the overall simplification of forms such as the cap-like hair, make the head even more powerful.

12.10 Head and hand of the colossal statue of Constantine, from the Basilica of Constantine, Rome. AD 313. Marble. Height of head 8ft 6ins (2·6m). Palazzo dei Conservatori, Rome

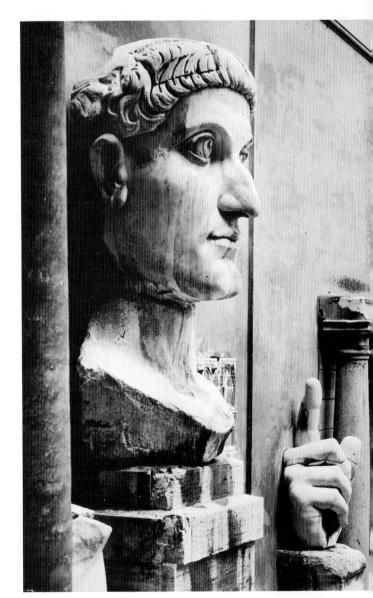

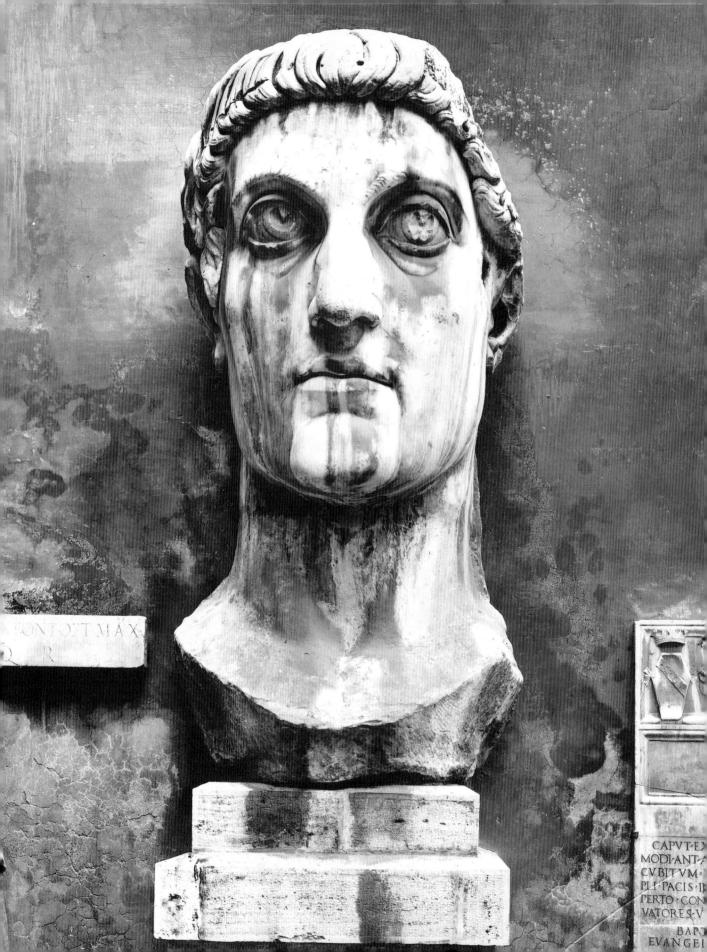

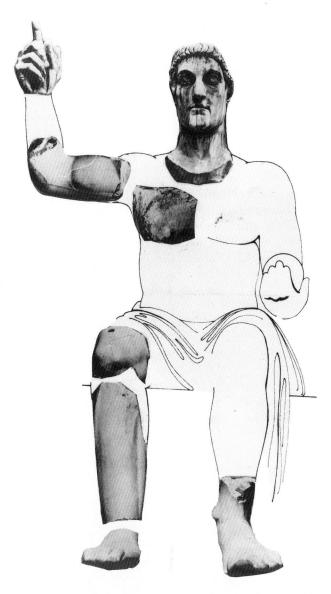

12.11 *Opposite* Colossal head of Constantine, close up. Marble. Height of head 8ft 6ins (2·6m). Palazzo dei Conservatori, Rome

12.12 *Above* Photomontage reconstruction of the colossal statue of Constantine from the Basilica of Constantine, Rome

This was the first time since Hadrian that an emperor had not worn a beard; the clean-shaven face emphasizes the powerful jaw and adds even more to the smooth outlines of the powerful head. It is the descendant of pagan cult statues, which were sometimes very large, and had something of the remote facial expression seen here. How this

piece must have dominated the huge space of the basilica in its original position can only be imagined.

A much smaller, but still well over lifesize head of Constantine (fig. 12.13) should be regarded as the kind of portrait that was much more typical throughout the empire. Impressive and abstract, it is, nevertheless, recognizable as a portrait of the emperor. Not only are the eyes and large nose and haircut characteristic, but so also is the fact that the ruler looks so distant and unapproachable.

The portrait of Dogmatius (fig. **12.14**), a senator of consular rank under Constantine, gives us an idea of the heights which sculptors of the fourth

12.13 Head of Constantine. *c.* AD 325. Marble. Height 3ft 1½ins (95·3cm). Metropolitan Museum of Art, New York, bequest of Mary Clark Thompson

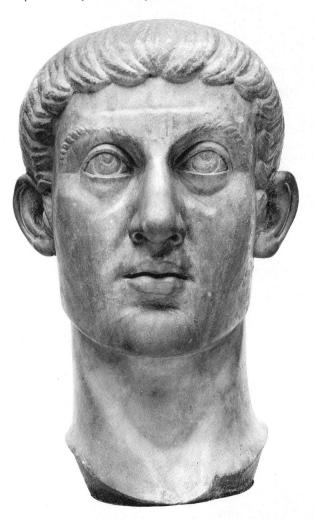

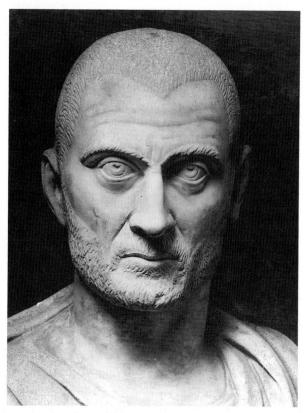

12.14 Portrait of Dogmatius. AD 326–333. Marble. Height of head 81/4ins (21cm). Museo Laterano, Rome

century could reach. The statue is probably the one set up by Dogmatius' son after his death. Intense and calculating, this head embodies all the strength inherent in portraits of the soldier emperors, and yet retains some of the abstraction that became the hallmark of the tetrarchy. On the other hand, we feel we know a good deal about this man - much more, say, than about the Tetrarchs themselves or Constantine in the two portraits just observed. It is hard to escape how formal and abstract are the lines of the hair which come to a peak just off center above the lines of the brow; or how harsh the lines formed by eyebrows, mouth, and the edge of the beard. Even the shape of the head has been squared to look almost like a block of stone. But notice how individual the eyes are, and the nose, the curve of the mouth, and the lines of the cheek. The dominating expression and the intelligent and calculating eyes tell us a great deal about the character of Dogmatius. It is a wonderful combination of abstraction and individuality, undoubtedly carved by one of the great masters of Constantinian Rome.

Architecture

Architecture under Constantine was, like sculpture and the other arts, in a transitional stage between what we have considered Roman, and what is thought of as Byzantine - that is, the Christian art that developed in the eastern part of the Roman empire. Some of the current practices were maintained, and the Basilica of Maxentius was appropriated by Constantine for his own, but eventually another format was chosen for Old St. Peter's. Instead of vaulting, the building had a flat timber ceiling (fig. 12.15), and the nave was defined by columns instead of huge piers. The focus was clearly aimed down the long axis of the building, toward the altar, whereas the Basilica of Maxentius had a second focus in the apsed niche at the middle of the north wall (see above, fig. 11.9).

12.15 Interior of Old St. Peter's, Rome. 16th-century wall painting after a drawing by Tiberio Alfarano. Vaticano, Rome

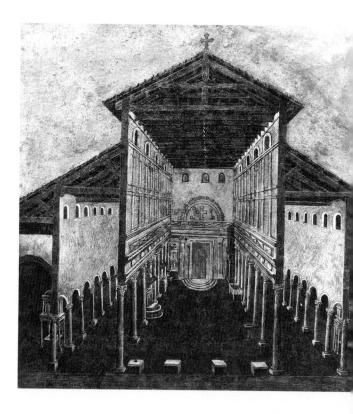

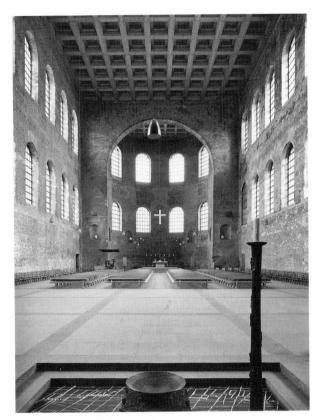

12.16 Interior of basilica at Trier. c. AD 310. Brick. Height 100ft (30·5m)

A generation or so after Trier had been established as the most northerly capital of the Roman empire, a Constantinian basilica was constructed there in yet another format (fig. 12.16). Instead of enormous vaulting as in the Basilica of Maxentius (see above, fig. 11.10), this building too has a flat ceiling and a trussed roof. And where the earlier basilica in Rome had three huge, vaulted bays on each side of the main nave, the Basilica at Trier has a single rectangular interior space, marked by an arch at the end with an apse behind it. Again it is very large, measuring 95 by 190 feet (100×200 Roman feet, or 29×58m), and 100 feet (30·5m) in height. One could look from one part of the building to another without the obstruction of piers or columns.

The walls of the Basilica at Trier are pierced by two rows of arched windows (fig. 12.17). Those in the apse are slightly smaller than those in the nave, and the upper row of windows is placed lower than the nave windows, thus giving the optical impression that the building is longer and vaster than it actually is. Today there is no decoration here, but only the austere space, the walls, and the light; however, in Roman times the floor and walls had marble inlays, and perhaps there were flat pilasters and other decorations.

On the exterior, the only features we see today are the windows, and the imposing tall and narrow blind arches that are articulated in the brick wall. The long flat sides of the building are quite plain and

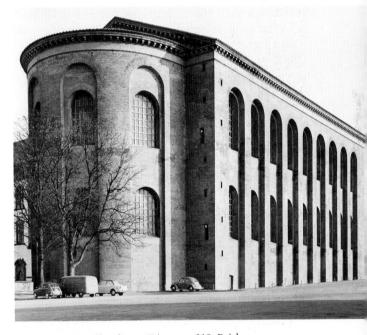

12.17 Exterior of basilica at Trier. c. AD 310. Brick

12.18 Basilica at Trier, reconstructed view

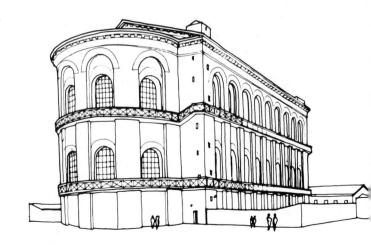

undecorated, except for the dramatically powerful arches. But we must imagine these walls covered with a pinkish stucco, of which traces remain, and we must realize that there were galleries on the lower levels of both tiers of windows (fig. 12.18).

The Basilica at Trier was a part of the palace completed by Constantine, and may have been the imperial audience hall, or place for the reception of important visitors. It is a major landmark in the history of architecture, both because of the huge, uninterrupted space, and because of the stark exterior with an emphasis on the blind arches. We can anticipate here the development toward Romanesque architecture of the Middle Ages.

Another of the important buildings of the era is the mausoleum constructed around the middle of the fourth century for Constantia, the daughter of Constantine (fig. **12.19**). Built on the outskirts of

12.19 Interior of Santa Costanza, Rome. Mid-fourth century AD. Brick vaults, granite columns, marble capitals

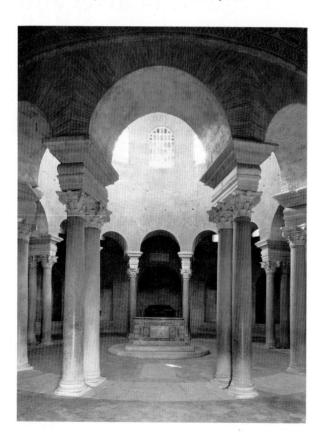

Rome, it was later converted into the church of Santa Costanza. The plan of the mausoleum follows the tradition of circular tombs, like that of Augustus (see above, fig. 3.3), and anticipates churches with central plans; but the internal arrangements are strikingly original. The architecture creates the impression of a two-story column of light and air. This appears to be supported by a wheel-like colonnade made of pairs of columns, set radially and connected by the same block supporting the arches.

This arrangement effectively sets the domed central space apart from the darker but richly decorated ring vault in the ambulatory (the walkway) that surrounds it, on which a good part of the original mosaic decoration still survives. The mosaics have a white background, against which are set grape-harvesting scenes and magnificent floral ornaments (fig. 12.6, p.272). Although built in a Christian context, for the daughter of the first Christian emperor, the imagery itself, both on the vault mosaics and on her sarcophagus (see below, fig. 12.26), is pagan. No attempt was made here to give a sense of three-dimensional space or a coherent narrative, but the flat decorative effect has never been surpassed.

Continued interest in covering spaces with domes can be seen in the remains of a building known since the 17th century as the Temple of Minerva Medica (figs. 12.20 and 12.21). It was not a temple, but a *nymphaeum* or fountain pavilion set in some formal gardens and later used as a park. It is comparable in intention, as well as in form, to the vestibule in the Piazza d'Oro at Tivoli (see above, fig. 7.4). Its ruins have always attracted notice because of the construction and design of the domed area that was the central feature of this building. Brick ribs are obvious in the upper structure that remains today, and they were even clearer in earlier illustrations (fig. 12.22), when more of the dome survived.

The original form was a single domed room created by ten piers set in a ring about 60 feet (18m) in diameter. At ground level the openings between the piers formed deep niches, which added to the overall breadth. The spaciousness was further enhanced by substituting columns for the continuous wall in two pairs of the side niches.

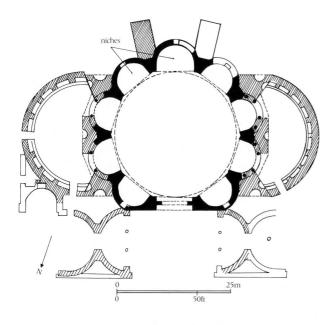

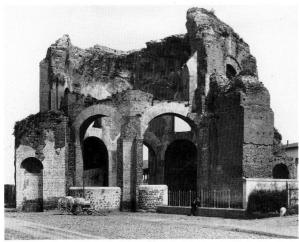

12.20 Plan of the "Temple of Minerva Medica," Rome. Early fourth century AD

12.21 "Temple of Minerva Medica," Rome. Early fourth century AD. Brick

12.22 "Temple of Minerva Medica," Rome, as it looked in the 18th century. Drawing by E. I. Kobell, 1780. Graphische Sammlung, Munich

Additional light was assured from windows in the second-story wall, over the front of the niches.

This daring plan succumbed to the pressures of the dome, and buttresses soon had to be added at the south. Additional courts at the sides were attached later, perhaps as extra buttressing for the central space. They have fallen, but at least part of the center still holds.

A domestic quarter and its paintings

We have studied a number of imperial buildings of the Constantinian era. Let us look now at a domestic area that has been excavated in recent years at Ephesus. This remarkable series of residential complexes is known by the German name of *Hanghäuser*, or slope houses, to describe the way the units seem to hang from the steep hill on which they are built near the city center (fig. **12.23**). Narrow alleys separate one group of houses from the next, while many share walls in the manner of apartment blocks.

Many well-preserved wall paintings from the first through the fifth centuries AD decorate the interiors of these houses. They are invaluable additions to our understanding of later Roman wall painting, which has been overshadowed by the great quantity preserved in Pompeii and other sites in the Naples area. Because the houses were occupied over a long period, the change of styles can be seen from the different layers of painted plaster laid one on top of the other (fig. 12.24). In some cases the old painted surface was methodically chipped so that the new coat of plaster would stick properly.

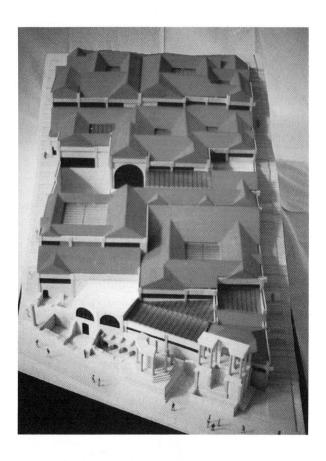

12.24 Several layers of painted plaster with different decorative schemes, in the slope houses, Ephesus

Although there are differences of approach and technique in particular rooms or complexes, the insistence upon rectangular frameworks is striking. They are usually outlined in red and reminiscent of the unlikely schemes of the Third Pompeian style. These later examples show that the architectural origins and the basic Roman scheme for decorating house walls were continued, even if in rather attenuated form. In the Constantinian period, we find a return to the detailed depiction of architectural elements, apparently for their own sake (fig. 12.25). Even though they do create elegant frames, there is nothing to frame but an expanse of solid color. The illusion of spatial depth was not sought for the whole scheme, even though there is some local indication of light falling upon the

columns to create shadows and a sense of reality. The overall impression is flat, although the details are shown with great clarity. An attempt was made to show the grooves and rings of the column bases and the fluting of the columns in reddish-brown outlines, with gray stripes beside them to indicate shadows and produce some impression of volume.

The primary responsibility of the artist seems to have been to indicate the organization of the wall and its panels, although the earlier tension between the actual wall surface and the representation on it was maintained. The painted plaster colonnade, framing a series of alternating dark and light panels, apparently made of different colored marbles cut in intricate decorative patterns, stands on a dado or surround that is made of real marble.

12.25 Architectural motifs painted in the slope houses, Ephesus. Early fourth century AD. Wall painting

Sarcophagi

An area where the traditions of the pagan and Christian worlds mingled easily was in the use of motifs for paradise and eternal life. The scenes of Dionysus and cupids bringing in the vintage, seen in the ceiling mosaics of the Mausoleum of Constantia, continued to be popular on sarcophagi. Indeed, they appeared on Constantia's enormous block-like porphyry sarcophagus (fig. 12.26) that originally sat opposite the entrance in her circular mausoleum. Here, amidst a huge, curving grapevine and its subsidiary tendrils, cupids again work the presses and prepare the wine. Peacocks and a sheep, symbols of eternity and of the congregational flock, complete the iconography on the front. Thus, what had begun as pagan subject matter associated with Dionysus was here transformed into Christian imagery.

One of the most important of Early Christian sarcophagi is that of Junius Bassus, Prefect of the city of Rome and former consul (fig. 12.27). The inscription on the sarcophagus not only identifies him but also says that he died in AD 359. It was, then, carved not long after Constantine had declared Christianity legal, and during the period when public Christian imagery was being established.

Artistically, it reflects many Roman elements, and yet the iconography is Christian rather than pagan. The scenes, taken from the Old and New Testaments, are as follows, left to right. Top tier: the sacrifice of Isaac, the arrest of Saint Peter, Christ enthroned between Saints Peter and Paul, and, taking up two bays, Christ brought before Pilate.

12.26 Sarcophagus of Constantia. c. AD 350. Porphyry. Height c. 7ft 5ins (2·26m). Musei Vaticani, Rome

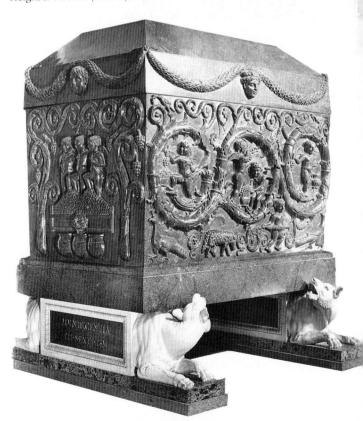

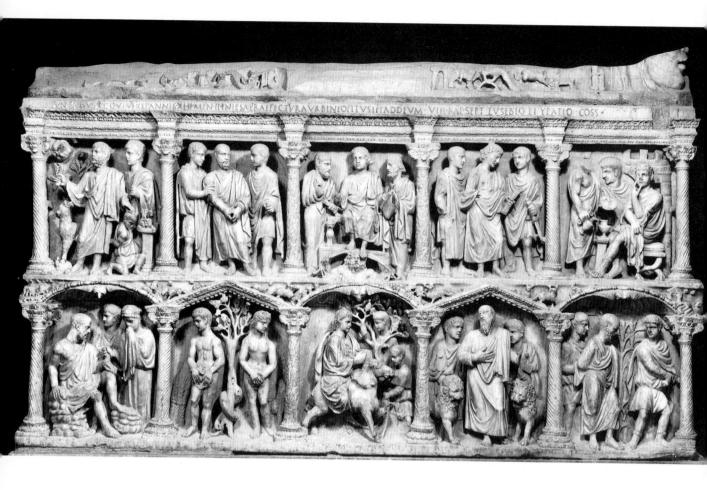

12.27 Sarcophagus of Junius Bassus. c.AD 359. Marble. Height 3ft 10^{1} /zins; length 8ft $(1\cdot18\times2\cdot44\text{m})$. Museo Laterano, Rome

Lower tier: Job on the dunghill, Adam and Eve, the entry into Jerusalem, Daniel in the lion's den, and Saint Paul being led to his martyrdom. The artist took care to balance his stories thematically and compositionally, so that martyrs were in similar positions at left and right. Some of these subjects, like Job on the dunghill, were not common in later art, but the choice reveals an interest in salvation through the tales of the Church, much as the pagan sarcophagi had used mythological stories to suggest salvation.

Why, then, should we include this piece in a book on Roman art? It is because in many ways it is still a Roman work of art. Architecturally, the

language is that of Roman architecture and pagan sarcophagi of the Asiatic type seen above in fig. **7.36**. Each scene appears to be enclosed in a pavilion, and is divided from its neighbor by a short Corinthian column, ornately carved with peopled scrolls or spiral fluting. A straight entablature is used above the upper group, but on the lower tier, alternating curved arches and pointed pediments cap each scene. The figures are in some cases carved almost free of the background, and there is some use of vegetation, much as on some Season sarcophagi (see above, fig. **9.31**). The clothing worn is the Roman toga, and the facial types are Roman too.

Even some of the imagery is taken from classical prototypes. The enthroned Christ, facing outward in a frontal pose and surrounded by others, is related to the representations of Constantine

himself (see above, fig. 12.5). The entry into Jerusalem is descended from the Roman imperial scene, called the adventus, where the emperor entered a city, and can even be compared to the grandiose rendition of Marcus Aurelius before his defeated enemies (see above, fig. 8.20). Another classicizing detail is the allegorical representation of the heavens under the feet of the youthful enthroned Christ in the top central panel. We saw this figure on the breastplate of the Prima Porta Augustus (see above, fig. 0.5), and in a way it seems we have come full circle, from a piece at the beginning of the Roman empire, to one at the end.

12.28 Great dish from Mildenhall. Mid-fourth century AD. Silver. Diameter c. 2ft (61cm). British Museum, London

Silver

The Late Roman period offers us several spectacular treasures of the metalsmith's art, some dug out of their original hiding places, especially in Britain and Germany, and some preserved in church or cathedral treasuries all over the empire. The frequency may, perhaps, be attributed to accidents of survival in the case of valuables hidden in the face of impending disaster, but we must also take into account the need for new classes of liturgical instruments, or at least a new requirement for the ostentation fitting to imperial patronage and Church foundations.

A frequent type of utensil is a shallow silver dish or tray, sometimes of enormous size and worked with intricate designs in relief. For example, a great dish found with several other silver objects, some with Christian associations, at Mildenhall,

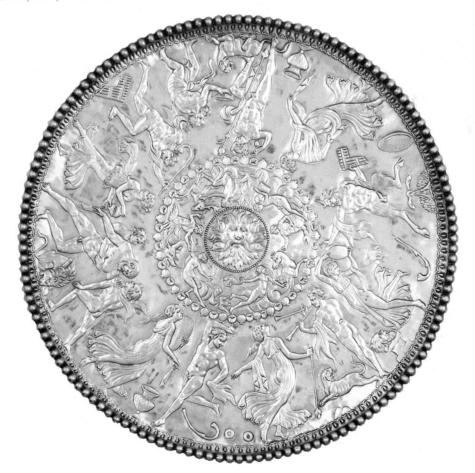

England, has scenes of bacchic (dionysiac) revelry swirling around it in several concentric registers (fig. 12.28). The subject is pagan and traditional, and the spirit seems to take us back to much earlier models. The flowing curves of the *maenads'* drapery and the shadows emphasized in the kick of the hems remind one more of painting than of metalwork (fig. 12.29). The extreme foreshortening of the drunken Hercules' left arm as he is being supported by two young satyrs (fig. 12.30) is unusual, as is the rendering of his lionskin cloak. All the figures show sensitive internal modeling of folds and muscles within quite definite outlines.

Another silver dish (fig. 12.31), found in Spain, and closely dated this time by its inscription to the occasion of the tenth anniversary of the reign of Theodosius I (AD 388), is decorated in a much more severe, formal style. It has more in common with large-scale imperial reliefs or the official art of coinage in both subject and presentation, than it does with private utensils like the Mildenhall dish. The emperor is seated in the middle of a monumental gateway with an arched pediment much like the actual entrance to the emperor's quarters in the Palace of Diocletian (fig. 11.4). He is

12.29 Bacchus, Silenus, a dancing satyr, and a *maenad*, detail from the outer zone of the Mildenhall dish. Mid-fourth century AD. Silver. British Museum, London

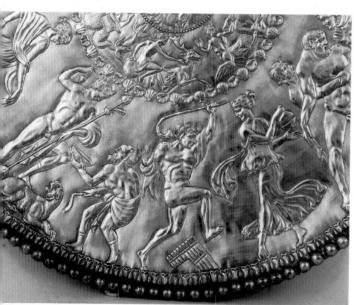

flanked by his co-emperors, Valentinian II and Arcadius (his son), who sit within the smaller openings to either side, and in their turn are flanked by members of the imperial guard. Both colleagues are holding orbs that symbolize their earthly power, while Theodosius is making a formal presentation to one of his officials, who is shown at a much smaller scale, as befits his lower status. Even the co-emperors are shown somewhat smaller, reflecting their age. The poses are familiar from the imagery of late Roman coinage, although the details of the feet and footstools retain something of the naturalistic pictorial tradition.

These two examples from about the same time, roughly half a century after the death of Constantine, show the continued divergence between official, formal requirements of design for imperial commemorations or celebrations, and the traditional attachment of the educated classes in their private lives to the naturalistic forms associated with the classical tradition. It is surely no accident that several other examples of fine metalwork have classical subjects on them, or that we first find illustrated manuscripts of Homer and Virgil preserved from this period.

12.30 Drunken Hercules supported by satyrs, detail from the outer zone of the Mildenhall dish. Mid-fourth century AD. Silver. British Museum, London

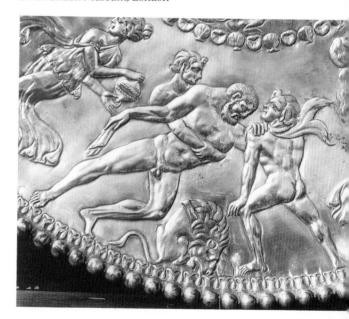

12.31 Theodosius I, Valentinian II, and Arcadius, on a ceremonial dish from Istanbul (?). AD 388. Silver. Diameter *c.* 2ft 5ins (73·6cm). Real Academia de la Historia, Madrid

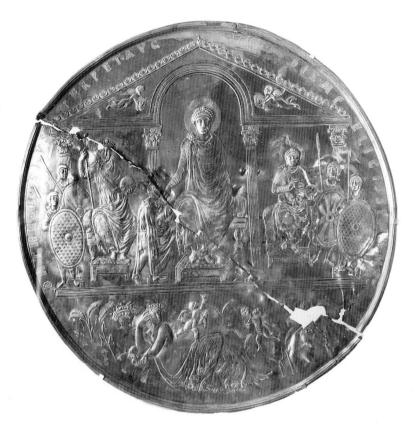

Conclusion

The Constantinian era and the moving of the capital do not in themselves mark the end of Roman art; the people of Constantinople thought of themselves as Romans, and therefore the guardians and true practitioners of Roman art, for several centuries. It is, however, a suitable place to close our survey because it represents both a culmination and a beginning: the last fanfare of the pagan empire and the prelude to the Christian state of Byzantium. Constantine made it possible to mix the two traditions and shaped the iconography for the emperors to come, much as Augustus had drawn on ancient Italian and Greek traditions to set the style for his time and for centuries thereafter.

The final phase of Roman art was inextricably bound up with the successive emperors' acceptance and encouragement of Christianity, so that it became the natural and unquestioned belief of the imperial house. This was neither immediate, nor total. Constantine had astutely taken advantage of the power of Christian belief to further his political aims, but later, the emperor Julian (AD 360–363), for example, tried to return to pagan traditions and reverse all the recent changes.

In concert with the political triumph of Christianity, we can see the beginnings of its artistic domination in east and west, when almost all images became intimately linked with religious purposes. In the fourth century the takeover was not complete, and in fact there were close connections with the traditions of pagan art in all areas. Much of the imagery should not be seen as primarily pagan, but rather as imperial.

In many ways the art of the earlier empire has had more effect on subsequent European art than the more recent art of the Constantinian era, or that of Byzantium. The writers and artists of the Renaissance were more drawn to the classical or Hellenistic forms that were favored in the early empire, and found in them a truer beauty. We can see the reflection of new finds, or careful study of standing monuments, in innumerable examples from the work of "old master" painters or sculptors, and get a feeling for the fascination the works of antiquity have had. The whole tradition of European art since the Renaissance depends upon Roman art. To this day, after purposeful rejection by some schools, Roman monuments of art and architecture continue to offer inspiration in ways that their creators could not have imagined.

Roman Emperors

The principal Roman emperors, and emperors mentioned in the text, with the dates of their reigns.

27 BC-AD 14	Augustus	AD 211–217	Caracalla
AD 14-37	Tiberius	AD 222-235	Alexander Severus
AD 37–41	Gaius (Caligula)	AD 235-238	Maximinus Thrax
AD $41-54$	Claudius	AD 238	Balbinus
ad 54–68	Nero	AD 244-249	Philip the Arab
AD 69–79	Vespasian	AD 253-268	Gallienus
AD 79–81	Titus	AD 270-275	Aurelian
AD 81–96	Domitian	AD 284-305	Diocletian
AD 96–98	Nerva	AD 286-305	Maximian
AD 98–117	Trajan	AD 305-306	Constantius Chlorus
AD 117-138	Hadrian	AD 305-311	Galerius
AD 138-161	Antoninus Pius	AD 306-312	Maxentius
AD 161-180	Marcus Aurelius	AD 307-324	Licinius
AD 161-169	Lucius Verus	AD 307-337	Constantine I, the Great
AD 180-193	Commodus	AD 379-395	Theodosius I
AD 193-211	Septimius Severus		

Ancient Authors

The following ancient authors are mentioned in the text.

- CICERO: The most famous orator and politician of the first century BC.
- DIONYSIUS OF HALICARNASSUS: A Greek writer of Augustan times, most famous for his *Roman Antiquities*.
- HERODOTUS: A Greek historian who took the Persian Wars as his main subject, but included much historical detail about earlier and neighboring cultures like the Lydians.
- Homer: The most famous Greek epic poet; author of *The Iliad* and *The Odyssey*.
- Livy: The author of a history of Rome from the founding of the city to the time of Augustus.
- PLINY THE ELDER: The writer of *Natural History*, an encyclopedia of useful knowledge on many subjects. Commander of the fleet at Misenum, he died in AD 79 at Pompeii. Uncle of Pliny the Younger.
- PLINY THE YOUNGER: An administrator in the time of Trajan, best known for his letter writing.

- PLUTARCH: A Greek philosopher and writer of biographies, who lived during the early empire. His *Parallel Lives* is an important source for the history and character of many eminent Greeks and Romans.
- Polybius: A Greek politician and historian of the second century BC, who was taken to Rome. His *History* covered the remarkable expansion of Rome in the third and second centuries BC.
- Suetonius: The author of *The Lives of the Caesars*, which is an important source for personal but not always reliable details of the early emperors. He was active in the time of Trajan and Hadrian.
- Virgil: An epic poet of the time of Augustus, and author of *The Aeneid*.
- VITRUVIUS: An architect of the time of Augustus, who wrote a manual for architects and builders and gave many definitions of Greek architectural terms.

Glossary

- **ACANTHUS** A broad-leafed plant with many spikes, used as a decorative pattern on Corinthian capitals and reliefs.
- **ACROLITHIC** A statue with the head (and sometimes hands and feet) made of stone, while the body is of some other material.
- **ACROTERIA** Ornaments at the apex of the gable and at the corners of the roof of a temple.
- **ADLOCUTIO** A formal speech, often given by the emperor to his troops. Sometimes used for the traditional stance, with one arm raised, associated with such a speech.
- **ADVENTUS** Latin for arrival. Used to represent the formal arrival of an emperor or general, with all its pomp and circumstance.
- **AEDICULA** A small pedimented pavilion forming part of a façade. Often used for the backdrop of theaters or for framing figures on sarcophagi.
- **AGGREGATE** The inert material, usually sand, gravel, or rubble, that is bound together with *pozzolana* to form concrete.
- **ALA** The wing or side section of a house or temple.
- **ALIMENTARIA** The custom of distributing food to the populace, often at the personal expense of the emperor.
- **APOTHEOSIS** The occasion when someone (often an emperor) becomes a god or goddess after death. Typically represented by the person being carried up to heaven.
- **APSE** A semicircular space, usually at the end of a hall or basilica.
- **ARA** Latin for altar. The word is often used for the ceremonial enclosure as well as the sacrificial stone itself.
- **ARCHITRAVE** The horizontal architectural element above the columns in a classical temple.
- **ARX** A citadel. At Rome the Arx was the fortified part of the Capitoline Hill.
- **ATMOSPHERIC PERSPECTIVE** A device for creating the illusion of distance by making faraway objects appear hazier than objects in the foreground.
- **ATRIUM** The central room of a traditional Roman house. **ATTIC** The upper portion of a triumphal arch.
- **AUGUSTUS** A title for the emperor meaning "revered." The name was originally taken by Octavian but was used subsequently for all reigning emperors.
- **AUREUS** The name for the standard Roman gold coin. It was about 3/4 inch (2cm) in diameter.
- **BARBARIANS** People who were from foreign lands, and

- by implication considered less civilized than the Romans.
- **BAROQUE** A term transferred from 17th-century art, suggesting ornamental enrichment and elaboration for its own sake, especially in architectural façades.
- **BASILICA** The conventional name for halls built to accommodate a crowd of people for civic and administrative purposes.
- **BUCCHERO** Fine black polished pottery made by the Etruscans, especially in the seventh and sixth centuries BC.
- CAESAR/CAESARES Title used by the imperial family.

 Derived from Julius Caesar, it was first a family name, and eventually came to designate a son or junior colleague destined for the imperial throne.
- **CALDARIUM** The hot room of a Roman bath.
- **CANOPIC URN** An Etruscan container for the ashes of the dead. The lid often takes the form of a human head, and sometimes schematic features of the human figure are added to the body of the jar.
- **CAPITAL** The upper, spreading element of a column, forming a transition between the vertical shaft and the horizontal elements of the architrave.
- **CAPITOLIUM** The main temple for civic worship in Roman colonies. Named for the deities (Jupiter, Juno, and Minerva) who were venerated on the Capitol in Rome.
- **CARDO** The name for a north–south street in the rectangular grid system of Roman town planning. Often used loosely for the principal north–south street (see *decumanus*).
- **CARYATID** A female figure used as a support, most commonly for columns or mirror handles.
- **CASTRUM** Latin for camp. Used for the rectangular ground plan of Roman colonial settlements that seem to have followed a similar layout.
- **CAVEA** The rounded hollow space in a theater where the seats were placed.
- **CELLA** An enclosed room of a temple, usually housing the cult statue.
- **CHIAROSCURO** The use of light and shadows to create the illusion of shape and volume in painting or sculpture.
- **CHIMAERA** A mythical beast in the form of a firebreathing lion, with the head of a goat (usually growing from its back) and the head of a snake (usually shown at the tip of the tail).
- **COFFERS** The box-like shapes in the ceilings of

- architectural monuments and triumphal arches. Used to reduce the mass of the vaulting.
- **COLONNADE** A row of columns, either surrounding a temple or standing as an independent architectural element.
- **COLUMBARIUM** A communal tomb with many niches to contain ash urns, named for its similarity to a bird house with many nesting boxes.
- **COMPOSITE** See fig. **3.6**, p.85, "The five orders of architecture."
- **CONSULS** The two chief administrators of the Roman state during the Republican period. They were elected annually. The office continued under the empire but became more of a titular post.
- **CORINTHIAN** See fig. **3.6**, p.85, "The five orders of architecture."
- **CUPOLA** Another word for a dome.
- **DACIANS** A nation whose homeland lay on the north side of the lower Danube, and was roughly equivalent to modern Rumania. They were the enemy in the reliefs on Trajan's Column.
- **DADO** Part of a wall, sometimes up to waist height, often decorated with designs imitating different kinds of stone.
- **DECUMANUS** An east—west street in the grid layout of Roman towns. Often used of the *decumanus maximus*, or principal east—west thoroughfare (see *cardo*).
- **DENARIUS** The most common Roman silver coin. It was about ¾ inch (2cm) in diameter.
- **DICTATOR** A person with sweeping powers appointed in a time of crisis to restore the government or defend the state. The word does not carry the ugliness of modern connotations.
- **DOMUS** A single family townhouse, as opposed to a villa, which is a country house.
- **DORIC** See fig. **3.6**, p.85, "The five orders of architecture." **EMBLEMA** The central motif in a mosaic; often set off by a
- frame, and better made than the background.
- **ENCAUSTIC** A painting technique where heated wax is used as a coloring and sealing medium.
- **ENGAGED COLUMNS** Half-columns projecting from a wall to give the appearance of a closed colonnade.
- **ENTABLATURE** The upper architectural elements of a temple, above the columns.
- **EXEDRA** A large curving space set back in a wall or colonnade. Generally uncovered and bigger than an apse.
- **FIBULA** An ornamental brooch rather like a safety pin.
- **FLUTING** Vertical grooves or channels on the columns. Doric fluting is shallow and meets at a sharp edge. Ionic and Corinthian fluting has a flat edge between the channels.
- **FORESHORTENING** An illusionistic device that reduces the length of objects seen obliquely, in order to suggest

- depth in an economical way on a flat surface.
- **FORUM** The public open space in a Roman city or town, originally used as a market; the center of political and administrative activities.
- **FREEDMAN** An emancipated slave. Freed slaves frequently became wealthy and important figures during the period of the Roman empire.
- **FRIEZE** The horizontal space above the main crossbeam in a classical temple, usually decorated with sculptured figures or floral ornament. Often used for any decoration arranged in a horizontal band.
- FRIGIDARIUM The cold room of a Roman bath.
- **FURY** One of a group of female personifications of vengeance who punished criminals, especially murderers who killed their own kin.
- **GROTTESCHI** Painted figures (especially imaginary creatures) copied or adapted in the Renaissance from the walls of the ancient buildings in Rome that were underground "grottoes" at the time.
- **GROUNDLINE** The pictorial representation of the surface on which figures stand.
- **HELLENISTIC** Refers to the period in Greek art and politics between the death of Alexander the Great (323 BC) and the establishment of Roman government in Greece and Asia Minor during the first century BC.
- **HIPPODROME** The Greek equivalent of a track for chariot racing. In Latin, it is called a *circus*.
- **IMPASTO** Thick grayish pottery made by many Iron Age communities in Italy.
- **IMPLUVIUM** A small pool that catches the rain coming through an opening in the roof in the middle of the *atrium* of a Roman house.
- **INDIGENOUS** Native to the geographical area, and not imported.
- INSULA A multiple dwelling in a Roman town, usually encompassing a whole block. Derived from the Latin word for "island."
- **IONIC** See fig. **3.6**, p.85, "The five orders of architecture."
- **IRON AGE** The period between 1000 BC and 700 BC, when the use of iron was becoming more widespread.
- **KOUROS** A standard sixth century BC Greek statue type of a standing male, usually shown nude.
- **LATIUM** The area to the south and east of Rome. Home of the Latin tribes.
- **MAENAD** A female follower of Dionysus, often seen holding cymbals or castanets in ecstatic dances.
- **MAPPA** A ceremonial cloth used as a starting flag.
- **MATERIAL CULTURE** The term used to encompass the whole range of objects made and used by a particular group of people.
- **MUNICIPIUM** A town whose inhabitants enjoyed Roman citizenship, although they usually followed their own laws.

- **NEOPLATONISM** A doctrine originating from the revival of interest in the philosophy of Plato in the third century AD.
- **NEREID** One of the daughters of Nereus. Also a general term for sea nymphs.
- **NYMPHAEUM** A term used for a formal fountain building in Roman imperial architecture.
- **OBELISK** A tapering pillar of square section, with a pointed top, set up by the ancient Egyptians, but often carried off for re-use by the Romans.
- **OCULUS** The round opening in a vault to let in light. Derived from the Latin word for "eye."
- **OPUS INCERTUM** A masonry technique using small stones of irregular size and shape to retain the concrete core of a wall.
- **ORCHESTRA** The flat, semicircular space in front of the stage within a theater.
- **PALAESTRA** The Greek and Latin word for a wrestling ground; a space for field events.
- **PAPYRUS** A reed that grows in the Nile delta. The stalk is used for making a material like paper that is also known as *papyrus*. Writings on this material are called *papyri*.
- **PARTHIANS** A nation that overran much of the area to the east of the River Euphrates in the second century BC, and was a constant threat to the eastern Roman provinces.
- **PATERA** A saucer-like dish often used for holding liquid offerings to the gods.
- **PATRICIANS** Citizens who were members of noble families. **PERISTYLE** The rectangular courtyard or garden of a Greek or Roman house.
- **PERSONIFICATION** The process of giving human shape to abstract ideas such as Justice, or to rivers and places, like the Danube or Africa.
- **PLEBEIANS** Citizens who made up the common people; not members of noble families.
- **PORPHYRY** A dense red volcanic stone quarried in Egypt. The Romans made general use of it for architectural decoration, but it was reserved by the imperial family for their own statuary and sarcophagi.
- **PORTICO** A porch, or a line of columns in a colonnade. **POZZOLANA** Volcanic earth from the area of Pozzuoli, near Naples, which sets hard like cement after it is mixed with water. The active ingredient in Roman concrete.
- **PRONAOS** The Greek word for the front porch of a temple.
- **PROVINCE** Technically the area of responsibility of a magistrate, but usually equated with a particular geographical region.
- **PYLONS** Important gateways, or the square pillars that support an arch.
- **QUOINS** Squared stones set at the outside corners of walls made of *opus incertum*. The effect is to strengthen the ends and make a neater line.

- **REGISTER** A horizontal division of a pictorial area; like a zone or band.
- **RINCEAU** A sinuous and branching scroll made of a plant stem and leaves.
- **ROMAN FOOT** This was slightly shorter than the modern standard, and measured about 11½ inches (29·5cm).
- **ROSTRA** The prows of captured ships set up in the Roman Forum and used as a pulpit for public speeches.
- **SARCOPHAGUS** A container to hold a dead body. Usually made of stone, but can also be of terracotta or metal.
- **SESTERTIUS** Originally a small silver coin worth one quarter of a *denarius*. In imperial times a large brass piece about 13/s inch (c. 3·5cm) in diameter.
- **SPANDREL** The triangular space between the springing and center of an arch. Usually occupied by a Victory.
- **STRIGIL** A curved piece of metal with a handle, used for scraping an athlete's body to remove sweat and dust after exercise.
- **STUCCO** Plaster used on walls or ceilings. Often referring specifically to three-dimensional ornament in plaster.
- **TEPIDARIUM** The warm room of a Roman bath.
- **TERRACOTTA** Baked clay, usually with reference to roof tiles or sculpture.
- **TESSERA** A squarish piece of stone or glass used to create a mosaic.
- **TESTUDO** Literally a tortoise. The name given to an army formation where the Romans attacking a town put their shields together over their heads for protection against the defenders on the walls.
- **TETRAPYLON** A four-way arch, usually triumphal or commemorative, found at a crossroads.
- **TETRARCHS** Four rulers of the late Roman empire, each with a particular sphere of influence in east or west. Two were subordinate, but were picked for succession to the higher positions.
- **TORQUE** A necklace made of a heavy piece of twisted gold. Worn by barbarians.
- **TRABEATED** An architectural term for a structure with horizontal beams set on vertical supports. Also known as post and lintel.
- **TRAVERTINE** A light-colored limestone that is commonly used for building in the region around Rome.
- TRICLINIUM A dining room.
- **TRITON** Male equivalent of a Nereid, i.e. a male sea creature. **TROPHY** A victory monument composed of the armor of the defeated enemy, which was set up on the battlefield.
- **TUFA** Soft stone composed of compacted volcanic ash.
- **TUMULUS** The type of round burial mound used by the Etruscans.
- **TUSCAN** See fig. **3.6**, p.85, "The five orders of architecture." **TYRRHENUS** A Lydian prince, supposed first leader of the Etruscan people.

A groin or cross vault is the intersection of two such tunnels and the configuration of the joined space.

VESTAL VIRGINS Priestesses of the goddess Vesta, who were required to be unmarried and chaste.

VICOMAGISTRI Local officials or magistrates; often freedmen.

VILLANOVANS The general name given to the Iron Age inhabitants of Italy.

VIRTUS Latin for courage and strength. The idea or quality associated with having those attributes.

Select Bibliography

The following list is limited mostly to books in English, but they should serve well to lead the reader to a wider bibliography. Many of the books listed under the "general" heading will also be useful under specific chapters, and some books listed under one chapter will help too for subsequent ones.

General

- Andreae, Bernard, *The Art of Rome*. New York: Harry N. Abrams, Inc., 1977.
- Bianchi-Bandinelli, Ranuccio, *Rome: the Center of Power*. New York: George Braziller Inc., 1970.
- Bianchi-Bandinelli, Ranuccio, *Rome: the Late Empire*. London: Thames and Hudson, 1971.
- Boëthius, Axel & John B. Ward-Perkins, *Etruscan and Roman Architecture*. Baltimore, MD: Penguin, 1970.
- Brendel, Otto J., *Prolegomena to the Study of Roman Art.* New Haven, CT: Yale University Press, 1979.
- Brilliant, Richard, *Roman Art from the Republic to Constantine*. London: Phaidon, 1974.
- Hanfmann, George M.A., *Roman Art*. Greenwich, CT: New York Graphic Society, 1964.
- Henig, Martin, ed., *Handbook of Roman Art*. Ithaca, NY: Cornell University Press, 1983.
- Kähler, Heinz, *The Art of Rome and her Empire*. New York: Crown, Inc., 1965.
- Kent, J.P.C., *Roman Coins*. New York: Harry N. Abrams, Inc., 1978.
- McKay, A.G., *Houses, Villas, and Palaces in the Roman World.* Ithaca, NY: Cornell University Press, 1975.
- MacKendrick, Paul, *The Mute Stones Speak: The Story of Archaeology in Italy*. New York: St. Martin's Press, 1960.
- Nash, Ernest, *Pictorial Dictionary of Ancient Rome I* and *II*. London: Thames and Hudson, 1968 (rev. ed.).
- Platner, S.B. & T. Ashby, *A Topographical Dictionary of Ancient Rome*. London: Oxford University Press, 1929.
- Pollitt, J.J., *Art in the Hellenistic Age*. New York: Cambridge University Press, 1986.
- Pollitt, J.J., *The Art of Rome* c.753 BG-AD 337 Sources and Documents. Englewood Cliffs, NJ: Prentice Hall, Inc., 1966.
- Potter, Timothy, *Roman Italy*. Berkeley, CA: University of California Press, 1987.
- Sear, Frank, *Roman Architecture*. Ithaca, NY: Cornell University Press, 1982.

- Strong, Donald, *Greek and Roman Gold and Silver Plate*. London: Methuen, 1966.
- Strong, Donald, Roman Art. New York: Penguin, 1980.
- Strong, Donald, Roman Imperial Sculpture: an introduction to the commemorative and decorative sculpture of the Roman Empire down to the Death of Constantine. London: Tiranti, 1961.
- Toynbee, J.M.C., *Death and Burial in the Roman World*. London: Thames and Hudson, 1971.
- Toynbee, J.M.C., *The Art of the Romans*. London: Praeger, 1965. Van Deman, Esther, *The Building of the Roman Aqueducts*.
 - Washington, DC; Carnegie Institution, 1934.
- Vermeule, Cornelius C., III, *Greek Sculpture and Roman Taste:*The Purpose and Setting of Graeco-Roman Art in Italy and the Greek Imperial East. Ann Arbor, MI; University of Michigan Press, 1977.
- Ward-Perkins, John B., *Roman Architecture*. New York: Harry N. Abrams, Inc., 1977.
- Wheeler, R.E.M., *Roman Art and Architecture*. New York: Thames and Hudson, 1964.
- Woodford, S., *The Art of Greece and Rome*. New York and London: Cambridge University Press, 1982.

1 The Villanovan and Etruscan Forerunners

- Breckenridge, J.D., *Likeness: a Conceptual History of Ancient Portraiture*. Evanston, IL: Northwestern University Press, 1968.
- Brendel, Otto J., Etruscan Art. New York: Penguin, 1978. Dennis, George, *The Cities and Cemeteries of Etruria*. London: John Murray, 1883 (3rd ed.).
- Frederiksen, Martin, *Campania*. London: British School at Rome, 1984.
- Hencken, Hugh, *Tarquinia and Etruscan Origins*. New York: Praeger, 1968.
- Pallottino, Massimo, Etruscan Painting. Geneva: Skira, 1953.
- Pallottino, Massimo, The Etruscans. New York: Penguin, 1975.
- Potter, Timothy, *The Changing Landscape of Southern Etruria*. New York: St. Martin's Press, 1979.
- Richardson, Emeline, *The Etruscans: Their Art and Civilization*. Chicago, IL: University of Chicago Press, 1964.
- Ridgway, David and Francesca Ridgway, eds, *Italy Before the Romans: The Iron Age, Orientalizing, and Etruscan Periods*. New York: Academic Press, 1979.
- Scullard, H.H., Etruscan Cities and Rome. London: Thames and Hudson, 1967.

2 The Roman Republic

- Andreae, Bernard, *Das Alexandermosaik aus Pompeji* Recklinghausen: Bongers, 1977.
- Brown, Frank E., *Cosa: the Making of a Roman Town*. Ann Arbor, MI: University of Michigan Press, 1980.
- Crawford, Michael H., Roman Republican Coinage. London: Cambridge University Press, 1974.
- Kleiner, Diana E.E., Roman Group Portraiture: the Funerary Reliefs of the Late Republic and Early Empire. New York and London: Garland Publishing, Inc., 1977.
- MacDonald, A.H., Republican Rome. New York: Praeger, 1966.Richter, Gisela M.A., Roman Portraits. New York: Metropolitan Museum of Art. 1948.
- Salmon, E.T., *The Making of Roman Italy*. London: Thames and Hudson; Ithaca, NY: Cornell University Press, 1982.

3 and 4 Augustus and the Imperial Idea and The Julio-Claudians

- Anderson, Maxwell L., "Pompeian Frescoes in the Metropolitan Museum of Art," *Metropolitan Museum of Art Bulletin* (Winter 1987/88). New York: Metropolitan Museum of Art, 1987.
- Boëthius, Axel, *The Golden House of Nero*. Ann Arbor, MI: University of Michigan Press, 1960.
- Hannestad, N., *Roman Art and Imperial Policy*. Aarhus: Jutland Archaeological Society, distrib. Aarhus University Press, 1986.
- MacDonald, William L., The Architecture of the Roman Empire 1: Introductory Study. New Haven, CT: Yale University Press, 1982 (2nd ed.).
- Maiuri, Amedeo, *Roman Painting*. Geneva: Skira, 1953.
- Pollini, John, *The Portraiture of Gaius and Lucius Caesar*. New York: Fordham University Press, 1987.
- Ryberg, Inez Scott, *Rites of the State Religion in Roman Art.* Rome: American Academy in Rome, 1955.
- Simon, Erika, *Ara Pacis Augustae*. Greenwich, CT: New York Graphic Society, 1967.
- Torelli, Mario, *Typology and Structure of Roman Historical Reliefs*. Ann Arbor, MI: University of Michigan Press, 1982.
- Von Blanckenhagen, Peter, and Christine Alexander, "The Paintings from Boscotrecase," *Römische Mitteilungen* Suppl. Vol. 6, Deutsches Archäologisches Institut. Heidelberg: EH. Kerle, 1962.
- Zanker, Paul, *The Power of Images in the Age of Augustus*. Ann Arbor, MI: University of Michigan Press, 1988.

5 The Flavians: Savior to Despot

Grant, Michael, *Cities of Vesuvius: Pompeii and Herculaneum*. Harmondsworth, Middlesex: Penguin, 1976.

- Jashemski, Wilhelmina F., *The Gardens of Pompeii*. New York: Caratzas, 1978.
- Mau, August, *Pompeii: its Life and Art.* New York: Macmillan, 1899.
- Ward-Perkins, John B. and Amanda Claridge, *Pompeii AD 79*. London: Imperial Tobacco Co., 1976.

6 Trajan, Optimus Princeps

- Hamberg, P.G., *Studies in Roman Imperial Art*. Uppsala: Almqvist & Wiksells, 1945.
- Lepper, F.A. & S.S. Frere, Trajan's Column: a New Edition of the Cichorius Plates. Wolfboro, NH: Alan Sutton Publishing, Inc., 1988.
- MacDonald, William L., *The Architecture of the Roman Empire II: an Urban Appraisal*. New Haven, CT: Yale University Press,
 1987.
- MacKendrick, Paul, *The Dacian Stones Speak*. Chapel Hill, NC: University of North Carolina Press, 1975.
- Rossi, L., trans. J.M.C. Toynbee, *Trajan's Column and the Dacian Wars*. Ithaca, NY: Cornell University Press, 1971.

7 Hadrian and the Classical Revival

- Birley, Robin, *On Hadrian's Wall: Vindolanda: Roman Fort and Settlement*. London: Thames and Hudson, 1977.
- Kähler, Heinz, *Hadrian und seine Villa bei Tivoli*. Berlin: Gebr. Mann. 1950.
- McCann, Anna Marguerite, *Roman Sarcophagi in the Metropolitan Museum of Art.* New York: Metropolitan Museum of Art, 1978.
- MacDonald, William L., *The Pantheon: Design, Meaning, and Progeny*. Cambridge, MA: Harvard University Press, 1976.
- Toynbee, J.M.C., *The Hadrianic School*. Cambridge: Cambridge University Press, 1934.

8 The Antonines

- L'Orange, H.P., Apotheosis in Ancient Portraiture. Oslo: H. Aschehoug & Co. for the Institutett for Sammenlingnende Kulturforskning, Series B Skrifter XIV, 1947. Reprint New Rochelle, NY: Caratzas, 1982.
- Morey, Charles Rufus, *Sardis V Part I: The Sarcophagus of Claudia Antonia Sabina*. Princeton, NJ: The American Society for the Excavation of Sardis, 1924.
- Vermeule, Cornelius C., III, Roman Imperial Art in Greece and Asia Minor. Cambridge, MA: Harvard University Press, 1968.
- Vogel, Lisa, The Column of Antoninus Pius. Cambridge, MA: Harvard University Press, 1973.

9 The Severans

Brilliant, Richard, *The Arch of Septimius Severus in the Roman Forum*. Rome: Memoirs of the American Academy in Rome XXIX, 1967.

Colledge, M.A.R., The Art of Palmyra. Boulder, CO: Westview Press, Inc., 1976.

Hanfmann, George M.A., *The Season Sarcophagus in Dumbarton Oaks*. Cambridge, MA: Harvard University Press, 1951.

McCann, Anna Marguerite, *The Portraits of Septimius Severus*. Rome: Memoirs of the American Academy in Rome XXX, 1968.

Yegül, Fikret K., *The Bath-Gymnasium Complex at Sardis*. Cambridge, MA: Harvard University Press, 1986.

10 The Soldier Emperors

Richmond, I.A., *The City Wall of Imperial Rome*. London: Oxford University Press, 1930.

Todd, M., The Walls of Rome. Totowa, NJ: Rowman and Littlefield, 1978.

Wood, Susan, *Roman Portrait Sculpture AD 217–260*. Leiden: E.J. Brill, 1986.

11 The Tetrarchs

Dorigo, Wladimiro, *Late Roman Painting*. New York: Praeger, 1971

Gentili, G.V., Mosaics of Piazza Armerina. Milan: Ricordi, 1964. L'Orange, H.P., Art Forms and Civic Life in the Late Roman Empire. Princeton, NJ: Princeton University Press, 1965.

Wightman, Edith Mary, *Roman Trier and the Treveri*. New York: Praeger, 1971.

Wilson, R.J.A., *Piazza Armerina*, Austin, TX: University of Texas Press, 1983.

12 Constantine and the Aftermath

Beckwith, J., The Art of Constantinople: An Introduction to Byzantine Art 330–1453. London: Phaidon, 1961.

Brown, Peter, *The World of Late Antiquity*. London: Thames and Hudson, 1971.

Grabar, André, Early Christian Art. New York: Odyssey Press, 1968.

Kitzinger, Ernst, Byzantine Art in the Making. Cambridge, MA: Harvard University Press, 1977.

Krautheimer, Richard, *Early Christian and Byzantine Architecture*. Baltimore, MD: Penguin, 1975 (rev. ed.).

MacCormack, S.G., Art and Ceremony in Late Antiquity. Berkeley, CA: University of California Press, 1981.

Painter, Kenneth S., *The Mildenhall Treasure*. London: British Museum Publications, 1977.

Weitzmann, Kurt, ed., *The Age of Spirituality: A Symposium*. New York: Metropolitan Museum of Art, 1980.

Acknowledgements

Most of the line drawings in this book have been specially drawn by Andrew Betteridge and Richard Foenander. John Calmann & King Ltd are grateful to all who have allowed their plans and diagrams to be reproduced. Every effort has been made to contact the copyright holders, but should there be any errors or omissions, they would be pleased to insert the appropriate acknowledgement in any subsequent edition of this publication.

Harry N. Abrams, Inc. 3.1, 7.10, 11.9, 11.10

Akademie Tanitma Merkez, Izmir 7.22

American Academy in Rome 2.41 (Reprinted from Frank E. Brown: Memoirs of the American Academy in Rome XXVI, 1960)

Archaeological Exploration of Sardis, Harvard University, Cambridge, MA 9.21

Bardi Editore, Rome 7.15, 7.18

British School at Rome 5.25

Cornell University Press, Ithaca, NY/Frank Sear 1.9, 6.1, 11.5 (Reprinted from Frank Sear: *Roman Architecture* © Frank Sear, 1982. Used by permission of the publisher)

L'Erma di Bretschneider, Rome 2.29

Loyola University of Chicago, Chicago, IL 2.37

Penguin Books, London 5.24, 11.11, 12.18, 12.20 (Reprinted from Axel Boëthius and John B. Ward-Perkins: *Etruscan and Roman Architecture* [Pelican History of Art], 1970 © the Estate of Axel Boëthius and John B. Ward-Perkins, 1970. Figs. 35, 194, 195A, and 198. Reproduced by permission of Penguin Books Ltd)

Denys Spittle, Hertfordshire, England 9.8, 9.10

Thames and Hudson, London 2.46 (Original drawing by Jon Wilsher) Yale University Press, New Haven, CT 4.23, 5.11, 6.6 (Reprinted from William L. MacDonald: *The Architecture of the Roman Empire*, 1965. Used by permission of the publisher)

Photographic Credits

John Calmann & King Ltd, the authors, and the picture researcher wish to thank the institutions and individuals who have kindly provided photographic material for use in this book, and in particular Dr Helmut Jung of the Deutsches Archäologisches Institut and Mary Jane Bright of the Fototeca Unione at the American Academy in Rome for their personal assistance. Museums and galleries are given in the captions; other sources are listed below.

Archivi Alinari, Florence/Art Resource, New York. Half-title, frontispiece, 0.5, 1.1, 1.3, 1.13, 1.15, 1.20, 1.21, 1.22, 1.23, 1.25, 2A, 2.6, 2.16, 2.23, 2.32, 2.43, 3.5, 3.7, 3.10, 3.16, 3.17, 3.18, 3.21, 3.22, 3.32, 4.6, 4.9, 4.19, 4.22, 5A, 5.2, 5.5, 5.7, 5.9, 5.10, 5.16, 5.20, 5.21, 5.31, 5.37, 5.38, 5.40, 6.2, 6.8, 7.8, 7.9, 7.14, 7.24, 7.25, 7.28, 7.29, 7.31, 7.32, 7.35, 8A, 8.4, 8.18, 8.20, 8.23, 8.36, 9.6, 9.11, 9.28, 10A, 10.4, 10.13, 10.14, 12.4, 12.5, 12.11, 12.21, 12.26, 12.27

Ancient Art and Architecture Collection, London 1.8, 7.27 Archiv für Kunst und Geschichte, Berlin 3.8 Barnaby's Picture Library, London 2.33, 5.27, 7.19, 7.21 Bodleian Library, Oxford 3.6, 9.17

British Museum, London 7.23

Ludovico Canali, Rome 1.5, 2.19, 3.26, 10.11

Courtesy of the Director of Antiquities, Nicosia, Cyprus 9.4 Deutsches Archäologisches Institut, Rome 0.4(41.1336), 1.8(70.928),

 $\begin{array}{l} 1.11(57896), 1.24(63.970), 2.5(63.1899), 2.13(72.2079), \\ 2.36(55.639), 2.38(58.1169), 2.39(67.615), 3.2(72.2922), \end{array}$

3.12(78.1929), 3.13(66.103), 4.4(65.112), 4.5(65.93),

4.13(79.3930), 5.17(4258), 5.19(77.1715), 5.28(67.616),

6.10(73.1799), 6.11(31.255), 6.12(31.254), 6.13(31.270),

6.14(41.1448), 6.15(89.15), 6.16(41.1479), 6.19(37.329),

6.20(68.2784), 7.3(76.2900), 7.4(59.1409), 7.20(3129), 7.37(34.648), 8.5(84.6), 8.15(69.2362), 8.23(59.53),

8.24(55.1164), 8.25(89.344), 8.26(36.628), 8.27(55.427),

8.28(61.1399), 8.31(58.36), 8.33(59.318), 9.7(33.51),

9.12(61.1699), 9.13(58.273), 9.16(61.2086), 9.32(68.3495), 10.2(72.482), 10.3(38.667), 10.15(57.1461), 10.16(59.20),

11.14(36.1089), 12.2(36.619), 12.7(32.8), 12.8(32.14),

 $12.10(59.1720),\,12.14(7271)$

Douglas Dickins, London 9.14 Ali Dögenci, Ankara 4.18 (Courtesy of Kenan T. Erim)

Editions Citadelles Edito S.A., Paris 12.12

Alfredo Foglia, Naples 5.36, 5.39

Fototeca Unione of the American Academy in Rome 1.14(11299), 2.1(10560F), 2.34(4350F), 2.35(4348F), 2.40(923), 2.45(5046),

2.47(1918), 3.3(1076), 3.4(9094F), 3.14(1049), 3.19(3247F), 3.24(14462F), 4A & 4.14(4365F), 4.20(1254), 4.21(5939É), 4.23(3513F), 5.4(6002), 5.15(5254F), 6.5(4750F), 6A & 6.9(5990F), 6.18(19721), 7.16(1102), 7.20(8503), 8.3(151), 8.22(5992F), 9.19(4361F), 11.8(5021), 11.12(6235), 11.15(5235F), 11.19(10858), 12.1(733), 12.3(4218F), 12.22(9079F)

French Archaeological School, Athens 2.2

Gabinetto Fotografico Nazionale, Rome 11.1

Gallimard, Paris 4.17 (L'Univers des Formes [La Photothèque])

Alinari/Giraudon, Paris 5.30

Lauros/Giraudon, Paris 2.3

Sonia Halliday Photos, Buckinghamshire, England 11.3 Harvard University Art Museums, Cambridge, MA 9.5, 9.22

(Courtesy of the Archaeological Exploration of Sardis) Hirmer Verlag Fotoarchiv, Munich 12.9, 12.19

Istituto Nazionale per la Grafica, Rome 5.3, 5.8, 7.2, 8.21, 11.7 A.F. Kersting, London 9.20

Landesmuseum, Trier 9.24, 12.16, 12.17

Mansell Collection, London 4.11, 5.1, 5.6, 11.17 (41 Alinari prints were kindly lent by the Mansell Collection)

Bildarchiv Foto Marburg 11.4

Leonard von Matt 7A & 7.13

Marina Mueller, Rome 1.7

New-York Historical Society (Photo © McKim, Mead & White, 1916) 9 30

Österreichisches Archäologisches Institut, Vienna 12.23 (© Nancy Ramage), 12.24, 12.25

Popperfoto, London 4.3, 9.1

Nancy Ramage, Ithaca, NY 4.2, 5.18, 8.16, 8.17, 9.9, 9.15, 9.23, 11.13 11.13

Oscar Savio, Rome 6.17

Scala Fotografico, Florence 1.26, 1.27, 2.17, 2.18, 2.24, 2.25, 2.26 & 2.27, 3.27, 3.28, 3.31, 5.32, 5.33, 5.34, 5.35, 11.2, 12.6

Raymond V. Schoder, Chicago, IL 2.37 (© 1989 Loyola University of Chicago)

Julius Shulman 2.30

Soprintendenza alle Antichità d'Etruria 1.10, 1.19, 10.8

Soprintendenza Archeologica di Milano 8.29

Soprintendenza Archeologica di Roma 3.25, 3.29, 4.12

Foto Tanjug, Belgrade 11.6

Werner Forman Archive, London 2.42, 4.16, 5.26, 5.29, 7.5, 7.6

Warburg Institute, London 5.22, 10.12 (© Dr Elisabeth Alfoldi)

Sara Waterson, London 5.12, 5.23

Index

Bold and italic numbers indicate illustrations.

Actium, Battle of 16, 80, 94 Adam, Robert 75 Adamklissi:Tropaeum Traiani 163, 6.17, 6.18 adlocutio scenes 17, 36, 212, 0.4, 8.26 Aegina: Temple of Aphaia 27, 1.8 Aemilius Paullus, monument to (Delphi) 47, 2.2 Aeneas 40, 43, 83, 92-3, 145, 196 Agrippa 93, 100, 175 Agrippina 111, 112 Alba Longa 43 Alexander III (the Great) 18-9

Acilia, sarcophagus from 251, 10.16

- portrait 53, 2.13 Alexander Mosaic 65-6, 131, 2.26, 2.27

Alfarano, Tiberio: Old St. Peter's 12.15 Algeria: Timgad (Thamugadi) 166-7,

6.25, 6.26

altar, funerary 215, 8.34 Altar of Augustan Peace see Ara Pacis Augustae

Altar of Augustan Piety see Ara Pietatis Augustae

Altar of Domitius Ahenobarbus 47, 2.3 Altar of Zeus, Pergamon 48-9, 110, 2.5 Ambush of Troilus by Achilles

(Etruscan wall painting) 36-7, 1.22 amphitheaters:

- El Djem, Tunisia 233, 9.20
- Pompeii 149, 5.40
- see also Colosseum
- amphorae:
- Etruscan 25, 1.6
- Villanovan 25, 1.5

Anaglypha Traiani (Rome) 164, 6.20

Anavysos Kouros 28–9, 1.12

Ancus Martius, King 40 Ankara: inscription of Res Gestae 83

Antinous 173, 183, 185–6, **7.30, 7.31**

Antonianos of Aphrodisias:

Antinous as Sylvanus 185-6, 7.30

Antonine period 194, 196

Antonine Wall 198

Antoninus Pius, Emperor 196, 8.1, 8.8

- Base of Column 205-7, 8.17-8.19
- sestertius 198, **8.6**
- Temple of Hadrian (Rome) 197-8,

Antoninus Pius and Faustina, Temple of (Rome) 197, 8.3 Aphrodisias:

- Augustus 115, 4.18
- Portico of Tiberius 107, 4.2
- The Sebasteion 115

Apollodorus of Damascus 172 Apollo of Veii 28-9, 1.11

apotheosis scenes 183, 205, 206, 7.29,

8.17

aqueducts 69, 71

- Aqua Claudia 117, 4.19
- Pont du Gard, Nîmes 69, 2,33
- Porta Maggiore 118, **4.20**

Ara Pacis Augustae 90-4, 99, 3.13,

3.14, 3.16, 3.18, 3.19, 3.22

Ara Pietatis Augustae 114

Arcadius, Emperor 286, 12.31

Archaic period 18, 40

- kouros 28-9, 1.12

arches:

- construction of 69, 71, 107, 126
- triumphal 128-9

Arnth Velimnas, urn of 31, 33, 1.15

ashlar masonry 71

Athens, sack of 19, 44

Attalus III, King of Pergamon 48

Augustan period:

- Caffarelli Sarcophagus 91, 3.15
- Gemma Augustea 106-7, 4.1
- silver bowl 94, 3.23
- stucco reliefs 103, 3.32
- wall paintings 99–100, **3.27–3.31**
- see also Augustus; relief sculpture Augusti 16, 255

Augustus, Emperor 16, 17-8, 50, 54,

80,83

- Ara Pacis Augustae 90-4, 99, 3.13, 3.14, 3.16, 3.18, 3.19, 3.22
- denarius 54, 2.15
- Forum 83, 104, 114, **3.1, 3.2, 4.14**
- portraits 17-8, 80, 86-7, 89, 115, 0.5, 3.7, 3.9, 3.10, 4.18
- Res Gestae 83, 103
- Theater of Marcellus 84-6, 3.5, 3.6
- Tomb 84, **3.3**

Augustus of Prima Porta 17–8, 86–7, 0.5, 3.7

Aulus Metellus, bronze statue of 35-6, 1.21

Aurelian, Emperor 248, 10.12 Aurelian Wall 248, 10.13

Baalbek: Temple of Venus 231, 9.19 Badminton Sarcophagus 238-9, 9.31 Balbinus, Emperor 243-4, 10.2, 10.3 basilicas:

- Basilica Aemilia 77, 96, 99, **3.24**, 3.25
- Basilica Julia 79
- Basilica of Maxentius and Constantine 258-9, 11.8-11.10
- Basilica Ulpia 155, 6.7
- at Trier 279-80, 12.16-12.18
- Underground Basilica 118, 4.21, 4.22

baths:

- Baths of Caracalla 236, **9.28**, **9.29**
- Baths of Diocletian 257, 11.1, 11.7
- Baths of Trajan and Titus 153, 6.1
- Great Baths, Hadrian's Villa, 171-2, 7.2, 7.3

Beatrizet, Nicolas: engraving 8.21 Benevento: Trajan's Arch 164-6,

6.21 - 6.24

Bône see Hippo Regius

Boscoreale: wall paintings 62–3,

2.20-2.22

Boscotrecase, villa at: wall painting 100, 3.30

Britain:

- Antonine Wall. Scotland 198
- Hadrian's Wall, England 79, 180-1
- Housesteads, England 79, 180-1, **7.18**
- Mildenhall, England: silver dish 266, 285–6, **12.28**

bronzes, Etruscan 29–30, 33–6, **1.1**, **1.13**, **1.17**, **1.19–1.21**

Brutus 77

– Etruscan bronze 34–5, **1.20** *bucchero*, Etruscan 25, **1.6** Bulfinch, Charles 75 Byzantium *see* Constantinople

Caesares 16, 255
Caffarelli Sarcophagus 91, **3.15**Caligula, Emperor 110, 117, **4.8**Cancelleria reliefs 132–3, **5.13, 5.14**Capitoline Wolf 29, **1.1**Capitolium, Ostia 74–5, **2.42**Caracalla, Emperor 175, 222, 225, 227, 235, 236, 239, **9.2, 9.7, 9.11, 9.25,**

9.26– Baths 236, **9.28, 9.29**

Carthage 19

castrum 79

Charles III, King of Naples 139 chiaroscuro 134; 183

Chimaera, Wounded (Etruscan) 30,

1.13

Cicero 18, 29, 289

Classical Greek art see Greece

Claudius, Emperor 110-1, 121, 4.9

- aqueducts 117-8

coffering 168, 177, **7.13**

coinage 17, 18

- antoninianus 236, **9.27**
- aureus of Hadrian 180, **7.17**
- denarius of Augustus 54, 2.15
- denarius of Julius Caesar 52, 2.10
- denarius of Pompey 53, 2.12
- denarius of second triumvirate 54,2.15
- sestertius of Antoninus Pius 198, 8.6
- solidus 236
- under soldier emperors 242
- under Tetrarchs 263

Colosseum, the 124, 126, 128, **5.2–5.6**

Commodus, Emperor 196, 216–7

- as Hercules 194, 216, 8.36

concrete, use of 71, 121, 177, 229

Constantia, Sarcophagus of 283, 12.26

Constantine I (the Great), Emperor 14, 16, 205, 236, 257–8, 259, 265, 266, 268, 287, **11.2**

- Arch 186, 264, 268, 271, 273-4, **7.32, 12.1-12.5, 12.7, 12.8**
- Basilica 258-9, 11.8-11.10
- statues 259, 275, 277, 12.10-12.13

Constantinople 16, 259, 287

- Obelisk of Theodosius 275, 12.9

Constantius Chlorus, Emperor 255,

263, 265, **11.16**

Corinth, sack of 19

Cos: Sanctuary of Asclepius 72, 2.37

Cosa: temple 74, 2.41

Crassus 53, 54

cremation 188, 250

Dacians, the 153, 155, 158–61, 163, 271, **6.10**, **6.13–6.15**, **6.18**, **6.19**, **12.3**

Darius III, King of Persia 65

Decebalus 161, 6.15

Decennalia relief 264, 11.19

Delos 54

- portraits from 54, 134, **2.14**

Delphi: monument to Aemilius Paullus 47. **2.2**

Demaratus 28

denarii see coinage

Diocletian, Emperor 236, 252, 255,

10.12

- Baths 257, 11.1, 11.7
- Palace at Spalato (Split) 255-7,

11.4-11.6

Dionysius of Halicarnassus 25, 289

Dionysus 63, 65

Dogmatius, statue of 277-8, 12.14

Domitian, Emperor 124, 129, 131,

132, 137, **5.22**

- Flavian Palace 131-2, **5.11**, **5.12**

Domus Aurea see Golden House of

Nero

Doryphorus (Polyclitus) 88–9, **3.8** drilling (of sculpture) 134, 136, 200,

218, 222, 225, 227, 229, 243, 264

Du Pérac, E.: Baths of Diocletian 11.7

Egypt, Fayum: portraits 203,

8.12-8.14

Elagabalus, Emperor 239

El Djem: amphitheater 233, 9.20

encaustic paintings 203, 8.12-8.14

Ephesus 137

- Great Antonine Relief 200, 8.7, 8.8

- *Hanghäuser* (slope houses) 281–2, **12.23–12.25**

Library of Colour 10

- Library of Celsus 182, **7.27**

- Temple of Hadrian 181-2, **7.20-7.22**

Etruscans 14, 19, 23-5, 40, 43

- animal bronzes 29-30, 1.1, 1.13

- architecture 25, 27, 1.7-1.9

- canopic urns 27, 1.10

- Mars of Todi (bronze statue) 33, 1.17

- portraits 34-6, 1.18-1.21

- sarcophagi 31, 33, 1.14, 1.16

- temple terracottas 28-9, 1.11

- urn of Arnth Velimnas 31, 33, 1.15

- wall paintings 36-40, 1.22-1.27

Fabius 55, 2.16

Fabius Pictor 44

Famulus 121

Fannius, 55, 2.16

Faustina the Elder 196-7, 8.2

Faustina II 200, 205, **8.8, 8.18**

Fayum: portraits 203, **8.12–8.14**

Flavian era 122, 124, 149

- Arch of Titus 122, 128-9, 131

5.7–5.10

- Colosseum 124, 126, 128, **5.2-5.6**

- Flavian Palace 131-2, **5.11**, **5.12**

- imperial reliefs 132-3

- plebeian reliefs 134

- portrait sculpture 134, 137,

5.17-5.22

- see also Herculaneum; Pompeii

Fortuna, Sanctuary of (Praeneste) 66,

71-2, 2.28, 2.34-2.36

Fortuna Virilis, Temple of (Rome) 73–4, **2.40**

Forum, Roman see Rome

France:
- Nîmes: Pont du Gard 69, **2.33**

- Orange: triumphal arch 107, 4.3

François, Alessandro 39

Frangipani Palace, Rome 129, 5.8

frescos see wall paintings

frontality 194, 212, 227, 261, 268, 275

Gaius Caesar 94, 104, 3.20

Gaius, Emperor see Caligula

Galba, Emperor 124

Galerius, Emperor 255

- Arch and Mausoleum, Thessalonica 259-61, 11.11-11.13

Gallienus, Emperor 246-7, 248, 10.10 Gemma Augustea 106-7, 131, 4.1 Germany: Trier

- Basilica 279-80, 12.16-12.18
- Porta Nigra 233, 235, 9.24

Gérôme, Jean-Léon: Thumbs Down 128, 5.6

Gessius family, tomb relief of 52, 2.9 Geta 222, 225, 227, 233, 9.2, 9.7, 9.11 Giulio Romano 121

Golden House of Nero 120-1, 124, 153, 4.16, 4.17, 4.23, 4.24, 6.1

Gordian, Emperors 243 Greece 18-9, 40, 44, 63

- Aegina: Temple of Aphaia 27, 1.8
- Anavysos Kouros 28-9, 1.12
- Delos 54, 134, 2.14
- Delphi: monument to Aemilius Paullus 47, 2.2
- Doryphorus (Polyclitus) 88-9, 3.8
- head of Laocoön 110. 4.6
- + Parthenon (frieze) 94, 3.21
- pottery 25
- Stele of Hegeso 92, 3.17
- Thessalonica: Mausoleum and Arch of Galerius 259-60, 11.11-11.13 grotteschi 121

Hadrian, Emperor 16, 121, 164, 165-6, 168, 171, 179-80, 186, 196, 200, 8.8

- Library of Celsus, Ephesus 182, 7.27
- Mausoleum 179, 7.16
- Pantheon 168, 175, 177-8, 7.9 - 7.13
- portraits 183, 7.26
- Temple at Ephesus 181-2, 7.20 - 7.22
- Temple of Venus and Roma 179, 7.14, 7.15
- Villa, Tivoli 171–4, **7.1–7.7** Hadrian's Wall 79, 180-1, 7.18, 7.19 hairstyle 89, 134-7, 222, 240, 243-4, 246, 3.11, 3.12, 5.17-5.22, 9.3, 10.1, 10.3, 10.6, 10.8

Hanghäuser (slope houses), Ephesus 281-2. 12.23-12.25 Haterii, Tomb of the 134, 5.16 Hegeso, Stele of 92, 3.17

Hellenistic art 19, 48-9, 110, 159, 203,

2.5, 4.6, 6.12, 8.11

Herculaneum 56, 62, 138, 139-40

- Basilica 145, 5.33
- Samnite House 61, 2.17
- Villa of the Papyri 67, 2.29
- wall paintings 61, 145, 2.17, 5.32, 5.33

Herodotus 24, 289

Hippocrates 72

Hippo Regius: mosaic from 261, 11.14

Homer 289

- *Iliad* 30
- Odyssey 65

houses see villas and houses

Housesteads 79, 180-1, 7.18

Hunt Chronicle (mosaic) 261, 11.14

impasto, Villanovan 25, 1.5

insulae 182, 7.24

Iron Age 20, 23

Ischia, island of 25

Istanbul see Constantinople

Italy, maps 0.2, 1.2

Jefferson, Thomas 75

Julia Domna 221, 222, 227, 230, 233,

9.2, 9.5, 9.12

Julian, Emperor 287

Julio-Claudian era 16, 100

- altar frieze 104, 114, 4.14
- Aqua Claudia 117-8, 4.19, 4.20
- emperors 103, 104, 106, 4.7
- patronage in provinces 107
- portrait sculptures 110-2,

4.8 - 4.10

- relief sculptures 114-5
- Sebasteion reliefs, Aphrodisias 115,
- Sperlonga sculptures 108, 110, 4.4,
- Underground Basilica 118, 4.21, 4.22
- Vigna Codini columbaria 112,

4.11 - 4.13Julius Caesar 17, 52, 53, 54, 79, 80, 83,

93, 160 - denarius **2.10**

Junius Bassus, Sarcophagus of 283-5,

12.27

- Jupiter:
- Augustus as 106, 4.1
- Claudius as 111, 4.9

Jupiter Anxur, Sanctuary of (Terracina) 72-3, 2.38, 2.39

Jupiter Capitolinus, Temple of (Rome) 27, 1.9

Juvenal 120

Kobell, F.I.: Temple of Minerva Medica 12.22

Kouros, Anavysos 28-9, 1.12

Laocoön, head of 110, 4.6

lararium 147, 5.38

Late Antique art 268

Latium 40

Leptis Magna 221, 228

- Arch of Septimius Severus 225, 227, 9.8-9.12

- Hunting Baths 229, 9.15, 9.16
- Severan Basilica 229, 9.14
- Severan Forum 228-9, **9.13**

Library of Celsus, Ephesus 182, 7.27 Libya:

- Sabratha: theater 233, **9.23**
- see also Leptis Magna

Livia 86, 89, 90, 93, 104, 106, 114, 3.11

- House, Palatine Hill 100, 3.29
- Villa, Prima Porta 86, 99-100, 3.26

Livy 40, 43, 289

Lucius Caesar 94, 104

Lucius Verus, Emperor 196, 200, 203,

8.8, 8.10, 8.11

Ludovisi Sarcophagus 240, 250-1,

10.14, 10.15

Lydians, the 24-5

Malibu, California: Getty Museum 67, 2.30

Manganello, head from 34, 1.18

marble, use of 50, 58, 61, 190

Marcellus, Theater of 84-6, 3.5, 3.6

Marcus Aurelius, Emperor 196, 200, 207, 8.8, 8.9

- Column 208, 210, 212, **8.21-8.26**

- equestrian statue 205, 8.15, 8.16
- triumphal arch 207-8, 8.20

Mark Antony 16, 54

- denarius 54, 2.15

Mars of Todi (Etruscan) 33, 1.17

Mars Ultor, Temple of (Rome) 83, 3.1,

masks, Republican 50, 62, 2.19

Mau, August 58

Maxentius, Emperor 257-8, 268, 11.2 - Basilica 258-9, 11.8-11.10 Maximian, Emperor 255, 257 Maximinus Thrax, Emperor 243, 10.1 megalography, Greek 63 Melfi: sarcophagus 215, 8.31 Michelangelo, Buonarroti: - Campidoglio, Rome 205, 8.16

– Santa Maria degli Angeli 257, 11.1 Mildenhall: silver dish 266, 285-6, 12.28 Milvian Bridge, Battle of 257-8,

268, **11.2** Minerva Medica, Temple of (Rome) 280-1. 12.20-12.22 Mithridates VI, of Pontus 54 mixed viewpoints (in painting and sculpture) 149, 160, 206-7, 227, 5.40, 8.19, 9.11

mosaics:

- Baths of Neptune, Ostia 174, 7.8 - fourth-century 261-2, 11.3, 11.14,

11.15

- in Hadrian's Villa 174, 7.7, 7.8

- Pompeian 147, 5.35

- Roman Republican 65-7, 2.26, 2.27

- in Santa Costanza 280, 12.6

Neptune, Temple of (Rome): reliefs 47-8, 2.3, 2.4 Nero, Emperor 108, 110, 111-2, 120, 121, 124, 4.10 - Golden House 120-1, 124, 153,

4.16, 4.17, 4.23, 4.24, 6.1 Nerva, Emperor 132

Nile Mosaic 44, 66-7, 2.28 Nîmes: Pont du Gard 69, 2.33

Octavian see Augustus oculus 120, 178, 7.13 Odysseus, head of 108, 110, 4.5 Odyssey Landscapes (wall paintings) 65, **2.25** Oplontis, villa at 62, 2.19 Orange: triumphal arch 107, 4.3 Orator, The (Etruscan bronze) 35-6, 1.21

orders, architectural 85-6, 3.6 Ostia:

- apartment houses 182, 7.24

- Baths of Neptune 174, 7.8

- Capitolium 74-5, 2.42

- castrum 79, 2.46, 2.47

- Horrea Epagathiana 183, 7.23

- plan 2.46

Otho, Emperor 124

Paderni, C.: Centaur and Youth holding Lyre 5.23

paintings: encaustic 203, 8.12-8.14 see wall paintings

Palladio, Andrea 75

Palmyra 230, 9.17

- funerary reliefs 230-1, 9.18

Pannini, Giovanni: Interior of the Pantheon 7.11

Pantheon, the 168, 175, 177-8, 7.9-7.13

Parthenon, the: frieze 94, 3.21

Parthia 166

patricians 16,18

pattern, use of 29, 33, 163, 231, 1.1,

1.17, 6.17, 9.18

Pennsylvania Railroad Station, New York City 236, 9.30

Pergamon: Altar of Zeus 48-9, 110, 2.5

Perrault, Claude: engraving 3.6

perspective, use of 48, 63, 65, 99, 145,

261, 286; see also mixed viewpoints Perugia: Tomb of the Volumnii 31, 33,

1.15

Philip the Arab, Emperor 244, 10.4, 10.5

Philoxenos of Eretria 65

Phoenicians, the 25

Piazza Armerina, Sicily: mosaic from 261-2, 11.3, 11.15

Piero della Francesca: Battle of the Milvian Bridge 258, 11.2

Piranesi, Giovanni 75

- Great Baths, Hadrian's Villa 171, 7.2

Pithecusae, Ischia 25

plaster, use of 61, 2.17; see also stucco decorations

plebeians 16

- style 18, 56

Pliny the Elder 28, 44, 58, 65, 66, 121, 289

Pliny the Younger 138-9, 289

Plotinus 247-8, 10.11

Plutarch 53, 289

Polybius 50-1, 289

Polyclitus: Doryphorus (Spearbearer) 88-9.3.8

Pompeian styles:

- First 58, 61, 2.17

- Second 61-3, 65, 99-100, 2.18-2.25, 3.26-3.29

-Third 100, 121, 3.30, 3.31, 4.16

- Fourth 121, 143, 145, 147, 149, 4.17, 5.30-5.34, 5.36-5.40

Pompeii 56, 58, 138, 139-40, 5.24,

- caldarium in Forum Baths 140, 5.26

- floor mosaic 147, 5.35

- House of the Faun 65

- House of Julia Felix 149, 5.36

- House of the Silver Wedding 67, 69, 2.32

- House of the Vettii 143, 145, 147, 5.29-5.31, 5.38

- sacred landscape 100, 3.31

- Stabian baths 140, 5.25

- Temple of Apollo 140, 5.28

- Villa of the Mysteries 63, 2.23, 2.24

- wall paintings 63, 65, 143, 145, 147, 149, 2.23, 2.24, 5.30, 5.31, 5.34, 5.36-5.40

Pompey, Emperor 17, 53, 2.11

- denarius **2.12**

- Theater 84, 3.4

Pont du Gard, Nîmes 69, 2.33

Poppaea 62

porphyry, use of 263, 264

Porta Nigra, Trier 233, 235, 9.24

portraits, encaustic 203, 8.12-8.14 portrait sculpture:

- Antonine 196-7, **8.1, 8.2**

- Augustan 86-9, 94, **0.5, 3.7,** 3.9-3.12, 3.20

- Constantinian 275, 277-8, 12.10-12.13

– Flavian era 134, 137, **5.17–5.22**

- Hadrianic 183, 185-6, 7.26, 7.28 - 7.31

- Julio-Claudian 110-2, 4.8-4.10

- under Marcus Aurelius and Lucius Verus 200, 203, 205, 8.9-8.11

- Republican 50-4, 2.6-2.8, 2.11, 2.13

- Severan 221-2, 235-6, 239,

9.2-9.5, 9.25, 9.26, 9.32

- under soldier emperors 242-8, 10.1, 10.4, 10.6-10.12

- Tetrarchic 263-4, 11.17, 11.18

- third-century 242-3

Portus: harbor 117

pottery:

- Etruscan 25, 1.6
- Greek 25
- Villanovan 25, **1.5**

pozzolana concrete 71, 117

Praeneste 40, 66

- Nile Mosaic 44, 66-7, 2.28
- portrait from 89, 3.12
- Sanctuary of Fortuna 66, 71–2,**2.34–2.36**

Prima Porta:

- Augustus 17-8, 86-7, **0.5, 3.7**
- Villa of Livia 86, 99–100, **3.26** propaganda, art as 16, 87, 90 Pupienus, Emperor 243

Rabirius 132

Raphael 121

recarving (of sculpted heads) 132 Regolini-Galassi Tomb 23, **1.4** relief sculpture 17–8

- Antonine 200, 8.8
- Augustan period 52, 90-4, 96, 99, **2.9**, **3.13-3.16**, **3.18-3.19**, **3.22**
- Constantinian 268, 271, 273-5, **12.2-12.5**, **12.7-12.9**
- Flavian era 132-3, 134
- Hadrianic 186, 188-91, 193, **7.32-7.38**
- Julio-Claudian 114-5
- in Marcus Aurelius' reign 205–8,210, 212, 214–6, 8.17–8.35
- Roman Republican 47-9, **2.2-2.5**
- Severan 222-3, 225, 227, 230-1, **9.1, 9.7, 9.9-9.14, 9.18**
- Tetrarchic 259, 260-1, 264, **11.13**, **11.19**
- Trajanic 156, 158-61, 163-6, **6.9-6.20, 6.22-6.24**

Renaissance, the 121, 126, 287

Roman Empire, map **0.1** Roman Republic:

- aqueducts 69, 71, 2.33
- architecture 67, 69, **2.29-2.32**
- coinage 52, 53, 54, **2.10, 2.12, 2.15**
- founding of 77
- funerary reliefs 52, 2.9
- historical relief sculpture 47–9,2.2–2.5
- mosaics 65-7, **2.26-2.28**
- portraiture 50-1, 52-4, **2.6-2.8**,

2.11, 2.13, 2.14

- sanctuaries 71-3, 2.34-2.39
- sarcophagus 46, 2.1
- -temples 73-5, 2.40-2.42
- villas and houses 67, 69, 2.29-2.32
- wall paintings 55–6, 58, 61–3, 65,2.16–2.25

Rome 14, 19, 0.3

- apartment houses 182-3, 7.25
- Arch of Constantine 186, 264, 268, 271, 273-4, **7.32**, **12.1**-**12.5**, **12.7**, **12.8**
- Arch of Septimius Severus 222–3,225, 9.1, 9.6, 9.7
- Arch of Titus *122*, 128–9, 131, **5.7–5.10**
- Aurelian Wall 248, 10.13
- Basilica Aemilia 77, 96, 99, **3.24, 3.25**
- Basilica Julia 79
- Basilica of Maxentius and Constantine 258–9, 11.8–11.10
- Basilica Ulpia 155, 6.7
- Baths of Caracalla 236, 9.28, 9.29
- Baths of Diocletian 257, 11.1, 11.7
- Baths of Trajan and Titus 153, 6.1
- Campidoglio 205, 8.16
- Cancelleria reliefs 132-3, **5.13, 5.14**
- Castel Sant' Angelo see Hadrian's Mausoleum
- Colosseum 124, 126, 128, **5.2-5.6**
- Column of Antoninus Pius 205–7,8.17–8.19
- Column of Marcus Aurelius 208, 210, 212, **8.21–8.26**
- Column of Trajan 17, 150, 153, 155–6, 158–61, 208, 210, 212, 0.4, 6.8–6.16
- Curia 75
- Esquiline Hill tomb wall painting 55–6, 2.16
- Flavian Palace 131-2, **5.11**, **5.12**
- Forum 74, 75, 77, 79, **2.43-2.45**
- Forum of Augustus 83, 104, 114, **3.1, 3.2, 4.14**
- founding of 40, 43, 92
- Frangipani Palace 129, 5.8
- Golden House of Nero 120–1, 124, 153, **4.16**, **4.17**, **4.23**, **4.24**, **6.1**
- Hadrian's Mausoleum 179, 7,16
- Head of Constantine 275, 277, **12.10–12.12**
- House of the Griffins 61-2, 2.18

- House of Livia 100, 3.29
- Marcus Aurelius on horseback 205,8.15, 8.16
- Markets and Forum of Trajan153–6, 6.3–6.7
- Old St. Peter's 278, **12.15**
- Palatine Hill 61, 108
- Pantheon *168*, 175, 177-8, **7.9-7.13**
- Porta Maggiore 118, **4.20**
- Sacred Way 75, 2.45
- Santa Costanza 280, 12.6, 12.19
- Temple of Antoninus Pius and Faustina 197, **8.3**
- Temple of Fortuna Virilis 73-4, 2.40
- Temple of Hadrian 197-8, **8.4**, **8.5**
- Temple of Jupiter Capitolinus (plan) 27, **1.9**
- Temple of Mars Ultor 83, 3.1, 3.2
- Temple of Minerva Medica 280-1, **12.20-12.22**
- Temple of Neptune: reliefs 47-8, **2.3**, **2.4**
- Temple of Venus and Roma 179,7.14, 7.15
- Temple of Venus Genetrix: frieze133, **5.15**
- Theater of Marcellus 84-6, 3.5, 3.6
- Tomb of Augustus 84, 3.3
- Tomb of the Haterii 134. 5.16
- Underground Basilica 118, 4.21,4.22
- Villa Farnesina 100, 103, 3.27,3.28, 3.32

Romulus and Remus 29, 43, 83, 93, 1.1, 8.17

Rumania, Adamklissi: Tropaeum Traiani 163, **6.17**, **6.18**

"rustication" 118

Sabina 183, 7.28, 7.29

Sabratha: theater 233, 9.23

sanctuaries:

- Asclepius, Cos 72, **2.37**
- Fortuna, Praeneste 66, 71–2, **2.28, 2.34–2.36**
- Jupiter Anxur, Terracina 72–3, 2.38,2.39

Santa Costanza, Rome 280, **12.6**, **12.19**

sarcophagi:

- from Acilia (c. AD 270) 251, 10.16

- Asiatic 191, 215, **7.36, 8.31**
- Attic 188-90, 191, **7.33-7.35**
- Badminton (Season) Sarcophagus 238-9.9.31
- of Balbinus 243-4, **10.2**, **10.3**
- -battle scenes 212, 8.27, 8.28
- -biographical 212, 214, 8.29
- Caffarelli Sarcophagus 91, 3.15
- Dionysiac themes 214-5, **8.30**
- Early Christian 283-5, 12.26, 12.27
- -Etruscan 31, 33, 1.14, 1.16
- garland 215-6, 8.35
- Ludovisi Sarcophagus 240, 250-1, 10.14, 10.15
- Roman Republican (of Lucius Cornelius Scipio Barbatus) 46, 2.1
- strigil 193, **7.37, 7.38**
- Velletri Sarcophagus 215, 8.32, 8.33
- Sardis 24, 107
- Marble Court 233, 9.21, 9.22
- Temple of Artemis 196-7
- sculpture see portrait sculptures; relief sculptures
- Sebasteion, Aphrodisias 115
- Senate, the 16, 17
- -building (Curia) 75, 2.44
- Severan period 84, 218, 220, 239 see Caracalla; Severus, Septimius
- Severus, Alexander, Emperor 239, 243,

- Severus, Septimius, Emperor 120, 175, 220-1, 228, 230, 233
- Arch, Leptis Magna 225, 227, 9.8-9.12
- Arch, Rome 222-3, 225, 9.1, 9.6, 9.7
- Basilica, Leptis Magna 229, 9.14
- Forum, Leptis Magna 228-9, 9.13
- portraits 221-2, 9.2-9.4
- shadow, use of (in painting) 61–2
- silver dishes 94, 285-6, 3.23,

12.28-12.31

- Sixtus V, Pope 158
- soldier emperors, the 16, 240, 242, 251
- coins 242
- portrait sculptures 242-8, 10.1, 10.4, 10.6-10.12
- sarcophagi 243-4, 250-1, 10.2, 10.3, 10.14-10.16
- Spalato see Split
- Spearbearer (Polyclitus) 88-9, 3.8

Sperlonga: Tiberius' villa 108, 110,

4.4, 4.5

Split: Diocletian's Palace 255-7,

11.4-11.6

- Stabiae 138
- stock themes 161, 189
- stucco decorations 103, 118, 3.32,

4.21, 4.22

- Suetonius 83, 110, 120-1, 289 Sulla, Lucius Cornelius 17, 44, 66
- Baalbek: Temple of Venus 231, 9.19
- Palmyra: funerary reliefs 230-1,
- Palmyra: ruins 230, 9.17

Tacitus 107, 120, 138, 147

- Tarquinia:
- Etruscan wall paintings 36-40, 1.22, 1.23, 1.25-1.27
- Villanovan amphora (Bocchoris Tomb) 25, 1.5
- Tarquinius Superbus 16, 34 temples:
- Antoninus Pius and Faustina 197, 8.3
- Artemis, Sardis 196-7
- Asclepius, Cos 72, 2.37
- Capitolium, Ostia 74-5, 2.42
- Cosa 74, 2.41
- Etruscan 25, 27, 1.7, 1.9
- Fortuna Virilis 73-4, 2.40
- Hadrian, Ephesus 181-2, 7.20-7.22
- Hadrian, Rome 197-8, **8.4, 8.5**
- Jupiter Capitolinus (plan) 27, 1.9
- Mars Ultor 83, 3.1, 3.2
- Minerva Medica 280-1, 12.20-12.22
- Neptune (reliefs) 47-8, 2.3, 2.4
- Venus, Baalbek 231, 9.19
- Venus and Roma 179, 7.14, 7.15
- Venus Genetrix (frieze) 133, 5.15
- Terracina: Sanctuary of Jupiter
- Anxur 72-3, 2.38, 2.39
- terracottas, Etruscan 28-9, 34, 1.11, 1.18; see also sarcophagi; urns
- tetrapylon 225, 259-60, 9.8, 11.12
- tetrarchic cubism 266
- Tetrarchs, the 16, 252, 255
- portrait sculpture 263-4, 11.17, 11.18
- relief sculpture 259, 260-1, 264, 11.13, 11.19
- see Constantius Chlorus; Diocletian;

- Galerius; Maxentius; Maximianus
- Thamugadi see Timgad
- theaters:
- Maritime Theater, Hadrian's Villa 173-4. 7.6
- Theater of Marcellus 84-6, 3.5, 3.6
- Theater of Pompey 84, 3.4
- Theater at Sabratha 233, 9.23
- see also amphitheaters
- Theodosius I, Emperor, 286, 12.31
- Obelisk 275, 12.9
- Thessalonica: Arch and Mausoleum of Galerius 259-61, 11.11-11.13
- Tiberius, Emperor 104, 106, 107, 108, 110
- Timgad 166-7, 6.25, 6.26
- Titus, Emperor 124, 128, 137, 5.22
- Arch 122, 128-9, 131, **5.7-5.10**
- Tivoli: Hadrian's Villa 171-4, 7.1-7.7
- Torre Annunziata: Villa of Oplontis
- wall painting 62, 2.19 tortoise formation 160-1, 6.14
- Trajan, Emperor 16, 150, 153, 164, 172, 6.2
- Anaglypha Traiani 164, 6.20
- Arch at Benevento 164-6,
 - 6.21-6.24
- Baths 120, 153, 6.1
- Column 17, 150, 153, 155-6, 158-61, 208, 210, 212, 0.4,
 - 6.8-6.16
- "Great Trajanic Frieze" 163, 6.19
- Markets and Forum 153-6,
- 6.3 6.7
- Timgad (Thamugadi) 166-7, 6.25,
- Tropaeum Traiani 163, 6.17, 6.18
- travertine masonry 126 Trebonianus Gallus 244-6, 10.6-10.8
- Basilica 279-80, 12.16-12.18
- Porta Nigra 233, 235, 9.24
- triumvirate, first 53, 54 triumvirate, second 54
- denarius 54, 2.15
- tufa, use of 46, 71
- Tunisia:
- Carthage 19
- El Djem: amphitheater 233, 9.20
- Hippo Regius (Bône): Hunt Chronicle mosaic 261, 11.14
- Sabratha: theater 233, 9.23

Turkey see Ankara, Aphrodisias, Constantinople, Cos, Ephesus, Pergamon, Sardis Tyrrhenus 25

Underground Basilica, Rome 118, **4.21, 4.22**

urns, Etruscan 27, 31, 33, 1.10, 1.15

Valentinian II, Emperor 286, **12.31** vaults, construction of 69, 71 Veii:

- Etruscan temple 25, 27, 1.7
- terracotta figures 28, 29, 1.11

Velletri Sarcophagus 215, 8.32, 8.33

Vel Saties, portrait of (François Tomb, Vulci) 39, **1.24**

Venice: St. Mark's Cathedral 263, 11.17

Venus and Roma, Temple of (Rome) 179, **7.14**, **7.15**

Venus Genetrix, Temple of (Rome): frieze 133, **5.15**

verism, Republican 50–1, **2.6–2.8** Vespasian, Emperor 122, 124, 132,

5.1, 5.14

Vesuvius, Mount 147, 5.39

- eruption of 122, 138-9

Vico, Enea: view of Rome 208, 8.21

vicomagistri 115, 4.15

views, portraying 160

Vigna Codini: columbaria 112,

4.11-4.13

Villanovans 14, 23

- amphora 25, 1.5

- fibula **1.4**
- helmet 1.3
- villas and houses:
- apartment houses, Ostia 182, 7.24
- apartment houses, Rome 182-3, 7.25
- Golden House of Nero, Rome 120-1, 124, 153, **4.16**, **4.17**, **4.23**, **4.24**, **6.1**
- House of the Faun, Pompeii 65
- House of the Griffins, Rome 61–2, **2.18**
- House of Julia Felix, Pompeii 149,**5.36**
- House of Livia, Rome 100, **3.29**
- House of the Silver Wedding, Pompeii2.32
- House of the Vettii, Pompeii 143, 145, 147, **5.29-5.31, 5.38**
- patrician Roman houses 67, 69, 2.31,2.32
- Samnite House, Herculaneum 61,**2.17**
- villa at Boscoreale 62–3,2.20–2.22
- villa at Boscotrecase 100, 3.30
- Villa Farnesina 100, 103, **3.27, 3.28,**
- Villa of Livia, Prima Porta 86, 99–100, **3.26**
- Villa of the Mysteries, Pompeii 63, 65, **2.23**, **2.24**
- Villa of Oplontis, Torre Annunziata62, 2.19
- Villa of the Papyri, Herculaneum 67,2.29

Virgil: The Aeneid 40, 43, 83, 93, 145

Vitellius, Emperor 124 Vitruvius 25, 74, 289 Vulca 27 Vulci:

- Etruscan tomb wall painting 39, 1.24

- sarcophagus 33, **1.16**

wall paintings 55, 56, 58

- Augustan period 99–100,3.27–3.31
- in Ephesus slope houses 281–2,12.24, 12.25
- from tomb on Esquiline Hill,Rome 55–6, 2.16
- Etruscan 36-40, 1.22-1.27
- First Pompeian style 58, 61, 2.17
- Second Pompeian style 99–100,3.26–3.29
- Third Pompeian style 100, 121, **3.30, 3.31, 4.16**
- Fourth Pompeian style 121, 143, 145, 147, 149, **4.17**, **5.30**-**5.34**, **5.36**-**5.40**

warehouses 183, 7.23

Wood, Robert: The ruins of Palmyra **9.17**

Wren, Sir Christopher 75

Yugoslavia:

- Split: Diocletian's Palace 255–7,
 11.4–11.6
- Sremska Mitrovica 255

Zeuxis 174, 7.7